How to draw your
DRAGON

HARPER
DESIGN

An Imprint of HarperCollins Publishers

First edition published in 2012 by
Harper Design
An Imprint of HarperCollins*Publishers*
10 East 53rd Street
New York, NY 10022
Tel.: (212) 207-7000
Fax: (212) 207-7654
harperdesign@harpercollins.com
www.harpercollins.com

Distributed throughout the world by
HarperCollins*Publishers*
10 East 53rd Street
New York, NY 10022
Fax: (212) 207-7654

Packaged by
maomao publications
Via Laietana, 32 4th fl. of. 92
08003 Barcelona, Spain
Tel. : +34 93 268 80 88
Fax : +34 93 317 42 08
www.maomaopublications.com

Publisher: Paco Asensio
Editorial coordination: Cristian Campos
Illustrations and texts: Sergio Guinot
Art direction and layout: Emma Termes Parera
Translation: Cillero & de Motta

Library of Congress Control Number: 2011942173

ISBN: 978-0-06206731-9

Printed in Spain
First Printing, 2012

Although we have tried to be as faithful and precise as possible to the original text in the translation, this book
may contain some inaccuracies due to changes in scientific nomenclature and the individual characteristics
of the original work.

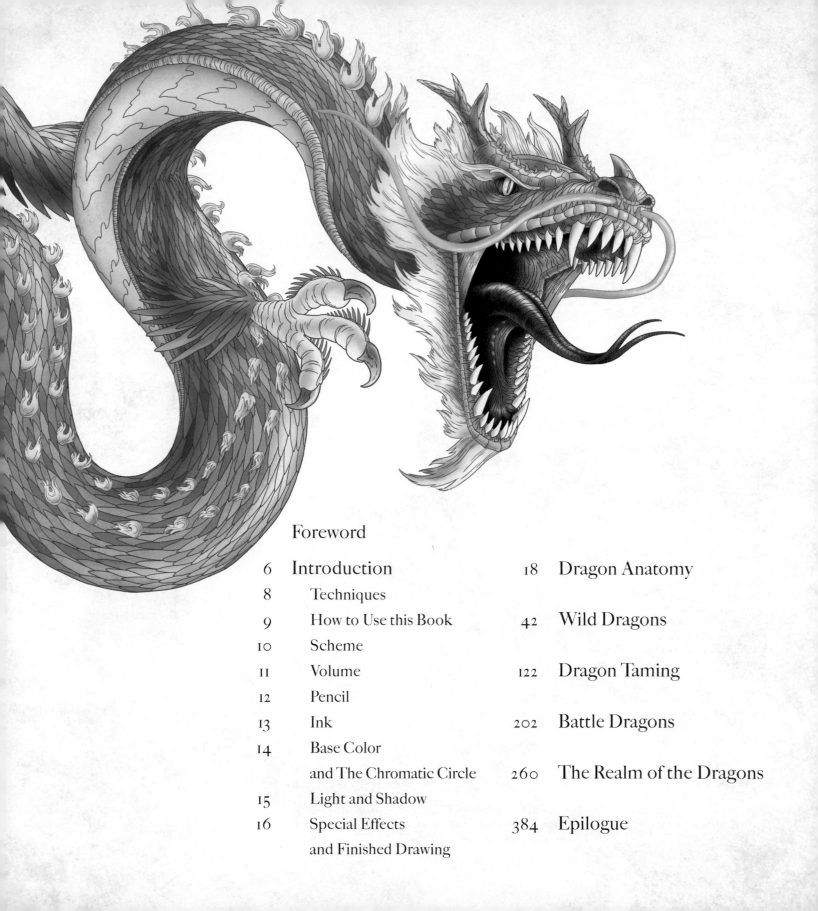

Foreword

Introduction

We are in the year 3112. My name is Sergio Guinot. I was born in 3073, and ten years ago, my life and the lives of all the inhabitants of the earth changed terribly. It began with a strange event that took place in Leenane, an old village in the west of Ireland. Its inhabitants claimed they were attacked by a terrible monster. It left scores of injured people and caused major damage, including the destruction of the bridge over the N59 road between Clifden and Westport.

Although word of the attack spread throughout the world, strengthened by tabloid media, it was never taken as more than an entertaining story probably created with the intention to publicize some old legend from the area. However, some months later, an Amazonian tribe described how they were attacked by a huge winged creature.

In the following months, two strange earthquakes attracted the attention of the authorities. The first of these was in Valencia, in the east of Spain, where something enormous tried to emerge from below the old riverbed of the Turin River, demolishing a large part of the age-old Serranos Towers and nearby buildings. Then again in Ireland, something shook the foundations of Leamaneh, leaving only the oldest wing of the structure standing.

The European government, for a reason I still do not understand, believed these incidents to be connected and set up an investigation team to study these events. Accompanied by an archaeologist and a paleontologist, and protected by seven elite soldiers

from the British SAS Y9, we set off to confirm or disprove the strange news and, if the information was correct, to identify and classify the beasts, study them, and discover their origins, their weak points, and how to trap them dead or alive.

As an illustrator, my mission is to gather all the evidence that the team considers important, and that is what I have been doing since we landed in Ireland's Shannon Airport. But since arriving at Leamaneh Castle, the terrible destruction has had a major impact on all of us. The earth has shaken again with such a roar that it seems to want to devour us.

Behind one of the destroyed walls and surrounded by dolmens, we found an old seal on the ground, on which we could see some ancient runes and strange sun symbols. Having studied them carefully, we concluded that this was an entrance to a sacred place. I believe that soon we will soon decode the enigma, we will open the seal, and we will go forward into the unknown. The sense of fear is ubiquitous. None of us is sure that we will get out of here alive.

I am going to reveal on these pages the key aspects of my work so that, should anything happen to me, someone else may continue my legacy.

If you are reading these lines, then maybe it is you who must take my place.

Techniques

There is not just a single way to draw.

There are as many ways of making an illustration as there are roads to Rome. Everything I am telling you is a suggestion based on my own experience. You should adapt my ideas to your own skills, reshaping my concept and choosing those paths that will help you find your own method, making you feel more comfortable and more satisfied with the results you obtain.

Much of the knowledge, tips, and secrets I will reveal to you in this work will be useful for you—and some of it will surprise you—but the truth is that an illustrator must be able to adapt to the circumstances, characteristics, and needs of the work. That is why we will not follow a single way of doing things in this book. We will follow different routes to achieve different objectives.

Since the end of the twentieth century, the boom in technology has meant that illustrations for publishing and web environments are mostly—or all—created using computers. This is due to several factors. Some related to creating the illustration, such as convenience, manageability, cleanliness, and the design tools offered by computers. Others unrelated, such as changes in printing technology, which has developed in order to physically reproduce the illustrations on the computer as accurately as possible. Undoubtedly, if you are an illustrator who wants to see your work published digitally or on paper, and you want to work for a publisher, it is essential that you use a graphics tablet with a light pen and become familiar with the most common graphics programs. The work you have in your hands is a clear example. It has been made using mostly digital methods, but many of the sketches and notes were done on the tablet that accompanies me wherever I go.

In any event, whether you opt for the latest technologies or for more traditional methods, I can assure you that this work, using explanations that are very simple and easily understood, will open the door to a wealth of new possibilities for expressing yourself using concepts you did not previously know or that you had not thought about in the way I will present them to you. These concepts are applicable to any illustration technique, whether digital or analog, modern or classical.

How to Use this Book

You do not need to understand all the concepts in depth from the beginning.

This book makes up a conceptual set, which for each exercise provides both general details on the illustration technique and specific details on the exercise, so you will get to learn more about the concepts as you advance through the book.

Each one of the exercises is divided into a presentation (in which you will be able to follow the incredible story that gave rise to this book) and several sections that will develop each one of the stages of the corresponding illustration.

We will go over basic ideas up to advanced drawing concepts, which will always be applied to the world of dragons, and we will progressively carry out exercises of differing methodology and complexity. Therefore, the concepts presented in one exercise will be applicable to the other exercises. Eventually, this will generate a solid base to carry out each step, which will allow us to apply the technique that is best matched to our next illustration. In addition, throughout the book there is a series of tips about what I believe a drawer should or should not do. These will help you to understand the concepts and will introduce you more easily to the world of professional illustrators.

Scheme

Creating the scheme is a stage in the illustration process that is typically unappreciated by aspiring drawers, but one that is considered very important by professionals. We do sometimes see professionals drawing a figure without pausing at this stage, but this is only because their extensive experience allows them to make a quick mental scheme when drawing simple figures and characters. But if we watch them in their day-to-day work, we will see that this stage is extremely important to them when they are creating complex characters.

Schemes, basic expressions of the figures to be drawn, are little more than a skeleton, mainly done using lines or volumes, which may be cubical or spherical. There has always been some dispute between those who opt for one method or the other, but perhaps it is most advisable to decide this on a case-by-case basis. In this work, we will make schemes using straight lines, curves, and cubic or spherical volumes depending on what is most appropriate and what will make our work easier.

Expressiveness transmitted by the scheme is passed on to all the subsequent stages of the illustration. Therefore, it is essential to have a correct scheme in order to achieve a good illustration. We should not simply accept the first scheme that comes from our pencil, but we should review it and modify it until we are certain it will be effective.

Volume

The stage of basic volumes and the pencil stage usually overlap, and the line between them is blurred. This is understandable, as it is difficult to define where a study of volumes finishes and where a sketch follows, and some artists use "volume stage" and "pencil stage" synonymously. In this work, we will differentiate the two.

By studying basic volumes, we will define the correct and main volumes of our character, giving body to the scheme, deciding the suitable space and weight of its parts, elements, and main accessories, and we will place them correctly in shape, size, and position. At this stage, it is not necessary to develop any of these elements. We will leave this to the next stage: the pencil.

In my case, even though I work in a digital environment, either because of nostalgia or because the opportunity presents itself, I sometimes carry out these first stages on paper or any other material on which I can use a pencil, pen, charcoal, or other device capable of making a line, and then I scan the best schemes and volumes. It is an advantage to know that these first stages of the illustrations can be carried out anywhere, even if you are far from your usual workplace and computer.

Pencil

The pencil may be carried out on different levels, from little more than a sketch up to a pencil that is very accomplished and detailed, depending on how sure you are about the drawing you are making. The best thing is to make marks and lines until you achieve the shape you are looking for, irrespective of whether the pencil is dirty and full of smudges. If you are not sure about the pencil, you should do another one or several more. The pencil often has more useless lines than the ink, which you make later to obtain a clean and definitive result.

A pencil is a spiritual and subjective instrument that is highly gratifying. It allows us to capture the essence of the drawn objects, their strength and movement. This is usually the stage of the drawing that offers the most freedom and fun, where we can imagine, change, and play with the elements of the drawing—much more than in any other stages of the illustration.

If the pencil is sufficiently detailed, the inking will be a simple process, and we will be able to focus on attaining a suitable line. In other words, if we have used the pencil to clarify "what," then with the ink, we can focus on "how."

On the other hand, if the pencil is not sufficiently detailed, we will be faced with a more complex inking process, in which the quality of our inking will fluctuate between areas of greater quality (those that had a more detailed pencil) and others with lower quality (those that had a more general pencil).

Ink

The classical method of freehand inking—tracing directly over the pencil on a new paper using a light table—found its equivalent in the addition of a new layer in drawing and design software. The result is the same: the ink defines the definitive appearance the drawing will have; we therefore need to pay it special attention.

The ink is the final frontier. It does not insinuate—it defines. Many people underestimate the importance of inking, but good drawers know that in order to obtain a high-quality illustration, we need to treat the pencil as if it is ink and the ink as if it is superior. Accordingly, the pencil is ink and the ink is life.

The different lines (fine, thick, soft, rough, straight, curved, angular, firm, shaky, etc.) will define different materials and textures. It is useful to search for new ways to represent different textures with a minimum of lines, while still making various elements of the illustration distinguishable and recognizable.

If you are working on a computer, you can decide to color the inks at any time. The best thing is to give the ink a similar, but darker, color than your character will be.

Warning: There are several methods of digital inking, but some make the ink too think or pixelated. I am going to explain an easy and safe method to correct this if it happens.

1. Select the ink layer.
2. Create a new layer and place it over the previous one. Remember that you can change the name and call it whatever you want ("colored ink," for example).
3. Choose a color using your program's main color selector.
4. In the new layer, fill in the selection that is still on your screen with the chosen color.

Easy, right? This new layer will prevent unpleasant surprises and will allow you to keep the original ink.

Base Color

In consideration of the modern coloring techniques of computers, it is a good idea to develop base colors on one or several layers, and on the higher layers to add light and shadows in such a way that the combination of them with the ink and colors creates the final desired appearance. The choice of colors is very important, and they need to be measured in saturation and range so as to create a balanced and attractive effect. With color, we define materials, textures, moods, goodness, evil, magic, reality, and fantasy.

It is a good idea to make small color sketches or notes, so as to study your options and remember important colors. Once you decide your base colors, you can apply them to your illustration.

In order to avoid a flat appearance in the coloring, it is best to offer some point of contrast, i.e. a touch of color that stands out from the general tone and makes the observer immediately aware of the illustration's chromatic richness.

The Chromatic Circle

If you do not know a great deal about color, the chromatic circle is an essential tool. Chromatic opposites usually combine well (red and blue or green and violet). Good results can also be obtained using only cold colors (blue or green) or warm colors (red, orange, and yellow).

Light and Shadow

In order to make it easier to visualize and study lights and shadows, they are presented in this book on a gray background with the inks removed.

The source of light, when there is one, will appear as a solar brooch burnished in gold, which has been specifically designed for this work. This icon shows us the direction from which the light illuminates the featured object and will help us to understand how we should place lights and shadows in order to obtain an optimum effect of solidity, volume, and three-dimensionality in the drawing. The source of light may be in any position along the 360° surrounding the illustration, but if the source of light is the sun, it is usually, as is to be expected, in the upper part.

We will mainly apply the following types of shadow:

OWN SHADOWS: those of the body due to its shape and position.

PROJECTED SHADOWS: those caused by the body or parts of the body on itself or on other surfaces.

HARD SHADOWS: those not softened or degraded.

SOFT SHADOWS: those that have been softened or degraded.

Whenever it is possible to freely choose the position of the source of light, we will place the source of light on the side to which the character is looking. This is important, as the face of a character defines it, and, when possible, should be illuminated and perfectly visible to the viewer. The source of light can always be on the level of the paper, a higher level than the paper, or a lower level.

Let us imagine a character looking at us from a full frontal position. If the source of light is on a level lower than the paper, the light will come from behind it, its face will be illuminated from behind. If the source of light is on the level of the paper, let us say to its left, one half of the character will be illuminated and the other half in shadows. If the source of light is on a higher level, outside the paper (which is the most common form, so as to have a good view of the front, face, and gesture of the character), then the character will appear illuminated and the shadows will be behind it—this also offers the advantage of helping to portray the character's volume.

Special Effects

Sometimes we will show the abilities or nature of the characters with so-called special effects, noting such things as brightness, auras, fire, and spiritual elements.

We will break down the method for obtaining the specific effects and discuss the use of computer techniques and filters that will allow us to obtain surprising results.

Finished Drawing

The finished drawing is the culmination of all the previous stages. In this stage, we see all the previous stages brought together, either matching perfectly or showing some unexpected defect that will force us to go back to work.

Sometimes in this stage, we retouch, change, or add something to the drawing—there is always time to adjust or improve details.

In the finished drawing stage, we should read the stages in reverse order. As we go back through the different steps, we will see how the combined layers separate, and this insight will guide us through future illustrations.

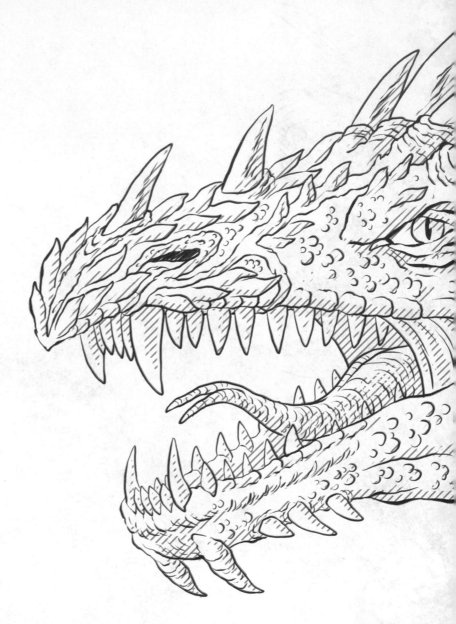

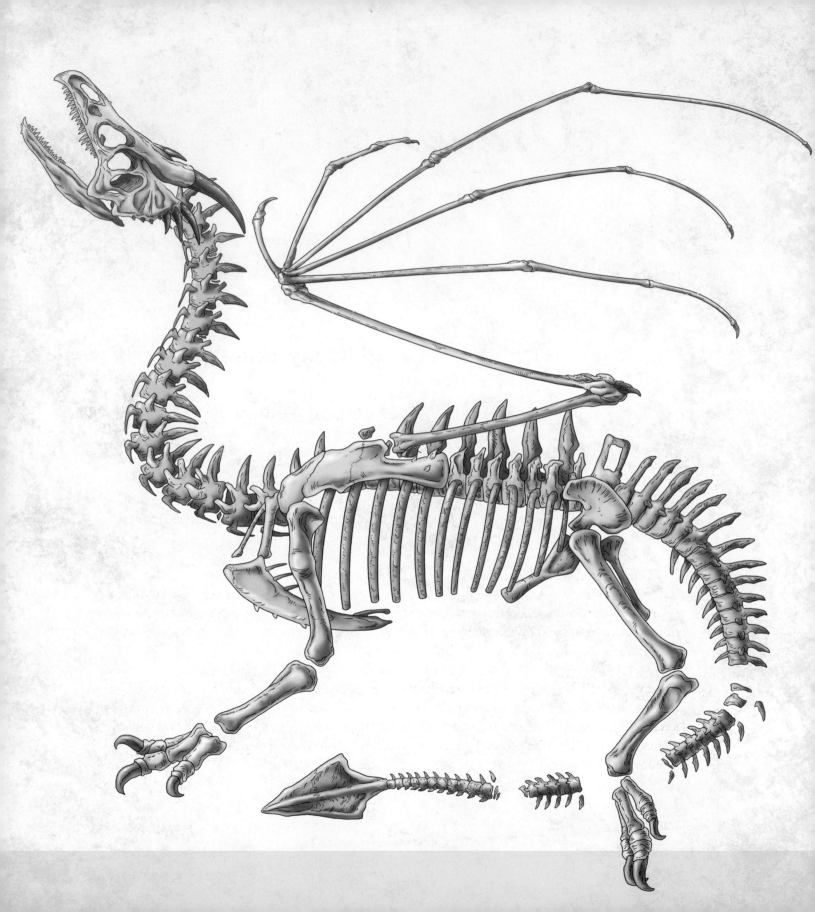

Dragon Anatomy

Dragon Skeleton

Dragon Teeth

Dragon Skin

Dragon Wings

To illustrate an animal, one should study animal anatomy. Knowledge about animal bone and muscle structures, and the function of these structures, will help us understand the body of an animal when we observe it and attempt to make realistic and believable drawings.

It is not only useful to examine the anatomy of current animals. Studying the anatomy of dinosaurs, the largest beasts to have ever set foot on the earth, and how modern illustrators have used their fossils to understand and interpret their anatomy, gives a vital comparison when making illustrations of large beasts and mythical or fantasy beings, about which we may only obtain some vague description.

What you must not do if you want to create a realistic or at least minimally convincing drawing, is to only use your imagination. You may forget essential aspects of animal anatomy, such as the size differences between the skull and jaw, the position and shape of the hips, the location of the shoulder blades, the size of the joints, the different types of skin, etc., and you will then run the risk of creating an unrealistic drawing.

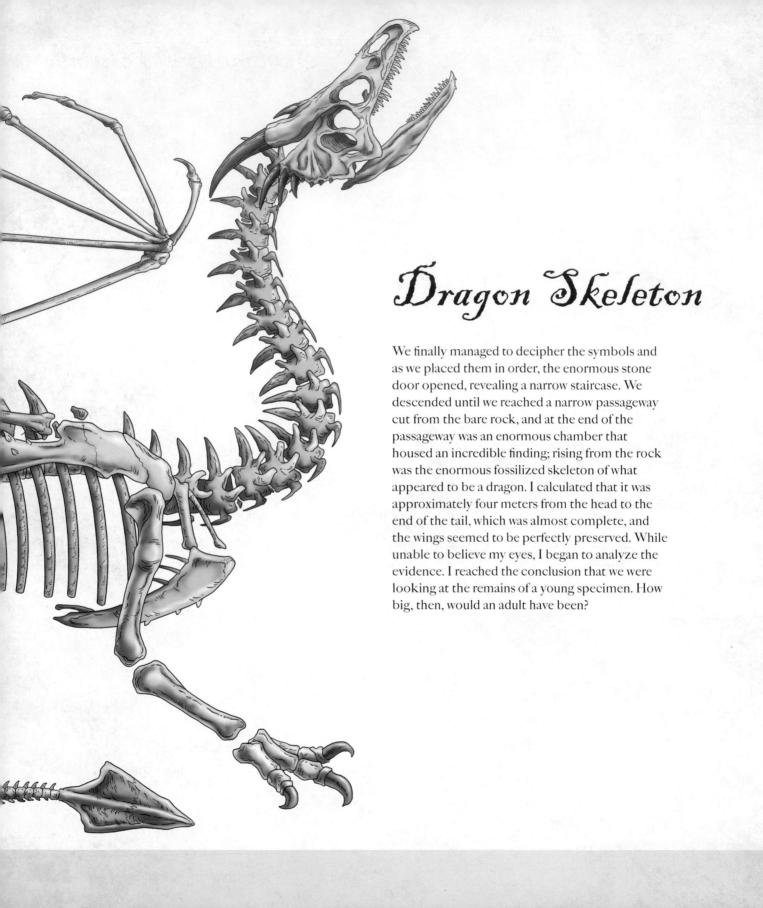

Dragon Skeleton

We finally managed to decipher the symbols and as we placed them in order, the enormous stone door opened, revealing a narrow staircase. We descended until we reached a narrow passageway cut from the bare rock, and at the end of the passageway was an enormous chamber that housed an incredible finding; rising from the rock was the enormous fossilized skeleton of what appeared to be a dragon. I calculated that it was approximately four meters from the head to the end of the tail, which was almost complete, and the wings seemed to be perfectly preserved. While unable to believe my eyes, I began to analyze the evidence. I reached the conclusion that we were looking at the remains of a young specimen. How big, then, would an adult have been?

Scheme and Volume

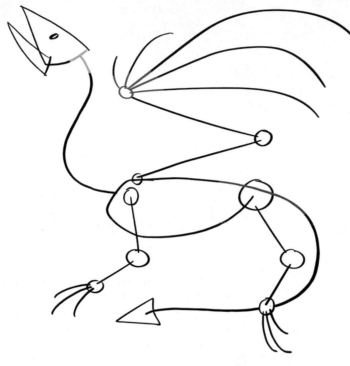

In the scheme, I highlighted three details: the neck, which comes out of the upper part of the cranium (green), not from the center or the lower part; the tail, which comes out from the upper part of the back (red); and the five bone structures that form the wing, which come from the same point (blue).

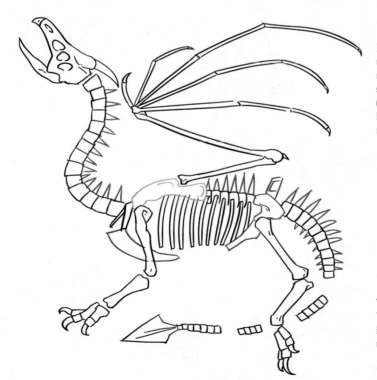

In making the basic volume, I placed the bones as spines running along the neck, back, and tail (blue); the monster shoulder blade, which held the wing (green), and the bones of the chest and hip (red)—keel of a bird and pelvis of a reptile... incredible!

TIP:
You can use colors to highlight important details or make it easier to understand each step.

Pencil and Ink

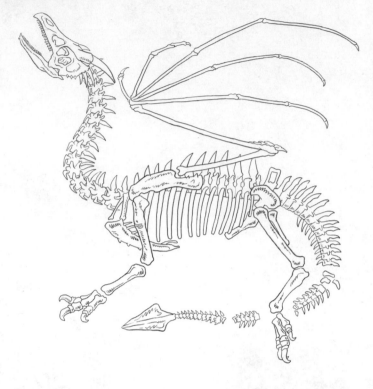

The pencil I present here is a pencil I cleaned up by tracing over my original pencil, which was so confusing that even I found it difficult to understand. However, I made sure that I included all the details that needed to appear in the finished drawing.

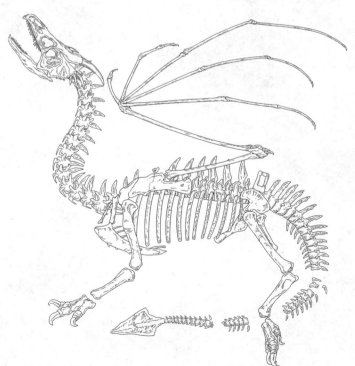

I knew that it would be easy to do a good inking from such a clean pencil. The short, curved lines were very useful for providing the bone with its characteristic appearance, volume, and texture. Thanks to them, the bone really looked like bone.

TIP:
Bear in mind that the errors in the pencil will be invisible, but the errors in the inking will always be visible.

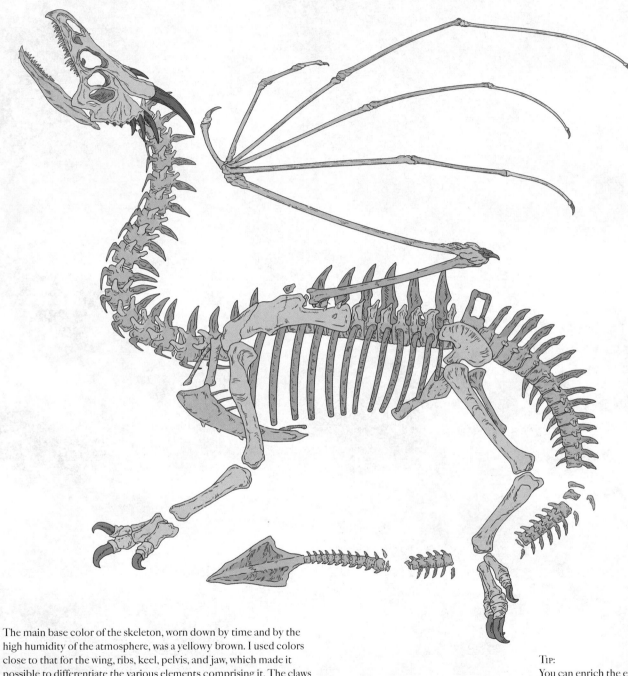

The main base color of the skeleton, worn down by time and by the high humidity of the atmosphere, was a yellowy brown. I used colors close to that for the wing, ribs, keel, pelvis, and jaw, which made it possible to differentiate the various elements comprising it. The claws of the legs and at the end of the wings, as well as the horns, were gray, indicating that they are of a different material and are harder than the bones. The teeth, although they can barely be seen at this stage, were of a clear color, almost white, and still frightening.

TIP:
You can enrich the elements of a single color, such as the bones of the wing, by giving close tones to each one of its parts.

Light and Shadow

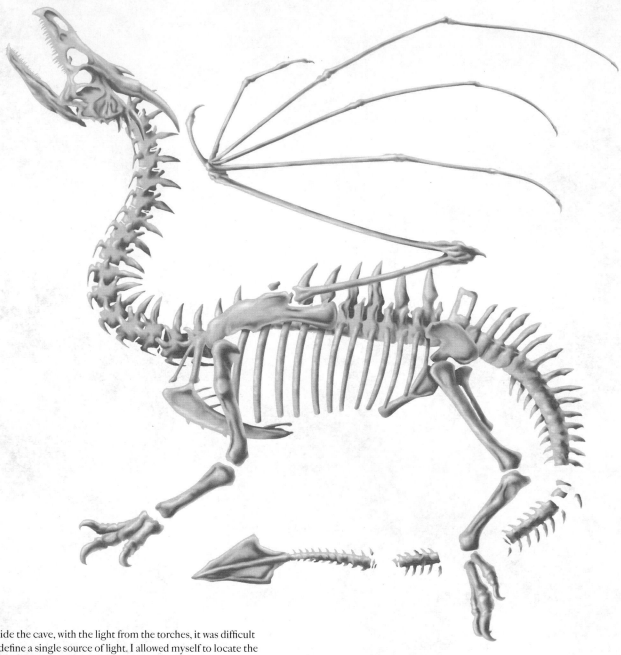

Inside the cave, with the light from the torches, it was difficult to define a single source of light. I allowed myself to locate the light and shadow in each one of the elements. The position of the light source and the shadow may seem contradictory in some cases, but the goal is to try to provide the figure with volume. I followed the ink lines, I removed the inking on this sheet, and I located the lights and shadows on a gray background so as to allow better visualization.

TIP:
If you are working with a computer, you should separate the layers of light from the layers of shadow.

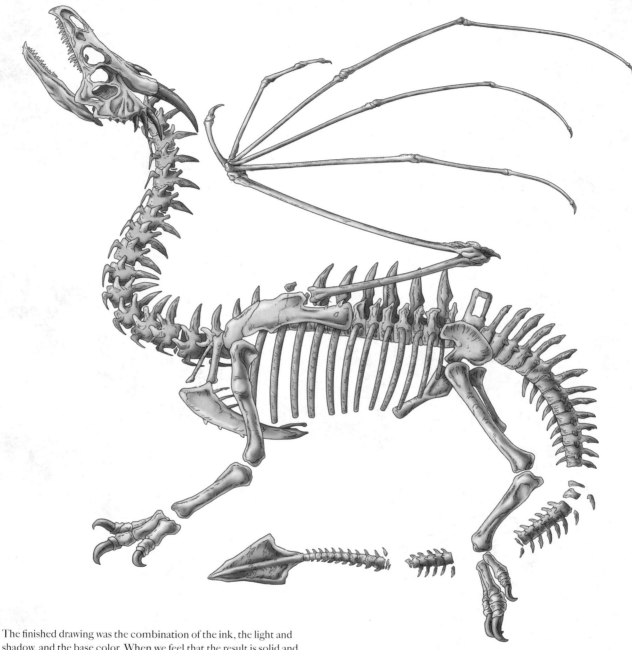

The finished drawing was the combination of the ink, the light and shadow, and the base color. When we feel that the result is solid and provides a sufficiently accurate reproduction of what we want to represent, we can consider it finished. However, if we are not satisfied by the final results or if there is something that does not fit, we should go back and adjust the ink (changing its color or its thickness), the lights and shadows (changing their opacity or color), or the base color (adjusting it).

TIP:
We should be careful not to be excessively perfectionist. There are some people who say we could spend our whole lives correcting just one work.

Dragon Teeth

After drawing the dragon's full skeleton, I focused on the skull of what once must have been a proud and fearsome beast. Some structures were common to those I had seen in the fossils of large, carnivorous dinosaurs, but strangely, it also possessed characteristics of herbivores and had cavities in the area of the nostrils that I had never seen before. Were these related to the dragon's mythical breath of fire?

What frightened me most were its numerous enormous and ghastly teeth, which, sharpened like saws and curving backward, would make it impossible for prey to escape from its lethal bite, and would rip through flesh like it was butter.

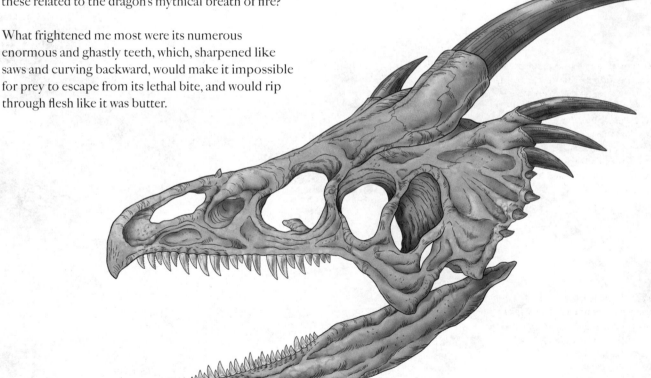

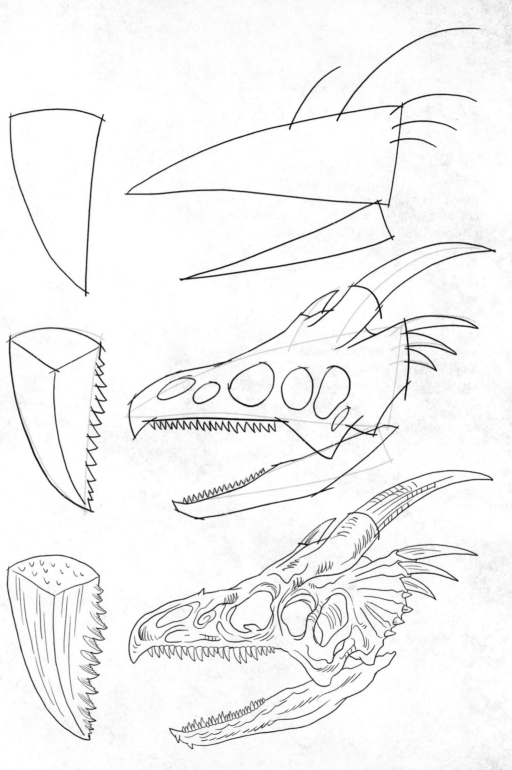

The scheme of the dragon's cranium was very simple: two triangles made with curved lines, with the upper triangle clearly bigger than the lower triangle. For the teeth, which we would show in detail, we followed the same principle.

I characterized the basic volumes by the appearance of the teeth, the gaps (with one, for the eye, clearly bigger than the others), the connection with the jaw, and the areas that would form the base for the horns. I performed a volume for the tooth in a simple way, dividing it into three areas and giving the area at the back the shape of a saw.

With the pencil, I included all the elements that would make that part of the inking. Perhaps the lines were not as perfect as they could have been, but the important thing is that they were all there.

TIP:
A scheme is good if you can imagine your perfectly finished drawing on those few lines.

Ink, Light, and Shadow

I decided to make the inking using pencil, although it was not very polished and was fairly crude. I felt I could do it, as I had already drawn the full skeleton and practiced with the type of ink lines necessary: short, curved lines that give the appearance of bone. I accompanied them with groups of dots that represent pores and small holes, and with long wavy lines that imitated the grooves typical of the bone. For the amplified tooth, the dots follow the shape of a V, and as it was a more polished material, the curved lines follow the shape of the tooth.

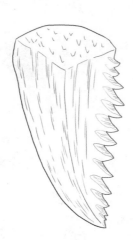

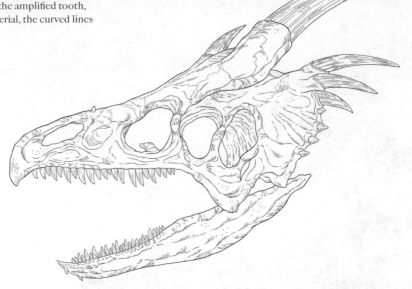

The general pattern for the light and shadow can be seen perfectly in the upper horn. I included a thick shadow on one side and slightly fine light on the opposite side. However, in the areas that sink toward the inside of the paper, I only included shadows. I did not yet take into account one single source of light because I was only practicing with the sensation of volume.

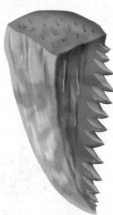

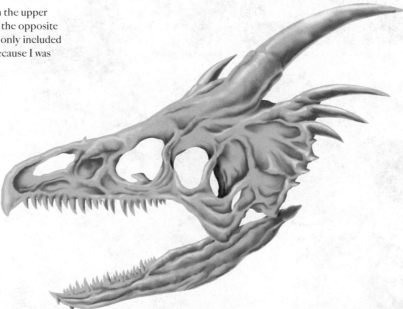

TIP:
As we have the light and shadow on separate layers, we can adjust them better, giving each one a different opacity.

Base Color and Finished Drawing

I used the same base colors as in the previous example: yellow brown for the bone, gray for the horns, and a lighter color for the teeth. I made some areas darker so as to further enhance the drawing and help with the sensation of volume given by the light and shadow.

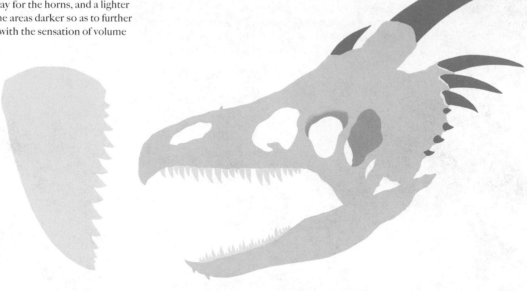

In the finished drawing, I added something special, making the inks dark red so that they would integrate better with other colors. Remember that in the section on inking in the introduction of the book, there are steps you can follow to easily color the inks if you are working with a computer. I also added a texture of smudges to give the cranium an ageing appearance.

TIP:
If you are going to work on a medium such as paper or canvas, you should decide beforehand whether to color the inks, and review the color profiles before finishing the drawing.

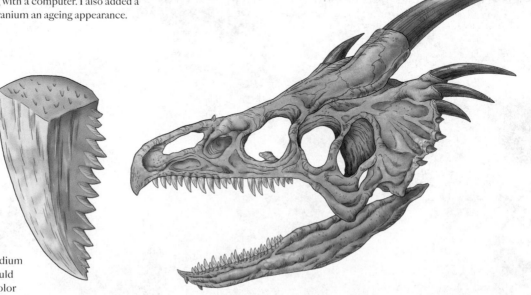

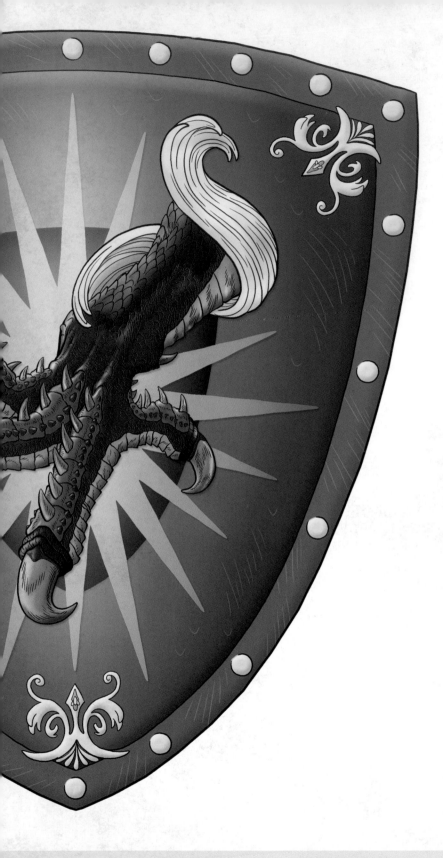

Dragon Skin

Hanging on both sides of the fossil as if they made up a small altar, two enormous, imposing medieval shields glistened despite the passing of centuries. I walked up to the shield on the left to inspect it more closely, and I was astonished; painted on a black metal coat of arms—perhaps lodestone—with gold rivets, I could see beautiful images. Their colors were still vibrant and they depicted the claw of a dragon as it must have been in life, with the skin shown down to the smallest detail. Each one of its sharp scales reinforced in our imagination a terrifying creature, with an armored skin impossible to penetrate and that must have inflicted serious wounds in close-quarter combat.

Scheme, Volume, and Pencil

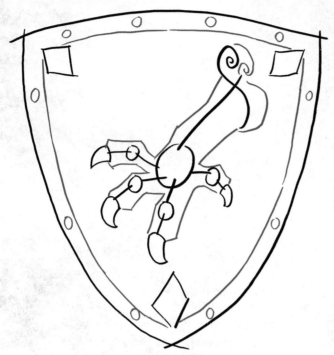

I made a simple (black) scheme by first drawing the external shape of the shield and, inside of it, a ball for the wrist joint, from which four finished lines originated, ending in four powerful hooks, with the back finger being the smallest. The rhombuses and the spiral line indicated where I would place the adornments.

I marked the lower part of the shield with its rivets and subsequently, the volume of the claw and its adornment.

In the pencil, I filled the dragon skin with a large number of plaques, scales, and spines. I filled the shield with lines, cuts, and many more rivets. At this time, it did not matter whether the elements were perfectly drawn or whether the line was shaky. I would fix that in the inking. I also added other decorative details (red).

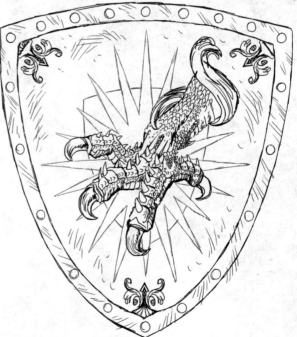

Ink

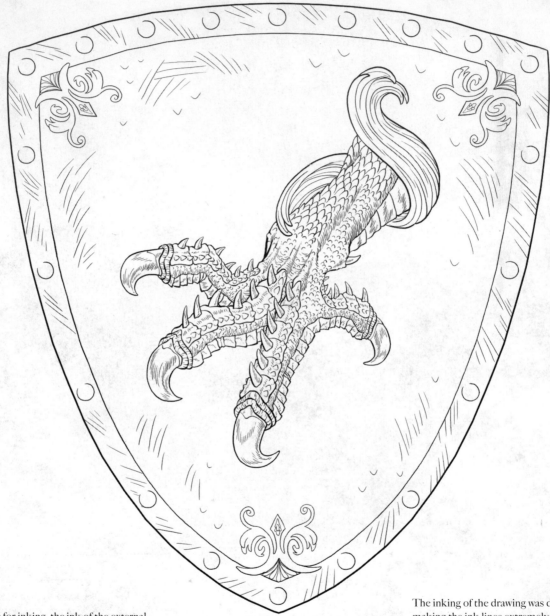

TIP:
As a general rule for inking, the ink of the external lines should be thicker than that of the internal lines.

The inking of the drawing was done thoroughly, making the ink lines extremely beautiful but also very strong, taking care of the small details such as the scales, which were placed one over the other, the small bulges of the plaques over the fingers (which accompanied the spines), and the tendons of the fingers, which appeared tense under the skin.

TIP:
Dark blue is the ideal solution when we want to paint a bright black object without darkening our inks.

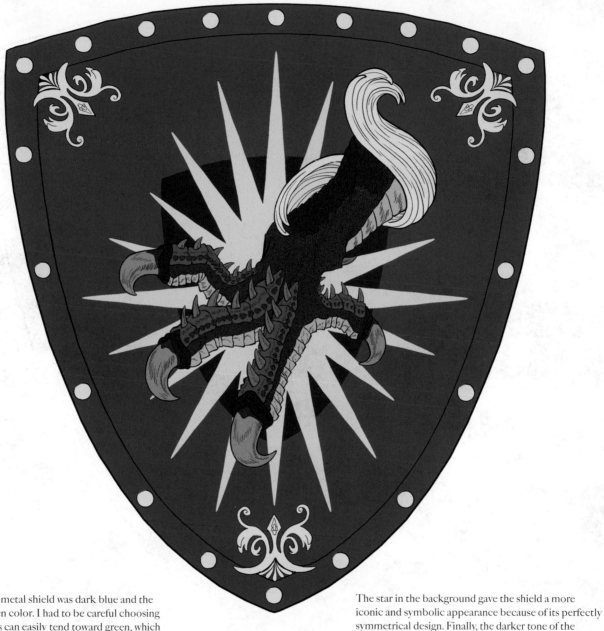

The base color of the metal shield was dark blue and the details were in a golden color. I had to be careful choosing the yellows, as yellows can easily tend toward green, which takes away warmth. The yellow of the gold tends slightly toward orange, giving it warmth and nobility. The upper part of the claw combined different reddish tones, which indicates aggressiveness, while the lower part was contrasted with a fairly neutral bluish gray.

The star in the background gave the shield a more iconic and symbolic appearance because of its perfectly symmetrical design. Finally, the darker tone of the center adornment provided a contrast and enhanced the visualization of the claw and the star.

Light and Shadow

TIP:
If working with a computer, we can make the light or shadow in any color and then change them to white and black (or vice versa).

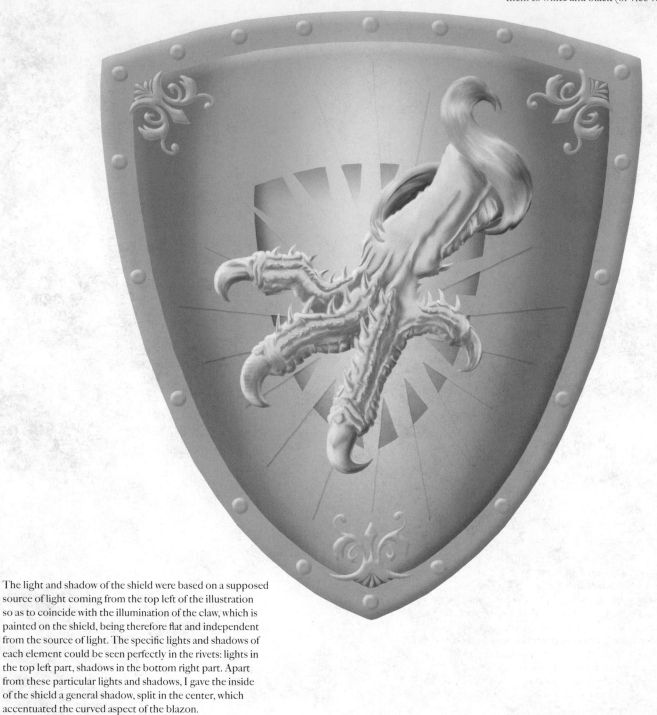

The light and shadow of the shield were based on a supposed source of light coming from the top left of the illustration so as to coincide with the illumination of the claw, which is painted on the shield, being therefore flat and independent from the source of light. The specific lights and shadows of each element could be seen perfectly in the rivets: lights in the top left part, shadows in the bottom right part. Apart from these particular lights and shadows, I gave the inside of the shield a general shadow, split in the center, which accentuated the curved aspect of the blazon.

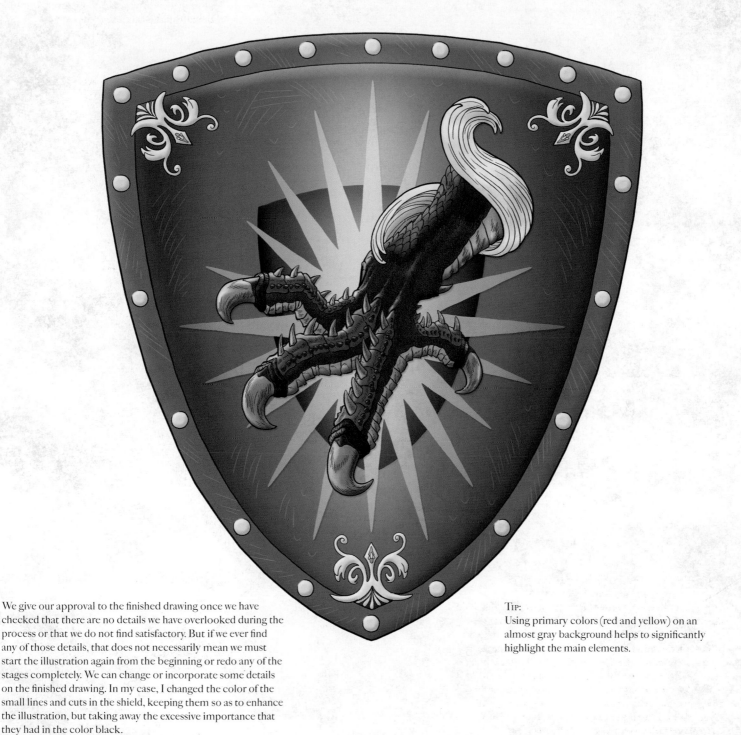

We give our approval to the finished drawing once we have checked that there are no details we have overlooked during the process or that we do not find satisfactory. But if we ever find any of those details, that does not necessarily mean we must start the illustration again from the beginning or redo any of the stages completely. We can change or incorporate some details on the finished drawing. In my case, I changed the color of the small lines and cuts in the shield, keeping them so as to enhance the illustration, but taking away the excessive importance that they had in the color black.

Tip:
Using primary colors (red and yellow) on an almost gray background helps to significantly highlight the main elements.

Dragon Wings

The second shield was even more incredible. Its size was also disproportionately large for a human being. Why would they have made such large shields? A superb gold, silver, and precious stone embossment over the emerald surface exquisitely depicted the wing of one of these fantastic creatures.

We were now convinced by the evidence that all of this was real, and with great respect, we contemplated the enormous muscular power shown in that work of art. I brushed my hand over the sharp surface, and my fingers immediately started to bleed. The armor-plated monster that inspired such a masterpiece must have been indestructible. We looked at each other, praying that we would never have to face such a creature.

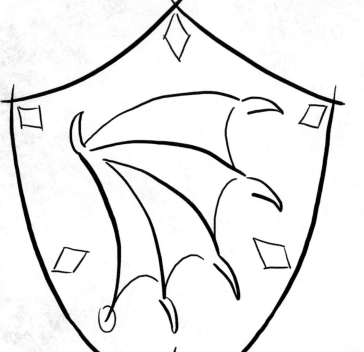

The scheme of the shield needed to capture its dimensions and its elegant classical design. Once again, I used rhombuses to indicate where the adornments would be placed, and with a simple scheme of lines, I sketched the position and volumes of the wing so as to reflect the perfect aesthetic balance with which the blazon was designed.

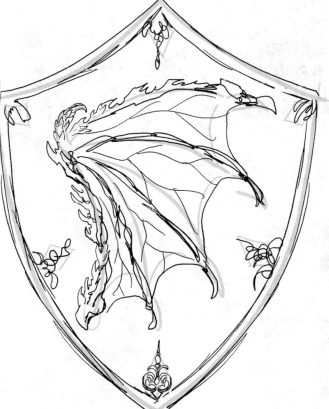

I performed the pencil directly, since I had already done another shield previously, and felt that my scheme defined the volumes fairly well. I quickly made my sketch and defined the small thumb and long remaining fingers, as well as the irregular and angular membranous surface. Finally, I sketched only one of the shield's adornments (the lowest one). The others would only be copies of this one.

Ink

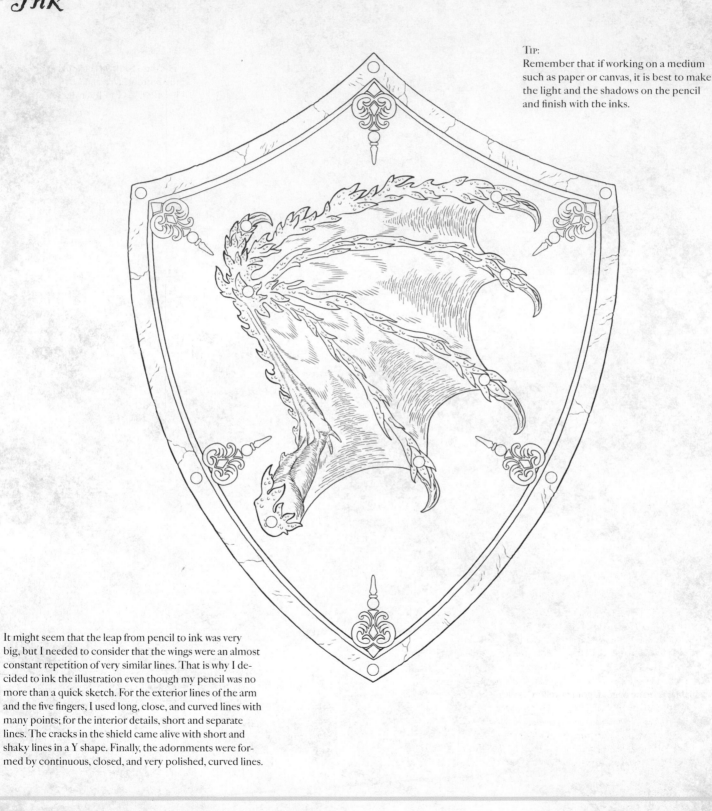

Tip:
Remember that if working on a medium such as paper or canvas, it is best to make the light and the shadows on the pencil and finish with the inks.

It might seem that the leap from pencil to ink was very big, but I needed to consider that the wings were an almost constant repetition of very similar lines. That is why I decided to ink the illustration even though my pencil was no more than a quick sketch. For the exterior lines of the arm and the five fingers, I used long, close, and curved lines with many points; for the interior details, short and separate lines. The cracks in the shield came alive with short and shaky lines in a Y shape. Finally, the adornments were formed by continuous, closed, and very polished, curved lines.

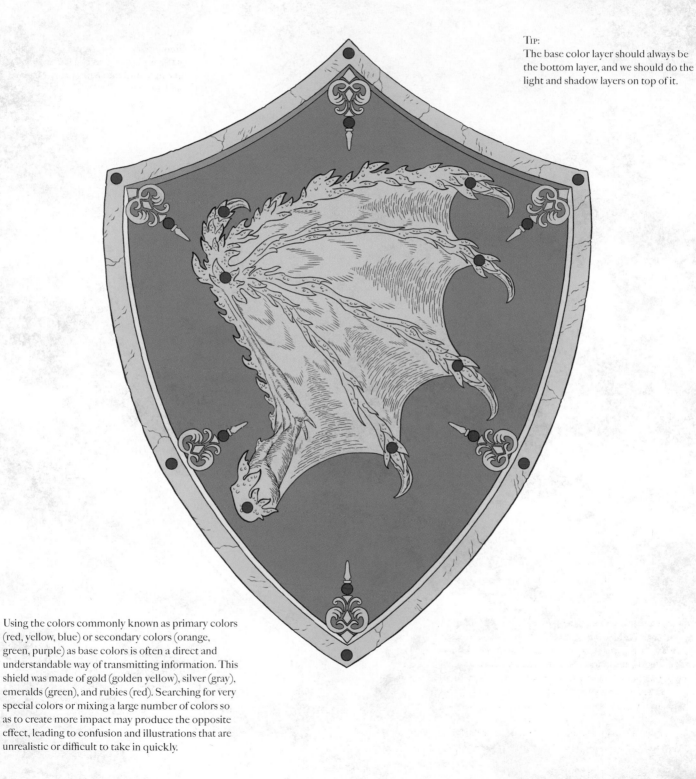

Using the colors commonly known as primary colors (red, yellow, blue) or secondary colors (orange, green, purple) as base colors is often a direct and understandable way of transmitting information. This shield was made of gold (golden yellow), silver (gray), emeralds (green), and rubies (red). Searching for very special colors or mixing a large number of colors so as to create more impact may produce the opposite effect, leading to confusion and illustrations that are unrealistic or difficult to take in quickly.

Light and Shadow

Tip:
We should place the lights and shadows on layers above the base color.

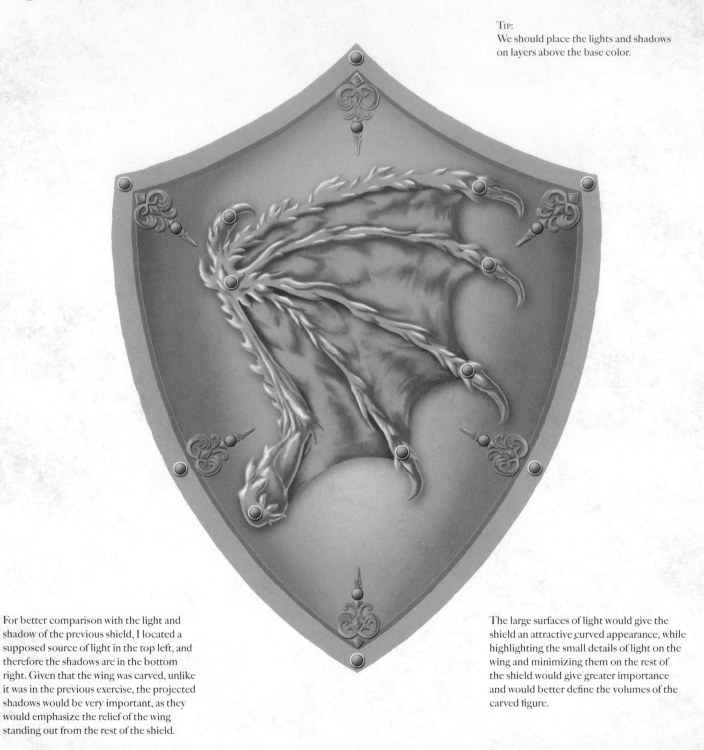

For better comparison with the light and shadow of the previous shield, I located a supposed source of light in the top left, and therefore the shadows are in the bottom right. Given that the wing was carved, unlike it was in the previous exercise, the projected shadows would be very important, as they would emphasize the relief of the wing standing out from the rest of the shield.

The large surfaces of light would give the shield an attractive curved appearance, while highlighting the small details of light on the wing and minimizing them on the rest of the shield would give greater importance and would better define the volumes of the carved figure.

Finished Drawing

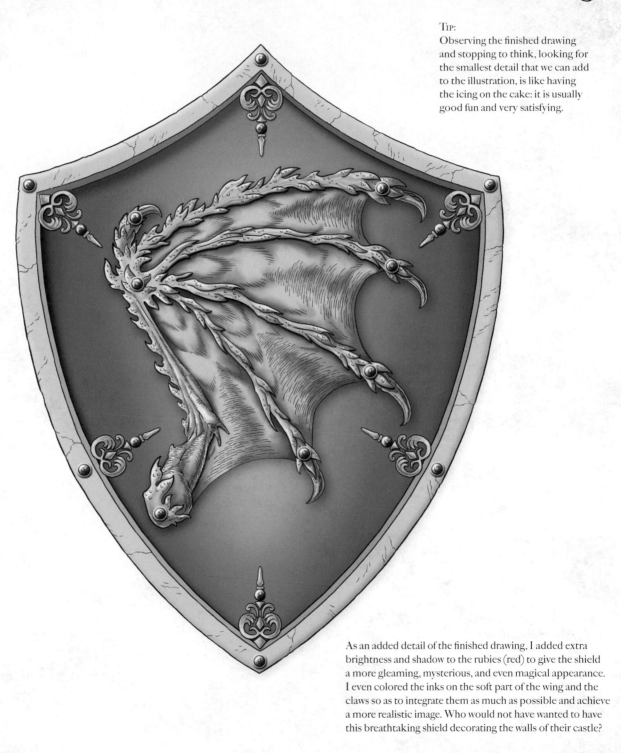

TIP:
Observing the finished drawing and stopping to think, looking for the smallest detail that we can add to the illustration, is like having the icing on the cake: it is usually good fun and very satisfying.

As an added detail of the finished drawing, I added extra brightness and shadow to the rubies (red) to give the shield a more gleaming, mysterious, and even magical appearance. I even colored the inks on the soft part of the wing and the claws so as to integrate them as much as possible and achieve a more realistic image. Who would not have wanted to have this breathtaking shield decorating the walls of their castle?

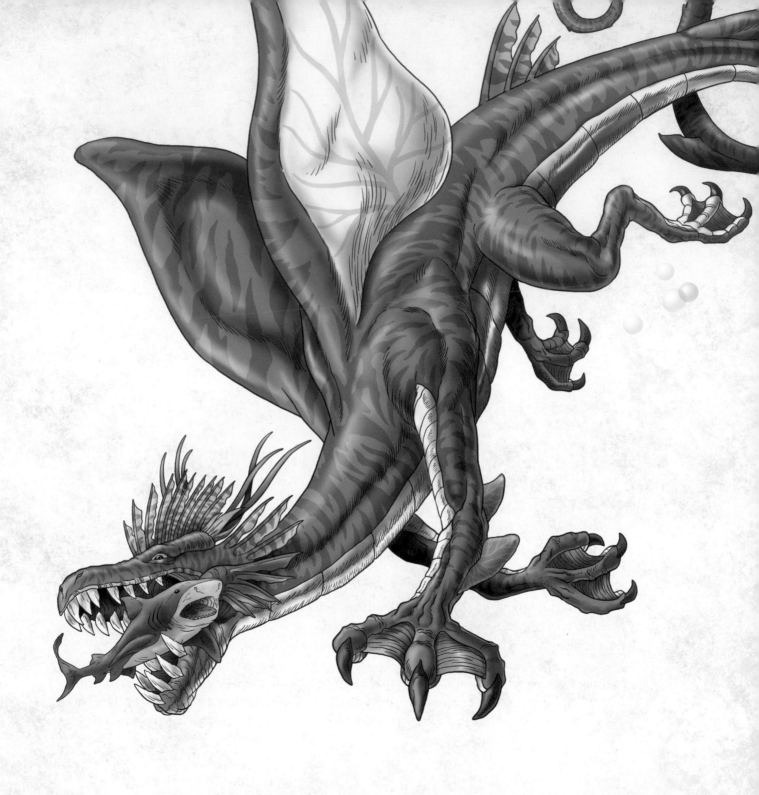

Wild Dragons

Western Dragons

Oriental Dragons

Amphiteres

Amphiteres with Feathers

Five-Headed Hydras

Polar Dragons

Marine Dragons

Miniature Dragons

Faerie Dragons

Baby Dragons

Megadragons

We worked for several hours, and after we had studied and catalogued the findings of the cave, we decided to continue our journey. Our mood had changed. Convinced that dragons had at some time in history been real, we now believed the reports. The dragons had returned.

However, the descriptions of the beasts did not match. Were there several types of dragons? How many? What would they be capable of? We had too many questions, and we had to find the answers as soon as possible, although we knew that facing one of those wild animals could cost us our lives.

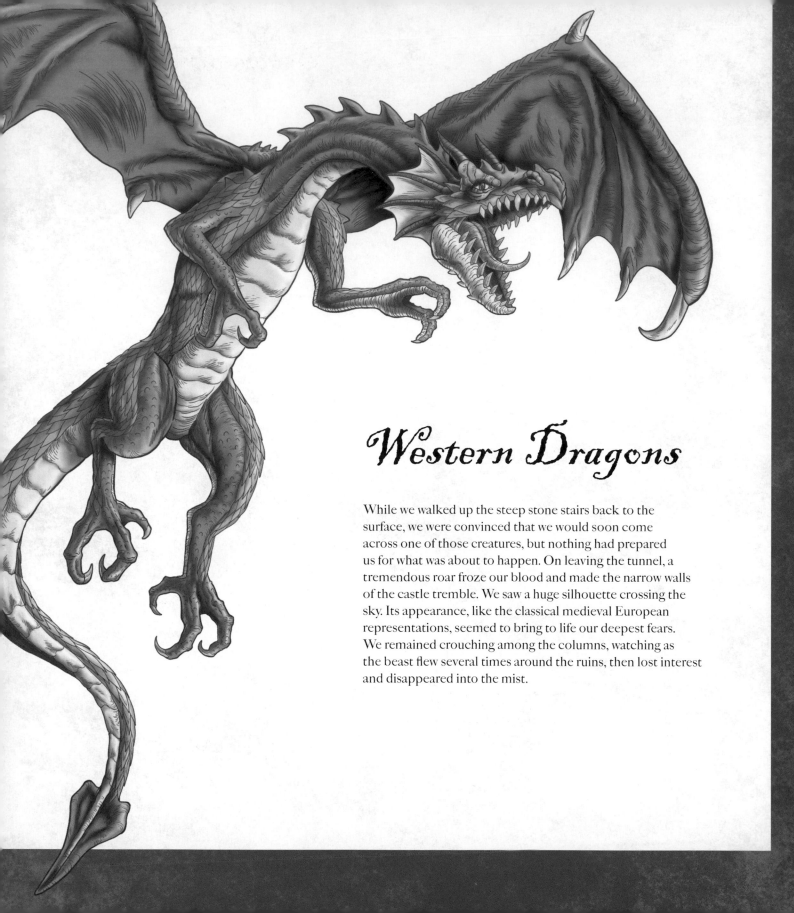

Western Dragons

While we walked up the steep stone stairs back to the surface, we were convinced that we would soon come across one of those creatures, but nothing had prepared us for what was about to happen. On leaving the tunnel, a tremendous roar froze our blood and made the narrow walls of the castle tremble. We saw a huge silhouette crossing the sky. Its appearance, like the classical medieval European representations, seemed to bring to life our deepest fears. We remained crouching among the columns, watching as the beast flew several times around the ruins, then lost interest and disappeared into the mist.

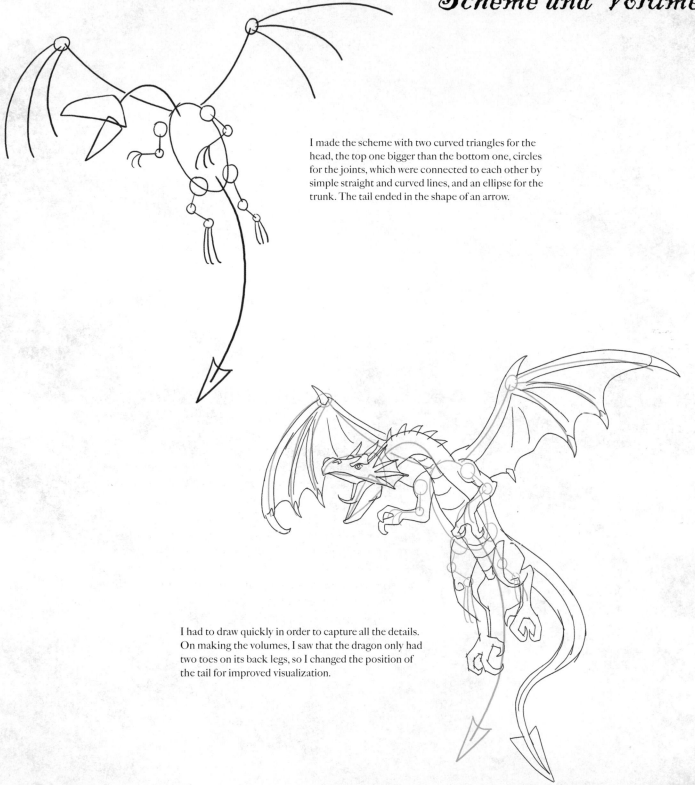

I made the scheme with two curved triangles for the head, the top one bigger than the bottom one, circles for the joints, which were connected to each other by simple straight and curved lines, and an ellipse for the trunk. The tail ended in the shape of an arrow.

I had to draw quickly in order to capture all the details. On making the volumes, I saw that the dragon only had two toes on its back legs, so I changed the position of the tail for improved visualization.

Pencil and Ink

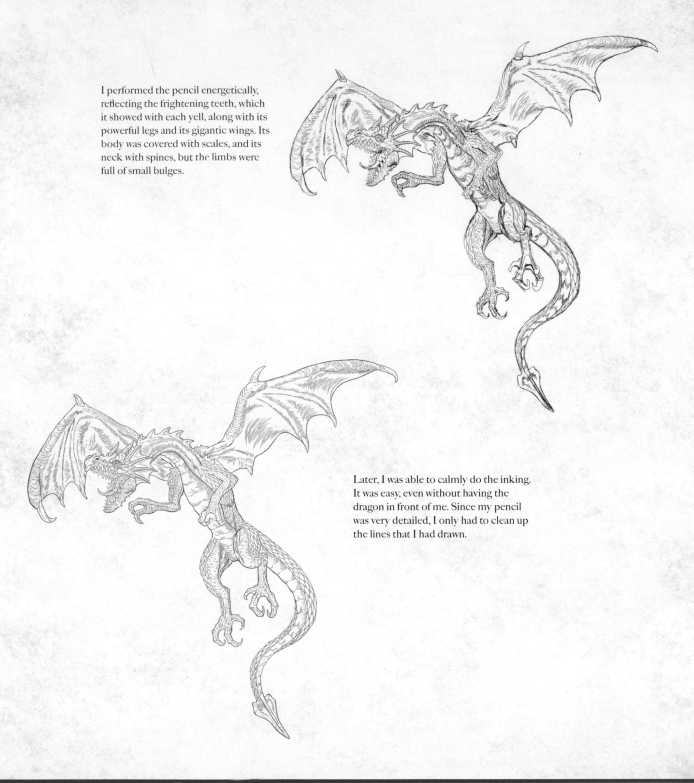

I performed the pencil energetically, reflecting the frightening teeth, which it showed with each yell, along with its powerful legs and its gigantic wings. Its body was covered with scales, and its neck with spines, but the limbs were full of small bulges.

Later, I was able to calmly do the inking. It was easy, even without having the dragon in front of me. Since my pencil was very detailed, I only had to clean up the lines that I had drawn.

I made use of the volumes to make a color scheme so I would not forget what I was seeing. When I was able to include the base colors, which I show to you here without inks, I was able to adjust and compensate each one of them. The dragon was mainly green, very reptilian, with a lighter belly, as is usual. The contrast of its blue tongue with its red mouth reminded us that we were facing an animal straight from myths and legends.

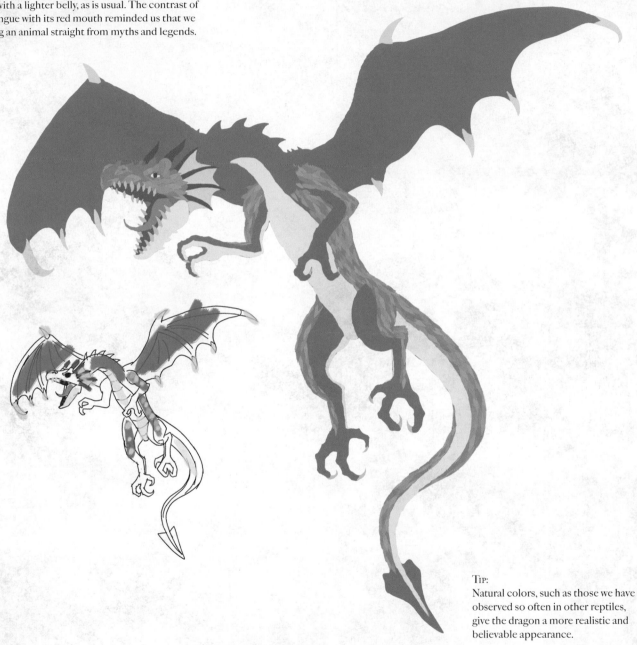

TIP:
Natural colors, such as those we have observed so often in other reptiles, give the dragon a more realistic and believable appearance.

Light and Shadow

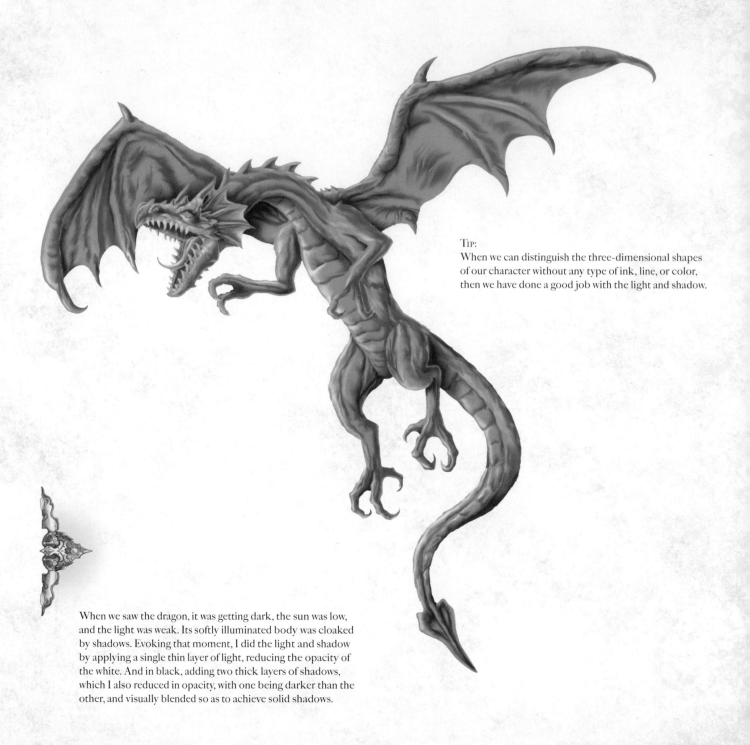

TIP:
When we can distinguish the three-dimensional shapes of our character without any type of ink, line, or color, then we have done a good job with the light and shadow.

When we saw the dragon, it was getting dark, the sun was low, and the light was weak. Its softly illuminated body was cloaked by shadows. Evoking that moment, I did the light and shadow by applying a single thin layer of light, reducing the opacity of the white. And in black, adding two thick layers of shadows, which I also reduced in opacity, with one being darker than the other, and visually blended so as to achieve solid shadows.

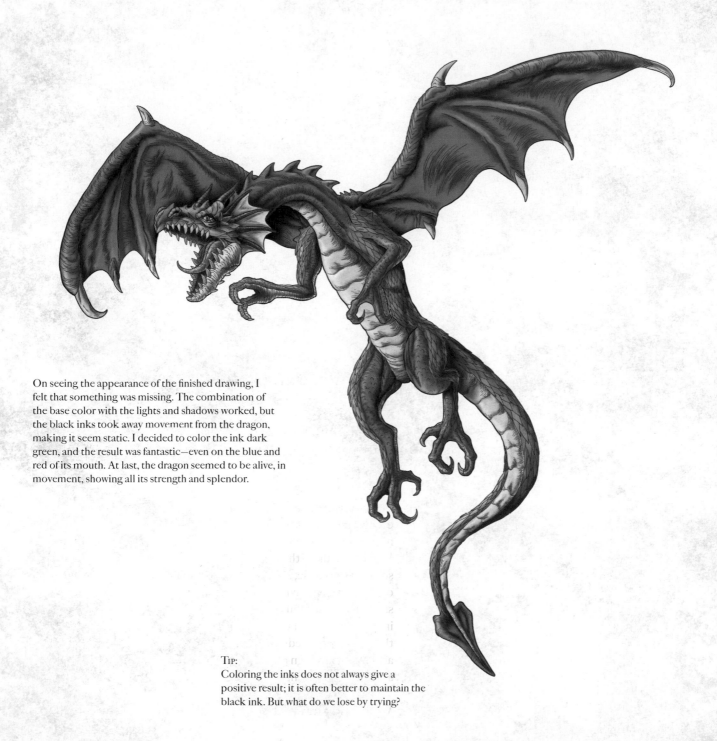

On seeing the appearance of the finished drawing, I felt that something was missing. The combination of the base color with the lights and shadows worked, but the black inks took away movement from the dragon, making it seem static. I decided to color the ink dark green, and the result was fantastic—even on the blue and red of its mouth. At last, the dragon seemed to be alive, in movement, showing all its strength and splendor.

TIP:
Coloring the inks does not always give a positive result; it is often better to maintain the black ink. But what do we lose by trying?

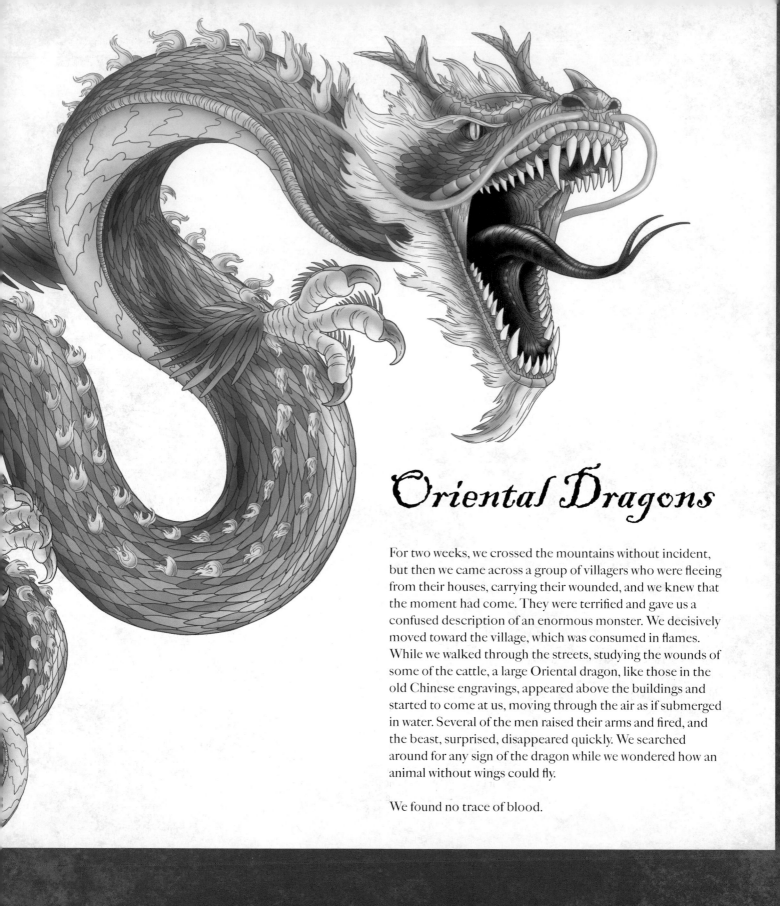

Oriental Dragons

For two weeks, we crossed the mountains without incident, but then we came across a group of villagers who were fleeing from their houses, carrying their wounded, and we knew that the moment had come. They were terrified and gave us a confused description of an enormous monster. We decisively moved toward the village, which was consumed in flames. While we walked through the streets, studying the wounds of some of the cattle, a large Oriental dragon, like those in the old Chinese engravings, appeared above the buildings and started to come at us, moving through the air as if submerged in water. Several of the men raised their arms and fired, and the beast, surprised, disappeared quickly. We searched around for any sign of the dragon while we wondered how an animal without wings could fly.

We found no trace of blood.

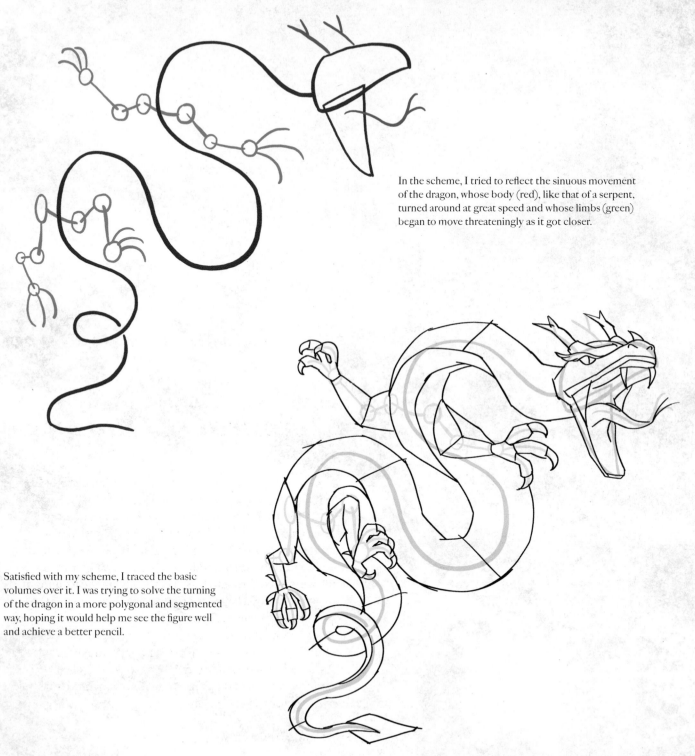

In the scheme, I tried to reflect the sinuous movement of the dragon, whose body (red), like that of a serpent, turned around at great speed and whose limbs (green) began to move threateningly as it got closer.

Satisfied with my scheme, I traced the basic volumes over it. I was trying to solve the turning of the dragon in a more polygonal and segmented way, hoping it would help me see the figure well and achieve a better pencil.

Pencil and Ink

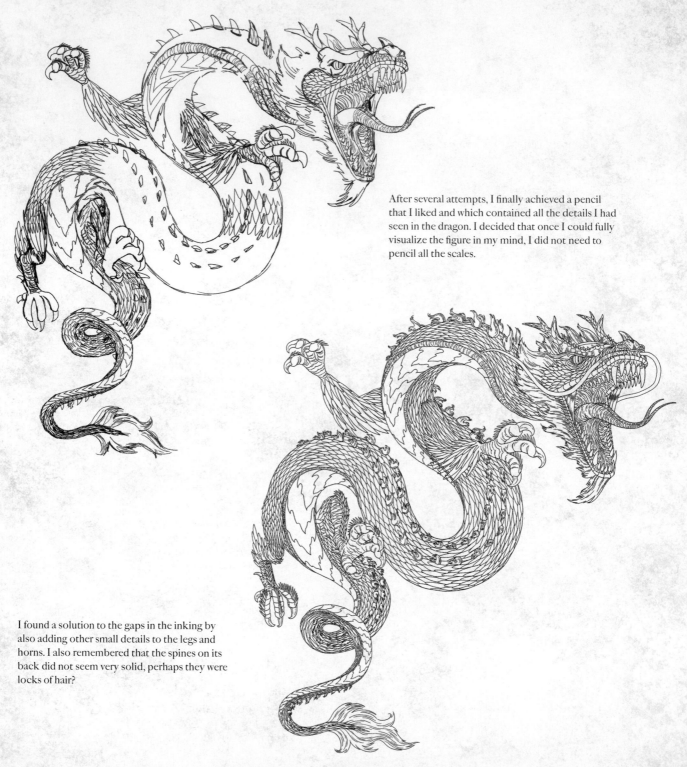

After several attempts, I finally achieved a pencil that I liked and which contained all the details I had seen in the dragon. I decided that once I could fully visualize the figure in my mind, I did not need to pencil all the scales.

I found a solution to the gaps in the inking by also adding other small details to the legs and horns. I also remembered that the spines on its back did not seem very solid, perhaps they were locks of hair?

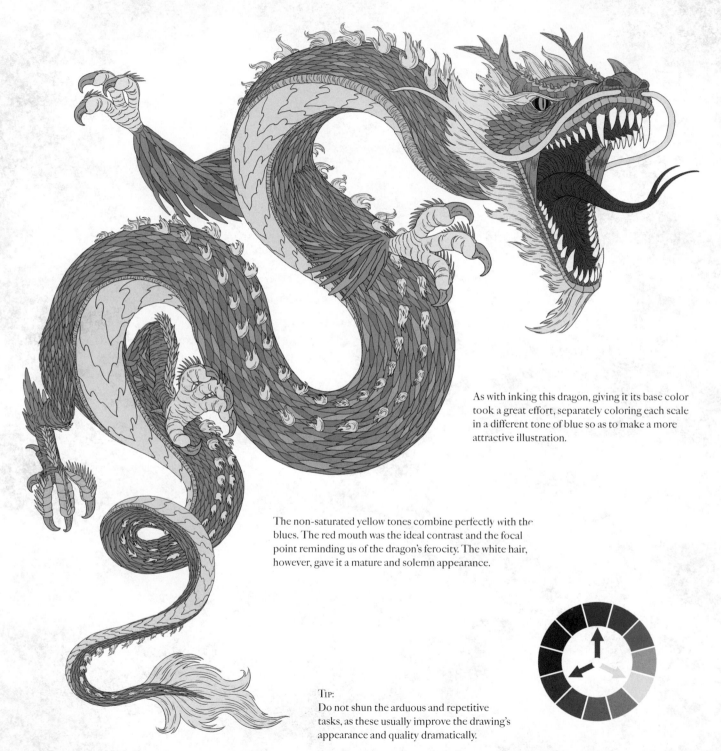

As with inking this dragon, giving it its base color took a great effort, separately coloring each scale in a different tone of blue so as to make a more attractive illustration.

The non-saturated yellow tones combine perfectly with the blues. The red mouth was the ideal contrast and the focal point reminding us of the dragon's ferocity. The white hair, however, gave it a mature and solemn appearance.

TIP:
Do not shun the arduous and repetitive tasks, as these usually improve the drawing's appearance and quality dramatically.

Light and Shadow

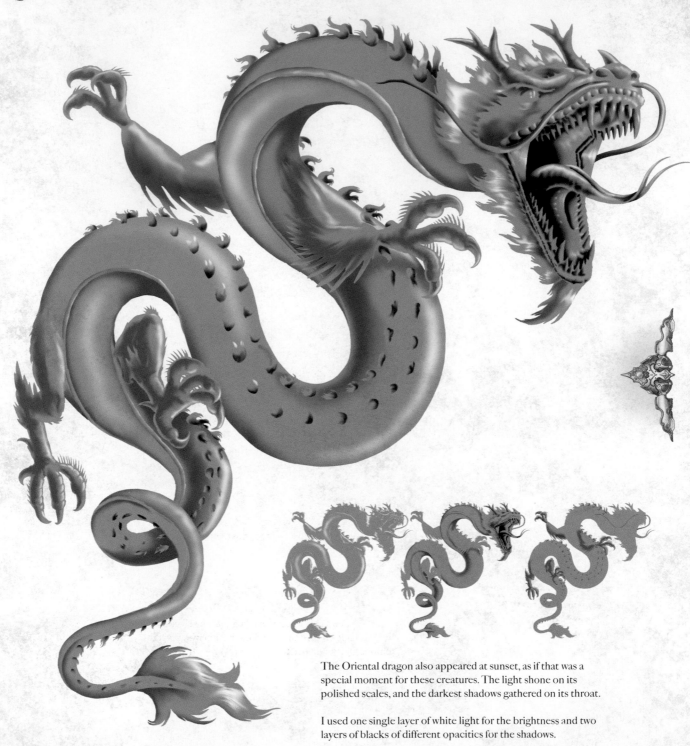

The Oriental dragon also appeared at sunset, as if that was a special moment for these creatures. The light shone on its polished scales, and the darkest shadows gathered on its throat.

I used one single layer of white light for the brightness and two layers of blacks of different opacities for the shadows.

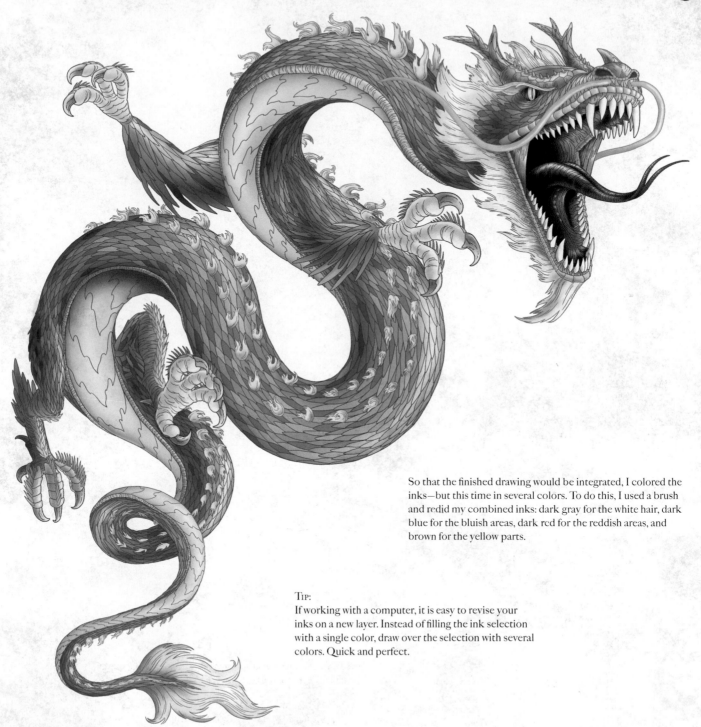

So that the finished drawing would be integrated, I colored the inks—but this time in several colors. To do this, I used a brush and redid my combined inks: dark gray for the white hair, dark blue for the bluish areas, dark red for the reddish areas, and brown for the yellow parts.

TIP:
If working with a computer, it is easy to revise your inks on a new layer. Instead of filling the ink selection with a single color, draw over the selection with several colors. Quick and perfect.

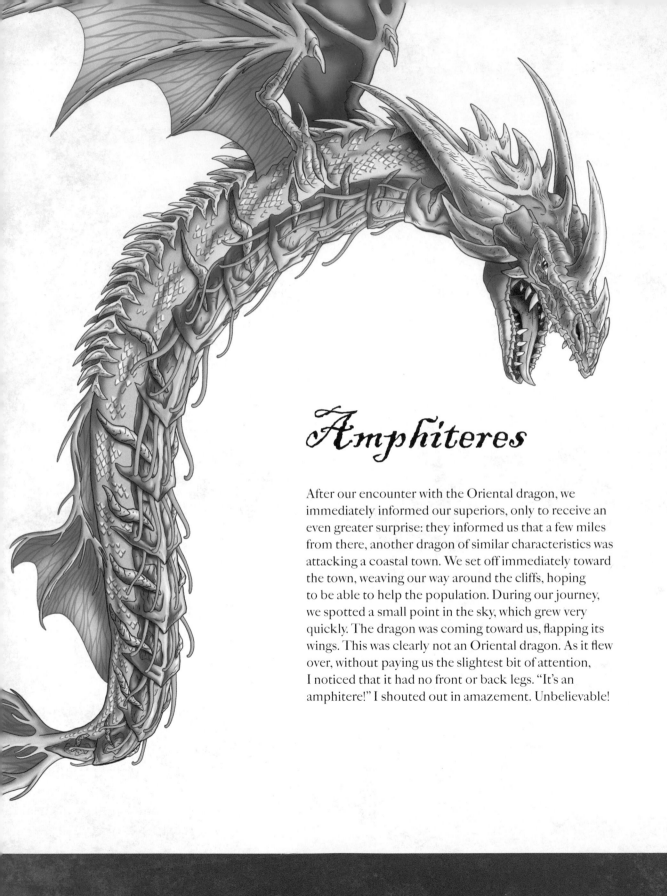

Amphiteres

After our encounter with the Oriental dragon, we immediately informed our superiors, only to receive an even greater surprise: they informed us that a few miles from there, another dragon of similar characteristics was attacking a coastal town. We set off immediately toward the town, weaving our way around the cliffs, hoping to be able to help the population. During our journey, we spotted a small point in the sky, which grew very quickly. The dragon was coming toward us, flapping its wings. This was clearly not an Oriental dragon. As it flew over, without paying us the slightest bit of attention, I noticed that it had no front or back legs. "It's an amphitere!" I shouted out in amazement. Unbelievable!

Scheme, Volume, Pencil, Ink, and Base Color

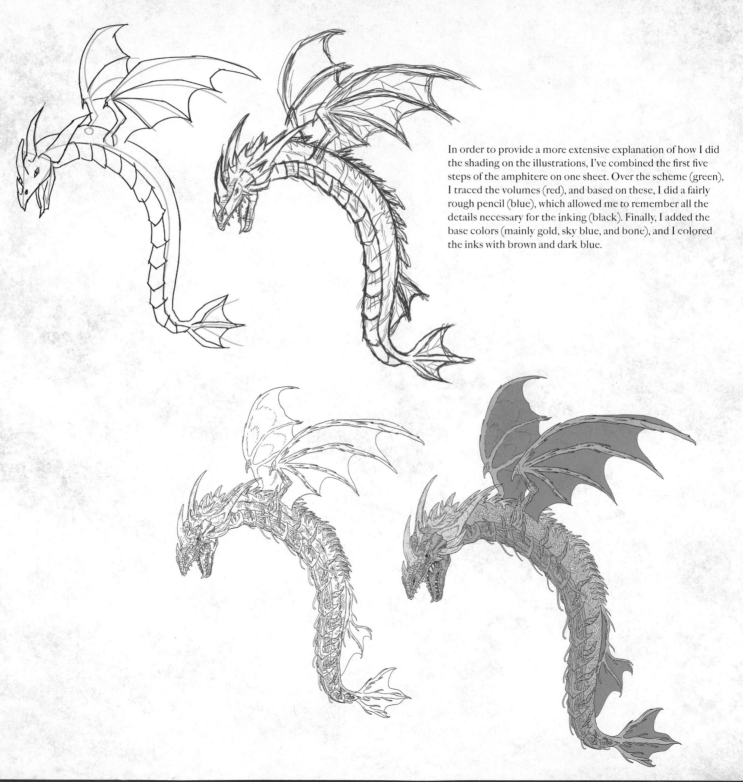

In order to provide a more extensive explanation of how I did the shading on the illustrations, I've combined the first five steps of the amphitere on one sheet. Over the scheme (green), I traced the volumes (red), and based on these, I did a fairly rough pencil (blue), which allowed me to remember all the details necessary for the inking (black). Finally, I added the base colors (mainly gold, sky blue, and bone), and I colored the inks with brown and dark blue.

Shadow 1

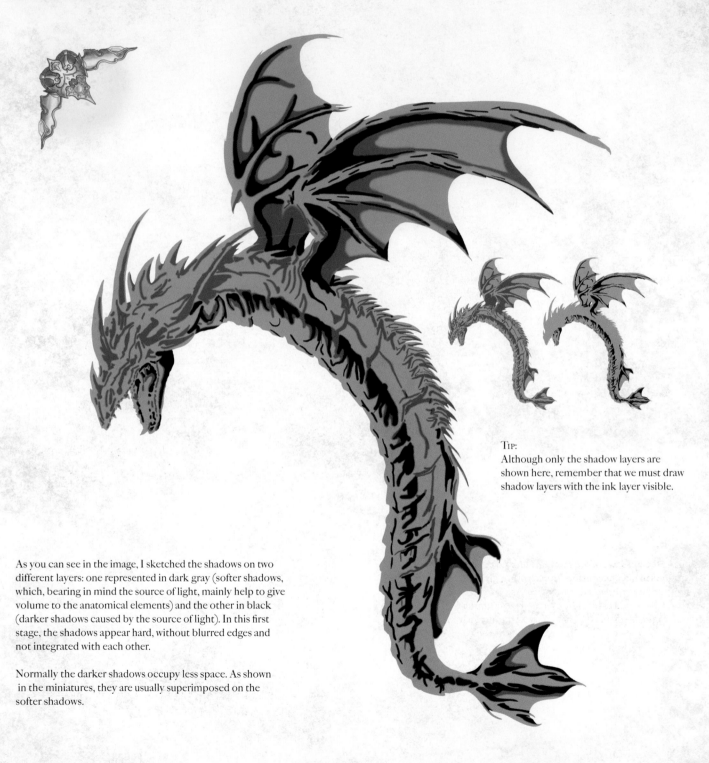

Tip:
Although only the shadow layers are shown here, remember that we must draw shadow layers with the ink layer visible.

As you can see in the image, I sketched the shadows on two different layers: one represented in dark gray (softer shadows, which, bearing in mind the source of light, mainly help to give volume to the anatomical elements) and the other in black (darker shadows caused by the source of light). In this first stage, the shadows appear hard, without blurred edges and not integrated with each other.

Normally the darker shadows occupy less space. As shown in the miniatures, they are usually superimposed on the softer shadows.

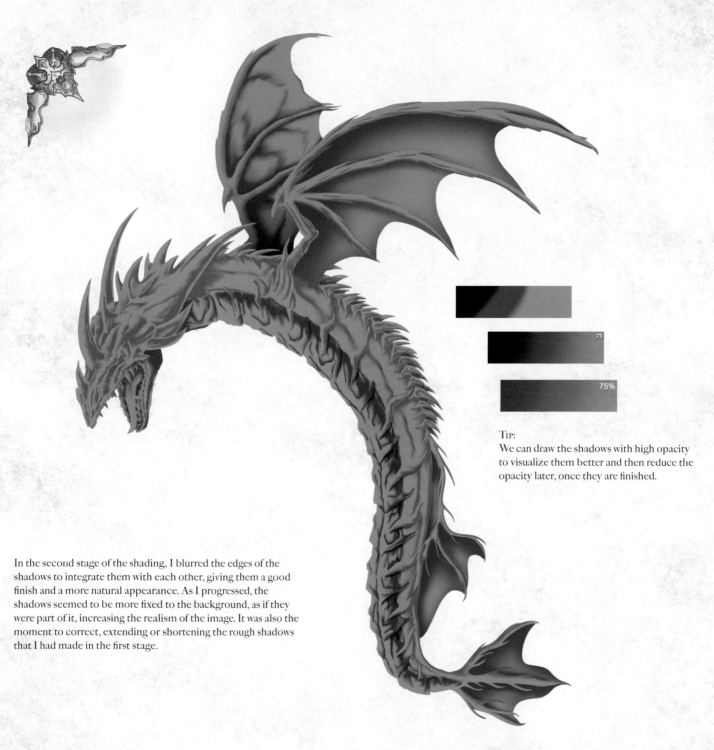

TIP:
We can draw the shadows with high opacity to visualize them better and then reduce the opacity later, once they are finished.

In the second stage of the shading, I blurred the edges of the shadows to integrate them with each other, giving them a good finish and a more natural appearance. As I progressed, the shadows seemed to be more fixed to the background, as if they were part of it, increasing the realism of the image. It was also the moment to correct, extending or shortening the rough shadows that I had made in the first stage.

Light

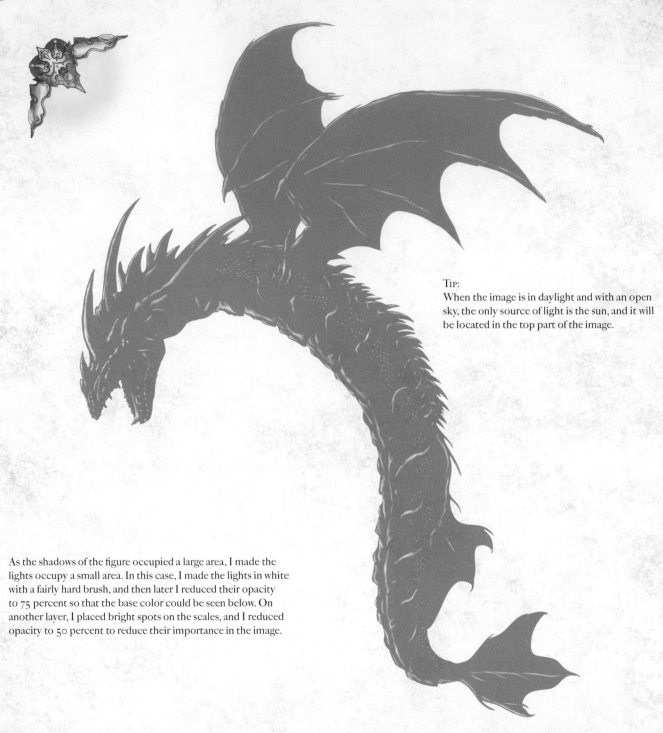

TIP:
When the image is in daylight and with an open sky, the only source of light is the sun, and it will be located in the top part of the image.

As the shadows of the figure occupied a large area, I made the lights occupy a small area. In this case, I made the lights in white with a fairly hard brush, and then later I reduced their opacity to 75 percent so that the base color could be seen below. On another layer, I placed bright spots on the scales, and I reduced opacity to 50 percent to reduce their importance in the image.

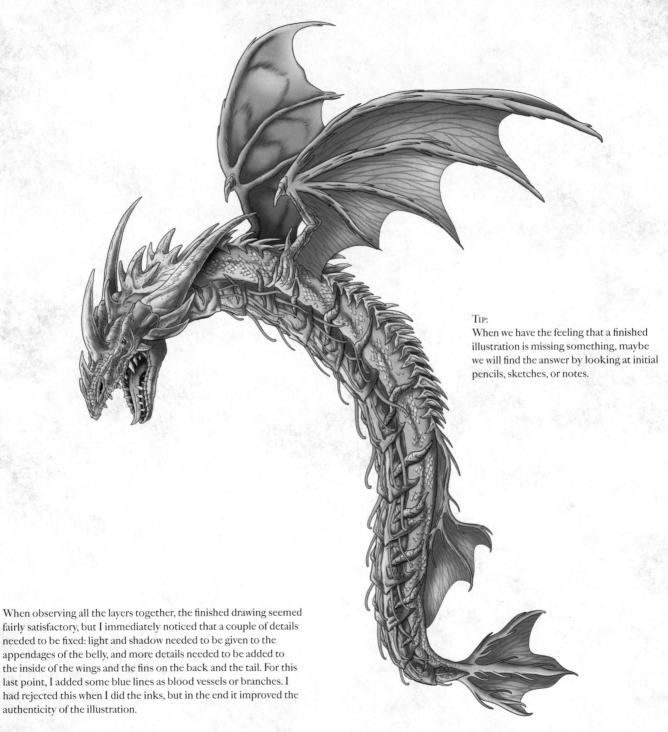

TIP:
When we have the feeling that a finished illustration is missing something, maybe we will find the answer by looking at initial pencils, sketches, or notes.

When observing all the layers together, the finished drawing seemed fairly satisfactory, but I immediately noticed that a couple of details needed to be fixed: light and shadow needed to be given to the appendages of the belly, and more details needed to be added to the inside of the wings and the fins on the back and the tail. For this last point, I added some blue lines as blood vessels or branches. I had rejected this when I did the inks, but in the end it improved the authenticity of the illustration.

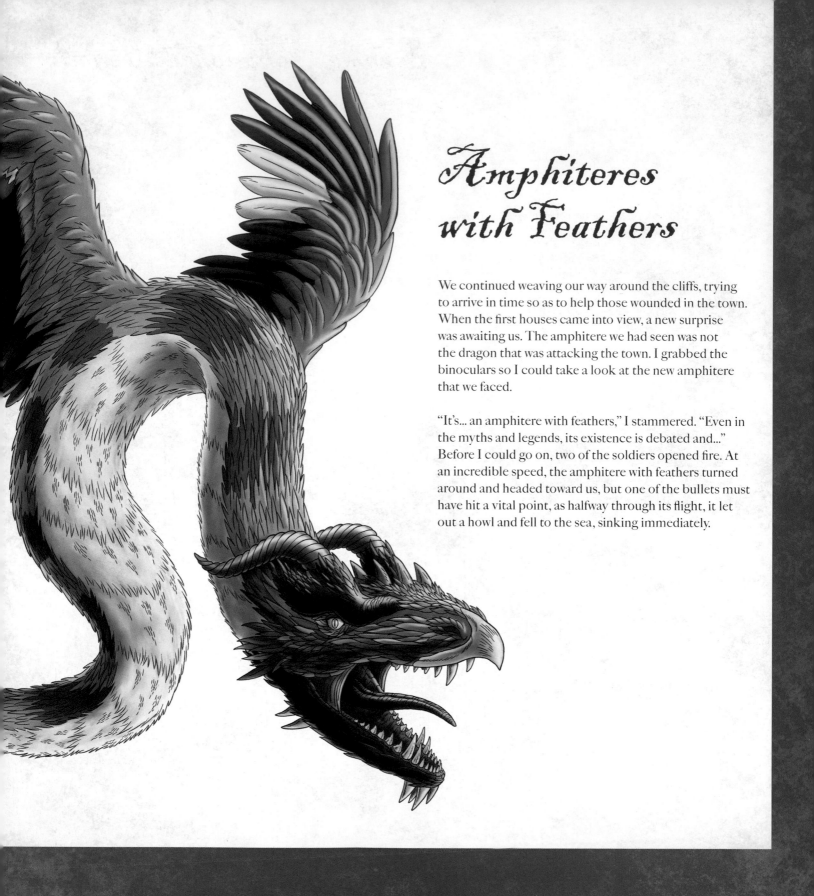

Amphiteres with Feathers

We continued weaving our way around the cliffs, trying to arrive in time so as to help those wounded in the town. When the first houses came into view, a new surprise was awaiting us. The amphitere we had seen was not the dragon that was attacking the town. I grabbed the binoculars so I could take a look at the new amphitere that we faced.

"It's... an amphitere with feathers," I stammered. "Even in the myths and legends, its existence is debated and..." Before I could go on, two of the soldiers opened fire. At an incredible speed, the amphitere with feathers turned around and headed toward us, but one of the bullets must have hit a vital point, as halfway through its flight, it let out a howl and fell to the sea, sinking immediately.

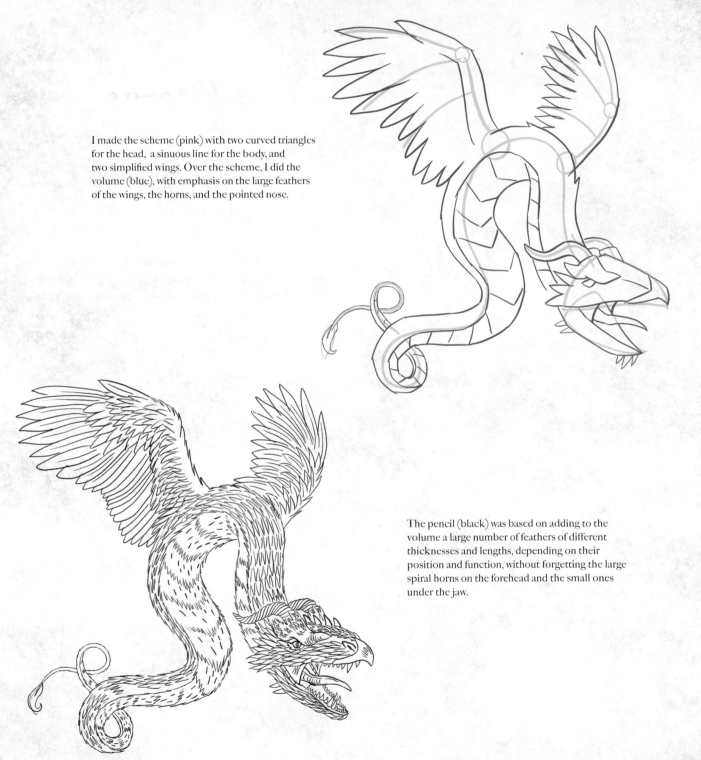

I made the scheme (pink) with two curved triangles for the head, a sinuous line for the body, and two simplified wings. Over the scheme, I did the volume (blue), with emphasis on the large feathers of the wings, the horns, and the pointed nose.

The pencil (black) was based on adding to the volume a large number of feathers of different thicknesses and lengths, depending on their position and function, without forgetting the large spiral horns on the forehead and the small ones under the jaw.

Ink

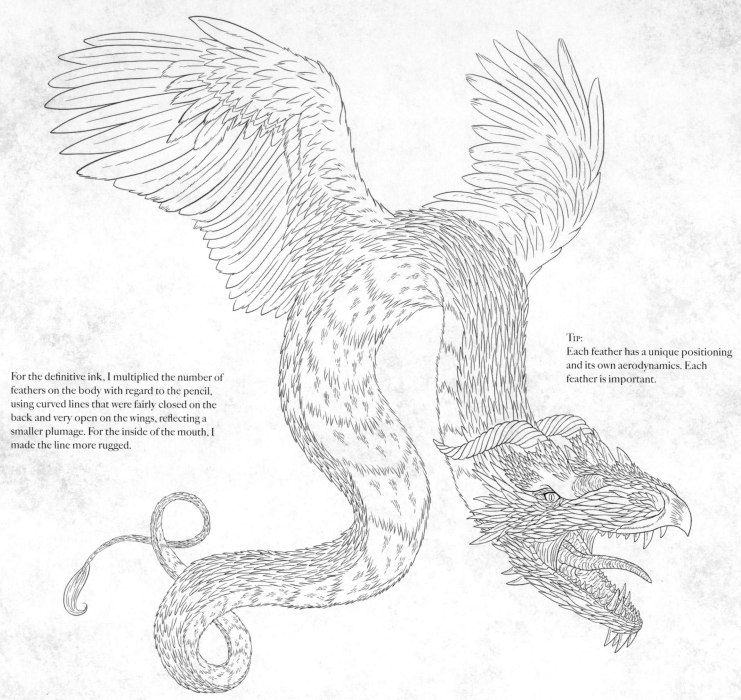

For the definitive ink, I multiplied the number of feathers on the body with regard to the pencil, using curved lines that were fairly closed on the back and very open on the wings, reflecting a smaller plumage. For the inside of the mouth, I made the line more rugged.

TIP:
Each feather has a unique positioning and its own aerodynamics. Each feather is important.

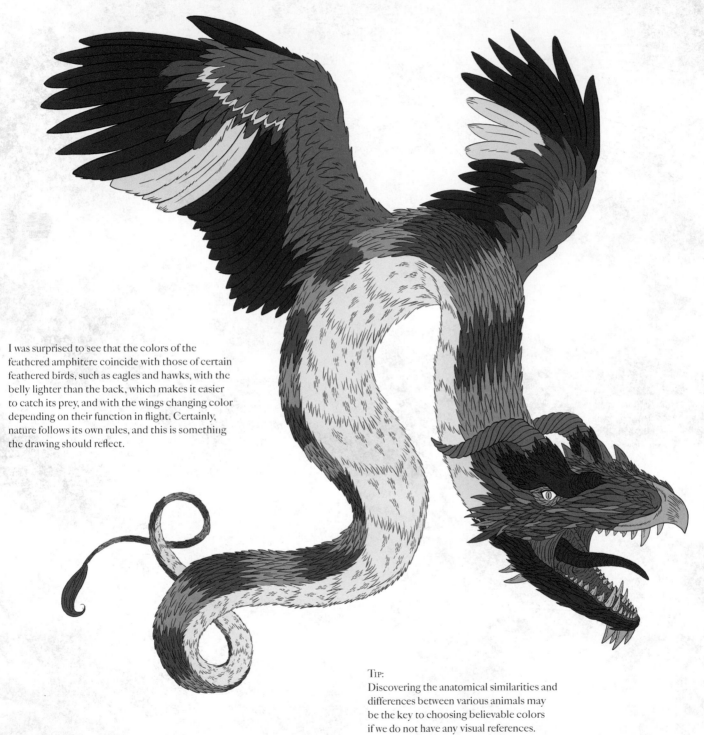

I was surprised to see that the colors of the feathered amphitere coincide with those of certain feathered birds, such as eagles and hawks, with the belly lighter than the back, which makes it easier to catch its prey, and with the wings changing color depending on their function in flight. Certainly, nature follows its own rules, and this is something the drawing should reflect.

TIP:
Discovering the anatomical similarities and differences between various animals may be the key to choosing believable colors if we do not have any visual references.

Lights and Shadows

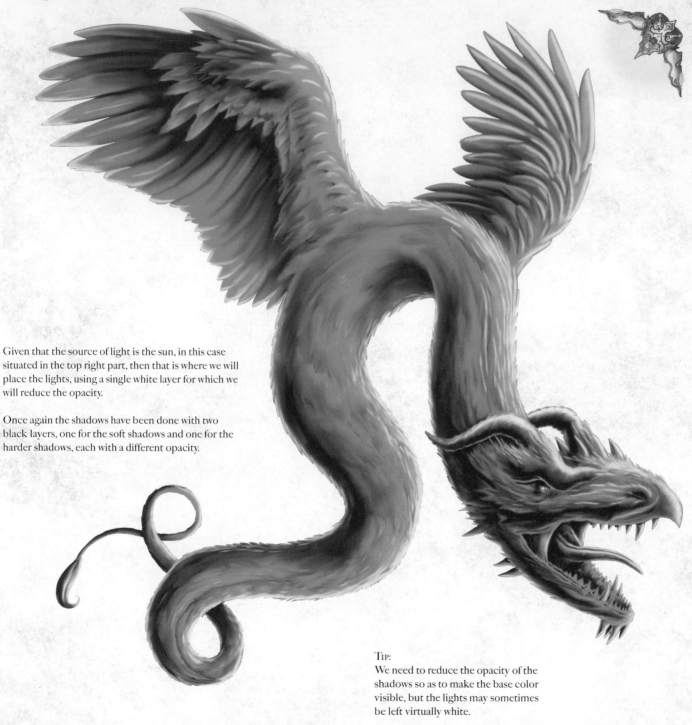

Given that the source of light is the sun, in this case situated in the top right part, then that is where we will place the lights, using a single white layer for which we will reduce the opacity.

Once again the shadows have been done with two black layers, one for the soft shadows and one for the harder shadows, each with a different opacity.

TIP:
We need to reduce the opacity of the shadows so as to make the base color visible, but the lights may sometimes be left virtually white.

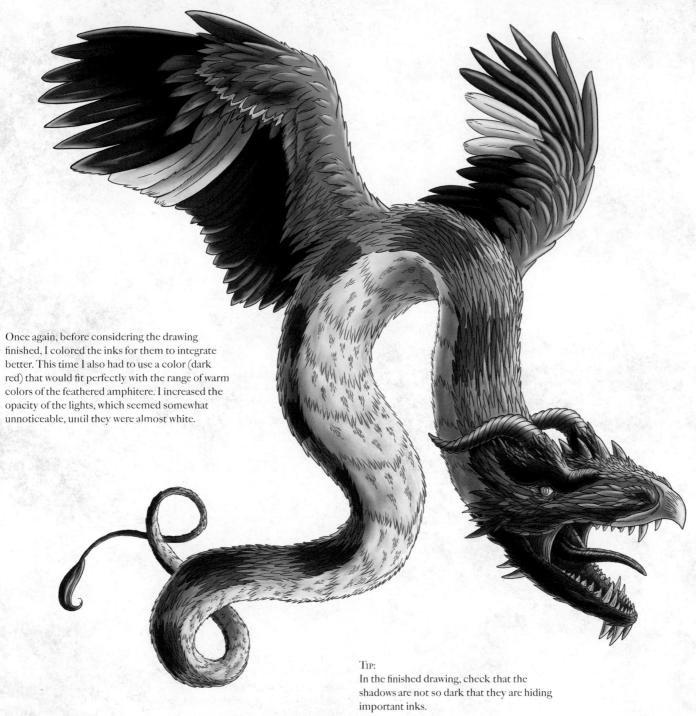

Once again, before considering the drawing finished, I colored the inks for them to integrate better. This time I also had to use a color (dark red) that would fit perfectly with the range of warm colors of the feathered amphitere. I increased the opacity of the lights, which seemed somewhat unnoticeable, until they were almost white.

TIP:
In the finished drawing, check that the shadows are not so dark that they are hiding important inks.

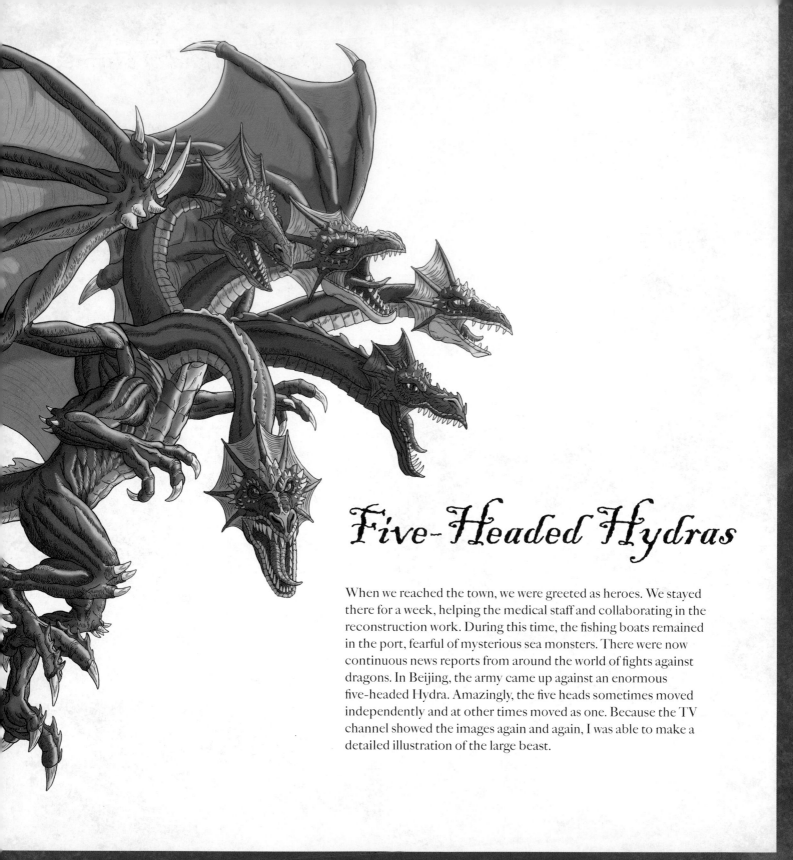

Five-Headed Hydras

When we reached the town, we were greeted as heroes. We stayed there for a week, helping the medical staff and collaborating in the reconstruction work. During this time, the fishing boats remained in the port, fearful of mysterious sea monsters. There were now continuous news reports from around the world of fights against dragons. In Beijing, the army came up against an enormous five-headed Hydra. Amazingly, the five heads sometimes moved independently and at other times moved as one. Because the TV channel showed the images again and again, I was able to make a detailed illustration of the large beast.

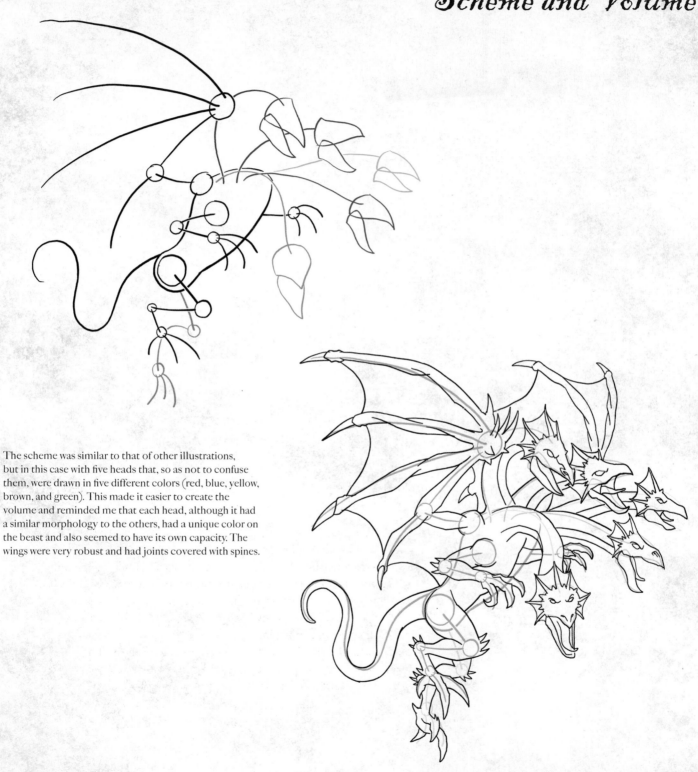

The scheme was similar to that of other illustrations, but in this case with five heads that, so as not to confuse them, were drawn in five different colors (red, blue, yellow, brown, and green). This made it easier to create the volume and reminded me that each head, although it had a similar morphology to the others, had a unique color on the beast and also seemed to have its own capacity. The wings were very robust and had joints covered with spines.

Pencil

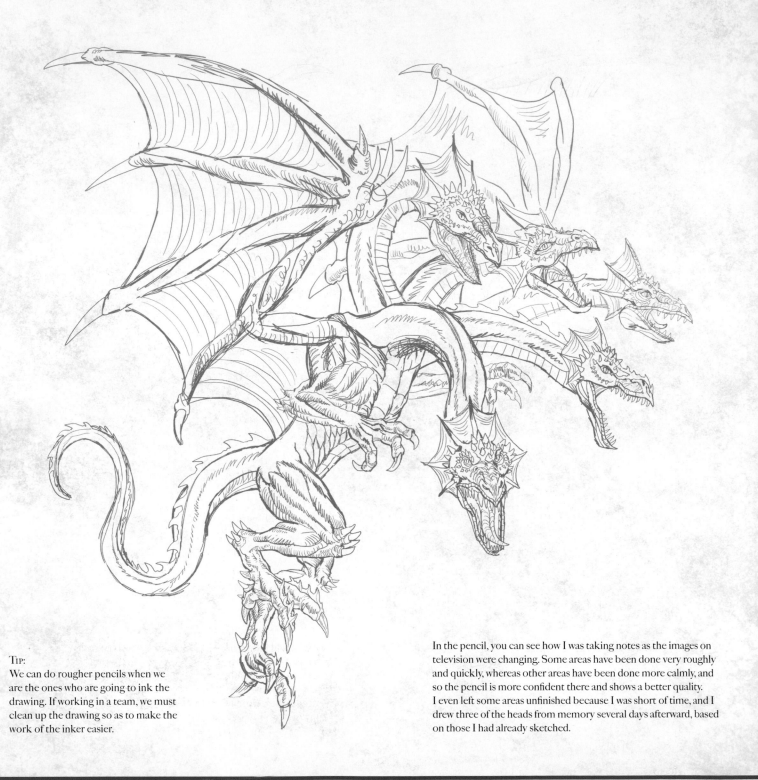

TIP:
We can do rougher pencils when we are the ones who are going to ink the drawing. If working in a team, we must clean up the drawing so as to make the work of the inker easier.

In the pencil, you can see how I was taking notes as the images on television were changing. Some areas have been done very roughly and quickly, whereas other areas have been done more calmly, and so the pencil is more confident there and shows a better quality. I even left some areas unfinished because I was short of time, and I drew three of the heads from memory several days afterward, based on those I had already sketched.

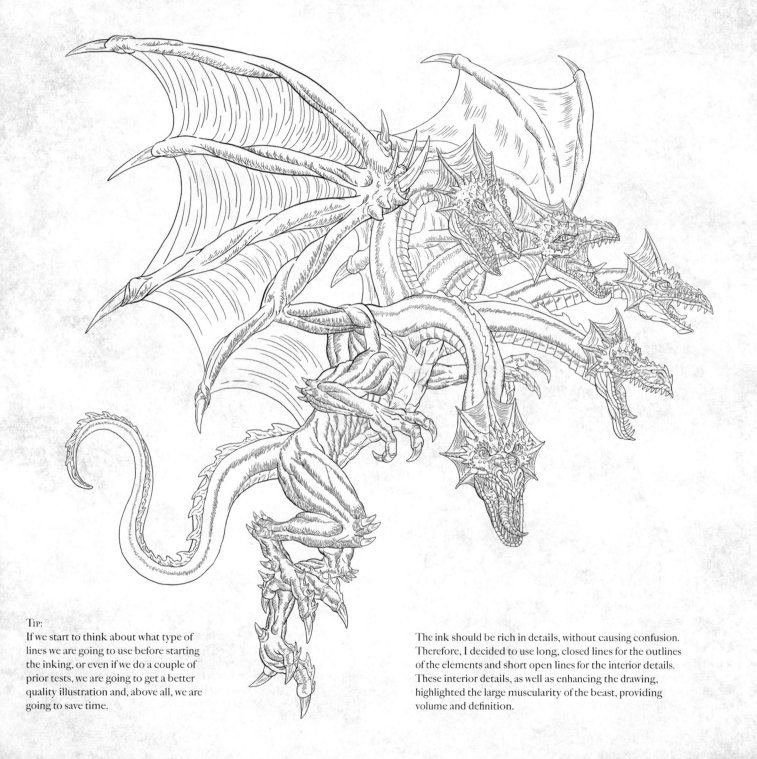

TIP:
If we start to think about what type of lines we are going to use before starting the inking, or even if we do a couple of prior tests, we are going to get a better quality illustration and, above all, we are going to save time.

The ink should be rich in details, without causing confusion. Therefore, I decided to use long, closed lines for the outlines of the elements and short open lines for the interior details. These interior details, as well as enhancing the drawing, highlighted the large muscularity of the beast, providing volume and definition.

Base Color, and Light

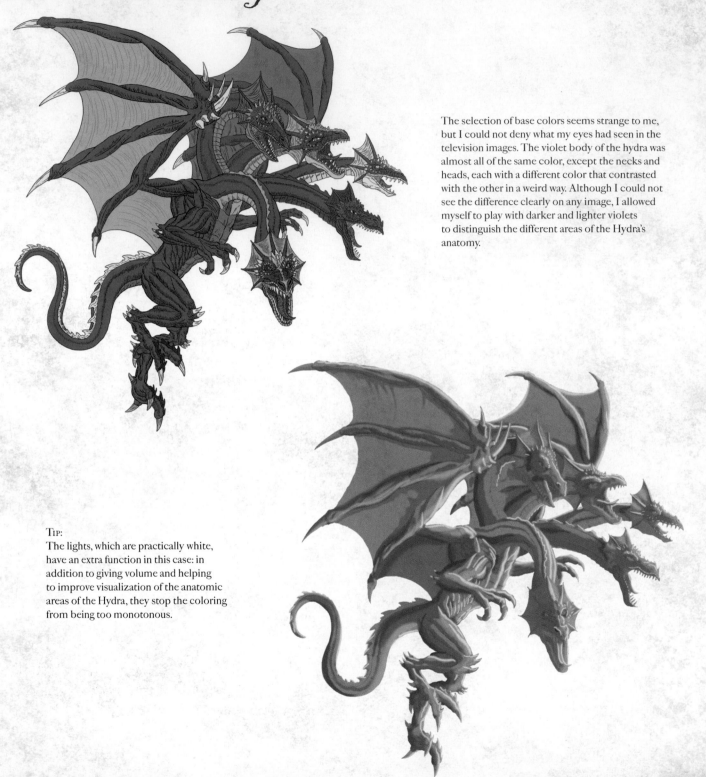

The selection of base colors seems strange to me, but I could not deny what my eyes had seen in the television images. The violet body of the hydra was almost all of the same color, except the necks and heads, each with a different color that contrasted with the other in a weird way. Although I could not see the difference clearly on any image, I allowed myself to play with darker and lighter violets to distinguish the different areas of the Hydra's anatomy.

TIP:
The lights, which are practically white, have an extra function in this case: in addition to giving volume and helping to improve visualization of the anatomic areas of the Hydra, they stop the coloring from being too monotonous.

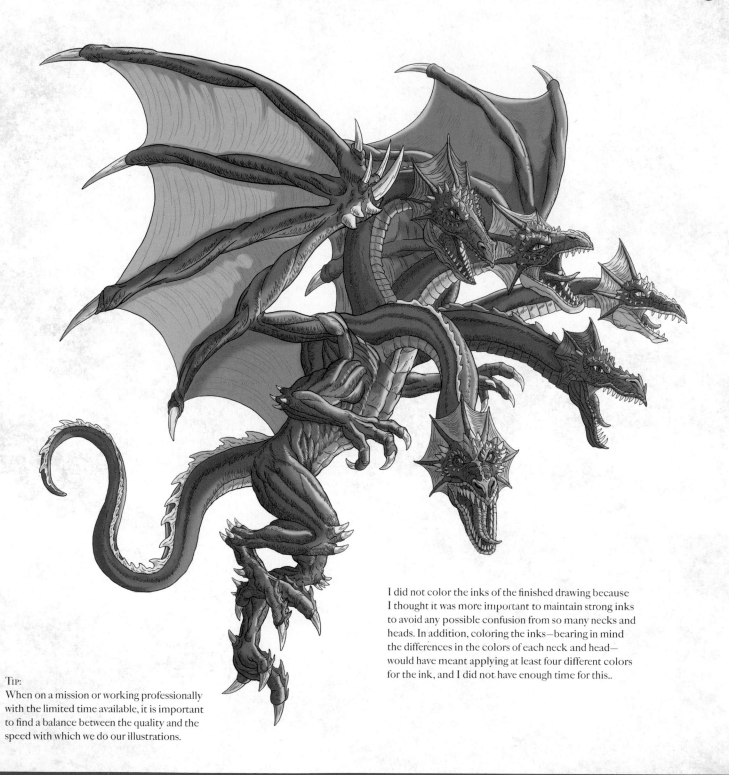

I did not color the inks of the finished drawing because I thought it was more important to maintain strong inks to avoid any possible confusion from so many necks and heads. In addition, coloring the inks—bearing in mind the differences in the colors of each neck and head— would have meant applying at least four different colors for the ink, and I did not have enough time for this..

TIP:
When on a mission or working professionally with the limited time available, it is important to find a balance between the quality and the speed with which we do our illustrations.

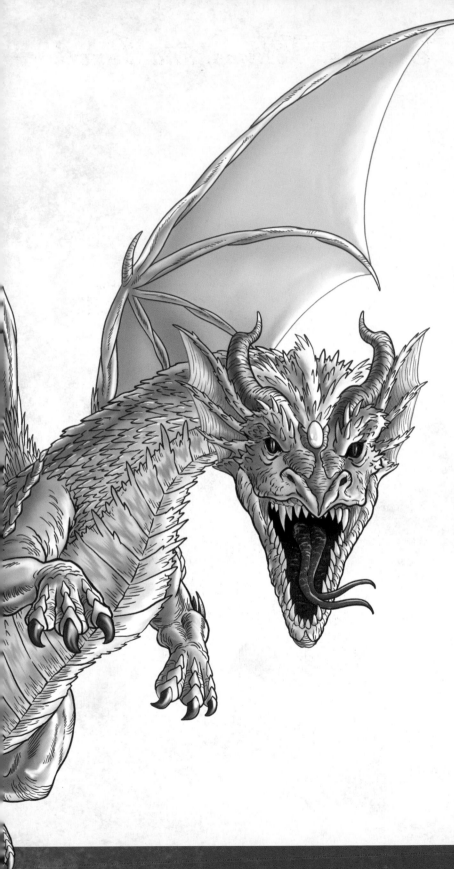

Polar Dragons

In the north of Canada, the cameras of a scientific station destroyed by a polar dragon recorded the fabulous reptile in full detail as it looked around the building for a long while before unleashing its fury. Fortunately, no lives were lost, but this has not been the case in many other places. Although the whole world is in shock, the governments seem more united than ever, coordinating armies and the population to protect themselves and fight against this common enemy whose origin and real destructive potential is still a mystery.

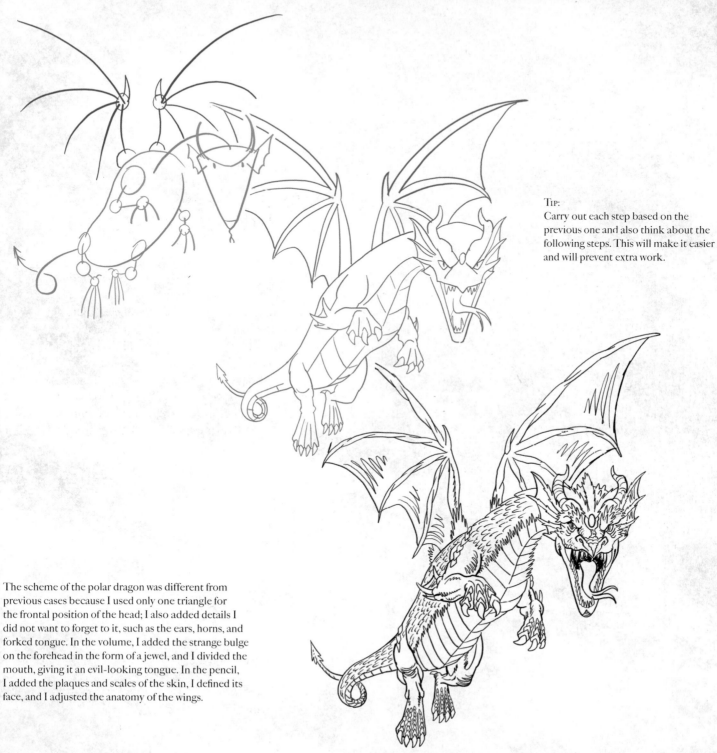

TIP:
Carry out each step based on the previous one and also think about the following steps. This will make it easier and will prevent extra work.

The scheme of the polar dragon was different from previous cases because I used only one triangle for the frontal position of the head; I also added details I did not want to forget to it, such as the ears, horns, and forked tongue. In the volume, I added the strange bulge on the forehead in the form of a jewel, and I divided the mouth, giving it an evil-looking tongue. In the pencil, I added the plaques and scales of the skin, I defined its face, and I adjusted the anatomy of the wings.

Ink

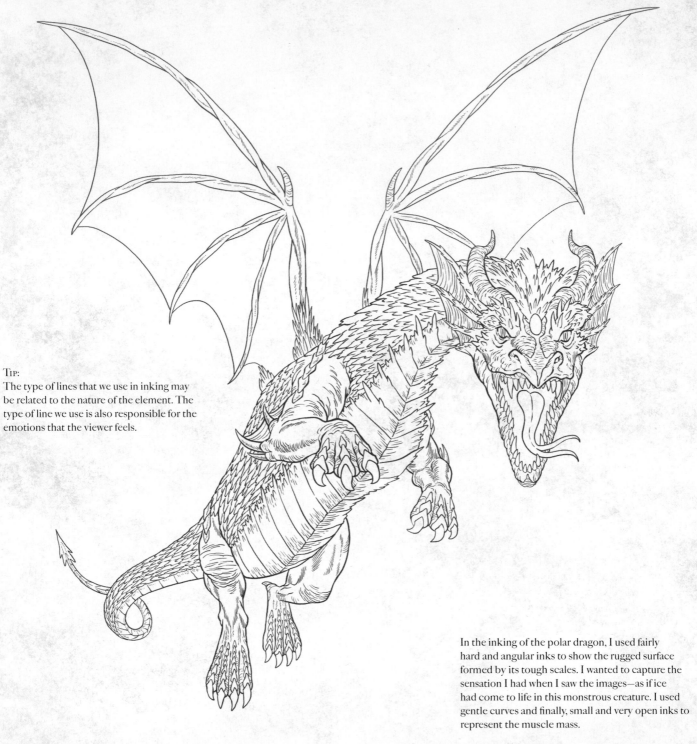

TIP:
The type of lines that we use in inking may be related to the nature of the element. The type of line we use is also responsible for the emotions that the viewer feels.

In the inking of the polar dragon, I used fairly hard and angular inks to show the rugged surface formed by its tough scales. I wanted to capture the sensation I had when I saw the images—as if ice had come to life in this monstrous creature. I used gentle curves and finally, small and very open inks to represent the muscle mass.

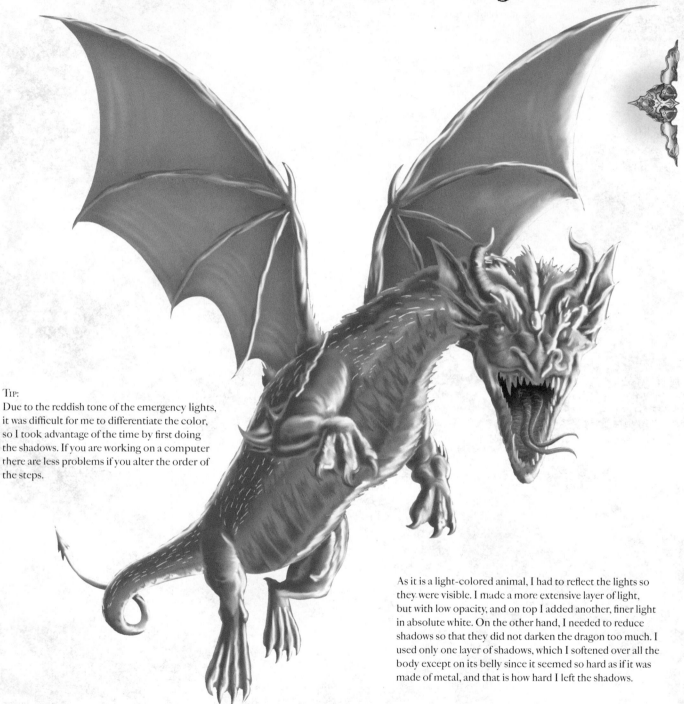

TIP:
Due to the reddish tone of the emergency lights, it was difficult for me to differentiate the color, so I took advantage of the time by first doing the shadows. If you are working on a computer there are less problems if you alter the order of the steps.

As it is a light-colored animal, I had to reflect the lights so they were visible. I made a more extensive layer of light, but with low opacity, and on top I added another, finer light in absolute white. On the other hand, I needed to reduce shadows so that they did not darken the dragon too much. I used only one layer of shadows, which I softened over all the body except on its belly since it seemed so hard as if it was made of metal, and that is how hard I left the shadows.

Base Color

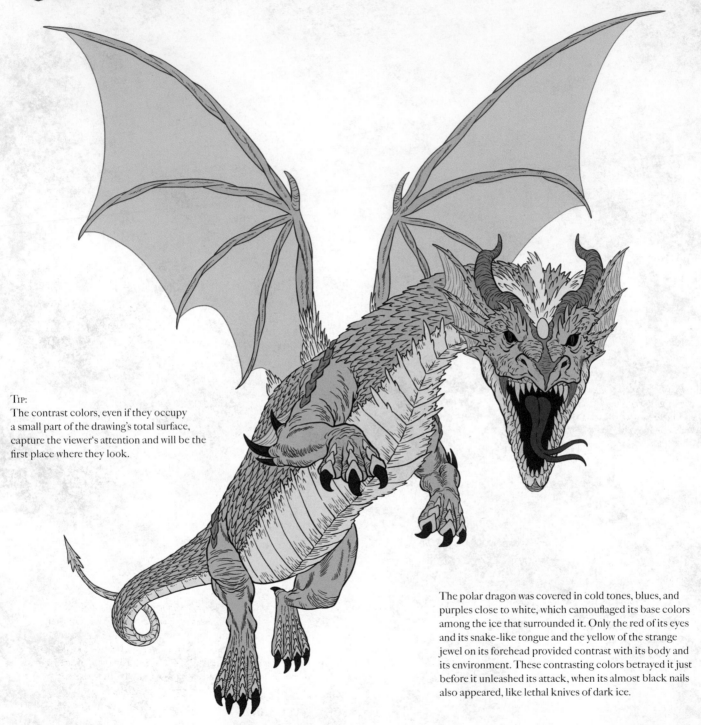

Tip:
The contrast colors, even if they occupy a small part of the drawing's total surface, capture the viewer's attention and will be the first place where they look.

The polar dragon was covered in cold tones, blues, and purples close to white, which camouflaged its base colors among the ice that surrounded it. Only the red of its eyes and its snake-like tongue and the yellow of the strange jewel on its forehead provided contrast with its body and its environment. These contrasting colors betrayed it just before it unleashed its attack, when its almost black nails also appeared, like lethal knives of dark ice.

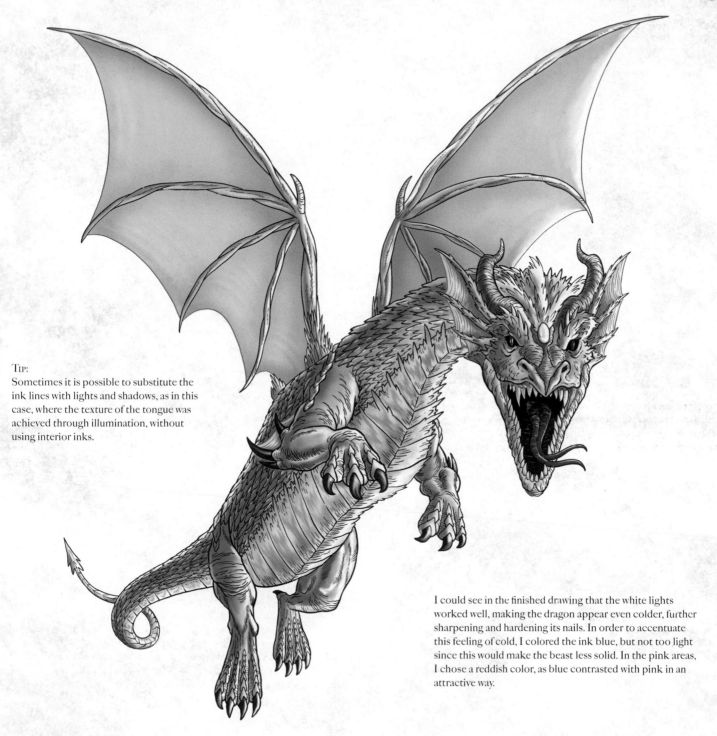

TIP:
Sometimes it is possible to substitute the ink lines with lights and shadows, as in this case, where the texture of the tongue was achieved through illumination, without using interior inks.

I could see in the finished drawing that the white lights worked well, making the dragon appear even colder, further sharpening and hardening its nails. In order to accentuate this feeling of cold, I colored the ink blue, but not too light since this would make the beast less solid. In the pink areas, I chose a reddish color, as blue contrasted with pink in an attractive way.

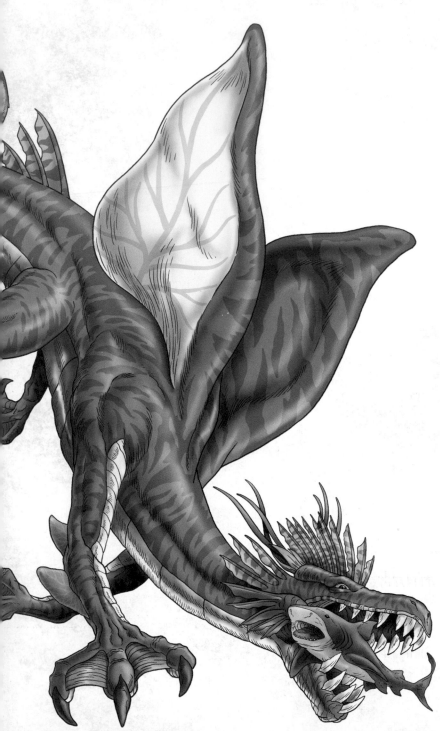

Marine Dragons

Transport and communications were slowly diminishing. Food started to become scarce and fishing reserves were down to minimum levels. We decided to explore the depths of the sea to confirm or dismiss the rumors about marine dragons. We set off on a scientific boat, equipped with metal cages, taking all the possible precautions. As we submerged, we immediately saw that something strange was happening under the surface. The remains of large animals floated in the water, and schools of large sharks calmly devoured the rotten flesh. Suddenly, at great speed, an enormous marine dragon appeared from above, trapped one of the sharks between its gigantic jaws, and disappeared into the darkness of the aphotic waters.

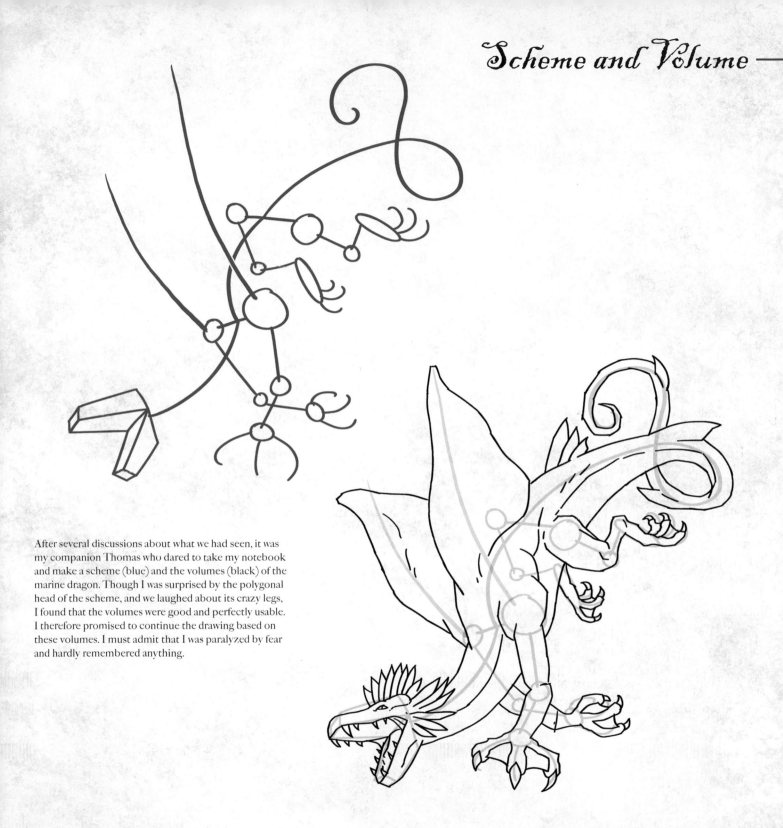

After several discussions about what we had seen, it was my companion Thomas who dared to take my notebook and make a scheme (blue) and the volumes (black) of the marine dragon. Though I was surprised by the polygonal head of the scheme, and we laughed about its crazy legs, I found that the volumes were good and perfectly usable. I therefore promised to continue the drawing based on these volumes. I must admit that I was paralyzed by fear and hardly remembered anything.

Pencil

TIP:
Listen to the criticism and opinions of
other people—it is something that is
very positive. If we take them correctly,
they can be very useful for finishing and
improving our illustrations.

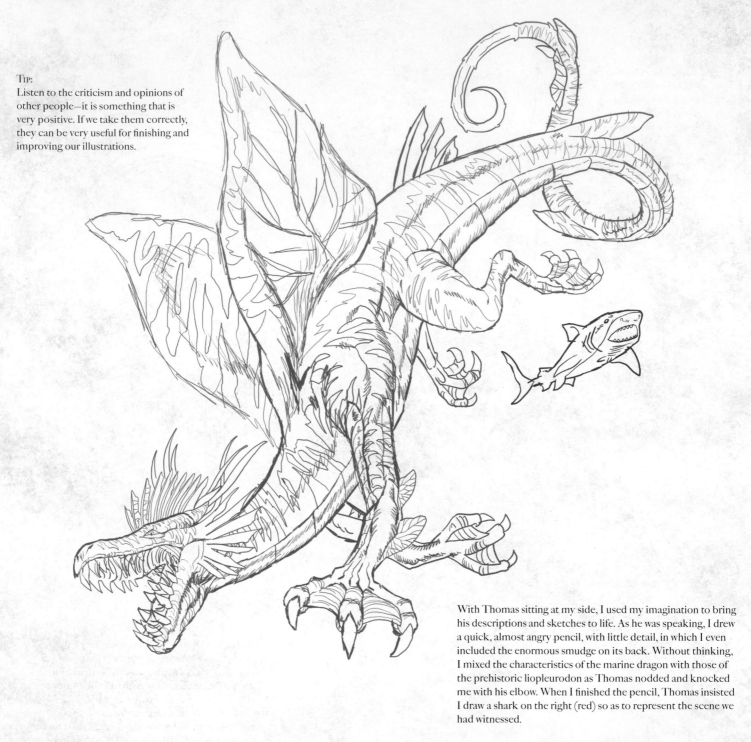

With Thomas sitting at my side, I used my imagination to bring
his descriptions and sketches to life. As he was speaking, I drew
a quick, almost angry pencil, with little detail, in which I even
included the enormous smudge on its back. Without thinking,
I mixed the characteristics of the marine dragon with those of
the prehistoric liopleurodon as Thomas nodded and knocked
me with his elbow. When I finished the pencil, Thomas insisted
I draw a shark on the right (red) so as to represent the scene we
had witnessed.

TIP:
More ink lines do not always produce a more attractive drawing. When inking, we work with balances between inks and white spaces. The latter are as important as the silences in a song.

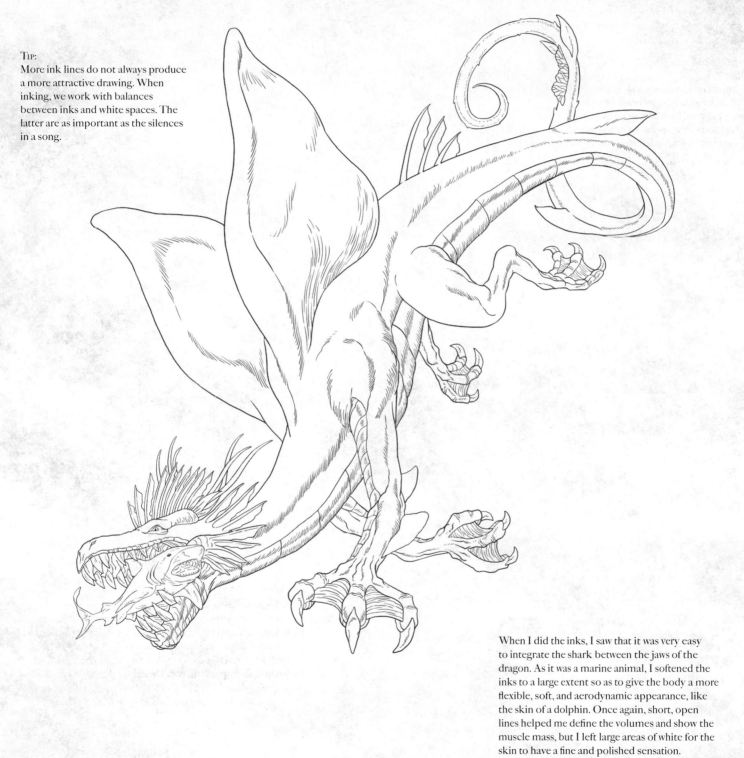

When I did the inks, I saw that it was very easy to integrate the shark between the jaws of the dragon. As it was a marine animal, I softened the inks to a large extent so as to give the body a more flexible, soft, and aerodynamic appearance, like the skin of a dolphin. Once again, short, open lines helped me define the volumes and show the muscle mass, but I left large areas of white for the skin to have a fine and polished sensation.

Light and Shadow

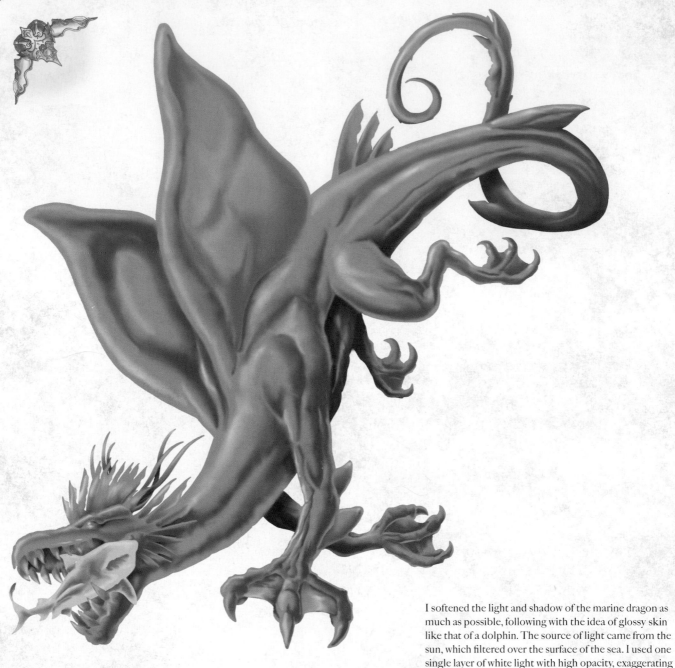

TIP:
In the same way that the shape of the ink lines can express hardness or softness or that a color can express heat or cold, shadows and lights are essential for defining hardness and texture.

I softened the light and shadow of the marine dragon as much as possible, following with the idea of glossy skin like that of a dolphin. The source of light came from the sun, which filtered over the surface of the sea. I used one single layer of white light with high opacity, exaggerating the brightness running along its body so as to achieve that characteristic appearance. Using a medium shadow, I gave volumes to the whole body, and by using dark shadows, I defined the bottom part of the animal and gave three-dimensionality to the legs and tail.

Tip:
Once again, natural evolution gives us the logical key to confirm the colors of the marine dragon. If the colors were the other way around, it would be easily visible and its prey would flee.

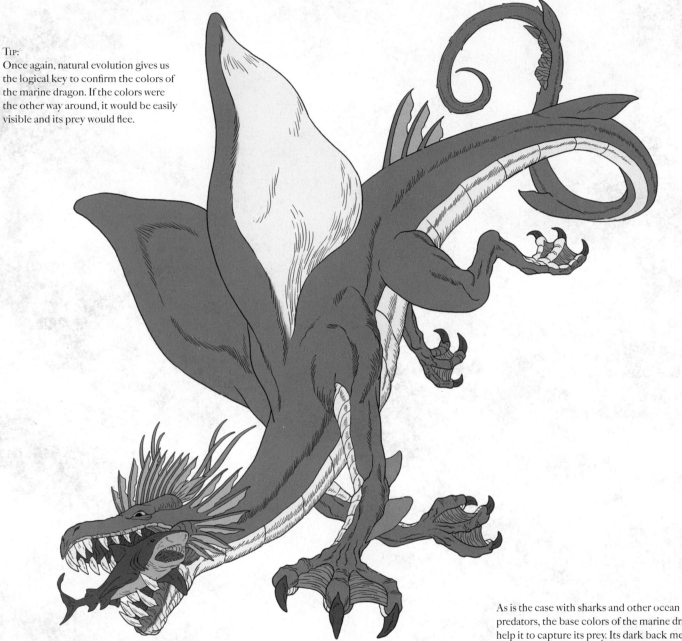

As is the case with sharks and other ocean predators, the base colors of the marine dragon help it to capture its prey. Its dark back means that it mixes with the bottom of the sea when it lurks below, and its light belly means it mixes with the surface when it spies from above. Once again, the dark nails indicate its toughness, and the purple fins provide the perfect contrast.

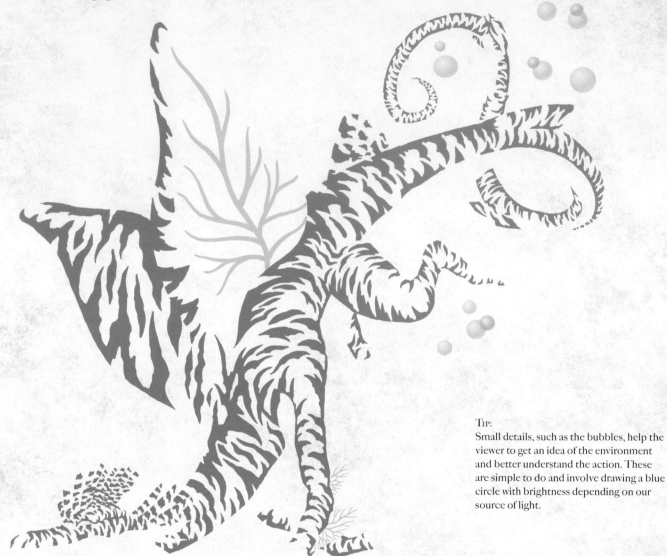

TIP:
Small details, such as the bubbles, help the viewer to get an idea of the environment and better understand the action. These are simple to do and involve drawing a blue circle with brightness depending on our source of light.

On a different sheet, I separated the smudges on its back, which would prove to be a simple resource for providing spectacular results. I did these smudges with visible inks so it would be clear where each smudge should twist when following the three-dimensional shape of the dragon's body. They are a series of simple dark blue smudges, like the stripes of a tiger. Some fish, such as the lionfish, use such stripes to camouflage themselves better and confuse their prey.

TIP:
Some good things happen by chance. We must be alert so as to be able to recognize them and not ignore them, even though they were not in our initial plan. If something works, why change it?

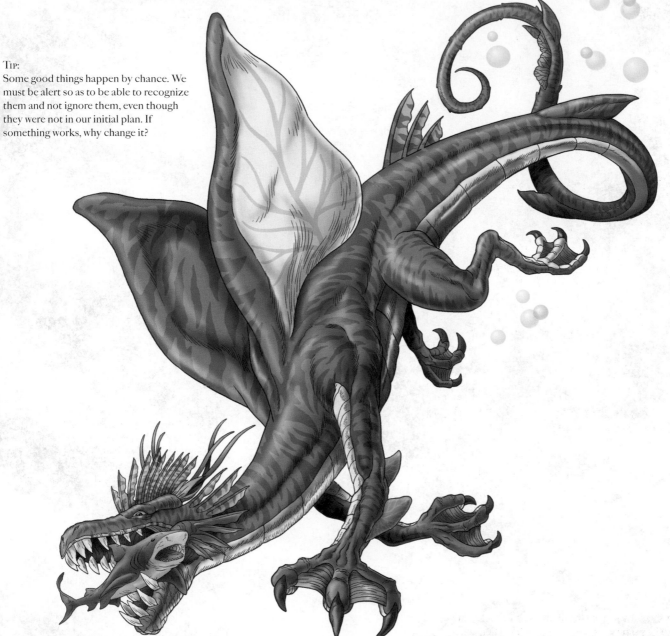

In the finished drawing, the marine dragon seemed to be coming from above at great speed, catching the shark unaware. The shark also acts as a size reference, letting us see the titanic dimensions of the dragon. The inks of the shark were colored gray and those of the dragon were colored only in blue. To my surprise, they matched well with the purple fins and even with the white teeth. My brain had accepted it, given that it was an underwater image.

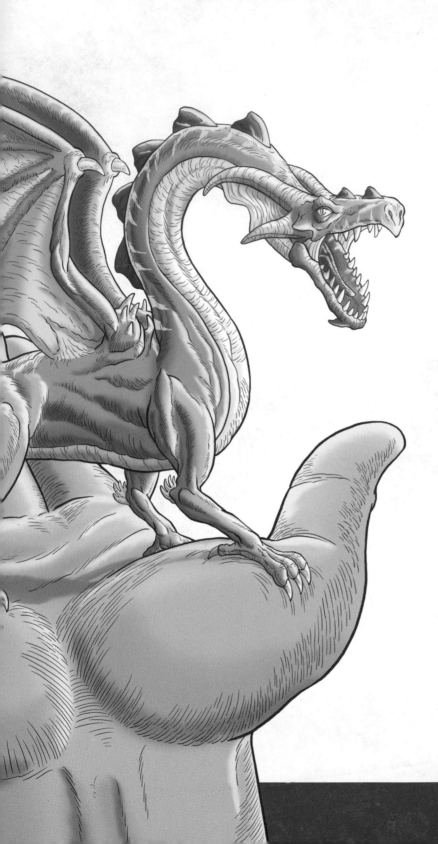

Miniature Dragons

We returned to the port feeling very down. The adaptation of the dragons to different environments was so advanced that we could not see how we could control them or defeat them. When we heard that several dragon eggs had been found in some deep caves under the old ruins of a walled fortress, and that we should study them, we began to feel a new sense of hope. What was the relationship between dragons and castles? What made them attack them or settle close to them? A military helicopter picked us up to take us to the place of the finding, but on entering the cave, we were once again surprised, this time by the most unexpected creatures. Miniature dragons appeared, attracted by the light of our flashlights. One of them flew toward me and settled on the palm of my hand.

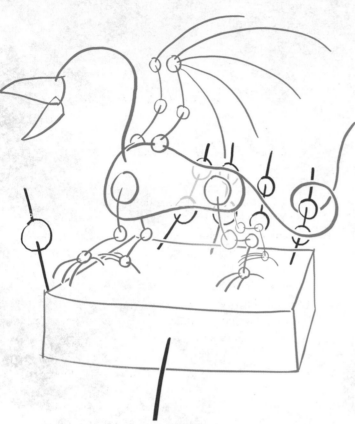

The scheme of the dragon (green) was similar to others carried out previously in which its volume (black) highlighted the spines of the neck and the tail wrapped around the little finger.

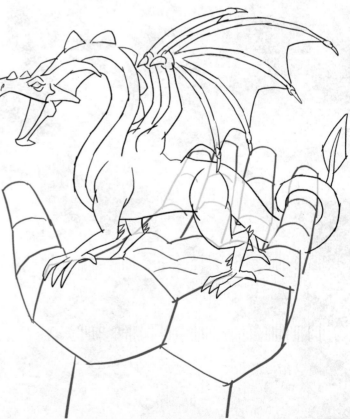

Pencil

I did the pencil with the feeling that I was tracing little more than a detailed volume: Within the volume of the mouth, I detailed the volume of the teeth and the tongue; within the volume of the legs and the wings, I detailed the volume of the muscle; within the volume of the neck and tail, I did curved lines, following their rotation; and within the volume of the hand, I did long lines in the areas of flexion and short lines to define the volume. It was a mechanical process. The only details that seemed creative to me were the end of the tail and the tendons of the wrist. Some days are better than others...

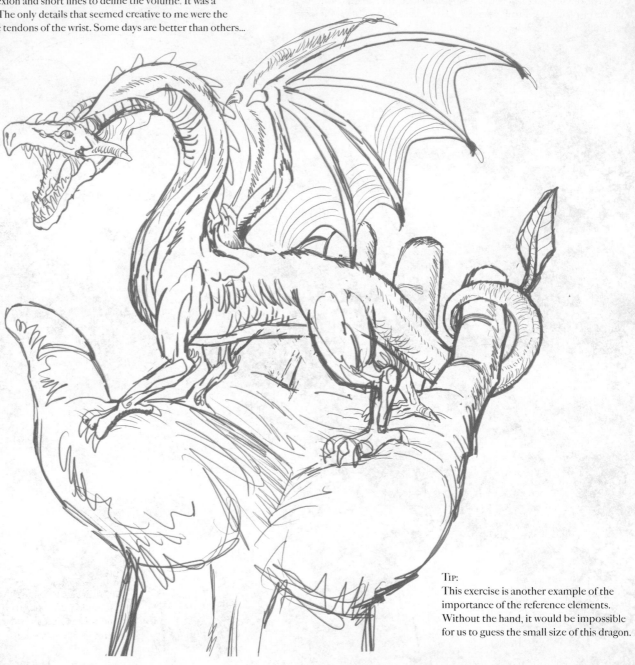

Tip:
This exercise is another example of the importance of the reference elements. Without the hand, it would be impossible for us to guess the small size of this dragon.

With the neutral sensations I had achieved with my pencil, I thought that if I was going to obtain a good illustration, then I needed to do a great job with the inking, which gave me the perfect excuse to break down the inking steps and explain a little more about this stage of the drawing. In the image, you can see how I first ink the external outlines of the elements, tracing over my own pencil. I focus on obtaining a suitable line (smooth, creased, rounded, angular, etc.), but one that is always visually pleasing. The external lines are always at least marginally thicker than the internal lines.

TIP:
If you decide to follow this method in any illustration, do not worry if you miss any interior line or you forget any external line. This is not an exam—enjoy your inking.

Ink

On this sheet, I only separated the lines of the internal inking. As you can see, I decided to enhance the illustration to make sure it was not just of average quality. The inking work, performed with short and open lines, is so thorough that we can almost see the full shapes only with these interior lines. Of course, when I did them, the external lines were visible, as well as my pencil, which I was tracing.

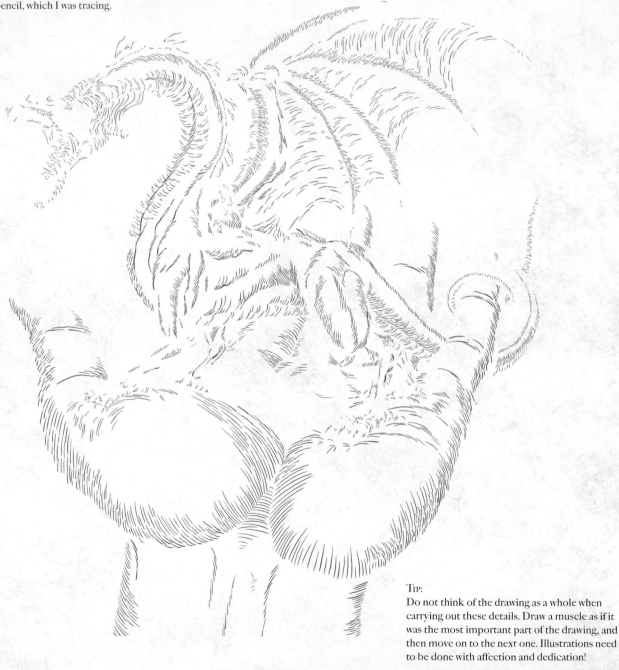

TIP:
Do not think of the drawing as a whole when carrying out these details. Draw a muscle as if it was the most important part of the drawing, and then move on to the next one. Illustrations need to be done with affection and dedication!

Taking green as the base color of the dragon, we gave the lighter areas (belly and wings) a lighter color and the harder areas (spines on the snout and neck) a darker color. The red of the mouth acts as a point of contrast, which is absolutely essential. The other details of the dragon, with regard to my illustration, enrich and prevent the coloring from being boring.

For the hand, a pinkish color, such as my own skin tone.

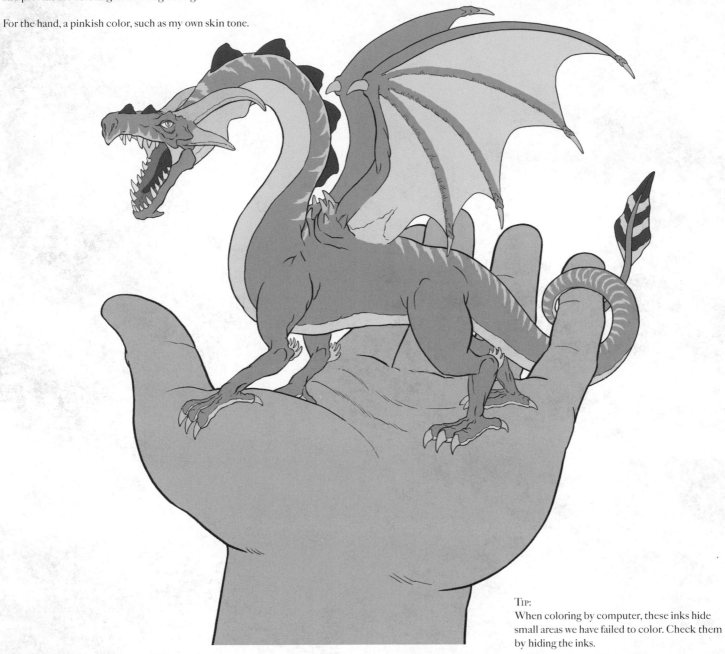

TIP:
When coloring by computer, these inks hide small areas we have failed to color. Check them by hiding the inks.

Light and Shadow

With a source of light in the top left part, I enhanced the entire top left profiles with a strong light. I added light to some profiles that are not facing that direction because I believe that light might also reach them, and it is very useful for me in order to define the volumes of the dragon and my hand. The two layers of shadows are clearly visible. With the wider shadow, which is also less dark, I define the general volumes. With the thinner shadow, which is also darker, I enhance the profiles that are facing away from the source of light, reasserting the volumes.

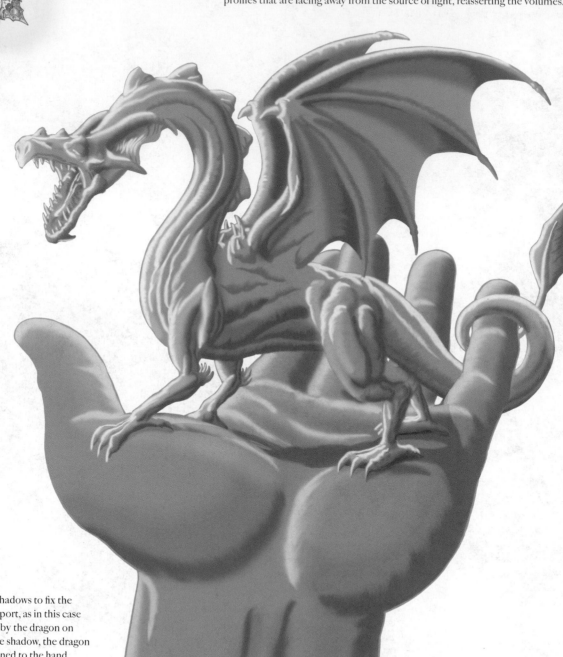

TIP:
We can also use the shadows to fix the elements to their support, as in this case with the shadow cast by the dragon on the hand. Without the shadow, the dragon would not be fully joined to the hand.

I felt good about the finished drawing, and I no longer had the feeling that it was unattractive drawing, as I had when I did the pencil. It is important to sense whether you are on the right track when you start a drawing, but it is also important to know that, even though the drawing does not start well, it may finish fantastically. Given that I had paid so much attention to enhancing the drawing, you will notice that I had to color the inks: dark green for the greenish areas and dark blue for the hand and the mouth.

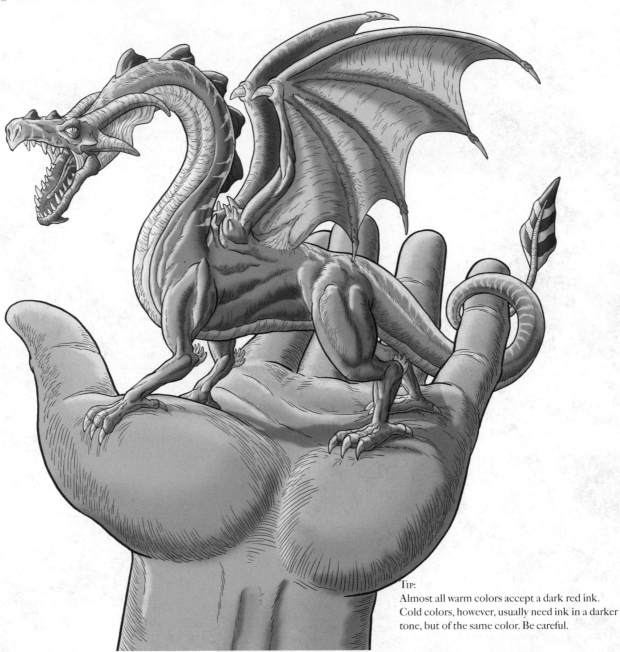

TIP:
Almost all warm colors accept a dark red ink. Cold colors, however, usually need ink in a darker tone, but of the same color. Be careful.

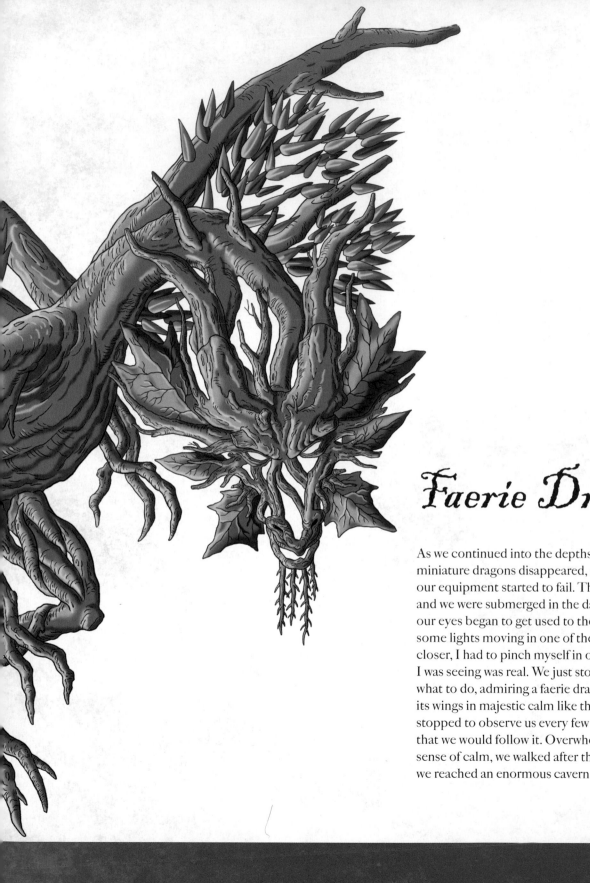

Faerie Dragons

As we continued into the depths of the cave, the miniature dragons disappeared, and a few minutes later, our equipment started to fail. The flashlights went off, and we were submerged in the darkness. Little by little, our eyes began to get used to the dark, and we spotted some lights moving in one of the passageways. As we got closer, I had to pinch myself in order to believe that what I was seeing was real. We just stood there, not knowing what to do, admiring a faerie dragon, which, moving its wings in majestic calm like the branches of a tree, it stopped to observe us every few stepss, as if it was hoping that we would follow it. Overwhelmed by an immense sense of calm, we walked after the magical creature until we reached an enormous cavern.

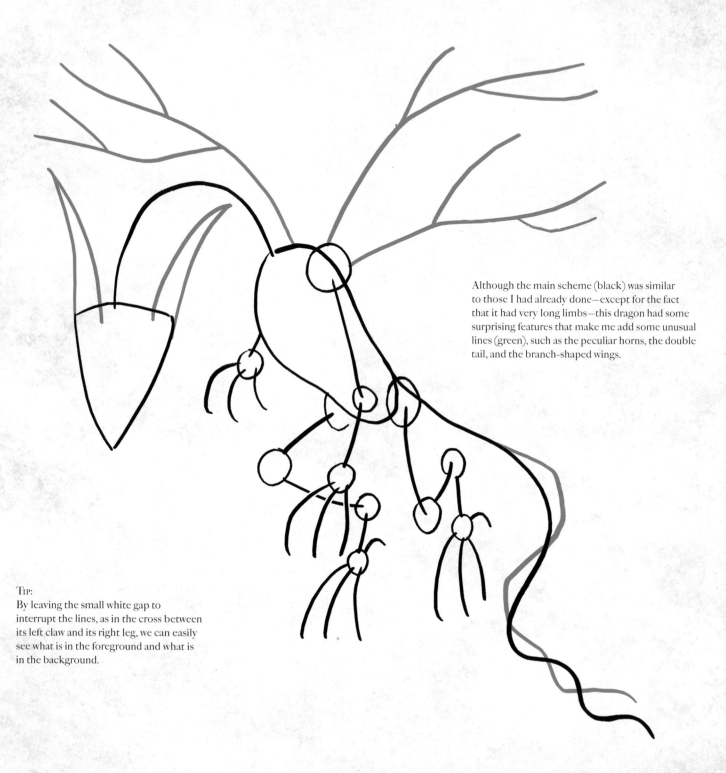

Although the main scheme (black) was similar to those I had already done—except for the fact that it had very long limbs—this dragon had some surprising features that make me add some unusual lines (green), such as the peculiar horns, the double tail, and the branch-shaped wings.

TIP:
By leaving the small white gap to interrupt the lines, as in the cross between its left claw and its right leg, we can easily see what is in the foreground and what is in the background.

Volume

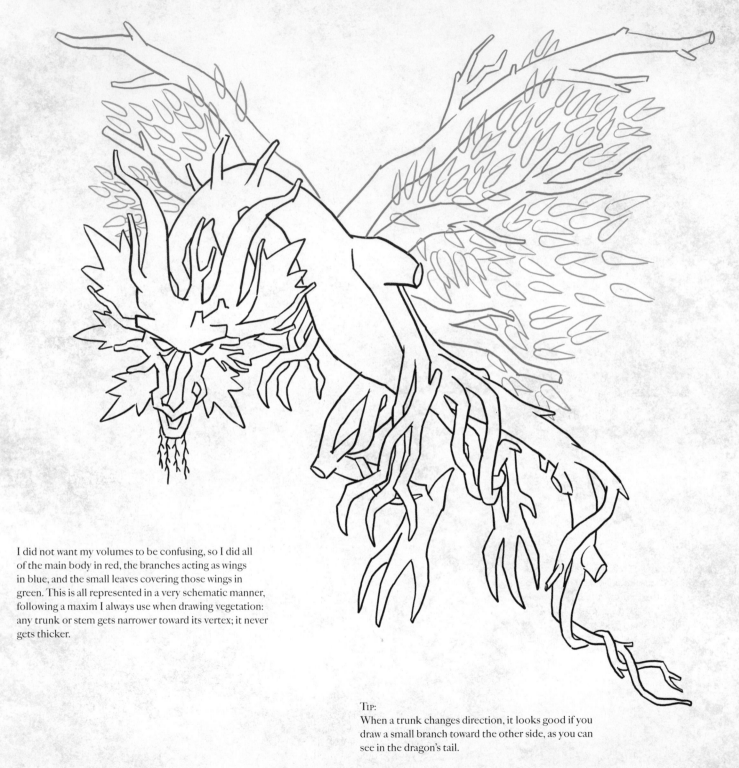

I did not want my volumes to be confusing, so I did all of the main body in red, the branches acting as wings in blue, and the small leaves covering those wings in green. This is all represented in a very schematic manner, following a maxim I always use when drawing vegetation: any trunk or stem gets narrower toward its vertex; it never gets thicker.

TIP:
When a trunk changes direction, it looks good if you draw a small branch toward the other side, as you can see in the dragon's tail.

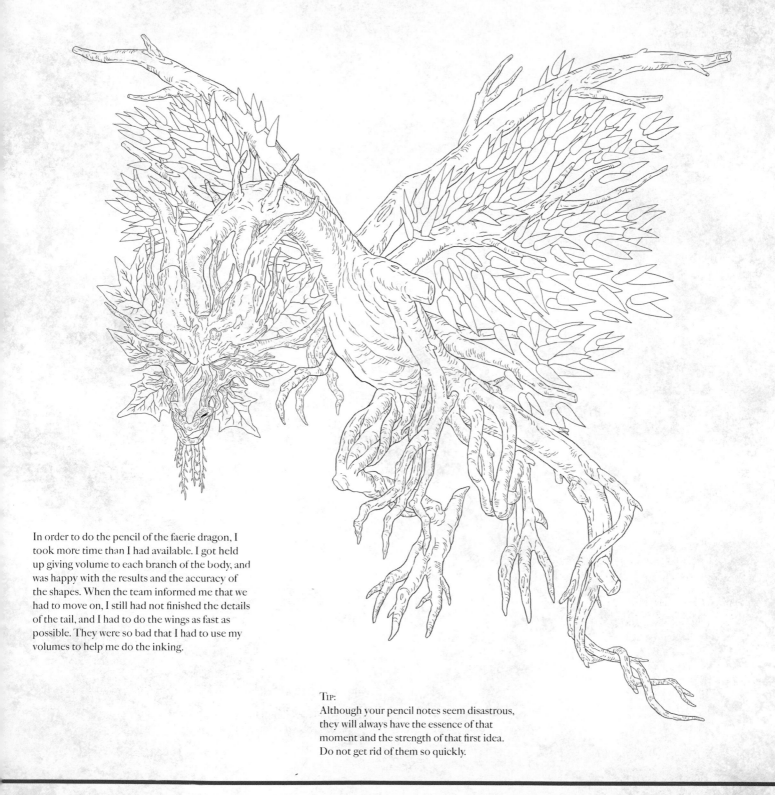

Pencil ——

In order to do the pencil of the faerie dragon, I took more time than I had available. I got held up giving volume to each branch of the body, and was happy with the results and the accuracy of the shapes. When the team informed me that we had to move on, I still had not finished the details of the tail, and I had to do the wings as fast as possible. They were so bad that I had to use my volumes to help me do the inking.

TIP:
Although your pencil notes seem disastrous, they will always have the essence of that moment and the strength of that first idea. Do not get rid of them so quickly.

Ink

TIP:
The knots are those small circles or ellipses that I draw now and again along the branches. Adding them produces a good effect when you are drawing tree trunks.

When I did the inking, I made sure that I was not going to be interrupted. I was so amazed by the creature that I took my time to ink each small detail with creased and quavering inks to give the sensation of the bark of a tree. If you look closely, the type of details of one branch are similar to any other: similar lines in similar positions. The key lies in not looking at any of the other branches when you are inking a branch. Therefore, however much you try, you will never achieve two that are the same.

TIP:
What is evident is often the best thing for allowing viewers to have an anchor point and to facilitate understanding of what they are seeing. In this illustration, color takes on that role.

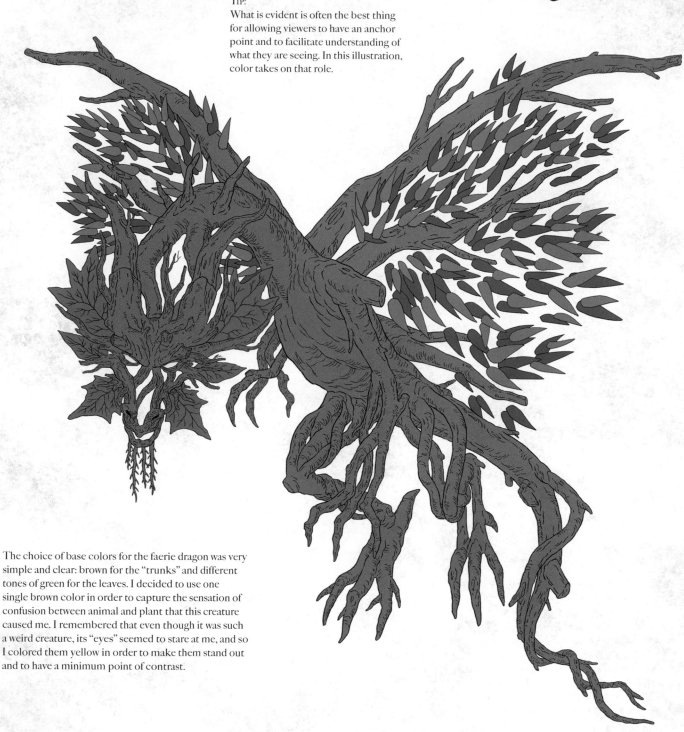

The choice of base colors for the faerie dragon was very simple and clear: brown for the "trunks" and different tones of green for the leaves. I decided to use one single brown color in order to capture the sensation of confusion between animal and plant that this creature caused me. I remembered that even though it was such a weird creature, its "eyes" seemed to stare at me, and so I colored them yellow in order to make them stand out and to have a minimum point of contrast.

Light and Shadow

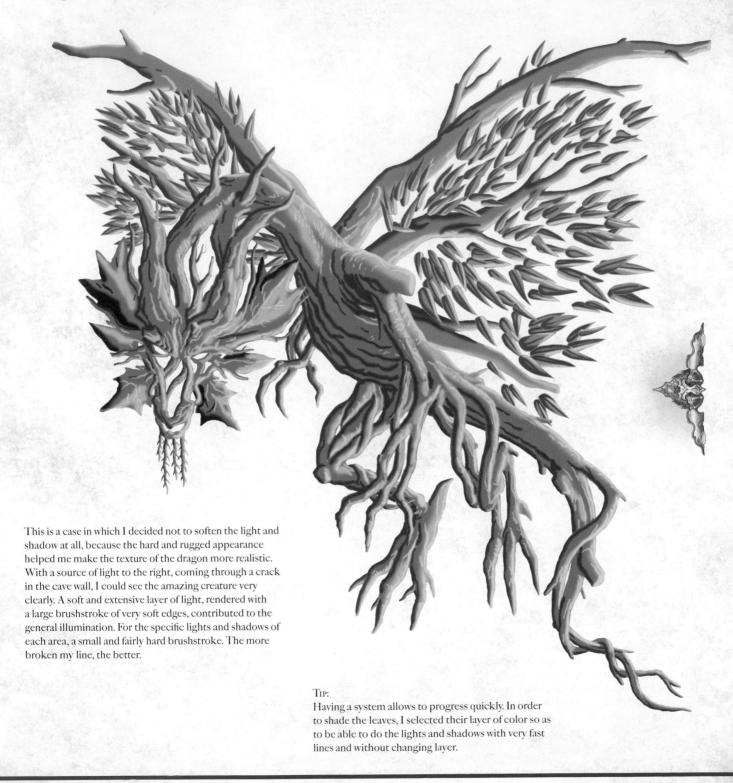

This is a case in which I decided not to soften the light and shadow at all, because the hard and rugged appearance helped me make the texture of the dragon more realistic. With a source of light to the right, coming through a crack in the cave wall, I could see the amazing creature very clearly. A soft and extensive layer of light, rendered with a large brushstroke of very soft edges, contributed to the general illumination. For the specific lights and shadows of each area, a small and fairly hard brushstroke. The more broken my line, the better.

TIP:
Having a system allows to progress quickly. In order to shade the leaves, I selected their layer of color so as to be able to do the lights and shadows with very fast lines and without changing layer.

TIP:
When I set about drawing this dragon, some
companions told me that it was impossible. Some
of them were not even able to describe it. But if
your brain can do it, your hands can draw it.

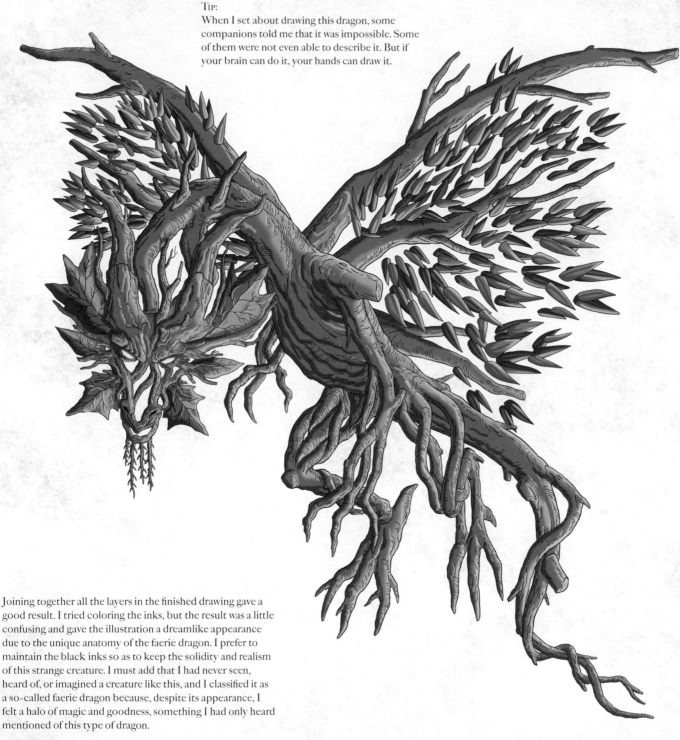

Joining together all the layers in the finished drawing gave a
good result. I tried coloring the inks, but the result was a little
confusing and gave the illustration a dreamlike appearance
due to the unique anatomy of the faerie dragon. I prefer to
maintain the black inks so as to keep the solidity and realism
of this strange creature. I must add that I had never seen,
heard of, or imagined a creature like this, and I classified it as
a so-called faerie dragon because, despite its appearance, I
felt a halo of magic and goodness, something I had only heard
mentioned of this type of dragon.

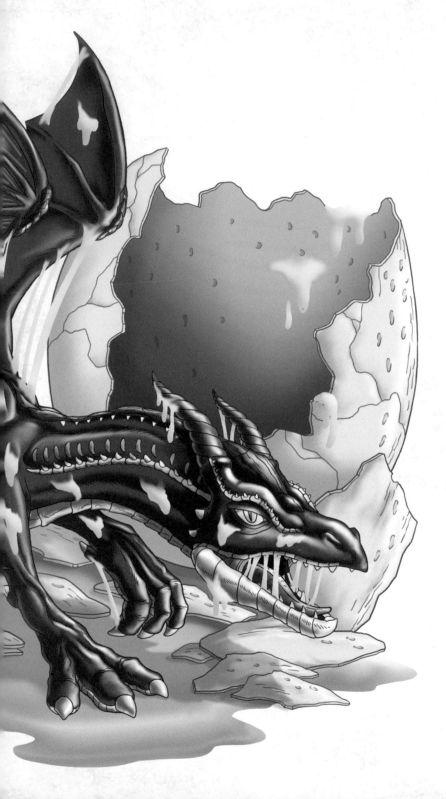

Baby Dragons

The vault of this astonishing underground hall was crowned by an enormous hole that allowed sunlight to stream through. In the center of the chamber, two dragon eggs remained intact, waiting to hatch. While the rest of the team set up their cameras, I walked toward one of the eggs and rested my hand on its soft surface. I could feel heat and movement under the shell—followed by a cracking sound that made me take two steps back. I turned toward my companions with an inquisitive look. Two of them, staring into the lens of the camera, raised their thumbs as if to say yes. We were going to be able to record in full detail the birth of a baby dragon.

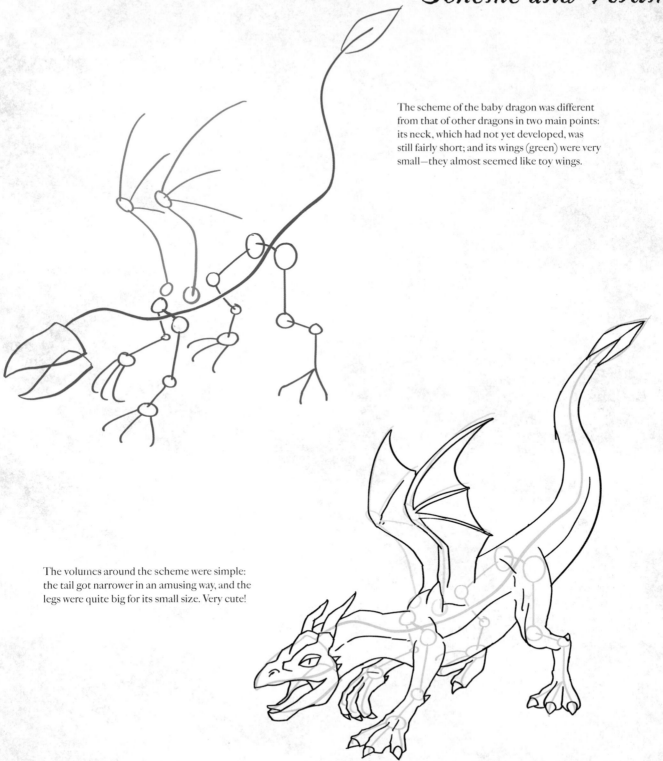

Scheme and Volume

The scheme of the baby dragon was different from that of other dragons in two main points: its neck, which had not yet developed, was still fairly short; and its wings (green) were very small—they almost seemed like toy wings.

The volumes around the scheme were simple: the tail got narrower in an amusing way, and the legs were quite big for its small size. Very cute!

Pencil

For the pencils, I used many colors in order to avoid confusions between the different elements, but, ironically, so much color ended up confusing me. I tidied up the pencil with only three colors. The pencil of the dragon (black) included all its details. The pencil of the egg (blue) aimed, above all, to be somewhat angular, with the fragments of the shell scattered over the floor. The pencil of the liquid that fell to the ground when the dragon emerged (green) shows that it did not spread evenly, since it was a fairly viscous substance.

TIP:
To represent rugged and porous surfaces well, such as the eggshell, we can make irregular, U-shaped lines.

The inks of the dragon had to be thicker than those of the egg, which lies in the background. The lines of the dragon would also be soft and rounded on its recently born skin and harder and angular where it had plaques or spines. On the edges of the shell, I drew a double line, which represented the thickness of the shell. Without that line of thickness, the egg would seem to be have been made of paper.

TIP:
Drawing cracks is like drawing a map with a series of rivers that break off in a disorderly manner.

Base Color

I did the eggshell all in gray with a slight touch of yellow. I used a darker gray for inside the egg in order to increase the sense of depth.

The selection of the dragon's base colors was a little more varied. The main color, red, was accompanied by purple plaques on its back and different tones of gray for the wings, belly, and details along the body. Its greenish tongue made me wonder whether it would maintain these colors throughout its life or whether its color would change when it became an adult.

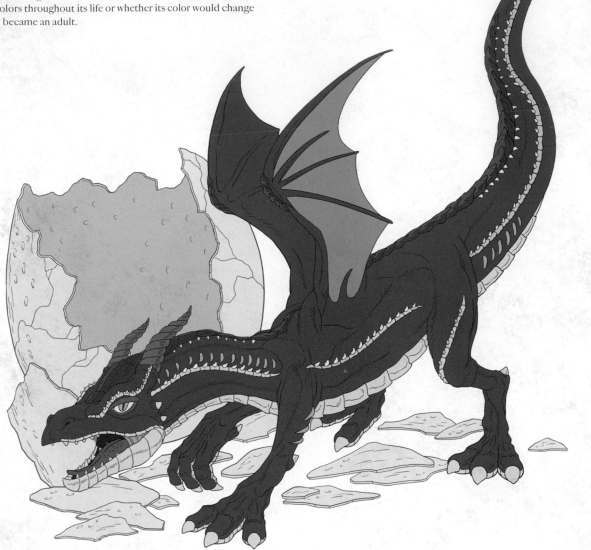

TIP:
Using a lighter or darker color to highlight the volumes gives a very good result for the exterior and interior and the top, bottom, and sides of a polygonal element.

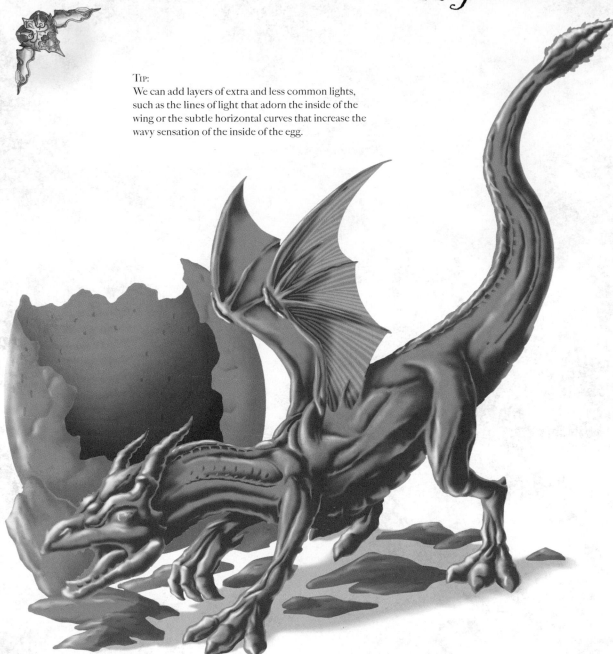

TIP:
We can add layers of extra and less common lights, such as the lines of light that adorn the inside of the wing or the subtle horizontal curves that increase the wavy sensation of the inside of the egg.

In order to make this drawing, I used three groups of light and shadow. For the dragon, I used a fine light to accompany the inks that were oriented toward the source of light and a thick, strong shadow that played with the different spaces between the inks. For the egg, the lines follow an ovoid shape, while the shadows follow the cracks. For inside the egg, I used a second shadow, dark and very soft, to further highlight the volume.

Special Effects

I incorporated what I call special effects to this drawing, which in my head include brightness, fire, lightning, textures, and many other things, including—as in this case—viscous liquids. I have done this by drawing the smudges in an intense green (to see it better), which I later lightened to give it this organic tone. The secret is in making the shadows stick to the edges, and not allowing the brightness to touch the edges (or vice versa).

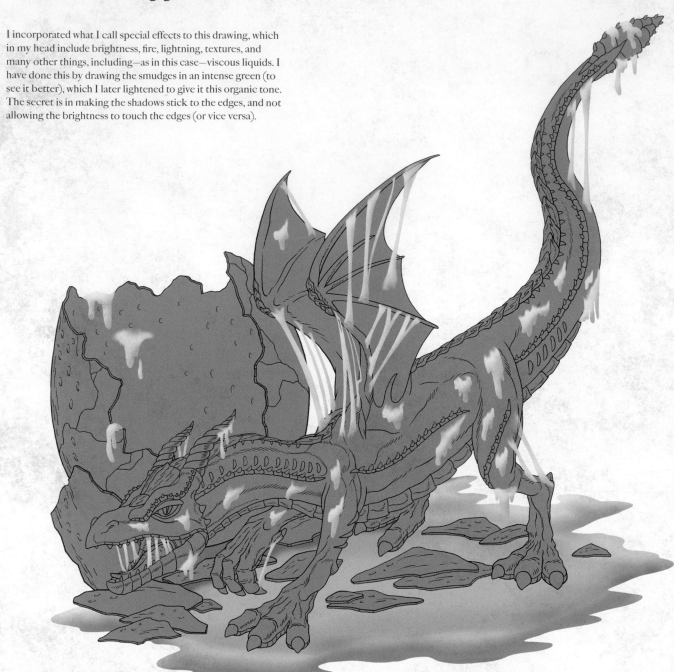

TIP:
Although the viscous liquid seems to be one unit, remember that it is divided into two layers. One on top of the whole drawing, and another below the whole drawing.

The combination of shadows, lights, and viscous liquid gives the finished drawing a convincing appearance. The inks have been colored red and gray for the dragon and a lighter gray for the eggshell.

The baby dragon seems to hesitate as it takes its first steps, ignoring us and opening its mouth as if calling to us in a way we cannot hear.

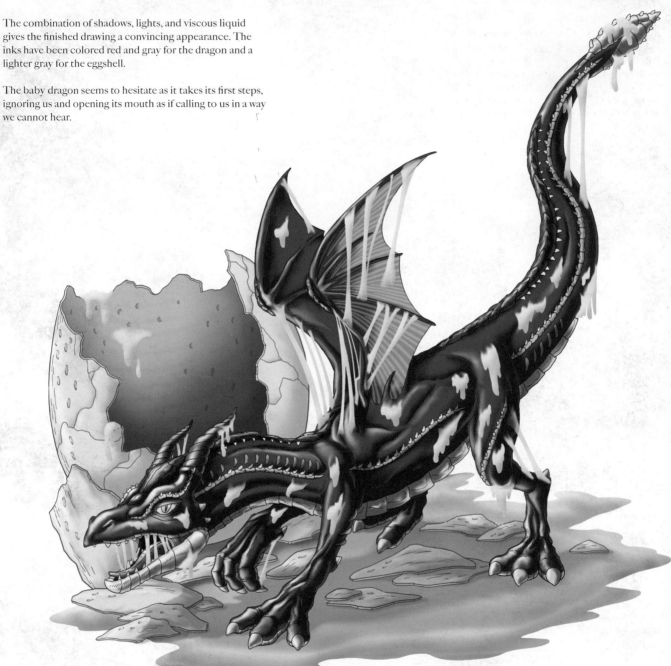

TIP:
The large eyes, small snout, and short limbs are typical characteristics of the offspring of almost all animal species.

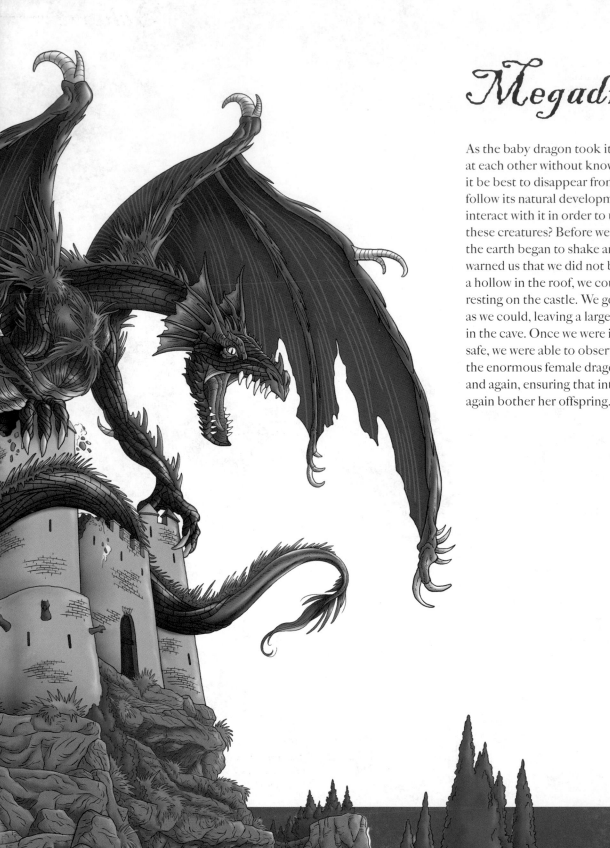

Megadragons

As the baby dragon took its first steps, we looked at each other without knowing what to do. Would it be best to disappear from there and let the baby follow its natural development, or should we try to interact with it in order to understand more about these creatures? Before we could make a decision, the earth began to shake and a deafening roar warned us that we did not belong there. Through a hollow in the roof, we could see a megadragon resting on the castle. We got out of there as fast as we could, leaving a large part of our equipment in the cave. Once we were in the forest and we felt safe, we were able to observe the magnificence of the enormous female dragon, which roared again and again, ensuring that intruders would never again bother her offspring.

The scheme of the dragon was characterized by especially large wings (orange), a very long tail (blue), and limbs (red) that settled solidly on the castle towers.

The castle on which the dragon rests (green), as well as the background landscape, were resolved with simple triangles or squares that also served as volumes.

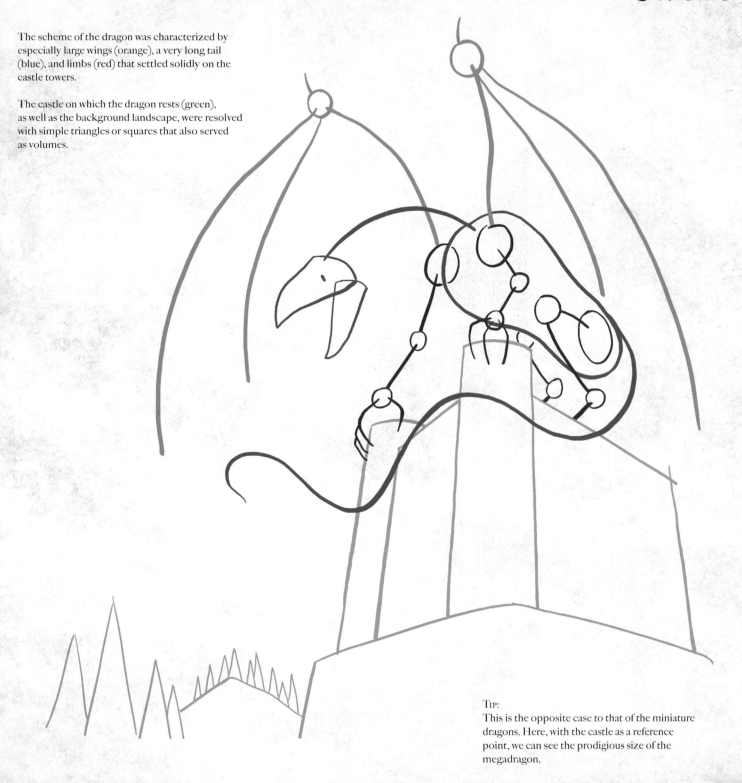

TIP:
This is the opposite case to that of the miniature dragons. Here, with the castle as a reference point, we can see the prodigious size of the megadragon.

Pencil

First, I did the pencil of the castle. Given that we were looking at the castle from a slightly low angle, the lines began to join as we rose toward the upper part. The uneven vegetation was resolved with curves and points. The gargoyles, buttresses, and details of the walls and rocks were added in a different color, although I later observed that doing it all in black would not have caused confusion, but better safe than sorry.

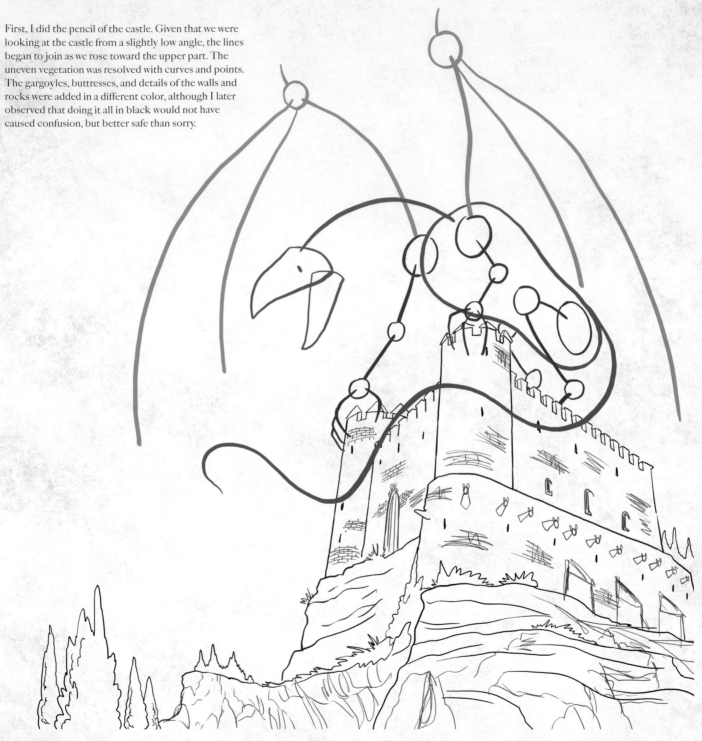

My inks of the castle, as well as of the trees and other plants, followed my pencil fairly accurately, but when I did the inks for the rocks, it seemed that they were not differentiated enough in the castle. Therefore, I added many more lines to give them the wild appearance of bare rock, compared with the more refined walls of cut rock. The tops of the towers and the embattlements, which were somewhat destroyed, had broken a little under the pressure and weight of the beast's claws.

TIP:
We can represent different materials not only with different treatments of the inking, but also with different ink densities.

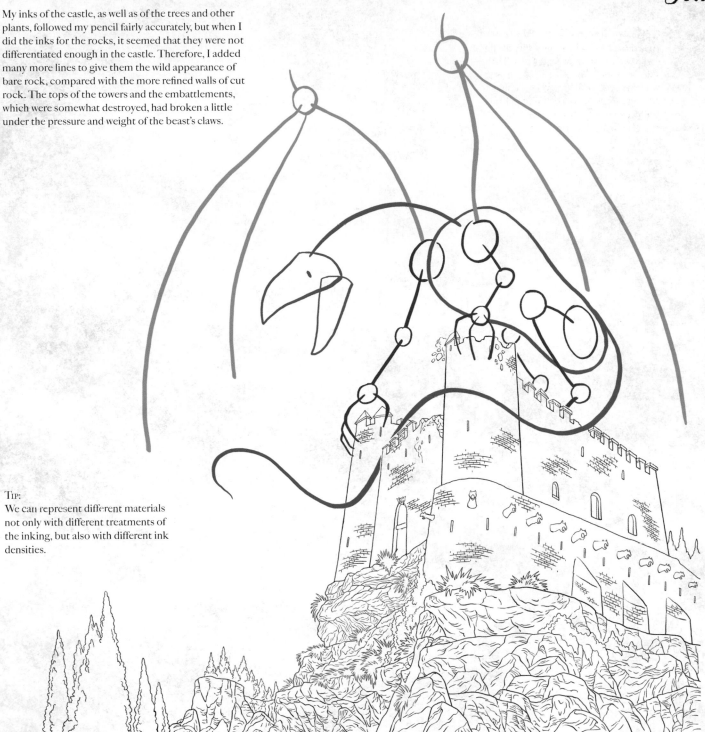

Volume

Once I had finished the ink of the castle, I began with the volumes of the dragon. Its limbs were very muscular, and its back was covered with spines up to the end of its tail. It had no horns on its head, but it had some bulges in the shape of fins. The wings were topped with large hooks, and its tail by what seemed to be a large lock of hair. Its open mouth roared, indicating its desperation to protect its offspring. It seemed clear that nothing would be able to remove it from the castle.

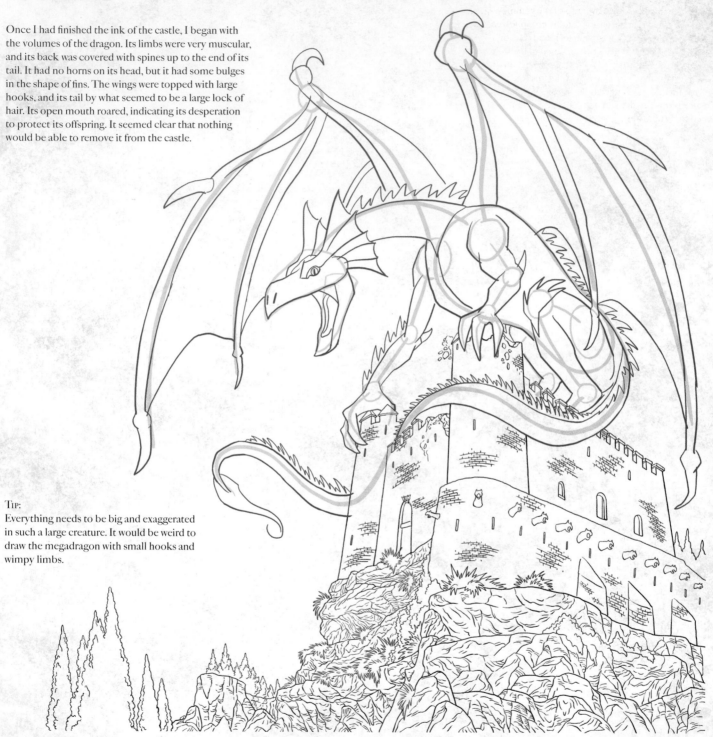

TIP:
Everything needs to be big and exaggerated in such a large creature. It would be weird to draw the megadragon with small hooks and wimpy limbs.

I did the pencil of the dragon on top of the volumes, since I knew beforehand that it was going to be complicated. The body of the megadragon was strange: It had tufts of hair at the base of its wings. Those wings seemed to be broken, and its dark skin seemed to be transparent and show its musculature, as if it was made up of large pieces connected together. I began, and I was more worried about capturing the concept than of doing a well-finished pencil, which seemed to me to be impossible.

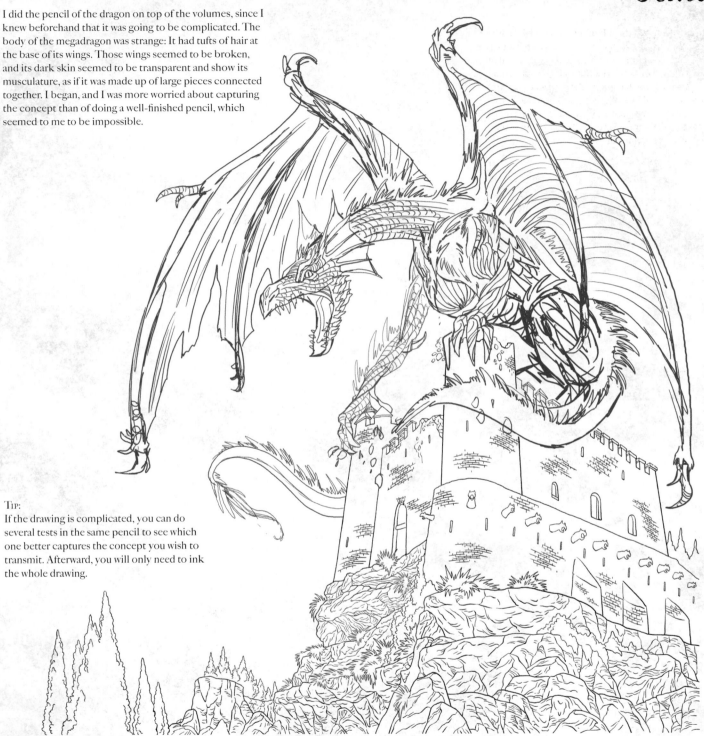

Tip:
If the drawing is complicated, you can do several tests in the same pencil to see which one better captures the concept you wish to transmit. Afterward, you will only need to ink the whole drawing.

Ink

The ink of the megadragon took me longer to do than I wanted. I took my time to give shape to the fibers and divide them into segments. To produce a more faithful image, I should have made many more divisions, but it would it have been possible to discern anything in the drawing? At least I was happy with the flaking appearance of the wings, which ended in groups of hooks.

TIP:
When we draw a small element, it is understandable that it has few details. If we want to represent a large element, we must increase the number of details.

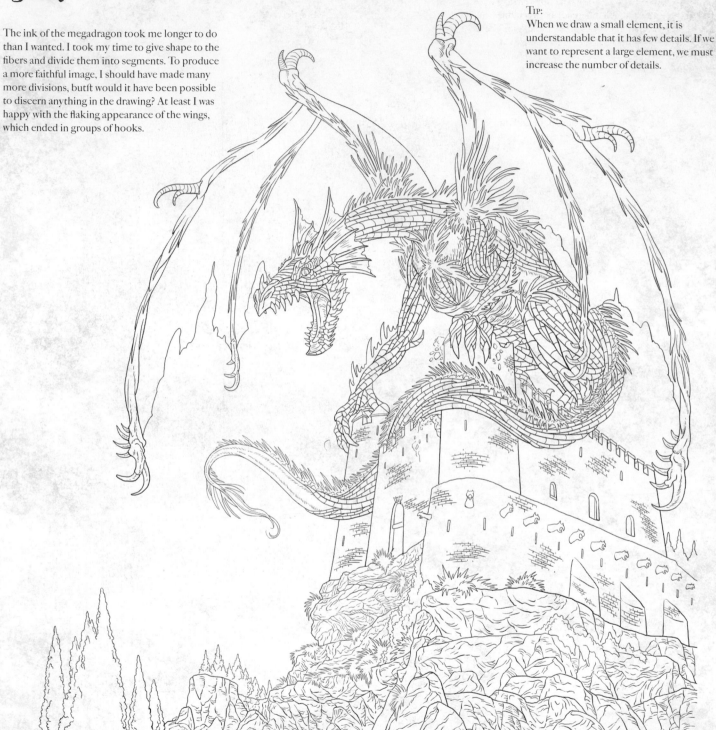

It was when I added the base colors that I understood why I felt there was so much difference between the stones of the castle and the rocks of the mountain. The colors were radically different; the castle stones had probably been brought from far away, and so I further separated the colors to increase this effect.

The dragon was shiny black. In order to achieve this effect, I used a dark blue base, which I would later adapt to the lights and shadows. The tongue and the eye were once again the points of contrast.

TIP:
How far can we darken blue in order to achieve a shiny black? Just up to when you are about to no longer see the inks.

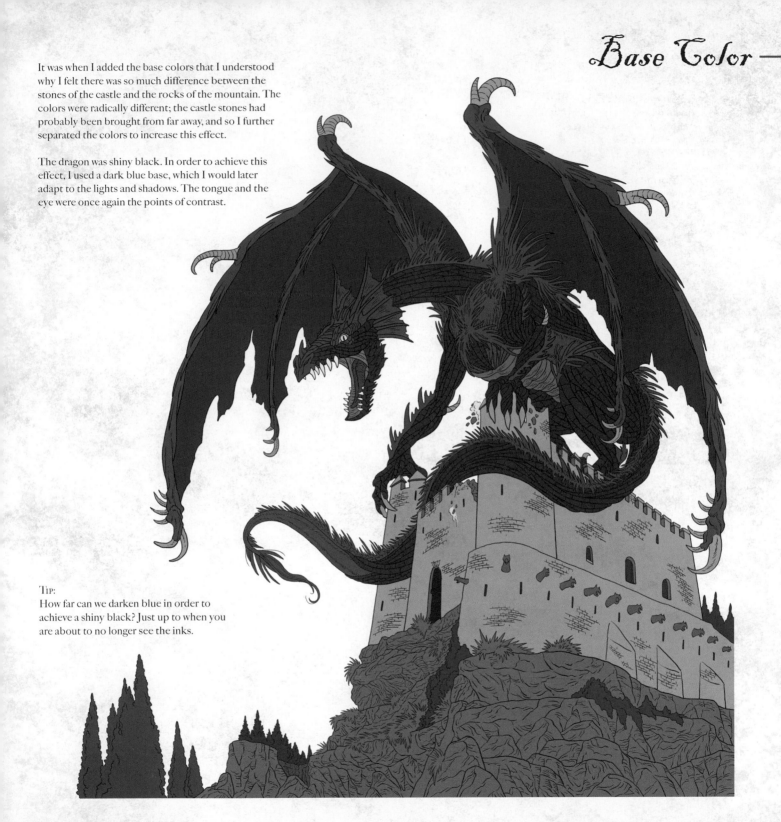

Light and Shadow

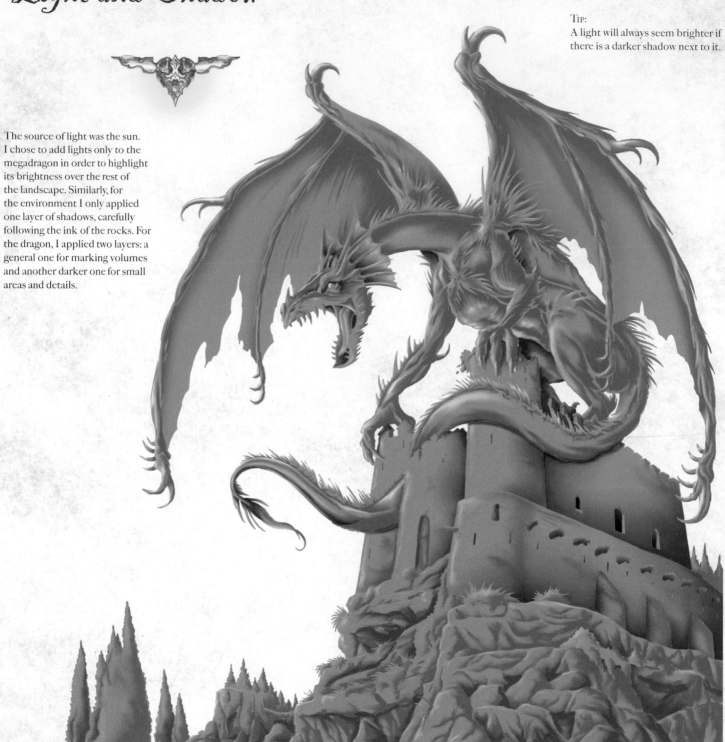

TIP:
A light will always seem brighter if there is a darker shadow next to it.

The source of light was the sun. I chose to add lights only to the megadragon in order to highlight its brightness over the rest of the landscape. Similarly, for the environment I only applied one layer of shadows, carefully following the ink of the rocks. For the dragon, I applied two layers: a general one for marking volumes and another darker one for small areas and details.

In order to make the megadragon stand out more, I covered the inks of the castle and the environment with relatively light colors. Noticing that this would make the viewer's eyes go directly to the dragon, I felt satisfied—but also I realized that so as not to unbalance the drawing, I should color the inks of the megadragon. I did this with a very, very dark blue. However, I felt that something was missing, so I checked the volumes and pencils. In these I found the location of my problem: the details of the interior of the wings. I solved this with a light blue ink. Another finished drawing.

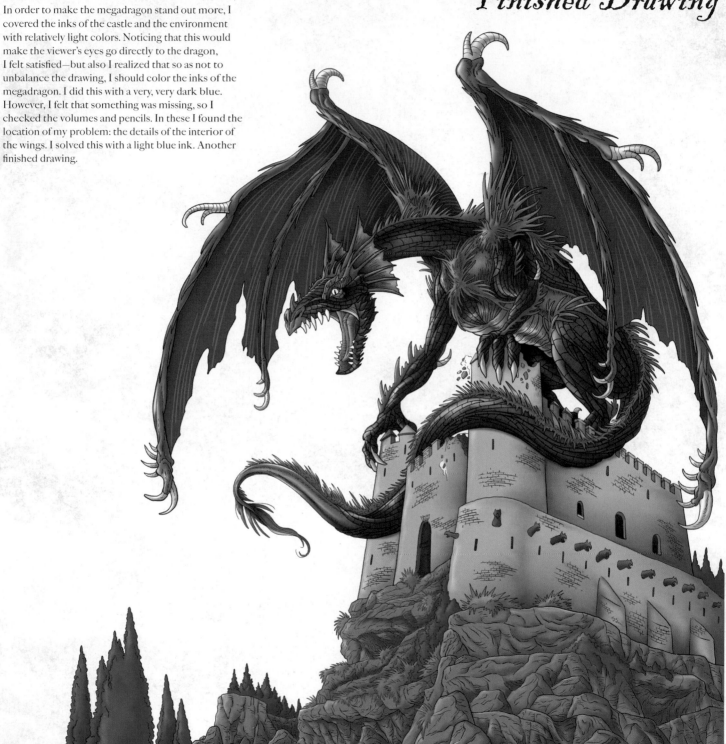

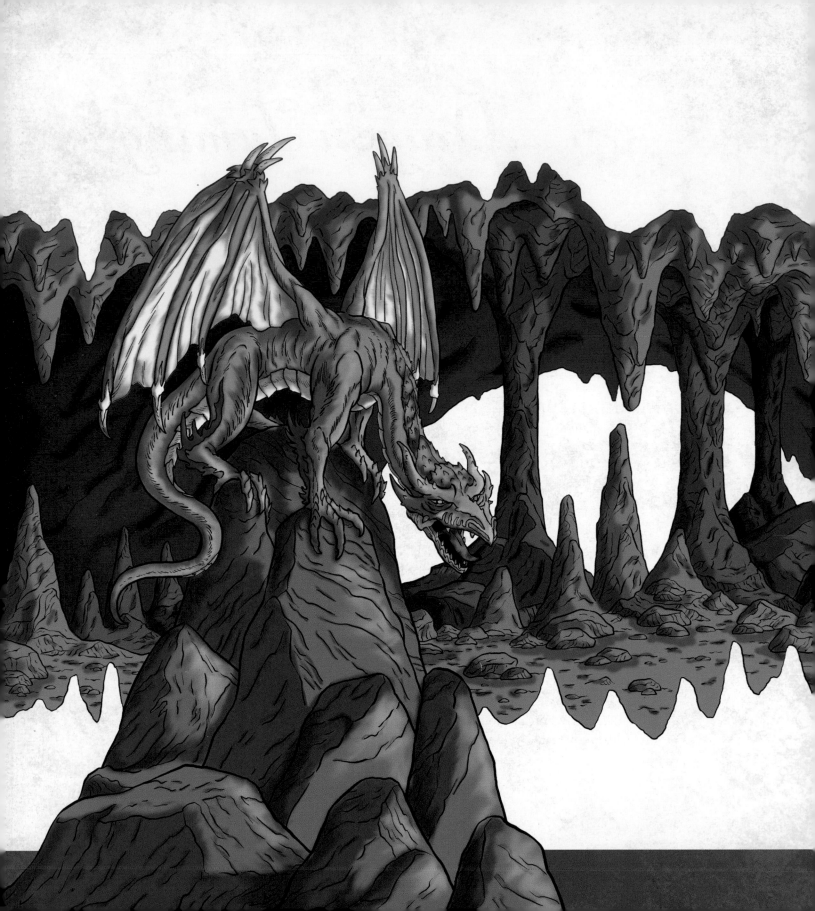

Dragon Taming

 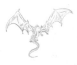
To our surprise, when we returned to the intelligence headquarters of the European government, located in Prague, capital of the Czech Republic, we had the chance to study a captured dragon, which, isolated in an underground antiaircraft shelter and locked in a titanium cage, we observed through high-resolution cameras and various sensors that monitored its vital signs. Over several weeks, we compared notes with other dragon-study teams, similar to our own, from all over the world. Every day, we sat in a large hall full of seats where, from a platform, each team described in detail their experiences and conclusions. They were incredible days in which each new story was a surprise that forced us again and again to reconsider our knowledge. Dragons organized themselves in very different ways, making it impossible to predict their behavior or their relationship to human beings. We all felt that there was something strange in this, something which did not fit, a piece that none of the people present could see but which we were all trying to discover.

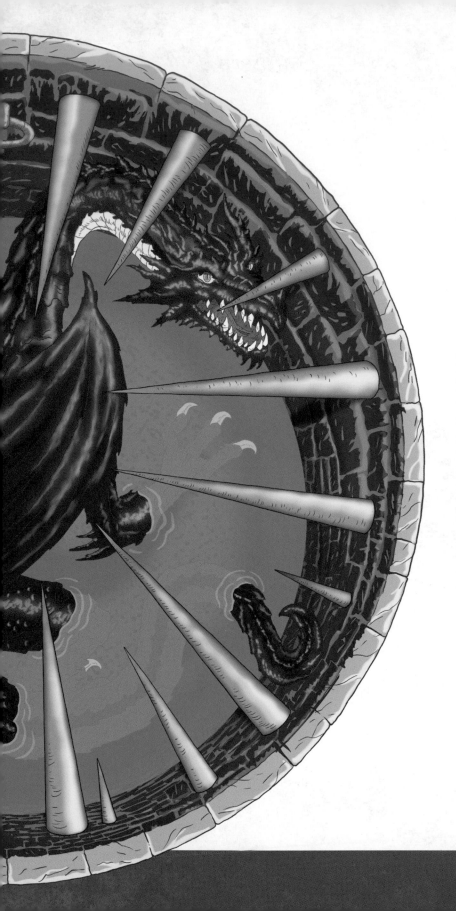

Dragon Traps

After several days of meetings, it came to the French team's turn. They informed us that they had entered into contact with a group of soldiers who claimed they had managed to catch a dragon in a trap that they themselves had devised and made. Although rudimentary, the trap had worked: they had used an old pool of water to which they had added a large number of metal stakes, hidden in the walls. After attracting the dragon with bait, the stakes slid out of the walls, leaving a hollow in the center. In this way, the dragon snagged its skin and wings each time it tried to get out, making its enormous brute force useless. Finally, with great effort, they were able to sedate it and bring it to the government facilities.

In the scheme, I marked the outside of the well with a circle (orange), the sharp iron bars with arrows (blue), the body of the dragon, seen from above, with the usual scheme (red), and over it, the folded wings (green).

In the volumes, I marked some bricks of the well (orange) in order to capture the perspective and make sure that the dragon (red) fit into that small space, contracting its tail and wings as I had been told.

Pencil

TIP:
Enjoy the latest fashionable illustrators, but
do yourself a favor and review the classics.

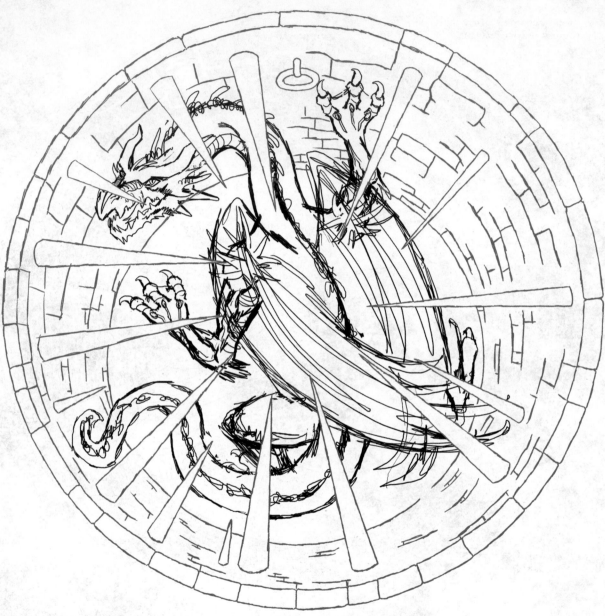

That zenithal view began to remind me of another, which I
had seen previously: the forgotten cartoon of a drawing genius
of the early twentieth century. I had studied that image in my
youth and learned so much from it. As a sign of my admiration,
I decided that in the well where Harold R. Foster enclosed his
beast in 1941, I would confine mine in 3112. The pencil of the
dragon, although simple, inspired me enough to do the inks.

Foster's well appeared on my pages in a reverential but coarse manner. I smiled at my homage to the great master and continued with the ink of the dragon, giving it a hard and rugged appearance, full of edges. Finally, I moved onto the iron spikes, and gave them some inner lines to reflect their hardness and solidity. As I planned to color each ink separately, I gave each one a different layer.

TIP:
If we have any doubts, it is better to do each ink separately. We will always have time to join them together or link the layers.

Base Color

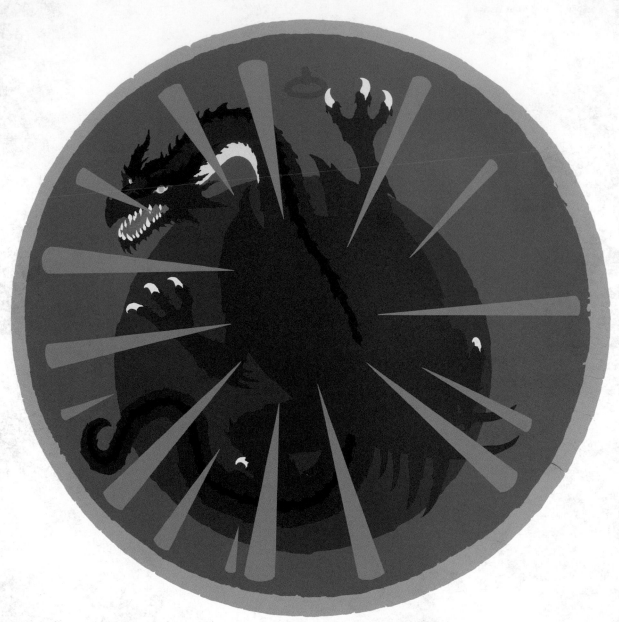

With so many elements on top of each other, I should not have complicated things further, and so I simplified the base colors: three tones of brown for the well, for its three different levels; red for the dragon, with its teeth and nails in white, highlighted over the dark well; and a contrasted bluish gray for the iron spikes.

TIP:
This is an example of how we can use lights and shadows to create an element that did not exist in the previous stages but fits perfectly into the illustration.

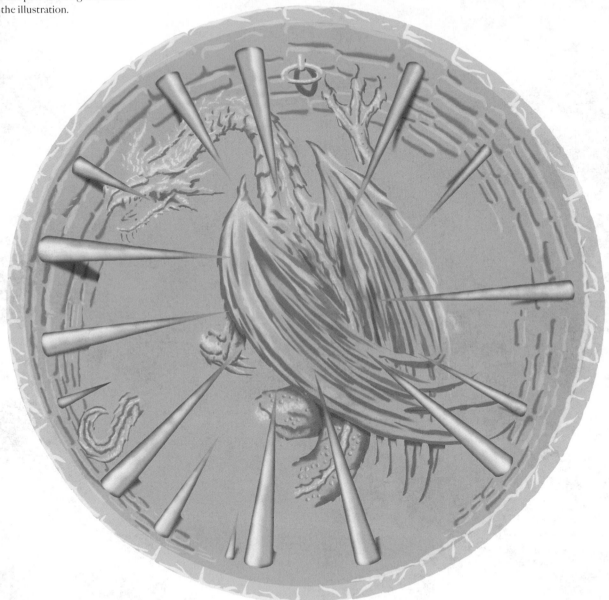

I added light and shadow to many of the bricks in the well, and in the same layers, I shaded and illuminated the dragon, paying great attention to the inks and adding points of volume to add texture to the dragon's skin. The metal spikes had shadows on the sides and were illuminated in the center. As I had planned to submerge parts of the dragon in the water, I did not shade that part at all.

Special Effect

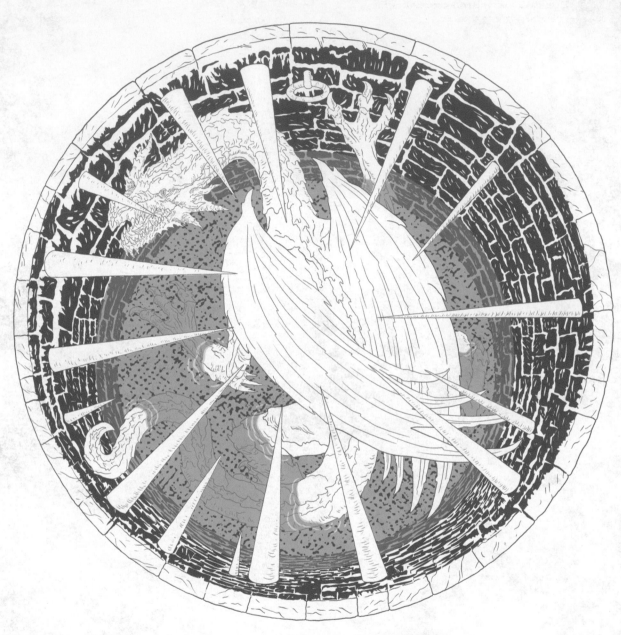

TIP:
In order to give the sensation of a certain volume of water, the blue circle must be wider than the bottom of the well.

In order to create the suggestion of the water, I merely painted a blue circle around the dragon to cover the parts of it that were submerged, specifically those I had not shaded. I then reduced the opacity of the blue layer andît water! In order to increase that effect, I drew some white lines around the limbs and the tail, just on the points in which they go in and come out of the water. I added a soil-like texture to the bottom of the well by using smudges.

I achieved the definitive appearance of the finished drawing when I colored the inks of the well dark brown, those of the dragon dark red, and those of the iron spikes dark gray. The illustration had great depth and explained with a simple glance a situation that is fairly difficult to explain in words. To the satisfaction of my French companions, the illustration actually represented what they had seen.

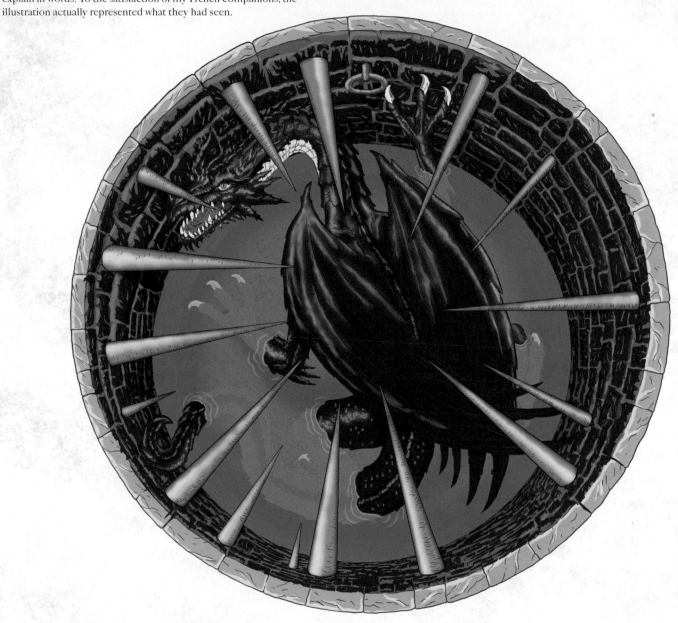

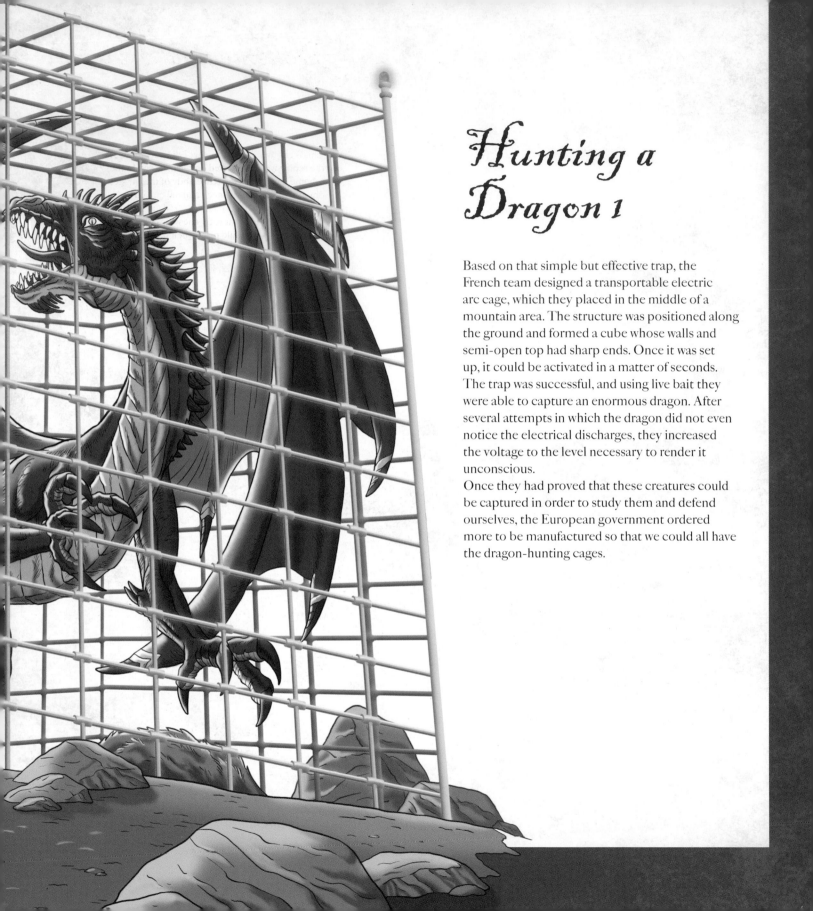

Hunting a Dragon 1

Based on that simple but effective trap, the French team designed a transportable electric arc cage, which they placed in the middle of a mountain area. The structure was positioned along the ground and formed a cube whose walls and semi-open top had sharp ends. Once it was set up, it could be activated in a matter of seconds. The trap was successful, and using live bait they were able to capture an enormous dragon. After several attempts in which the dragon did not even notice the electrical discharges, they increased the voltage to the level necessary to render it unconscious.

Once they had proved that these creatures could be captured in order to study them and defend ourselves, the European government ordered more to be manufactured so that we could all have the dragon-hunting cages.

This is another illustration that I did according to the report we had received on the incident. In the scheme, I imagined the tense body of the enraged dragon (blue), with the neck and tail curved around. Leaning on its back legs (red), it would try to fly by lifting its front legs. The wings were half-open (green) and would react when they felt the first electrical discharges.

In the volume (black), I gave certain anatomical characteristics that were totally invented since the report only reflected the technical aspects of the encounter and barely mentioned the dragon itself. I also added the bait, which had been thrown on the ground, and some surrounding stones.

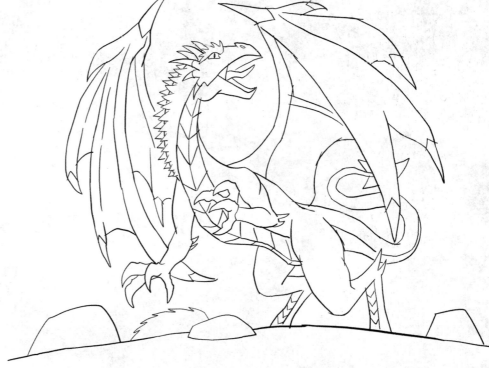

Pencil

When doing the pencil, I used my prior experience with dragons to make a believable anatomy. I abandoned a terrible first idea—from which I only got the wings—and I added some more stones around the dragon to make up the surroundings for the cage. I was happy with the pencil once I felt that the dragon was as believable, or as unbelievable, as any of the others I had seen and drawn.

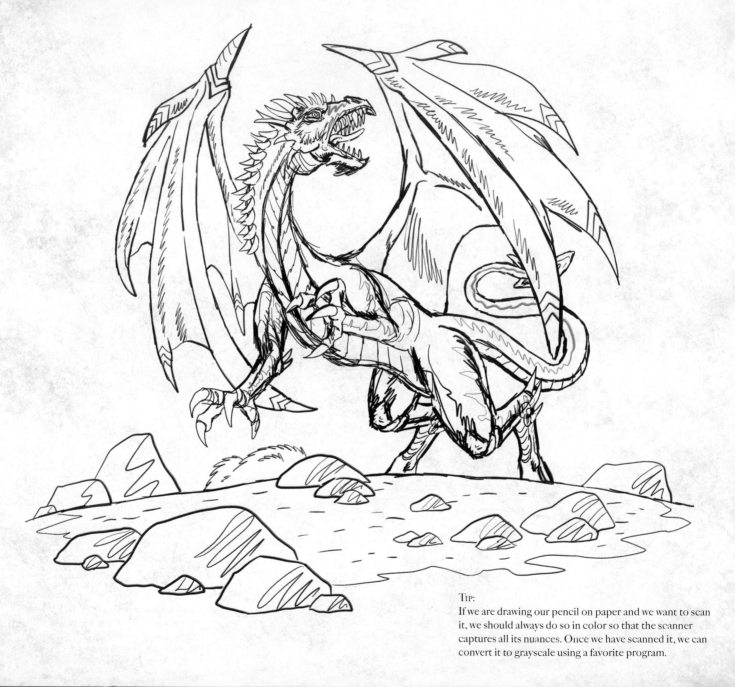

TIP:
If we are drawing our pencil on paper and we want to scan it, we should always do so in color so that the scanner captures all its nuances. Once we have scanned it, we can convert it to grayscale using a favorite program.

The ink was an easy choice for this imaginary dragon. I used the concepts I already knew—long lines, thicker and more closed for the outlines; and short, thin, and more open lines for the interior details. The line of the stranding rocks was more creased and shaky and with much less ink density than I used for the dragon.

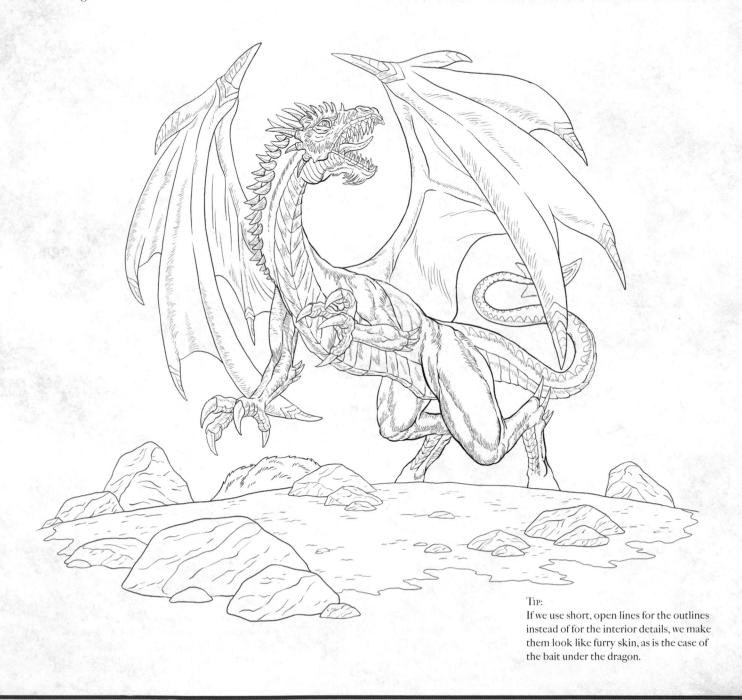

TIP:
If we use short, open lines for the outlines instead of for the interior details, we make them look like furry skin, as is the case of the bait under the dragon.

Base Color

As it was my decision, I wanted to find a base color for the dragon that I had not yet used. I did not have many options, and I started to wonder what a pink dragon would look like. It seemed an interesting challenge to color the dragon in pink tones while maintaining all its strength and fury. I must admit that after several attempts, I had to use more violet than I had planned. But at last I had my pink dragon—with the help of dark claws to maintain its fearsome appearance. For the anonymous bait, I chose a neutral gray, and for the ground and the rocks, I chose brown tones.

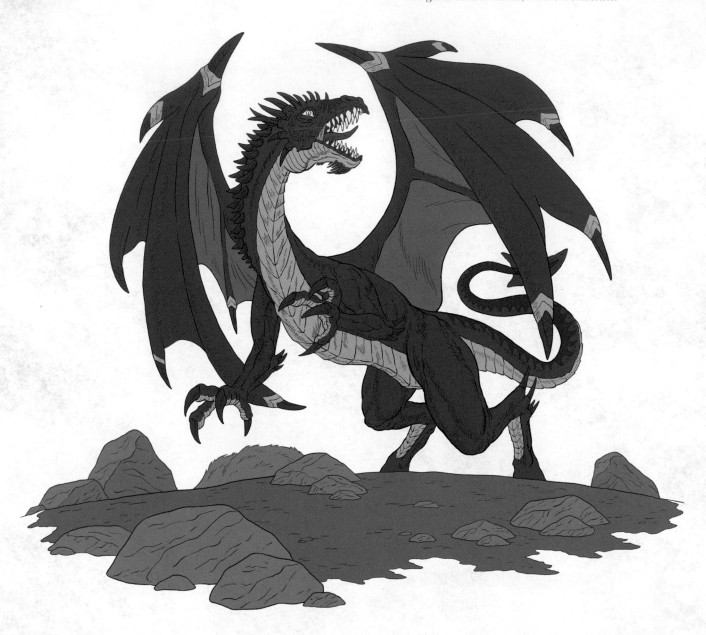

With the sun strategically located opposite the face of the dragon, I did the lights using two different layers. The first layer was softer and wider and illuminated more of the general areas, providing an overall volume. I also applied this first light to the stones.

A second layer of light was white, more opaque and finer, and it defined specific structures, highlighting them from the overall image. I only applied this second layer to the dragon.

Shadow

For the shadows, I used a similar method as for the lights, giving them two different layers. The first layer was softer and wider, and I used it for more general areas, where it provided an overall volume. The second layer of shadows defined, again, specific structures. I applied both layers of shadows both to the dragon and to the rocks.

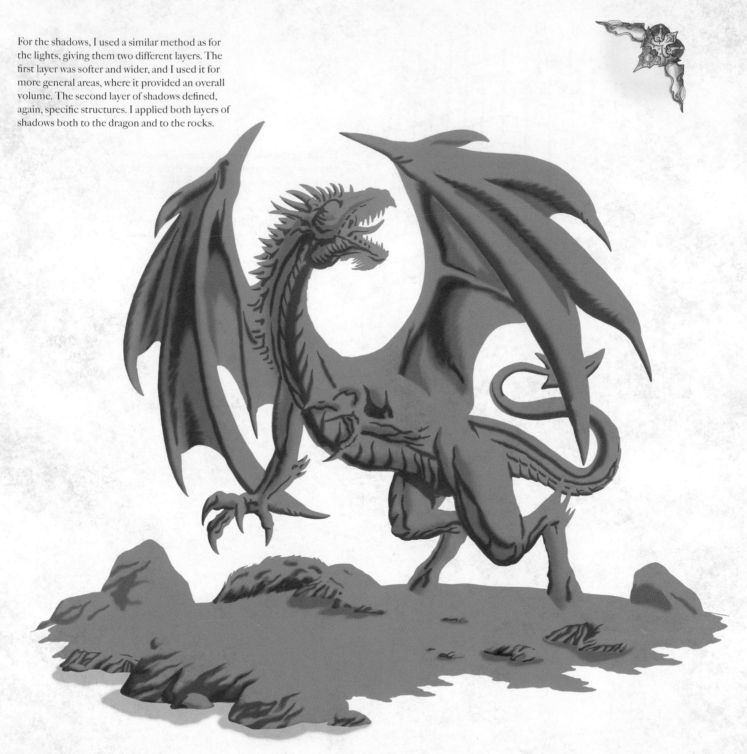

Producing the scheme for the cage required applying very basic concepts of perspective. Because the image was at a low angle, the vertical lines of the cage (blue) came together as they rose. The horizontal lines (black) of the two visible sides of the cage got closer together as they moved away from the center—i.e., as they moved away from the viewer.

I outlined three main vertical lines over the scheme, and I topped these with red alarm lights, which was the standard protocol of the cages. The small golden details represent the crossing points of the other horizontal and vertical bars.

Cage 2

After adding the other horizontal and vertical bars (gray) as indicated in my initial scheme, I tidied up the whole drawing, adding simple lights and shadows.

Underneath, in dark gray, I included three sides of the cage in the background, re-creating a sense of depth. Finally, I illuminated the alarm lights using a soft brush and an orange color with high transparency.

Above the illustration of the dragon, I placed the two sides of the cage that appear in the foreground; the three sides of the cage that are in the background, I placed below. I had trapped my dragon, and it became furious behind bars. My satisfaction ended the moment I remembered that the first test with electrified cages had a dramatic ending.

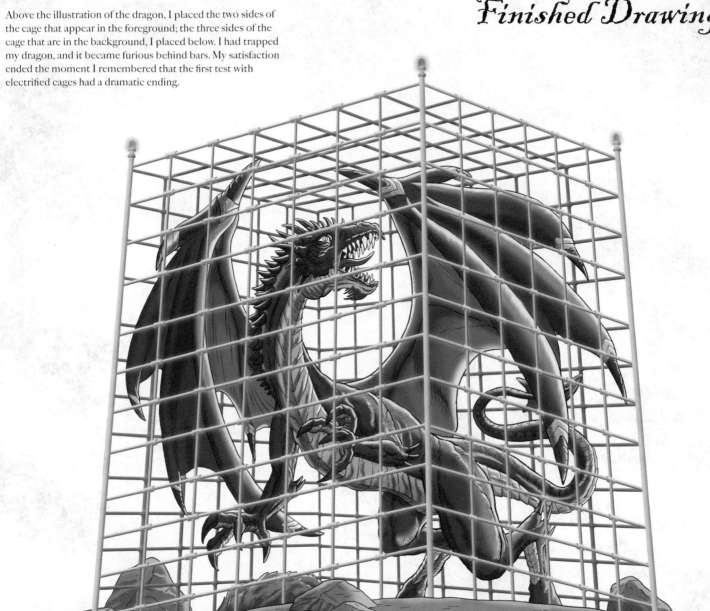

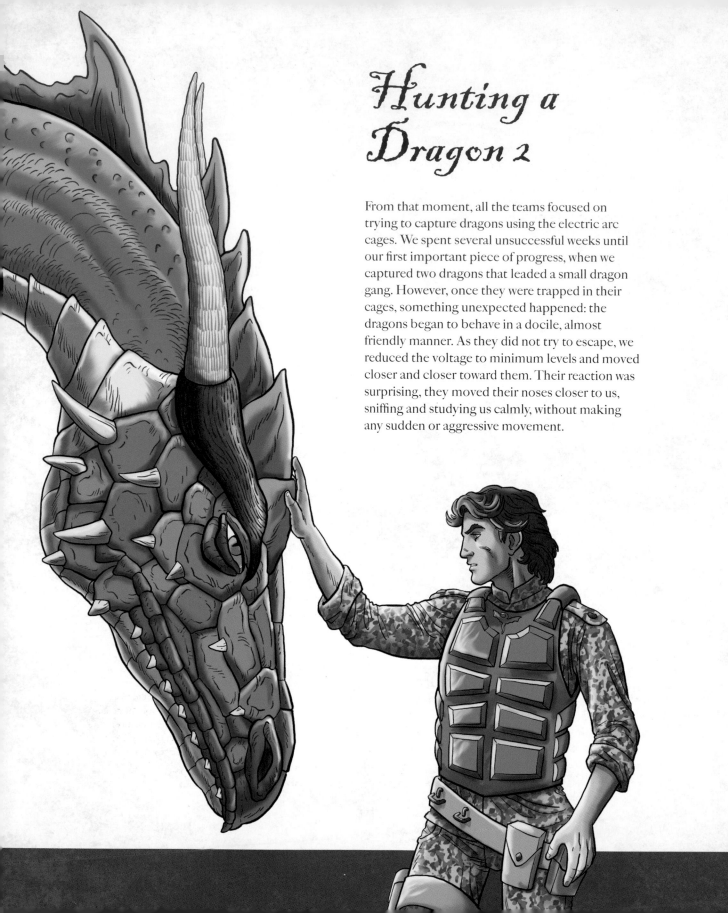

Hunting a Dragon 2

From that moment, all the teams focused on trying to capture dragons using the electric arc cages. We spent several unsuccessful weeks until our first important piece of progress, when we captured two dragons that leaded a small dragon gang. However, once they were trapped in their cages, something unexpected happened: the dragons began to behave in a docile, almost friendly manner. As they did not try to escape, we reduced the voltage to minimum levels and moved closer and closer toward them. Their reaction was surprising, they moved their noses closer to us, sniffing and studying us calmly, without making any sudden or aggressive movement.

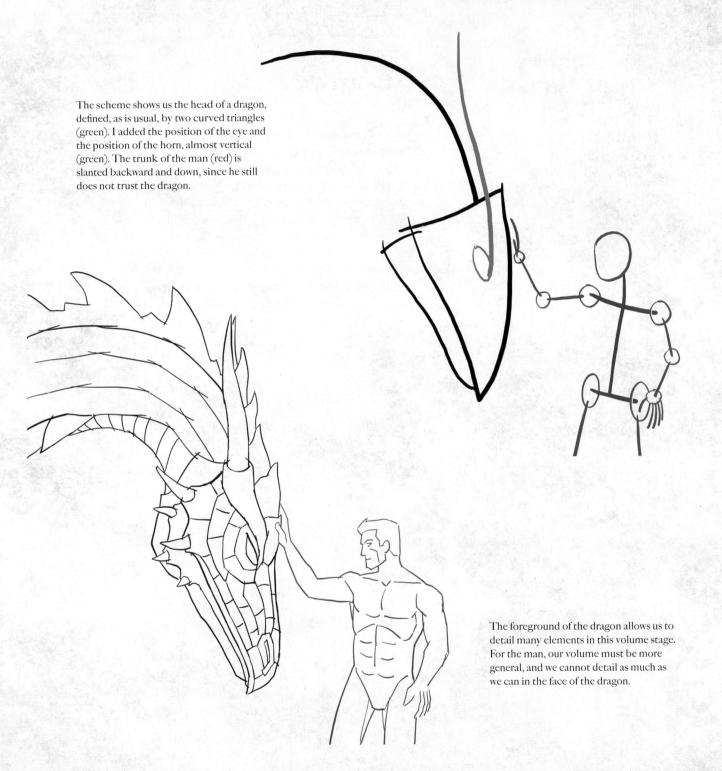

Scheme and Volume

The scheme shows us the head of a dragon, defined, as is usual, by two curved triangles (green). I added the position of the eye and the position of the horn, almost vertical (green). The trunk of the man (red) is slanted backward and down, since he still does not trust the dragon.

The foreground of the dragon allows us to detail many elements in this volume stage. For the man, our volume must be more general, and we cannot detail as much as we can in the face of the dragon.

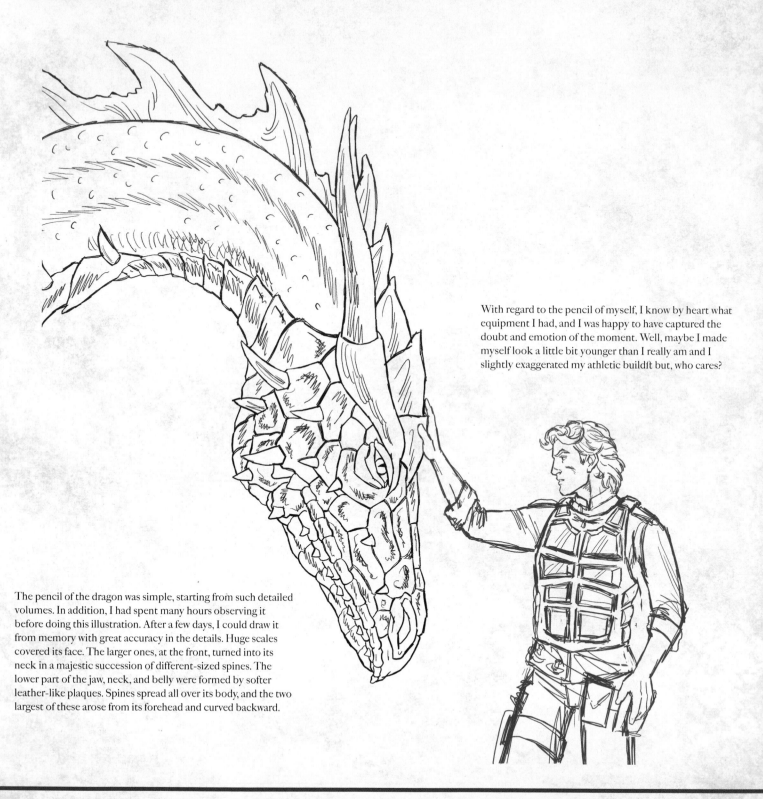

Pencil

With regard to the pencil of myself, I know by heart what equipment I had, and I was happy to have captured the doubt and emotion of the moment. Well, maybe I made myself look a little bit younger than I really am and I slightly exaggerated my athletic build but, who cares?

The pencil of the dragon was simple, starting from such detailed volumes. In addition, I had spent many hours observing it before doing this illustration. After a few days, I could draw it from memory with great accuracy in the details. Huge scales covered its face. The larger ones, at the front, turned into its neck in a majestic succession of different-sized spines. The lower part of the jaw, neck, and belly were formed by softer leather-like plaques. Spines spread all over its body, and the two largest of these arose from its forehead and curved backward.

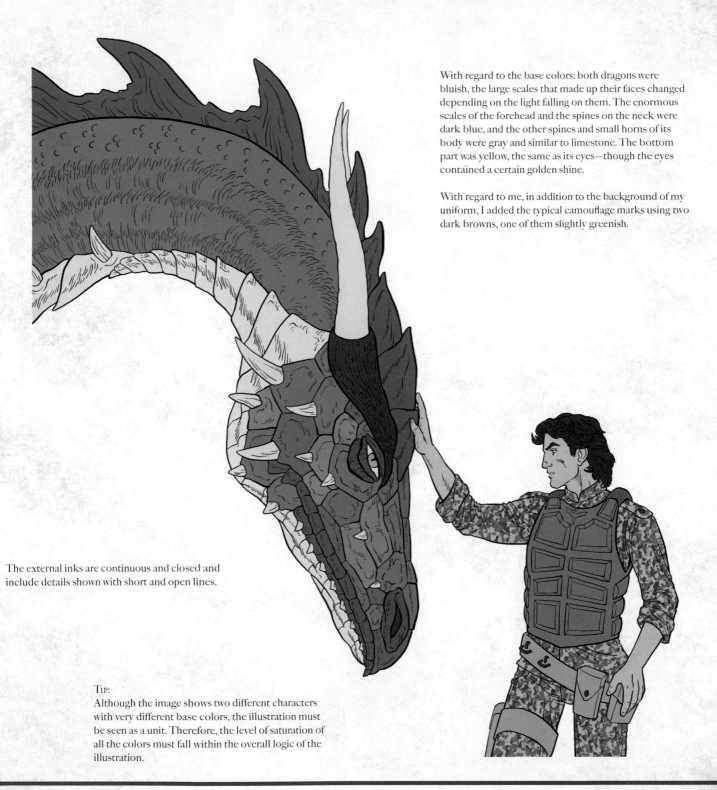

With regard to the base colors: both dragons were bluish, the large scales that made up their faces changed depending on the light falling on them. The enormous scales of the forehead and the spines on the neck were dark blue, and the other spines and small horns of its body were gray and similar to limestone. The bottom part was yellow, the same as its eyes—though the eyes contained a certain golden shine.

With regard to me, in addition to the background of my uniform, I added the typical camouflage marks using two dark browns, one of them slightly greenish.

The external inks are continuous and closed and include details shown with short and open lines.

TIP:
Although the image shows two different characters with very different base colors, the illustration must be seen as a unit. Therefore, the level of saturation of all the colors must fall within the overall logic of the illustration.

Lights and Shadow

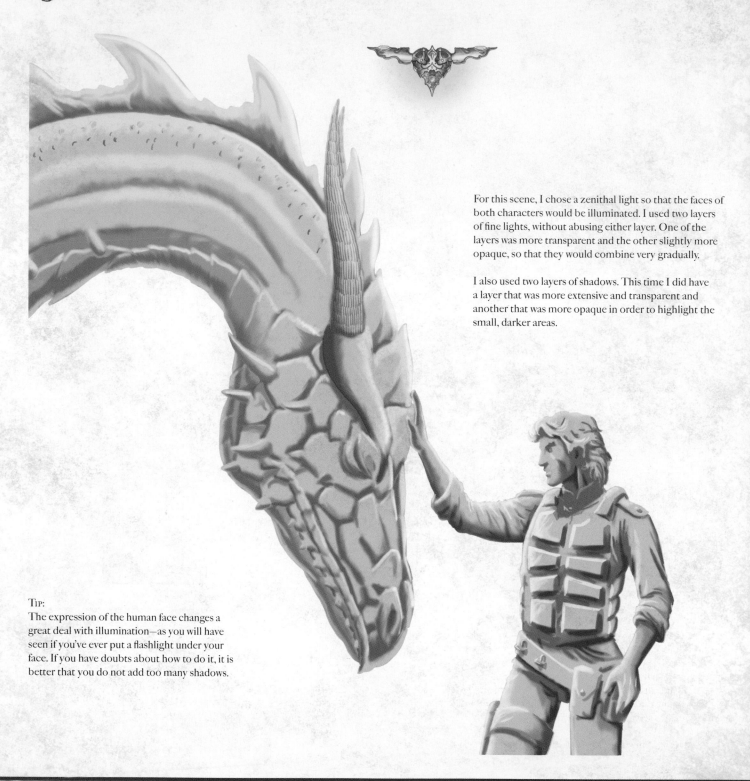

For this scene, I chose a zenithal light so that the faces of both characters would be illuminated. I used two layers of fine lights, without abusing either layer. One of the layers was more transparent and the other slightly more opaque, so that they would combine very gradually.

I also used two layers of shadows. This time I did have a layer that was more extensive and transparent and another that was more opaque in order to highlight the small, darker areas.

TIP:
The expression of the human face changes a great deal with illumination—as you will have seen if you've ever put a flashlight under your face. If you have doubts about how to do it, it is better that you do not add too many shadows.

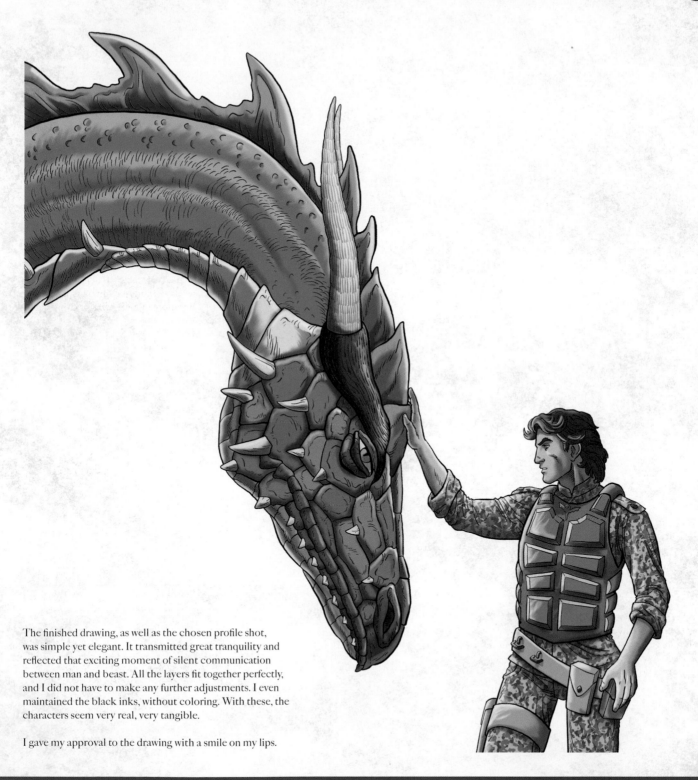

The finished drawing, as well as the chosen profile shot, was simple yet elegant. It transmitted great tranquility and reflected that exciting moment of silent communication between man and beast. All the layers fit together perfectly, and I did not have to make any further adjustments. I even maintained the black inks, without coloring. With these, the characters seem very real, very tangible.

I gave my approval to the drawing with a smile on my lips.

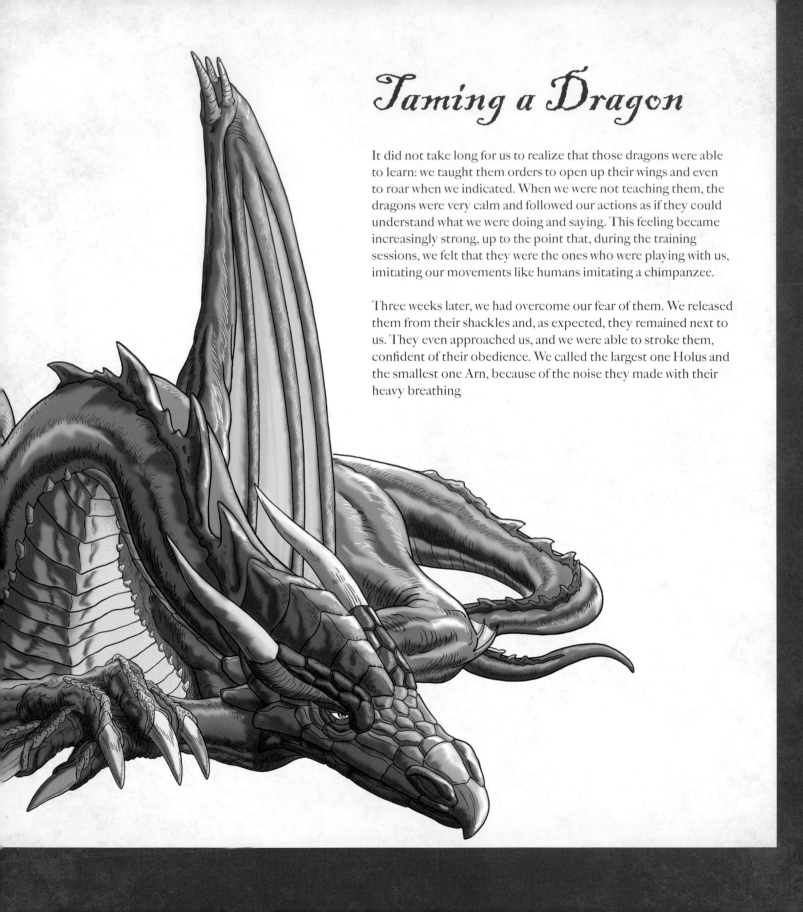

Taming a Dragon

It did not take long for us to realize that those dragons were able to learn: we taught them orders to open up their wings and even to roar when we indicated. When we were not teaching them, the dragons were very calm and followed our actions as if they could understand what we were doing and saying. This feeling became increasingly strong, up to the point that, during the training sessions, we felt that they were the ones who were playing with us, imitating our movements like humans imitating a chimpanzee.

Three weeks later, we had overcome our fear of them. We released them from their shackles and, as expected, they remained next to us. They even approached us, and we were able to stroke them, confident of their obedience. We called the largest one Holus and the smallest one Arn, because of the noise they made with their heavy breathing

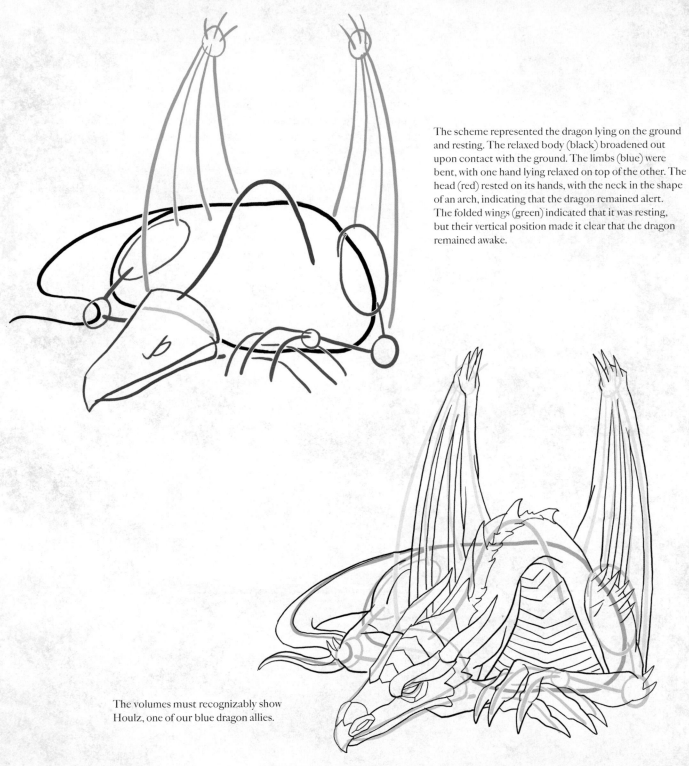

Scheme and Volume

The scheme represented the dragon lying on the ground and resting. The relaxed body (black) broadened out upon contact with the ground. The limbs (blue) were bent, with one hand lying relaxed on top of the other. The head (red) rested on its hands, with the neck in the shape of an arch, indicating that the dragon remained alert. The folded wings (green) indicated that it was resting, but their vertical position made it clear that the dragon remained awake.

The volumes must recognizably show Houlz, one of our blue dragon allies.

Pencil

The pencil of this dragon was a real challenge—not because I did not know its anatomy perfectly, but because I had to show a relaxed body that at the same time was solid and powerful. In addition, the perspective of the elements (wings, head, neck, horns, etc.) varied, and although their pencil was totally different, they must be recognizable, with their relative sizes maintained.

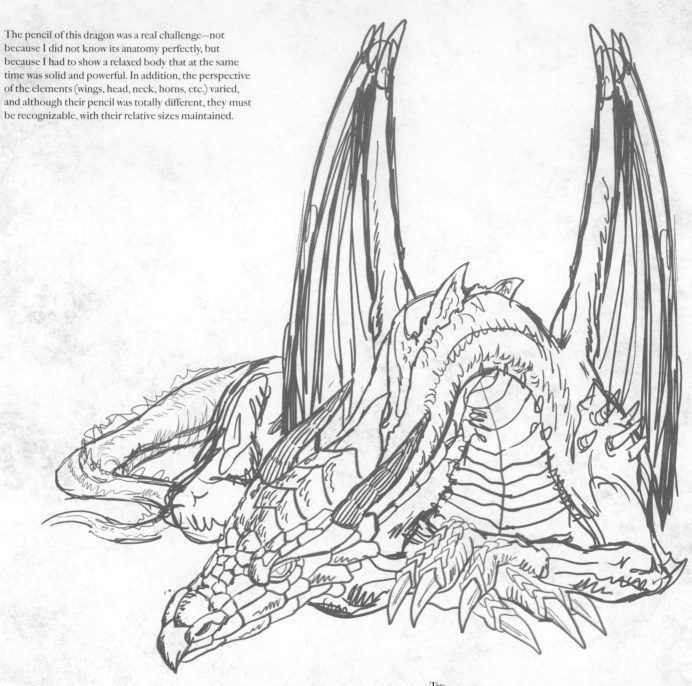

Tip:
If we have a favorite character that we want to tell illustrated stories about, it is essential that we become familiar with it, drawing it from several positions and different angles.

Once again, the inking is based on outlines with long, thick, and closed lines, together with interior details made with short lines that are finer and more open. Due to the resting position of the dragon, the inks have been softened a little more than in the previous image, making them a little more rounded.

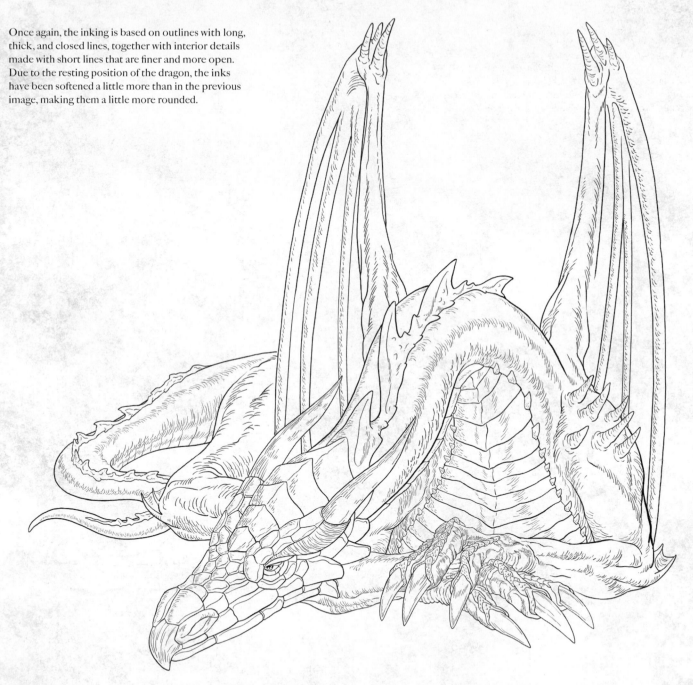

Tip:
Small changes in the ink may indicate changes in a character's mood.

Light

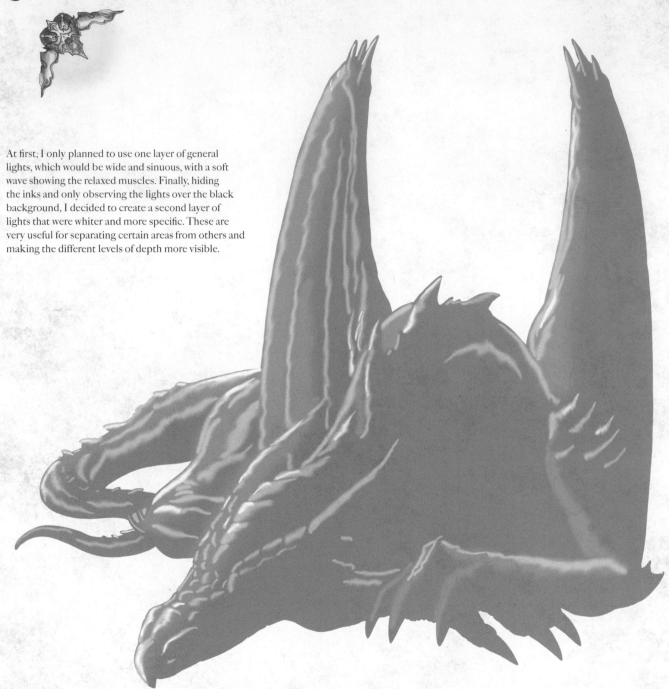

At first, I only planned to use one layer of general lights, which would be wide and sinuous, with a soft wave showing the relaxed muscles. Finally, hiding the inks and only observing the lights over the black background, I decided to create a second layer of lights that were whiter and more specific. These are very useful for separating certain areas from others and making the different levels of depth more visible.

TIP:
It is common for some lights to seem badly done when seen on their own, but the important thing is for them to look good in the finished drawing.

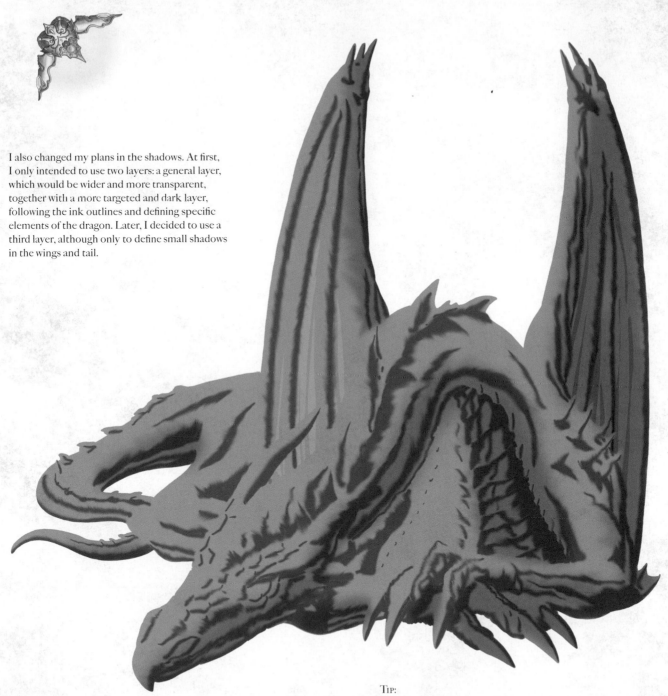

I also changed my plans in the shadows. At first, I only intended to use two layers: a general layer, which would be wider and more transparent, together with a more targeted and dark layer, following the ink outlines and defining specific elements of the dragon. Later, I decided to use a third layer, although only to define small shadows in the wings and tail.

Tip:
Although it is not normally necessary to use a large number of different shadows, many people prefer to make each shadow independently, with different characteristics of opacity or even color. Do your own tests, and choose what you feel most comfortable with.

Base Color

Given that the base colors of these dragons had already been established, I only had to reproduce them. In selecting the colors of the areas not seen in the previous drawing, I needed to be careful not to move outside logical tones for no reason. However, because the tones of its scales vary according to how the light falls on them, it is not necessary for all the scales to have identical tones. It is enough for the tones to be spread out in a similar and recognizable manner.

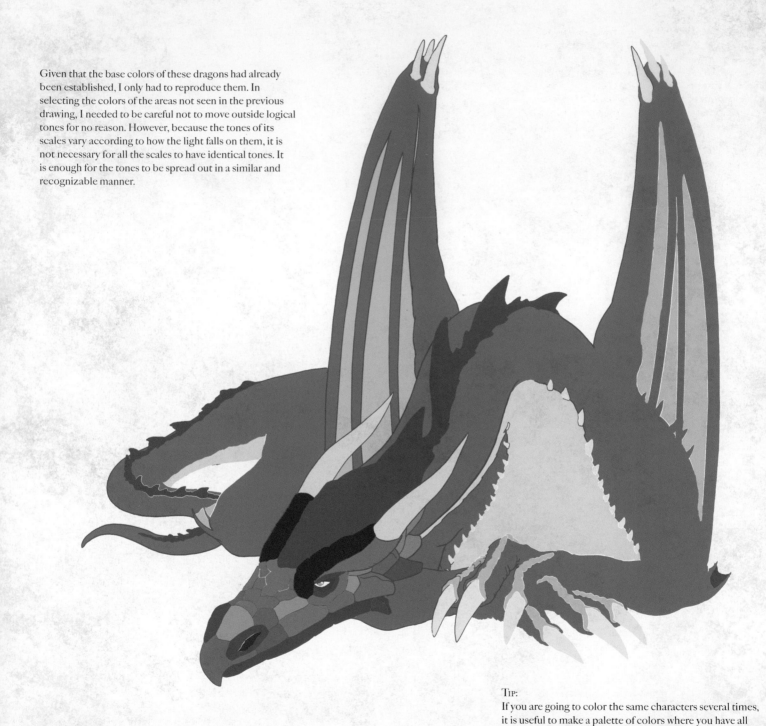

TIP:
If you are going to color the same characters several times, it is useful to make a palette of colors where you have all the colors of all the characters on one canvas or in one file.

The combination of all the steps gave the expected result in the final drawing; it can be clearly observed how different parts of the body have a different texture and harshness. We could see the softness in the Dragon's relaxed muscles and also perceive the enormous power that they could develop when tensed. The contrast between the light and the shade also creates a sense of tranquility.

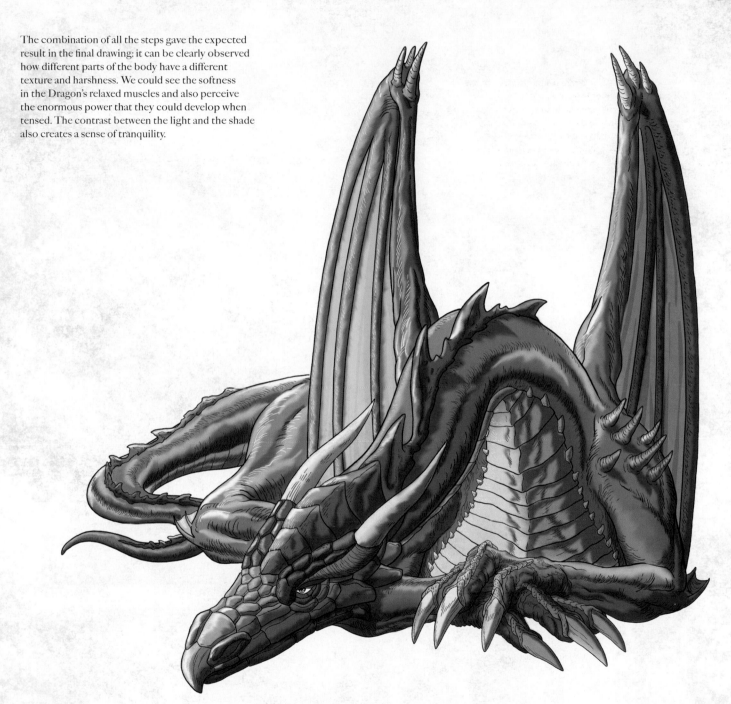

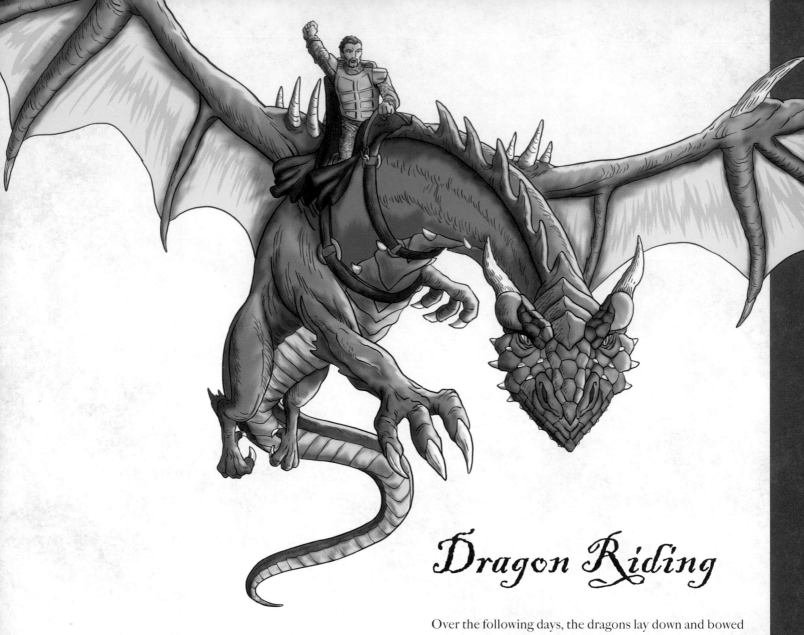

Dragon Riding

Over the following days, the dragons lay down and bowed their heads whenever Thomas, the youngest of the SAS soldiers, or I walked toward them. They seemed to be offering for us to get onto their backs. Fascinated by the possibility of sailing through the sky riding on a dragon, we prepared some basic saddles that allowed us to be firmly strapped to the animal.

We climbed up onto our incredible mounts, which rose up on their four legs. My heart was beating faster than ever when I saw how Houlz's wings moved, and slowly and softly we rose up toward the clouds.

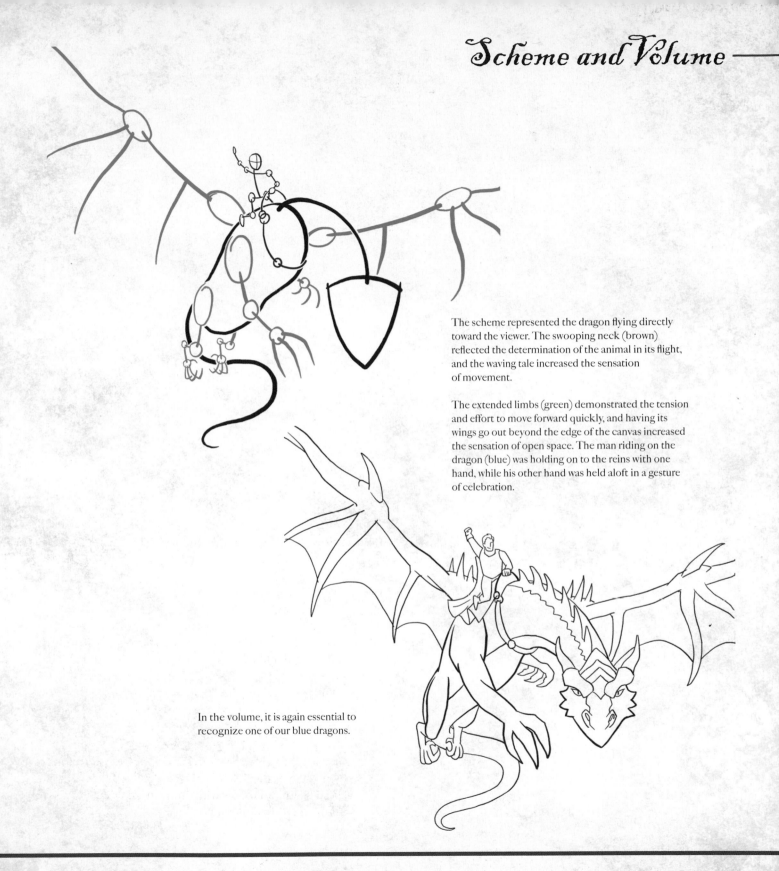

The scheme represented the dragon flying directly toward the viewer. The swooping neck (brown) reflected the determination of the animal in its flight, and the waving tale increased the sensation of movement.

The extended limbs (green) demonstrated the tension and effort to move forward quickly, and having its wings go out beyond the edge of the canvas increased the sensation of open space. The man riding on the dragon (blue) was holding on to the reins with one hand, while his other hand was held aloft in a gesture of celebration.

In the volume, it is again essential to recognize one of our blue dragons.

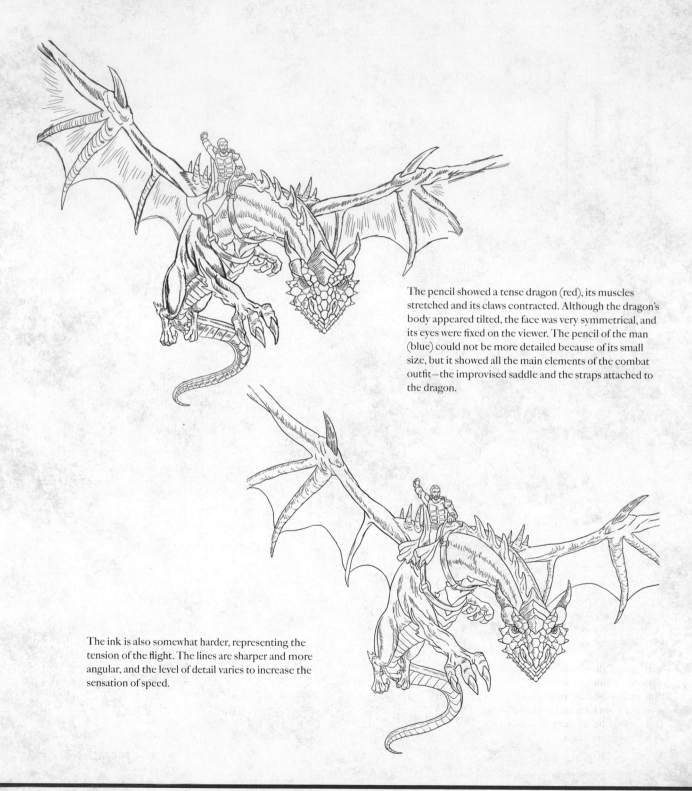

The pencil showed a tense dragon (red), its muscles stretched and its claws contracted. Although the dragon's body appeared tilted, the face was very symmetrical, and its eyes were fixed on the viewer. The pencil of the man (blue) could not be more detailed because of its small size, but it showed all the main elements of the combat outfit—the improvised saddle and the straps attached to the dragon.

The ink is also somewhat harder, representing the tension of the flight. The lines are sharper and more angular, and the level of detail varies to increase the sensation of speed.

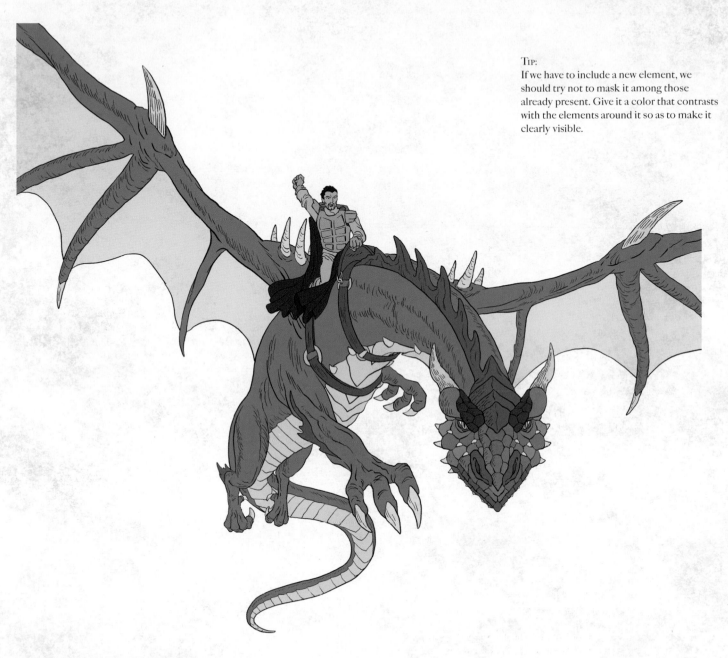

TIP:
If we have to include a new element, we should try not to mask it among those already present. Give it a color that contrasts with the elements around it so as to make it clearly visible.

With the base colors of the uniform that Thomas was wearing, which was the same as mine, and of the dragons, the only noteworthy point is the reddish color of the fabric covering the saddle and the brownish color of the leather straps.

Light and Shadow

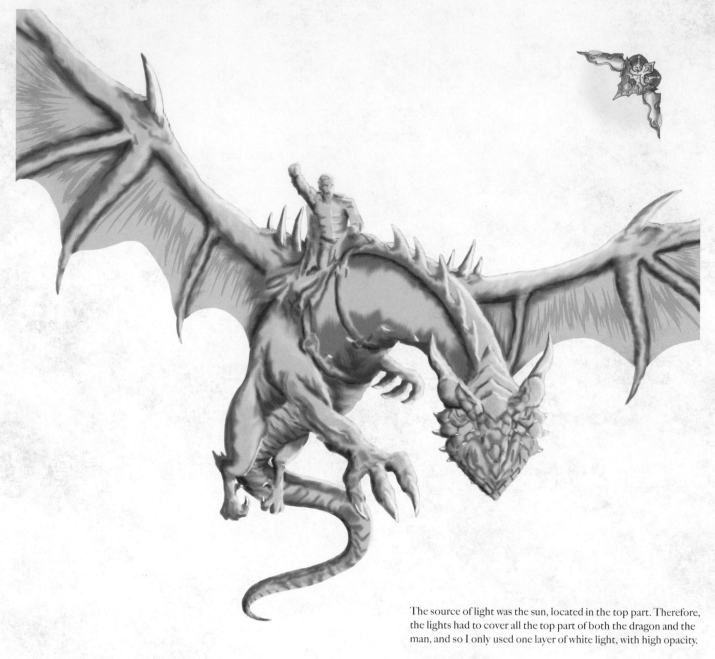

The source of light was the sun, located in the top part. Therefore, the lights had to cover all the top part of both the dragon and the man, and so I only used one layer of white light, with high opacity.

I did the shadows using two layers of black with different opacity. I then joined these, giving different tones of shadows, which highlighted the volume. A third layer of sharp shadows gave the wings an appearance of speed.

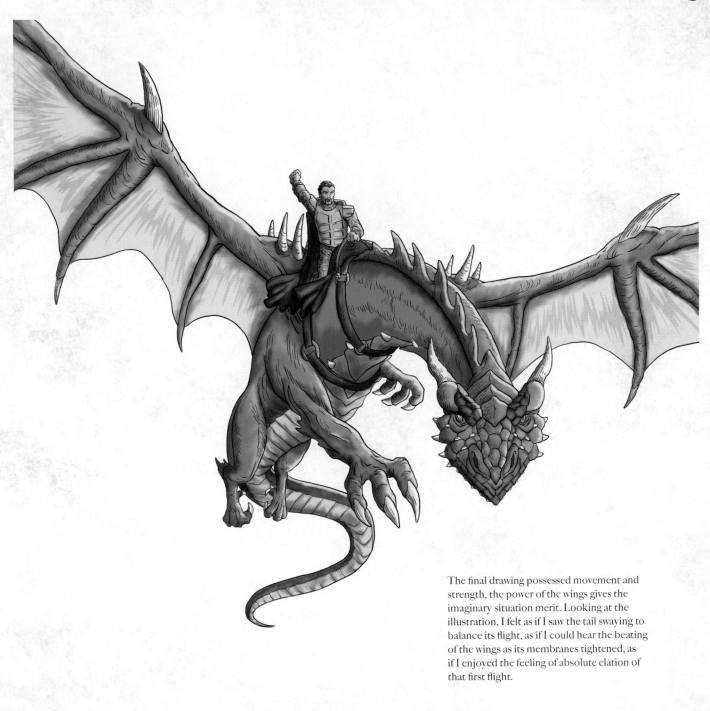

The final drawing possessed movement and strength, the power of the wings gives the imaginary situation merit. Looking at the illustration, I felt as if I saw the tail swaying to balance its flight, as if I could hear the beating of the wings as its membranes tightened, as if I enjoyed the feeling of absolute elation of that first flight.

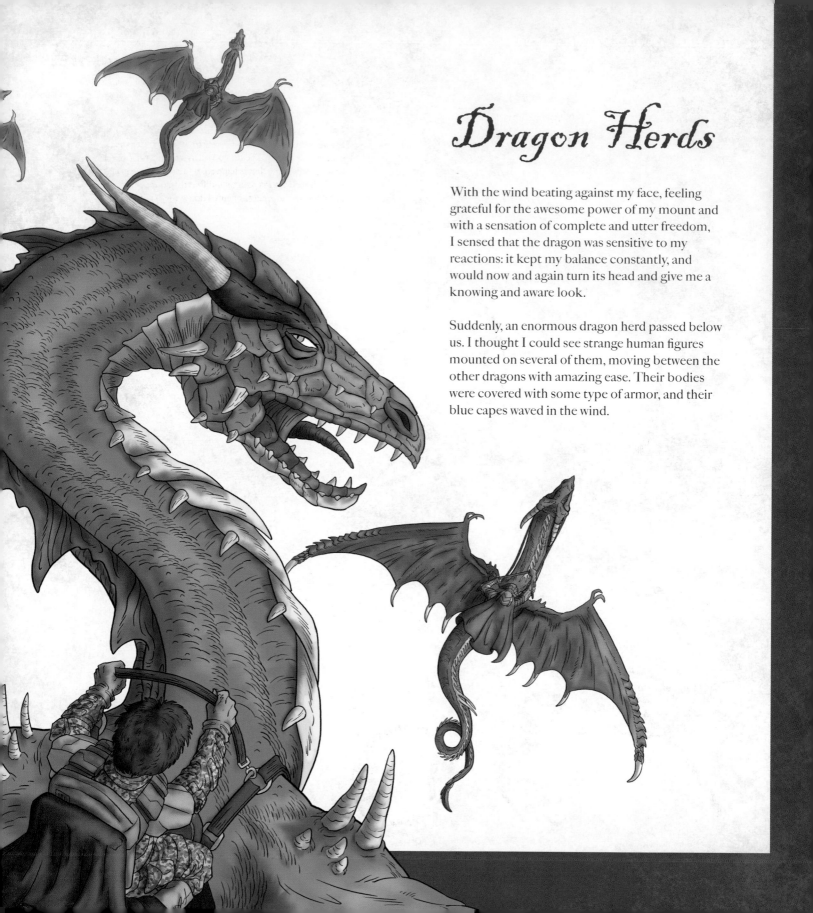

Dragon Herds

With the wind beating against my face, feeling grateful for the awesome power of my mount and with a sensation of complete and utter freedom, I sensed that the dragon was sensitive to my reactions: it kept my balance constantly, and would now and again turn its head and give me a knowing and aware look.

Suddenly, an enormous dragon herd passed below us. I thought I could see strange human figures mounted on several of them, moving between the other dragons with amazing ease. Their bodies were covered with some type of armor, and their blue capes waved in the wind.

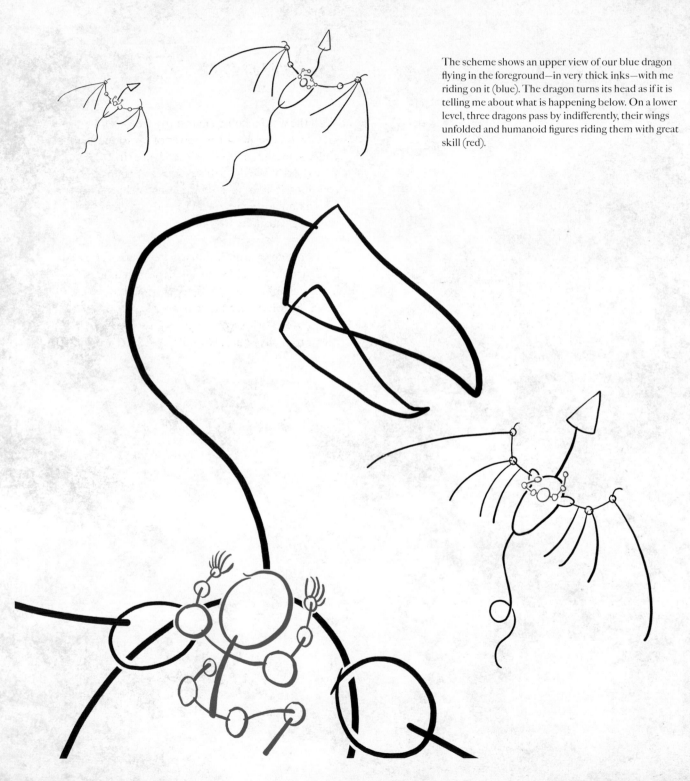

The scheme shows an upper view of our blue dragon flying in the foreground—in very thick inks—with me riding on it (blue). The dragon turns its head as if it is telling me about what is happening below. On a lower level, three dragons pass by indifferently, their wings unfolded and humanoid figures riding them with great skill (red).

Volume

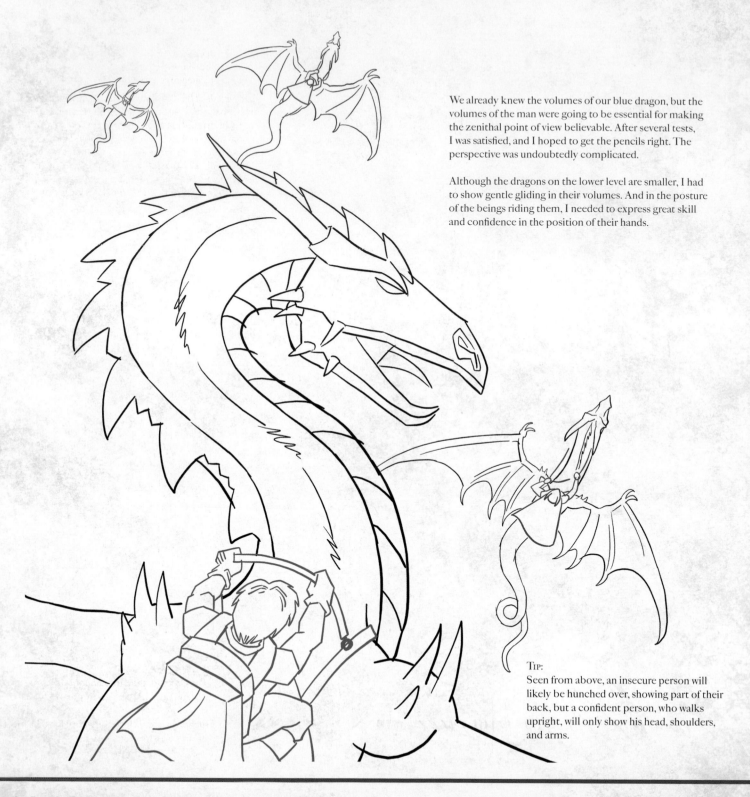

We already knew the volumes of our blue dragon, but the volumes of the man were going to be essential for making the zenithal point of view believable. After several tests, I was satisfied, and I hoped to get the pencils right. The perspective was undoubtedly complicated.

Although the dragons on the lower level are smaller, I had to show gentle gliding in their volumes. And in the posture of the beings riding them, I needed to express great skill and confidence in the position of their hands.

TIP:
Seen from above, an insecure person will likely be hunched over, showing part of their back, but a confident person, who walks upright, will only show his head, shoulders, and arms.

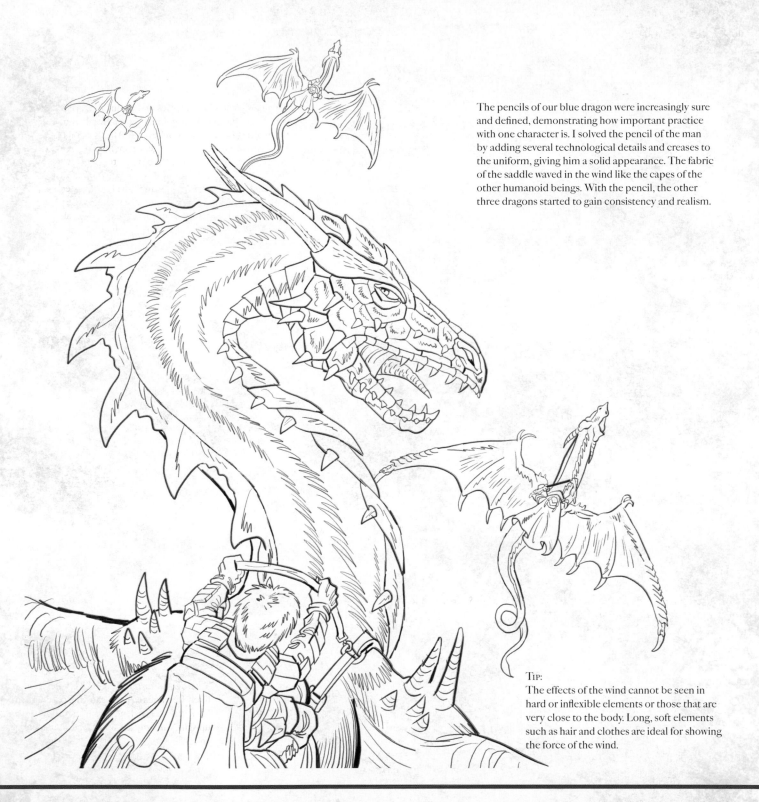

The pencils of our blue dragon were increasingly sure and defined, demonstrating how important practice with one character is. I solved the pencil of the man by adding several technological details and creases to the uniform, giving him a solid appearance. The fabric of the saddle waved in the wind like the capes of the other humanoid beings. With the pencil, the other three dragons started to gain consistency and realism.

TIP:
The effects of the wind cannot be seen in hard or inflexible elements or those that are very close to the body. Long, soft elements such as hair and clothes are ideal for showing the force of the wind.

Ink

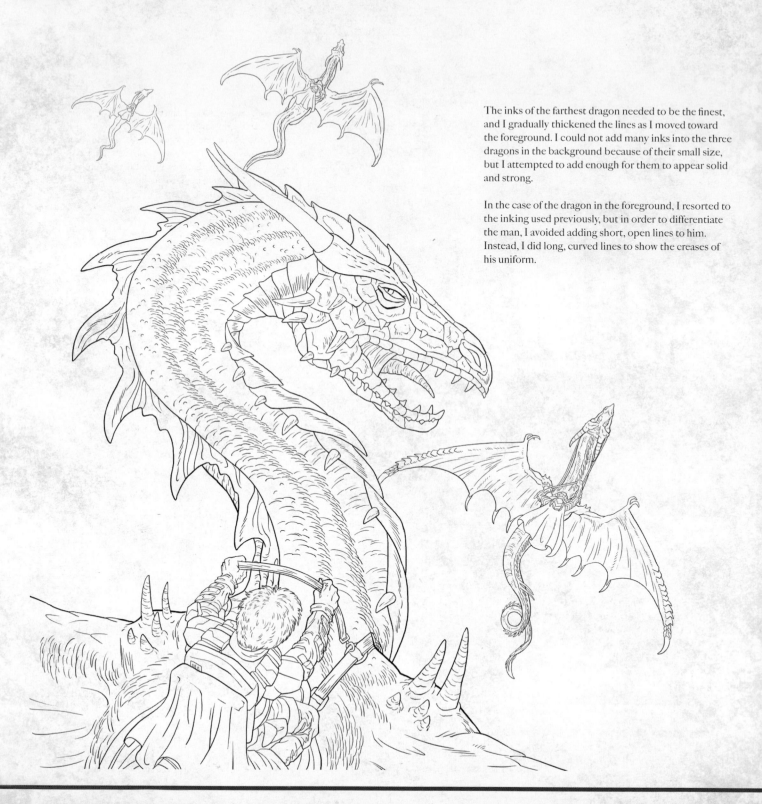

The inks of the farthest dragon needed to be the finest, and I gradually thickened the lines as I moved toward the foreground. I could not add many inks into the three dragons in the background because of their small size, but I attempted to add enough for them to appear solid and strong.

In the case of the dragon in the foreground, I resorted to the inking used previously, but in order to differentiate the man, I avoided adding short, open lines to him. Instead, I did long, curved lines to show the creases of his uniform.

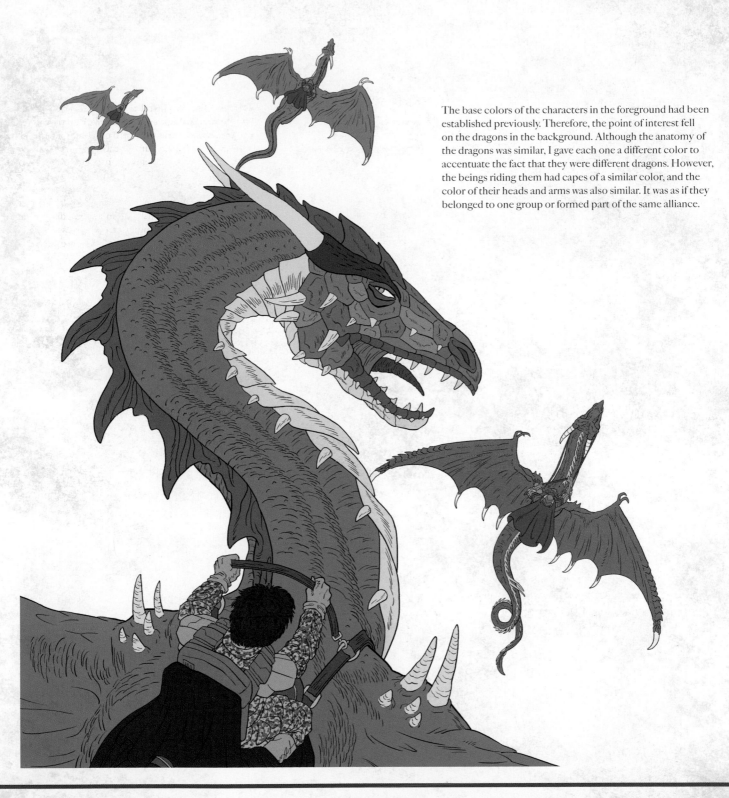

The base colors of the characters in the foreground had been established previously. Therefore, the point of interest fell on the dragons in the background. Although the anatomy of the dragons was similar, I gave each one a different color to accentuate the fact that they were different dragons. However, the beings riding them had capes of a similar color, and the color of their heads and arms was also similar. It was as if they belonged to one group or formed part of the same alliance.

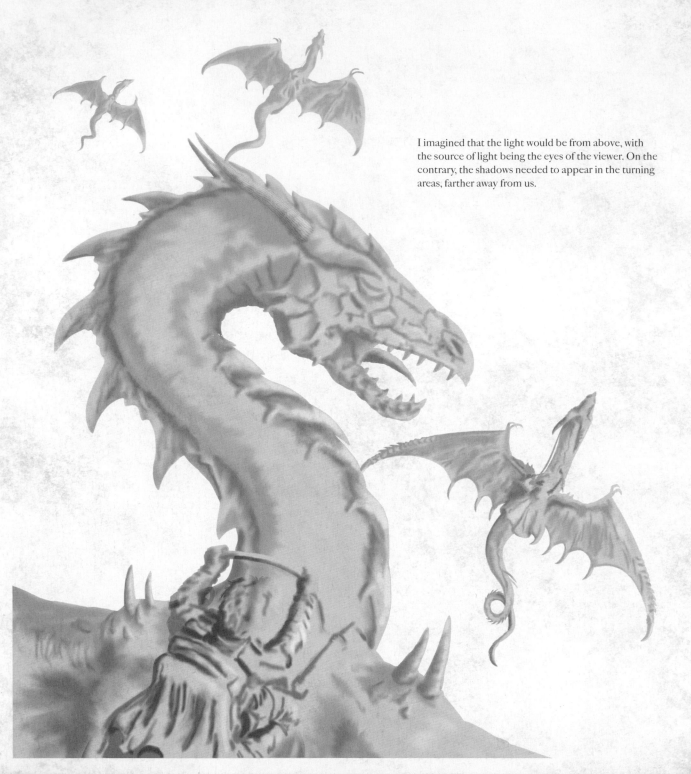

I imagined that the light would be from above, with the source of light being the eyes of the viewer. On the contrary, the shadows needed to appear in the turning areas, farther away from us.

Finished Drawing

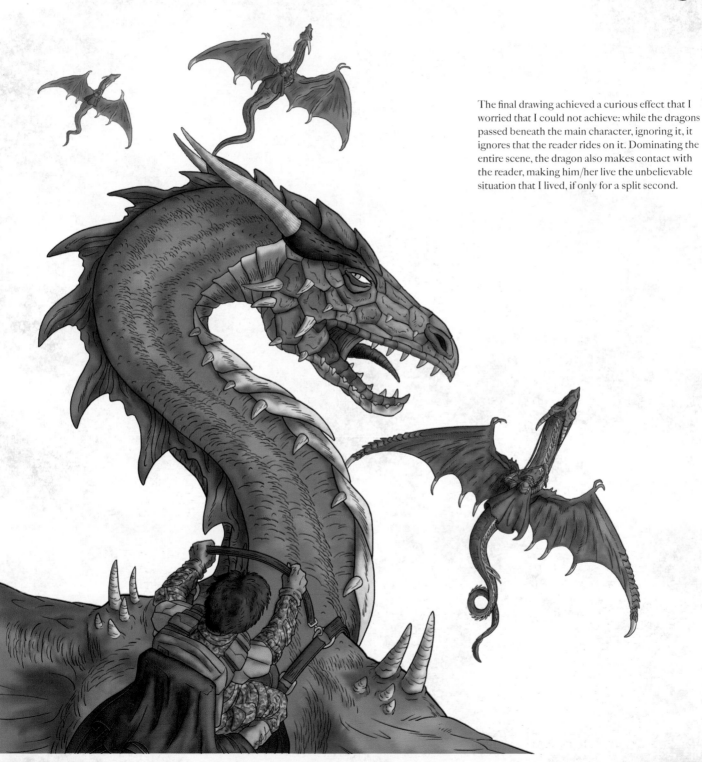

The final drawing achieved a curious effect that I worried that I could not achieve: while the dragons passed beneath the main character, ignoring it, it ignores that the reader rides on it. Dominating the entire scene, the dragon also makes contact with the reader, making him/her live the unbelievable situation that I lived, if only for a split second.

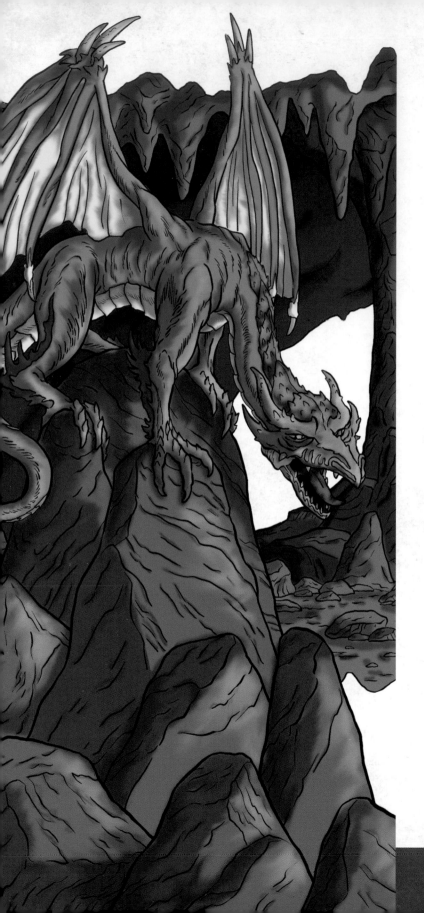

The Dragon's Lair

Soon after, Thomas and I noticed that our dragons were following a specific direction. How stupid of us! We had not realized that the two dragons were a couple. Houlz, the larger dragon, must be the female, and Arn, the male. They were probably headed toward their shelter, and yet we felt no fear at all.

Finally, halfway up an enormous vertical wall of rock, far from the reach of any human being, both dragons entered into a narrow crack. As soon as our eyes got used to the darkness, we saw an enormous vault above us full of stalactites, which were being reflected in a small water spring deep within the rocks.

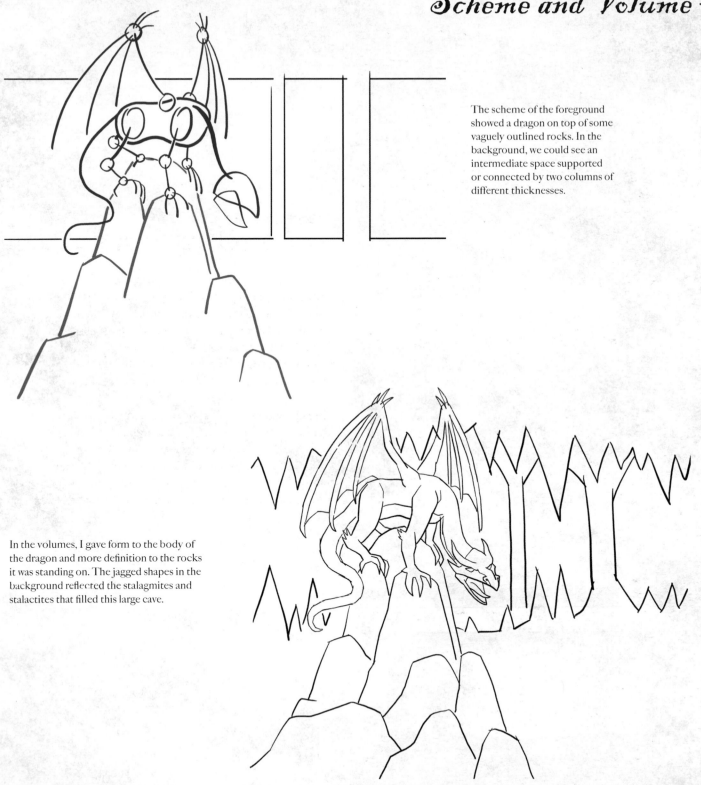

The scheme of the foreground showed a dragon on top of some vaguely outlined rocks. In the background, we could see an intermediate space supported or connected by two columns of different thicknesses.

In the volumes, I gave form to the body of the dragon and more definition to the rocks it was standing on. The jagged shapes in the background reflected the stalagmites and stalactites that filled this large cave.

Pencil and Ink

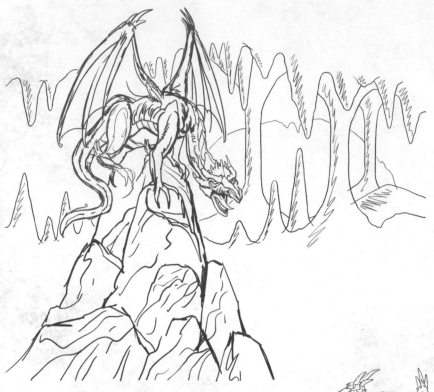

In the pencil of the foreground, I added the muscular elements of the dragon, and I defined its face. In the pencil of the background, I decided the position and final size of the stalagmites, stalactites, and columns. I also added a large arch in the background, which led on to another chamber.

The ink of the dragon only showed short lines for the musculature of the body and tail. The long lines of the wings showed us that they were semi folded, with little tension. The ink of the background defined the appearance and hardness of the cave's rocks

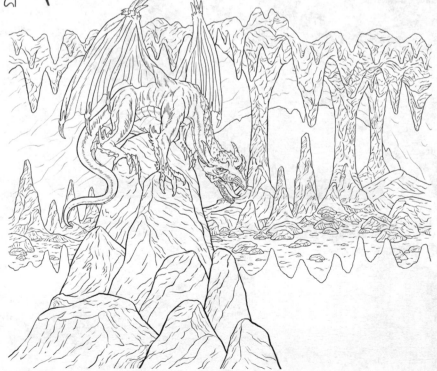

For the rocks in the foreground, I chose a gray base color, which contrasts with the luminous greens of the dragon. The cave in the background has darker colors, as well as backlighting due to the closeness of the cave entrance.

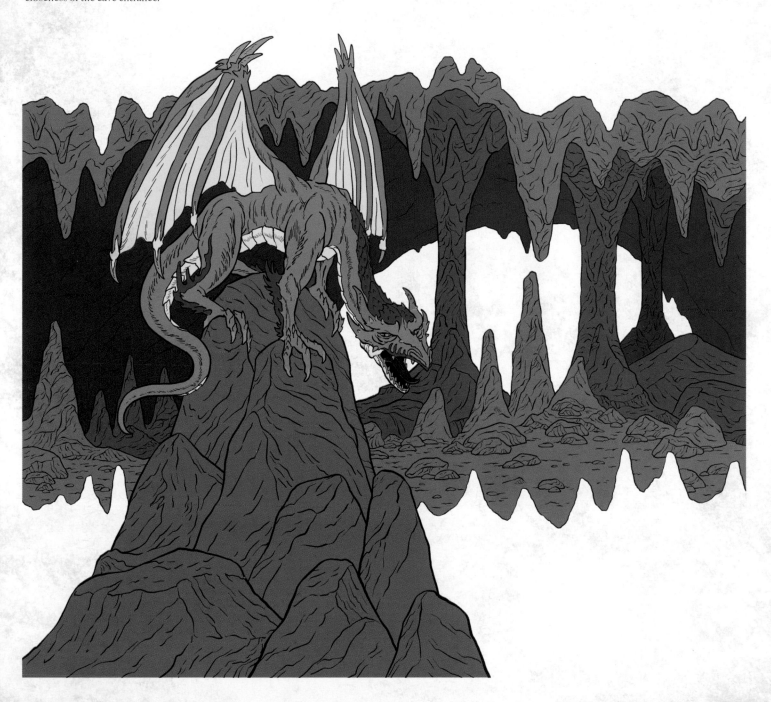

Light and Shadow

No light penetrated the interior of the cave. Everything was in shadows. Two layers of dark shadows of differing opacity provided sufficient volume. The closer we get to the foreground, the more complex and fuller the shadows are.

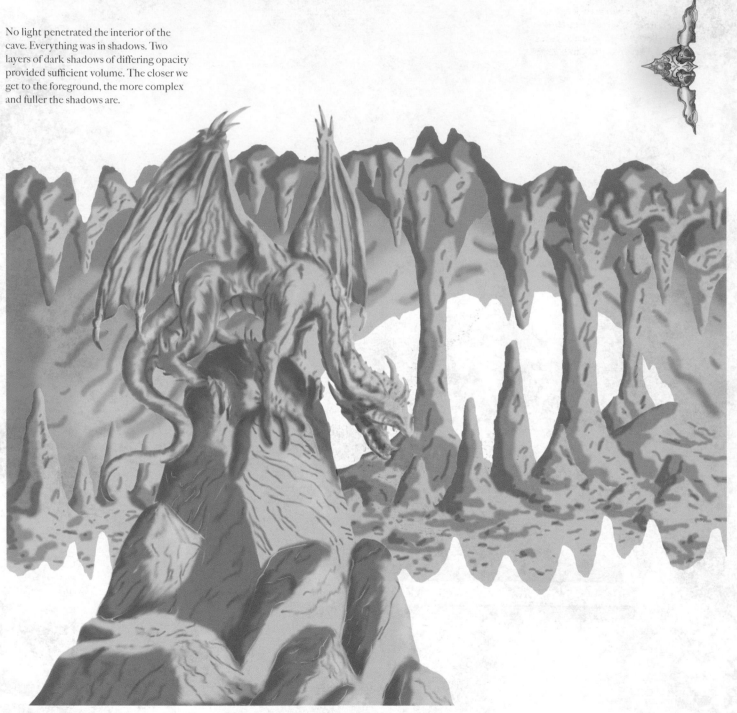

The somber tone, the virgin rock and no human traces whatsoever make up this cave that seems to devour us. The final drawing will be a success if we feel that this place is not for us.

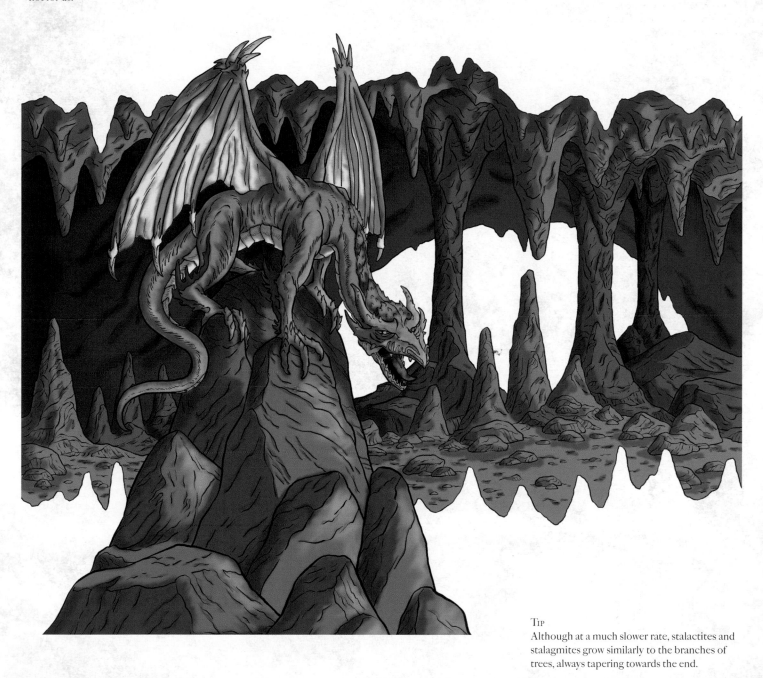

Tip
Although at a much slower rate, stalactites and stalagmites grow similarly to the branches of trees, always tapering towards the end.

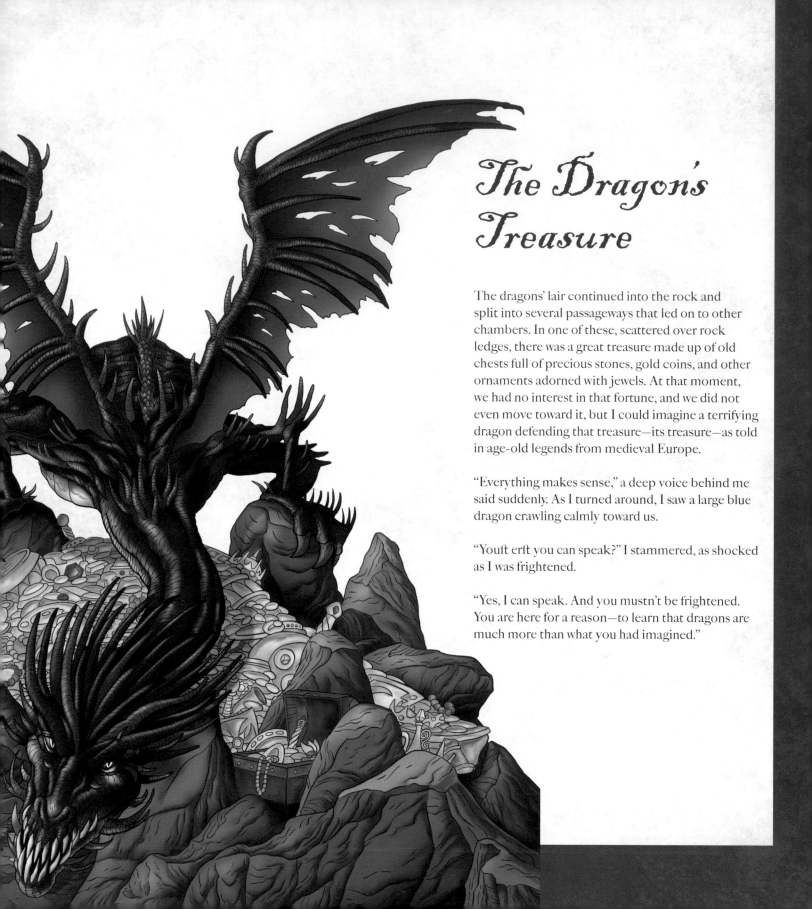

The Dragon's Treasure

The dragons' lair continued into the rock and split into several passageways that led on to other chambers. In one of these, scattered over rock ledges, there was a great treasure made up of old chests full of precious stones, gold coins, and other ornaments adorned with jewels. At that moment, we had no interest in that fortune, and we did not even move toward it, but I could imagine a terrifying dragon defending that treasure—its treasure—as told in age-old legends from medieval Europe.

"Everything makes sense," a deep voice behind me said suddenly. As I turned around, I saw a large blue dragon crawling calmly toward us.

"Youſt erſt you can speak?" I stammered, as shocked as I was frightened.

"Yes, I can speak. And you mustn't be frightened. You are here for a reason—to learn that dragons are much more than what you had imagined."

The scene came to my imagination suddenly, and I set about drawing it. First, I did the scheme of what I had seen in my mind: The body of the dragon (black) approached a small mound of rocks (brown), lowering its neck in a threatening sign, with its tail restless and twisting around itself. The limbs and wings (red) remained tense, waiting for the right moment to jump on the intruder.

TIP:
Writing our ideas in words before putting them into an image may help to clarify those ideas.

Volume

TIP:
Allow the imagination to fly. Although not everything we imagine can be directly included in our illustration, our ideas may affect what can be included in ways we would never have imagined.

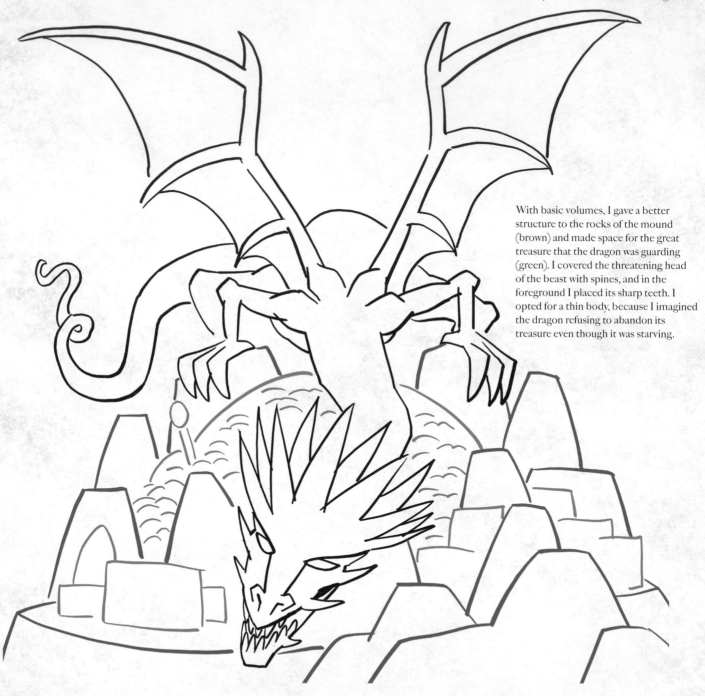

With basic volumes, I gave a better structure to the rocks of the mound (brown) and made space for the great treasure that the dragon was guarding (green). I covered the threatening head of the beast with spines, and in the foreground I placed its sharp teeth. I opted for a thin body, because I imagined the dragon refusing to abandon its treasure even though it was starving.

The form of the spines caused me lots of headaches. I began several pencils until I arrived at the definitive appearance—which seemed very similar to the original. After these spines, the rest of the dragon was easy. The back and the tail were also full of spines, and its face was thin and elongated, with fine, long teeth. Its limbs were slender and, of course, covered in spines.

In order to do the pencil of the treasure, I made use of an old drawing I had outlined years ago, and which at last I would be able to use. I had to recompose it a little, but it fitted perfectly in the mound of rocks I had developed.

TIP:
Do not lose your old illustrations you could not make use of. Maybe some of them contain an interesting concept for the next project.

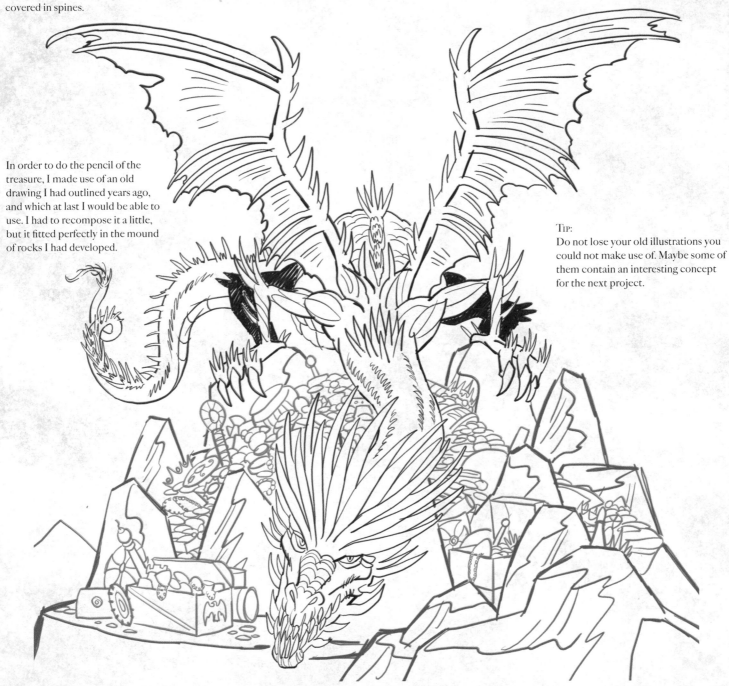

Ink

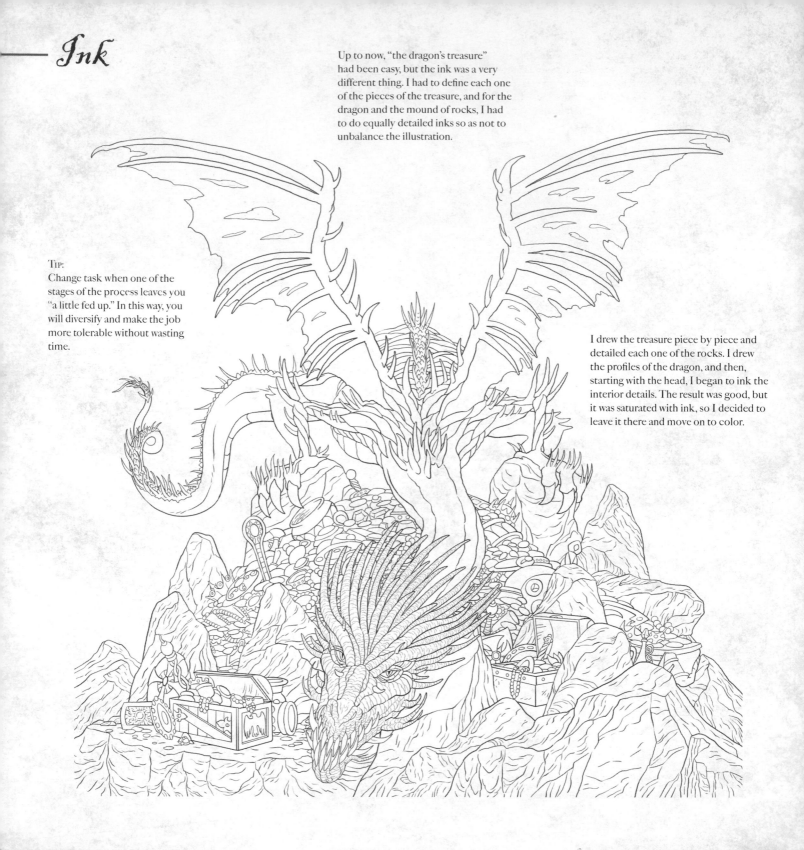

Up to now, "the dragon's treasure" had been easy, but the ink was a very different thing. I had to define each one of the pieces of the treasure, and for the dragon and the mound of rocks, I had to do equally detailed inks so as not to unbalance the illustration.

TIP:
Change task when one of the stages of the process leaves you "a little fed up." In this way, you will diversify and make the job more tolerable without wasting time.

I drew the treasure piece by piece and detailed each one of the rocks. I drew the profiles of the dragon, and then, starting with the head, I began to ink the interior details. The result was good, but it was saturated with ink, so I decided to leave it there and move on to color.

Without having finished the inking, I moved directly onto the base color. I mainly used three base colors: a wide range of yellows for the treasure, several tones of gray for the rocks, and different tones of red for the evil dragon. The gray of the nails and the wings further accentuated its evil. The gold was still gleaming, but the dragon and its environment were corrupted by ambition.

TIP:
Try not to leave your illustrations half-done. There is a hidden lesson to be learned behind each finished illustration.

Once I had done the base color, I felt keen to continue with the inking. I added ink details to the dragon's skin from the snout to the end of the tail, which felt like a major achievement to me.

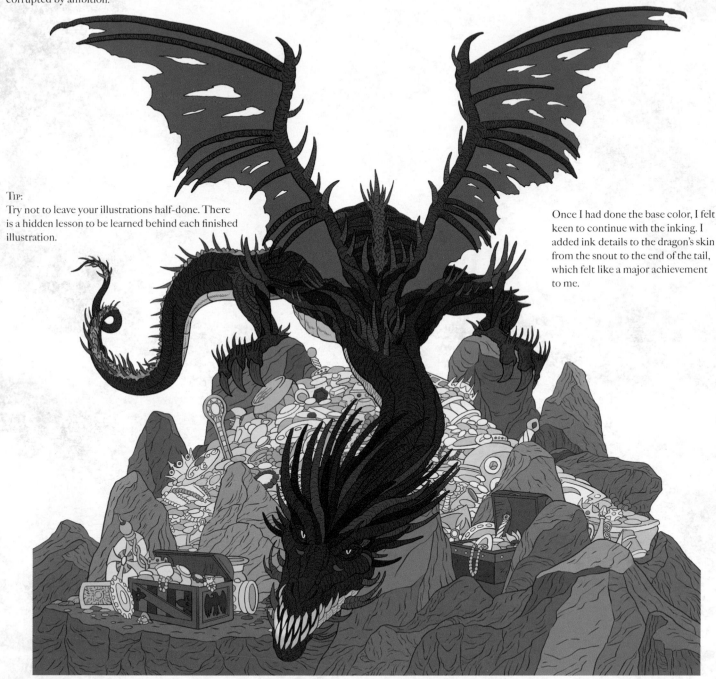

Light and Shadow

The light and shadow work had to be consistent with the great inking and coloring work. For the dragon, I superimposed several layers of shadows in the shape of small circles, which I softened to mix them up. With these shadows, I wanted to give the dragon's skin a burned appearance, as if evil was consuming it from the inside.

For the mountains, I used an extremely soft light and two layers of shadows, which I mixed so as to get a little more volume from the inks.

On the other hand, I placed the lights with respect to a source of light in the top left part, as I needed to highlight the dragon's shapes. I must confess, I did not follow any idea or rule for the treasure. I added lights and shadows to create volume indiscriminately because I wanted it to appear that the abundance of treasure had been thrown there without any sense of order.

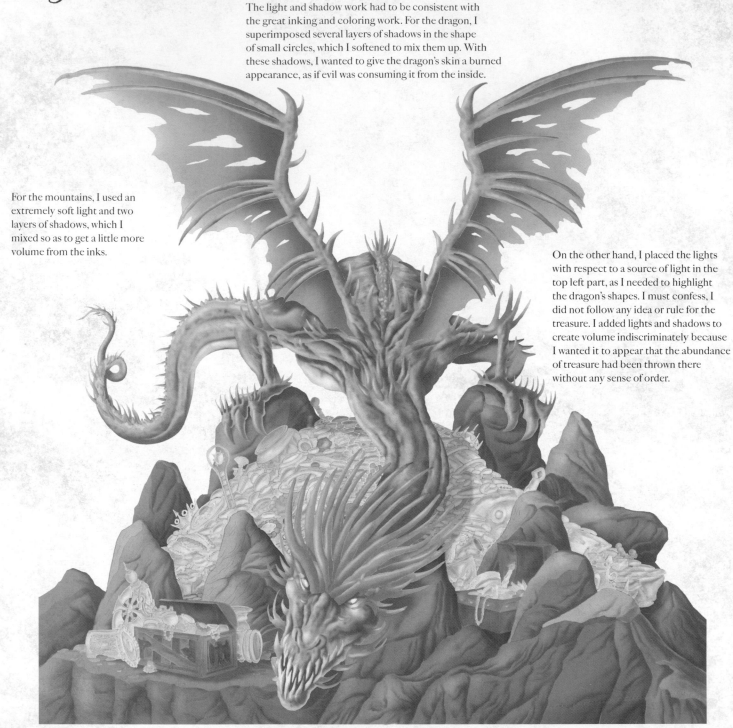

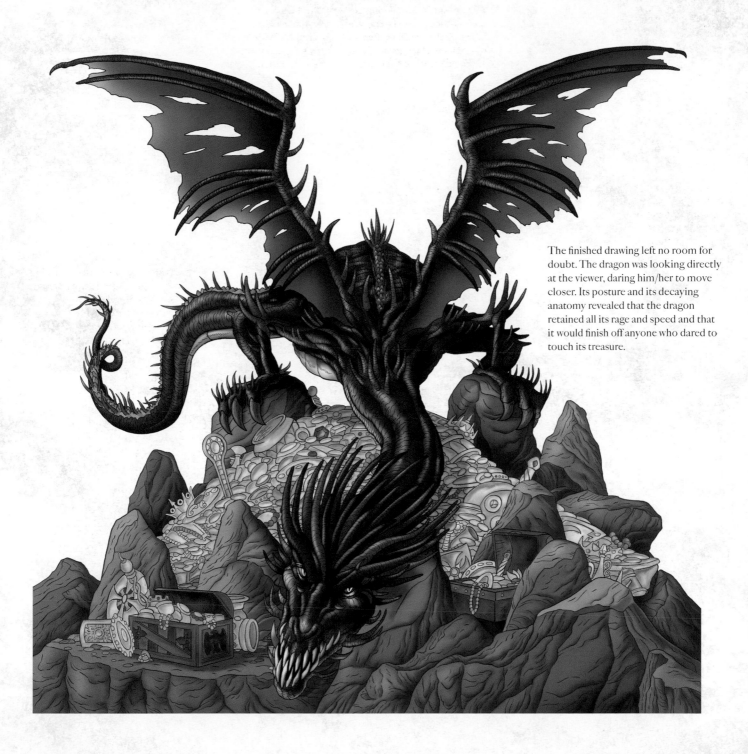

The finished drawing left no room for doubt. The dragon was looking directly at the viewer, daring him/her to move closer. Its posture and its decaying anatomy revealed that the dragon retained all its rage and speed and that it would finish off anyone who dared to touch its treasure.

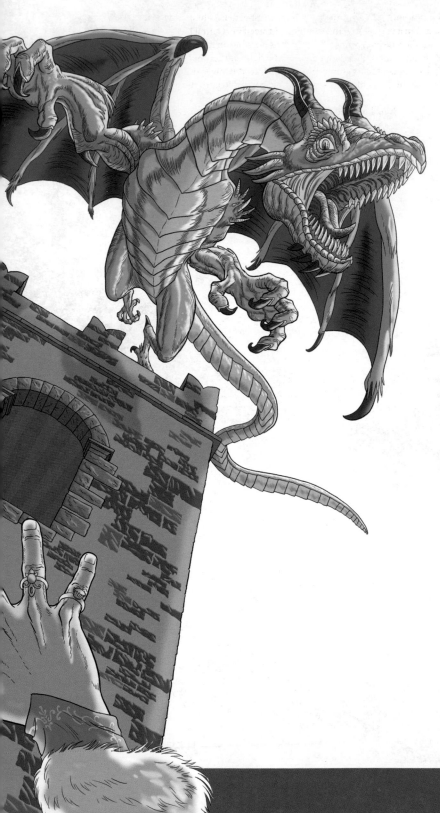

Castles and Dragons

After the shock of hearing that dragon speaking to us, Thomas reacted by taking a step forward.

"Are you suggesting that you are not our enemies? You have attacked whole towns, causing deaths, destroying buildings, castles?"

"Listen," the dragon continued, "You must realize that the old castles were not built where they were by chance. Most are located over power centers, which attracted the subconscious energy of humans, the same as this cave. Dragons can capture and understand that energy, feed from it, and at the same time maintain it. That is why many dragons live in caves under castles—we occupy them when they are abandoned, or we expel their governors when their incapacity or their evil weakens the power center. And as a punishment, we destroy their armies and hide their wealth so that they may never repeat their despicable actions."

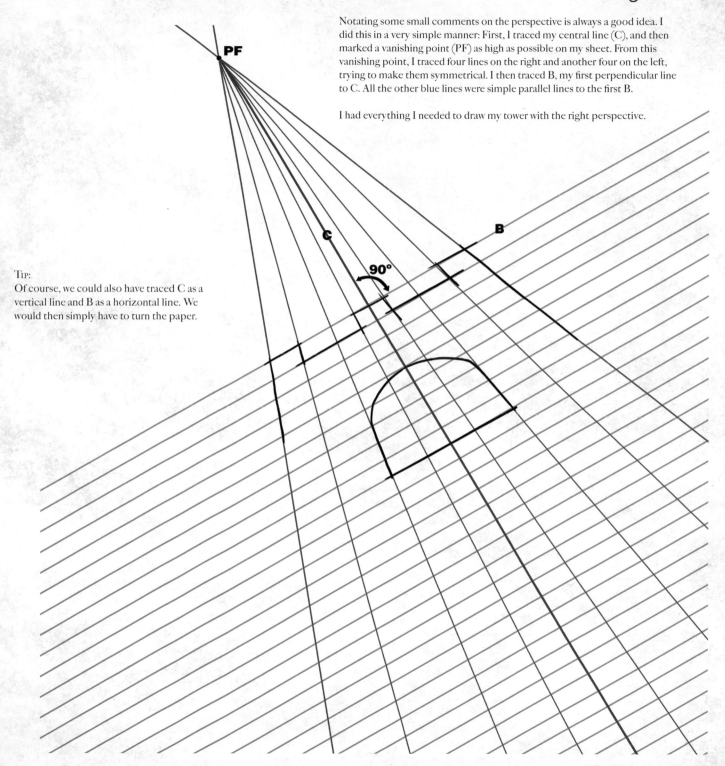

Notating some small comments on the perspective is always a good idea. I did this in a very simple manner: First, I traced my central line (C), and then marked a vanishing point (PF) as high as possible on my sheet. From this vanishing point, I traced four lines on the right and another four on the left, trying to make them symmetrical. I then traced B, my first perpendicular line to C. All the other blue lines were simple parallel lines to the first B.

I had everything I needed to draw my tower with the right perspective.

TIP:
Of course, we could also have traced C as a vertical line and B as a horizontal line. We would then simply have to turn the paper.

PF

C

B

90°

Scheme

With my background perspective, I could trace my scheme. From the top of the tower, a fearsome dragon sets upon the viewers, who ineffectually try to protect themselves with their hands.

For the perspective to work, the front legs needed to appear much bigger than the back limbs. The hands are no more than two pentagons from which the five fingers appear.

TIP:
Find a way to show all the possible elements of the dragon, clearly separating its limbs and placing its tail in a visible position.

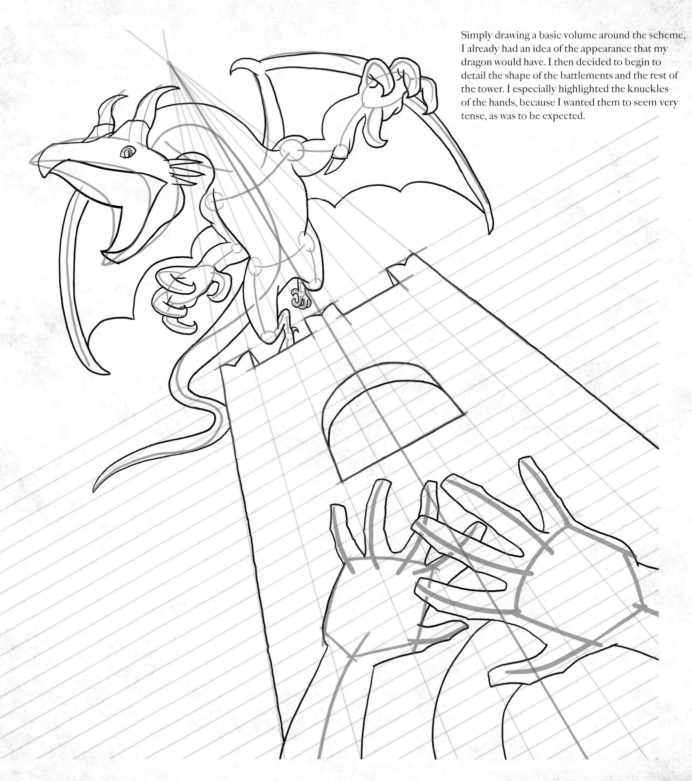

Scheme and Volume 1

Simply drawing a basic volume around the scheme, I already had an idea of the appearance that my dragon would have. I then decided to begin to detail the shape of the battlements and the rest of the tower. I especially highlighted the knuckles of the hands, because I wanted them to seem very tense, as was to be expected.

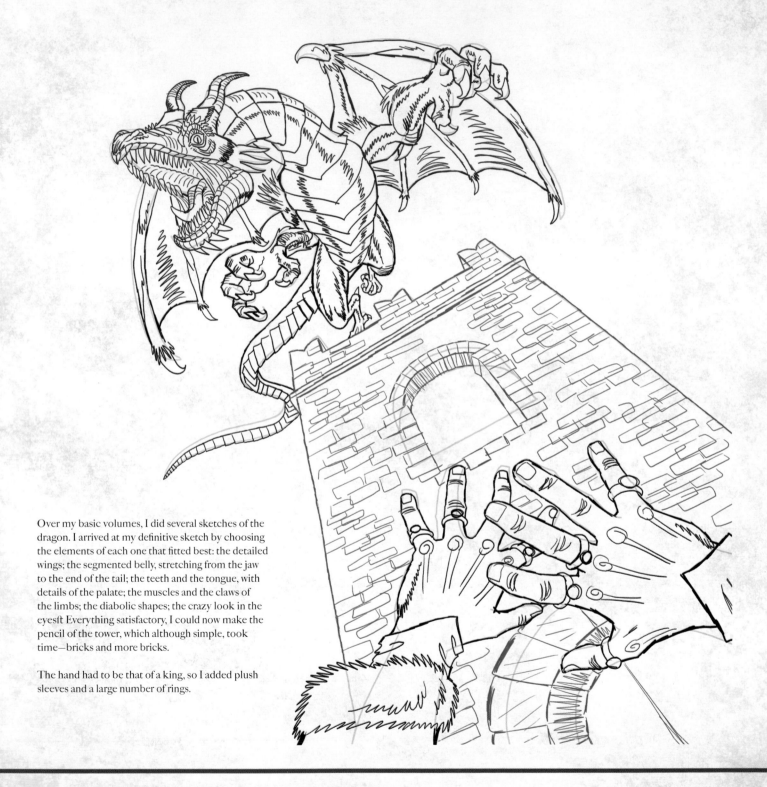

Over my basic volumes, I did several sketches of the dragon. I arrived at my definitive sketch by choosing the elements of each one that fitted best: the detailed wings; the segmented belly, stretching from the jaw to the end of the tail; the teeth and the tongue, with details of the palate; the muscles and the claws of the limbs; the diabolic shapes; the crazy look in the eyes⸮ Everything satisfactory, I could now make the pencil of the tower, which although simple, took time—bricks and more bricks.

The hand had to be that of a king, so I added plush sleeves and a large number of rings.

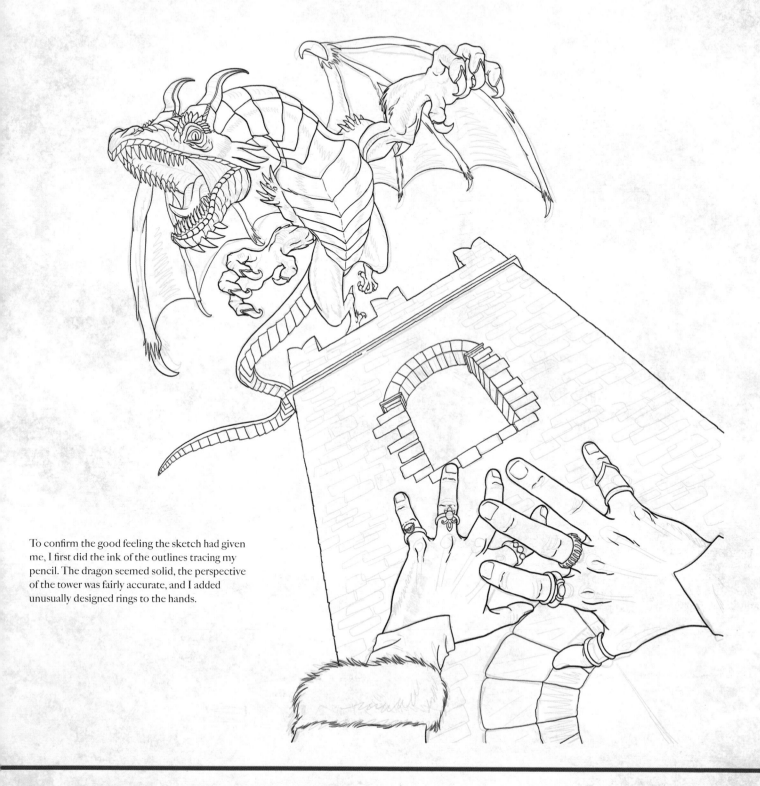

To confirm the good feeling the sketch had given me, I first did the ink of the outlines tracing my pencil. The dragon seemed solid, the perspective of the tower was fairly accurate, and I added unusually designed rings to the hands.

Ink 2

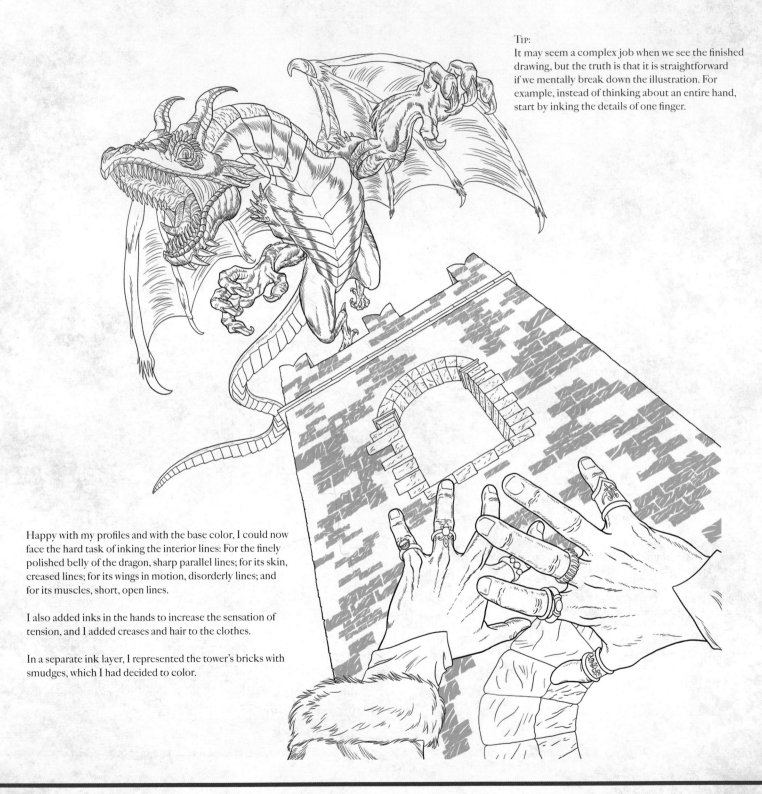

TIP:
It may seem a complex job when we see the finished drawing, but the truth is that it is straightforward if we mentally break down the illustration. For example, instead of thinking about an entire hand, start by inking the details of one finger.

Happy with my profiles and with the base color, I could now face the hard task of inking the interior lines: For the finely polished belly of the dragon, sharp parallel lines; for its skin, creased lines; for its wings in motion, disorderly lines; and for its muscles, short, open lines.

I also added inks in the hands to increase the sensation of tension, and I added creases and hair to the clothes.

In a separate ink layer, I represented the tower's bricks with smudges, which I had decided to color.

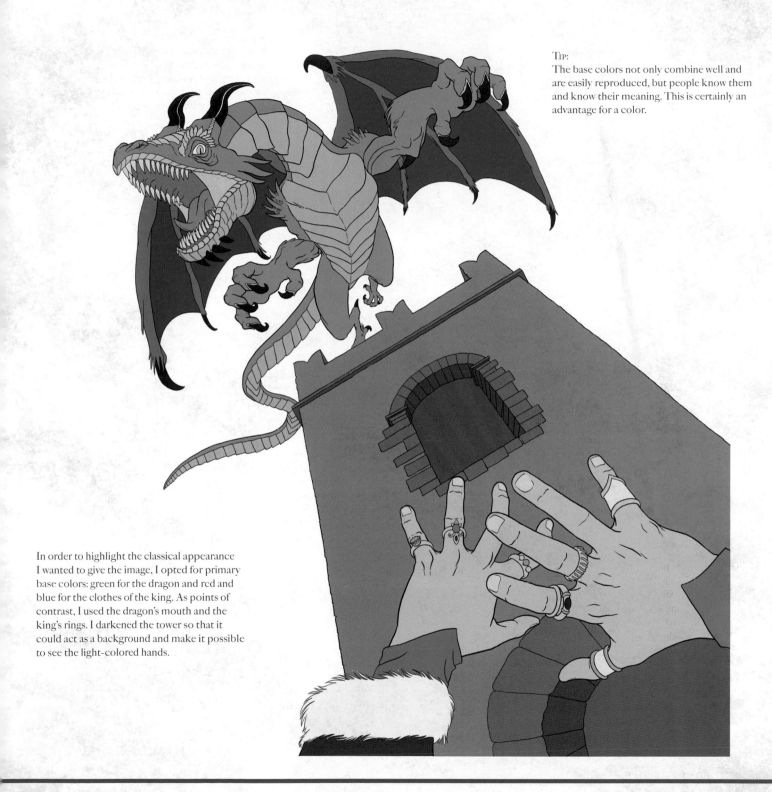

TIP:
The base colors not only combine well and are easily reproduced, but people know them and know their meaning. This is certainly an advantage for a color.

In order to highlight the classical appearance I wanted to give the image, I opted for primary base colors: green for the dragon and red and blue for the clothes of the king. As points of contrast, I used the dragon's mouth and the king's rings. I darkened the tower so that it could act as a background and make it possible to see the light-colored hands.

Light and Shadow

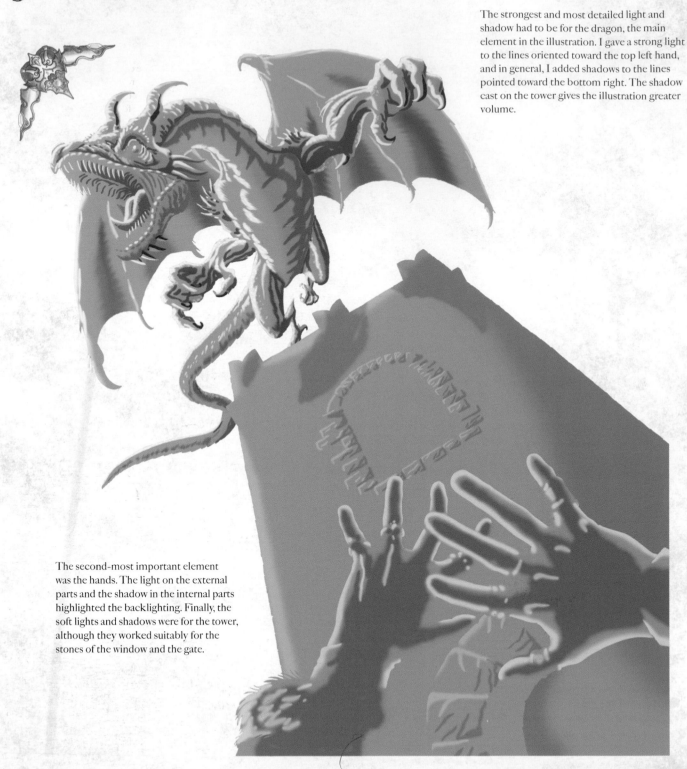

The strongest and most detailed light and shadow had to be for the dragon, the main element in the illustration. I gave a strong light to the lines oriented toward the top left hand, and in general, I added shadows to the lines pointed toward the bottom right. The shadow cast on the tower gives the illustration greater volume.

The second-most important element was the hands. The light on the external parts and the shadow in the internal parts highlighted the backlighting. Finally, the soft lights and shadows were for the tower, although they worked suitably for the stones of the window and the gate.

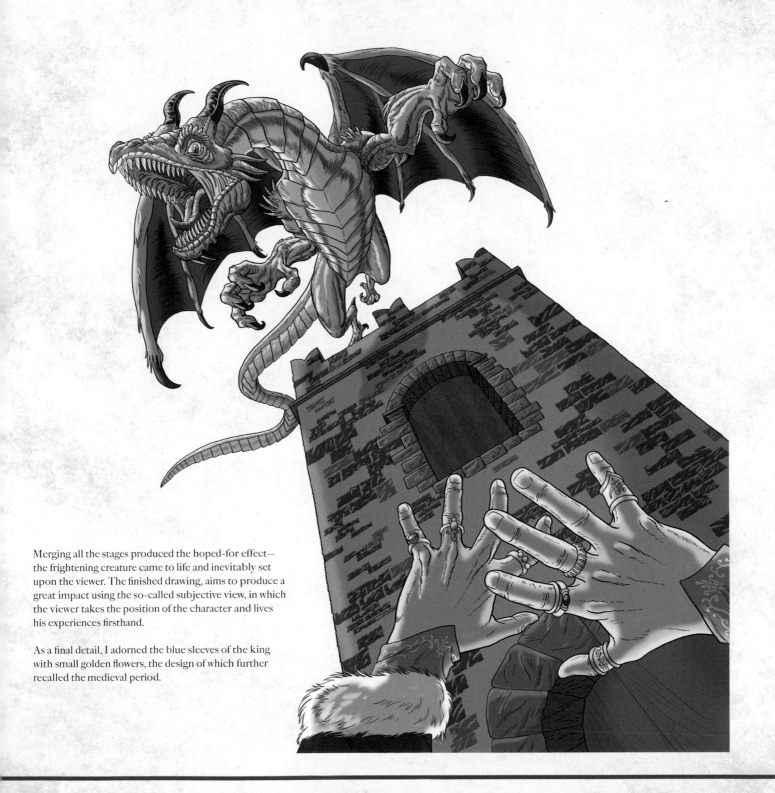

Merging all the stages produced the hoped-for effect—the frightening creature came to life and inevitably set upon the viewer. The finished drawing, aims to produce a great impact using the so-called subjective view, in which the viewer takes the position of the character and lives his experiences firsthand.

As a final detail, I adorned the blue sleeves of the king with small golden flowers, the design of which further recalled the medieval period.

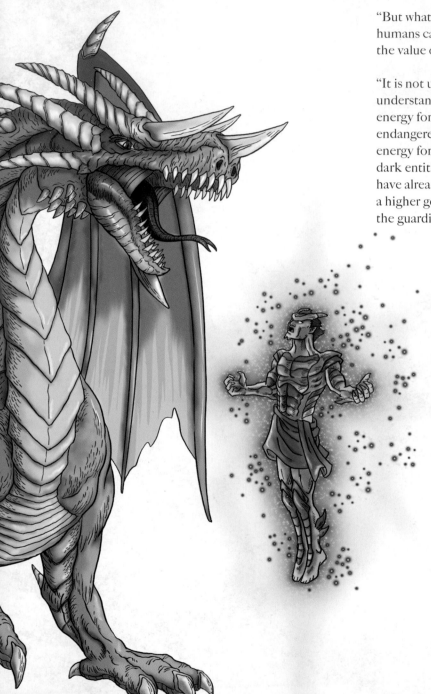

Pacts with Dragons

"But what is the importance of these power centers? Why should humans care about them?" I asked, somewhat offended. "What is the value of that energy for you to attack us the way that you do?"

"It is not us that attacks you," the dragon replied. "You must understand that these power centers accumulate a fundamental energy for maintaining this planet and that this energy is endangered. There are dark entities that wish to take over that energy for their own purposes. The dragons possessed by these dark entities are your enemies and also our enemies. Some of you have already understood and sacrificed your humanity to defend a higher goal—helping us, the Üru dragons, the defenders of good, the guardians of the eternal flame."

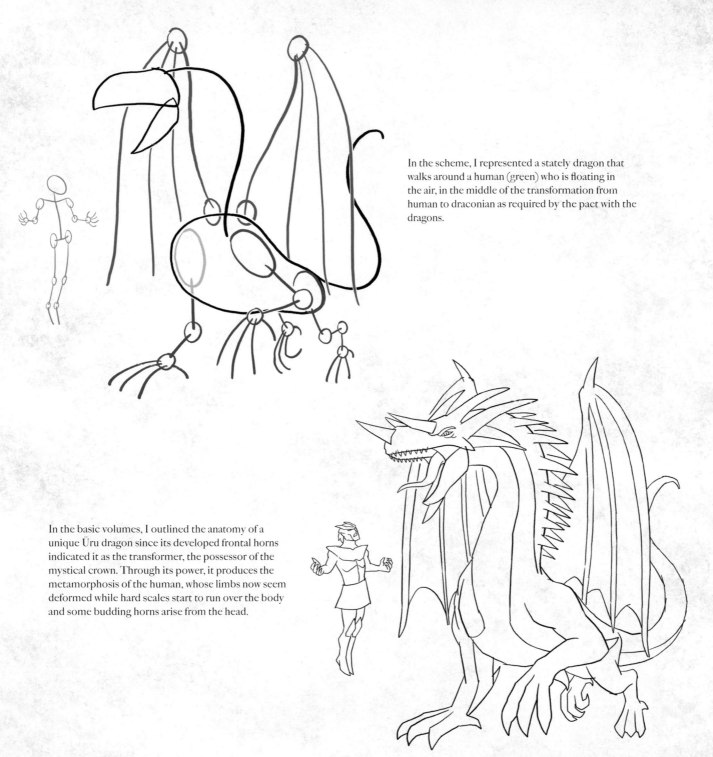

In the scheme, I represented a stately dragon that walks around a human (green) who is floating in the air, in the middle of the transformation from human to draconian as required by the pact with the dragons.

In the basic volumes, I outlined the anatomy of a unique Üru dragon since its developed frontal horns indicated it as the transformer, the possessor of the mystical crown. Through its power, it produces the metamorphosis of the human, whose limbs now seem deformed while hard scales start to run over the body and some budding horns arise from the head.

Pencil

TIP:
If we want to draw well, we must find a place where we feel relaxed and at ease for creating. If we want those around us to respect this place, we must start by doing so ourselves.

I started drawing after comparing several sheets of notes, helped by long, calm hours in which I was not interrupted.

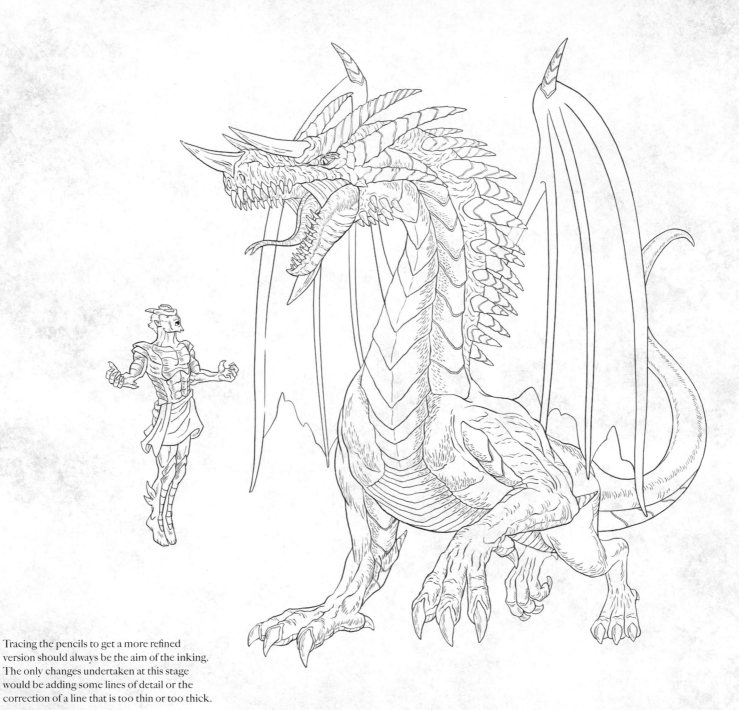

Tracing the pencils to get a more refined version should always be the aim of the inking. The only changes undertaken at this stage would be adding some lines of detail or the correction of a line that is too thin or too thick.

Base Color

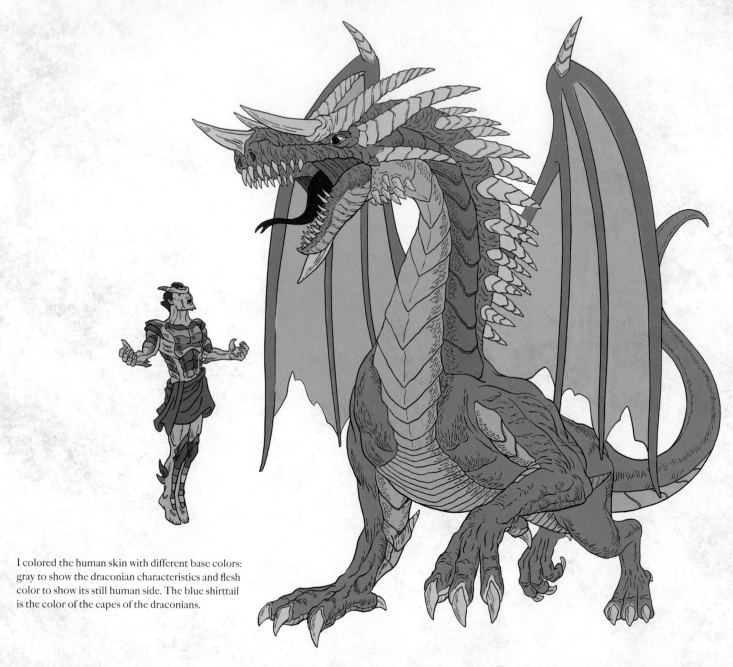

I colored the human skin with different base colors: gray to show the draconian characteristics and flesh color to show its still human side. The blue shirttail is the color of the capes of the draconians.

The colors of the dragon were difficult for me to re-create. They were somewhere between brown, green, and orange. I performed various tests, and I got as close to the real colors as I could.

I rendered the magic that surrounded the man during
his metamorphosis to a draconian in three steps:

In the first step, I combined a violet silhouette of the
man with an exterior explosion of the same violet, but
with lower opacity.

In the second step, I carefully added some pale
stars to the whole drawing with a small paintbrush.

In the third step, I incorporated purple stars,
which are no more than circular smudges of
different sizes. I deleted the center of the largest
ones with a very fine eraser.

TIP:
Experiment with brightness, openwork, stars, and spirals.
Create your own special effects and design your own magic.

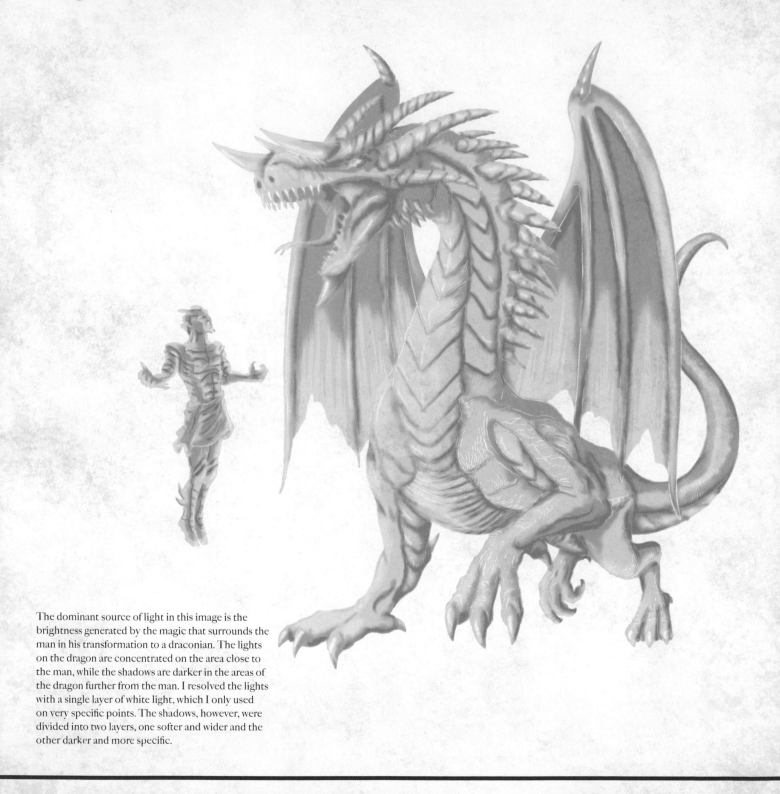

The dominant source of light in this image is the brightness generated by the magic that surrounds the man in his transformation to a draconian. The lights on the dragon are concentrated on the area close to the man, while the shadows are darker in the areas of the dragon further from the man. I resolved the lights with a single layer of white light, which I only used on very specific points. The shadows, however, were divided into two layers, one softer and wider and the other darker and more specific.

In the final drawing, energy and links are sensed, beyond what was seen with the naked eye. The interaction of the dragon with the magic that surrounds the man became clear. The dragon conducts it, absolutely focused on it, so that the transformation occurs successfully. The man devotes himself in body and soul, without hesitation, knowing that he is serving a greater good.

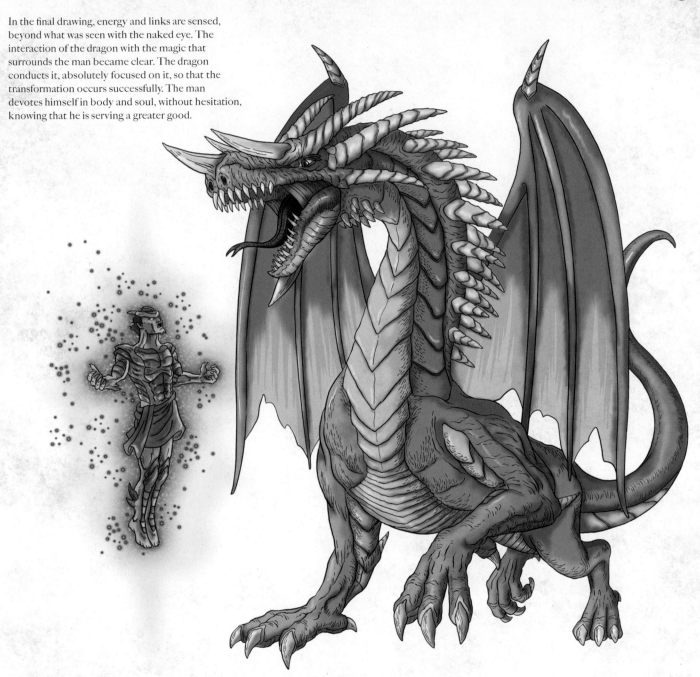

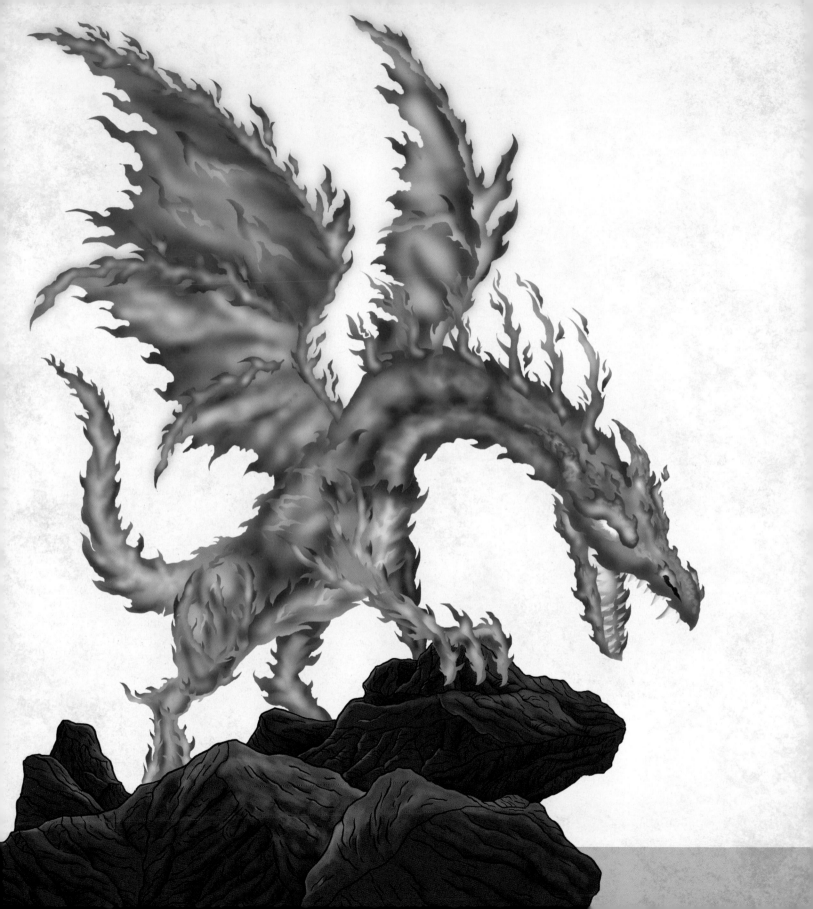

Battle Dragons

Thomas and I looked at each other without knowing what to do, without knowing whether we should believe the words of the creature, which continued to look at us closely.

"I can feel the doubt in your hearts," the dragon said. "Place your hands on my chest and you will know the truth."

Trembling, we did what he asked us and immediately vivid images overwhelmed our brains, awakening something that was asleep inside us, an ancient pact between Üru dragons and humans. We saw those creatures through time, not as a set of wild beasts whose immense power was a danger to human beings, but as something much more complex. We now understood that we were part of a battle that had been going on for thousands of years and that humans held the balance to prevent the world from falling toward the side of the shadows.

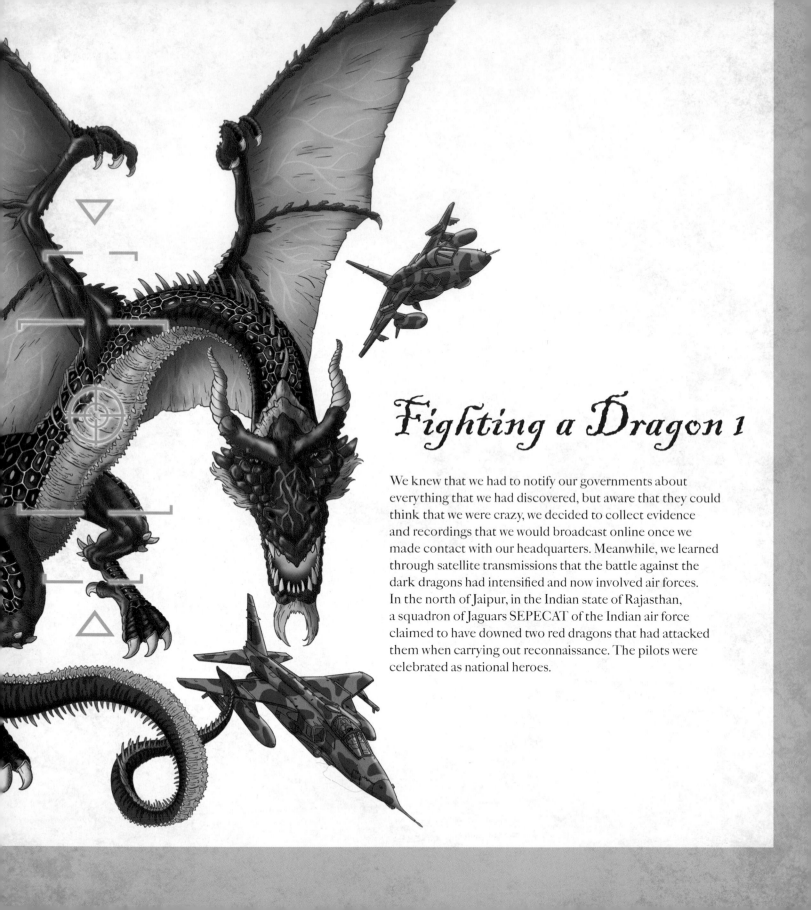

Fighting a Dragon 1

We knew that we had to notify our governments about everything that we had discovered, but aware that they could think that we were crazy, we decided to collect evidence and recordings that we would broadcast online once we made contact with our headquarters. Meanwhile, we learned through satellite transmissions that the battle against the dark dragons had intensified and now involved air forces. In the north of Jaipur, in the Indian state of Rajasthan, a squadron of Jaguars SEPECAT of the Indian air force claimed to have downed two red dragons that had attacked them when carrying out reconnaissance. The pilots were celebrated as national heroes.

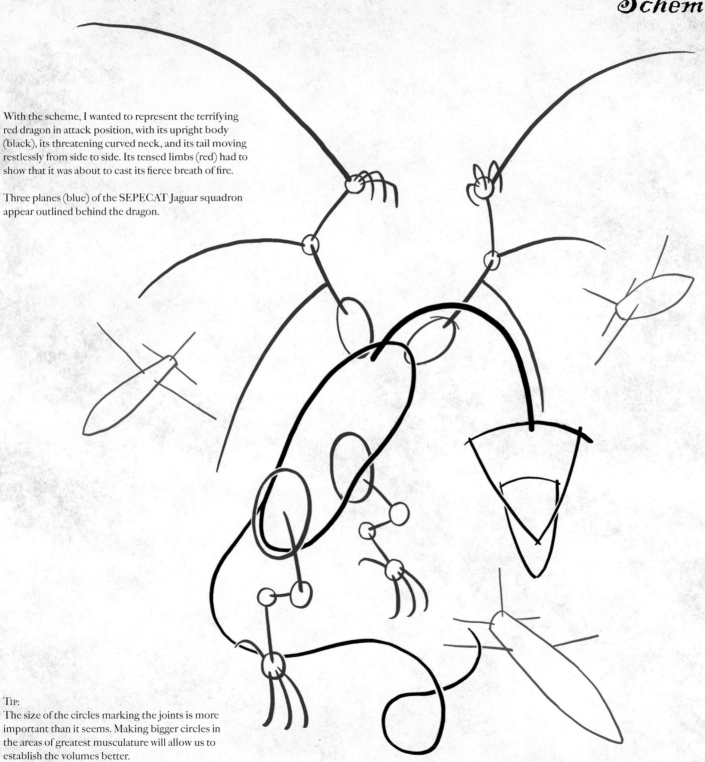

With the scheme, I wanted to represent the terrifying red dragon in attack position, with its upright body (black), its threatening curved neck, and its tail moving restlessly from side to side. Its tensed limbs (red) had to show that it was about to cast its fierce breath of fire.

Three planes (blue) of the SEPECAT Jaguar squadron appear outlined behind the dragon.

TIP:
The size of the circles marking the joints is more important than it seems. Making bigger circles in the areas of greatest musculature will allow us to establish the volumes better.

Volume

TIP:
Do not hesitate to consult several sources of information to correctly render the technology, both civil and military.

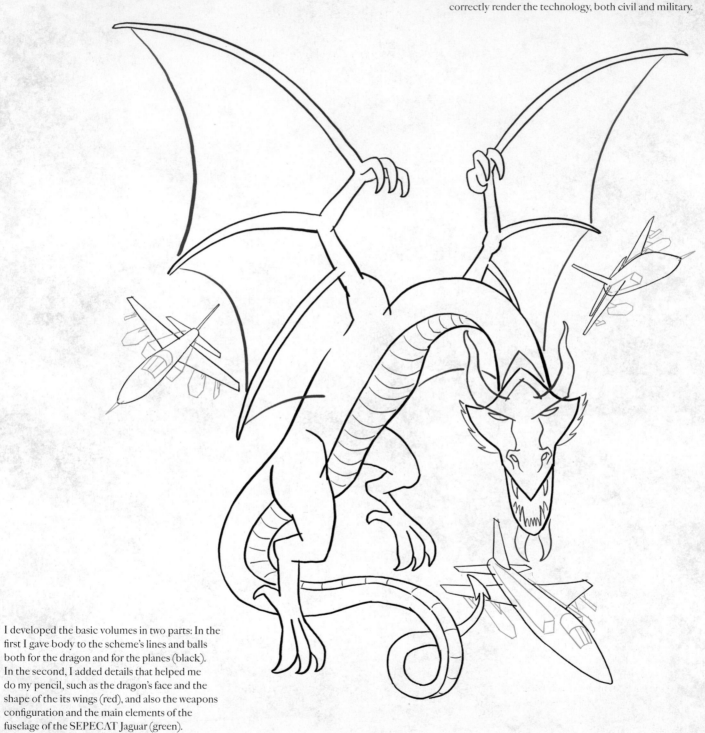

I developed the basic volumes in two parts: In the first I gave body to the scheme's lines and balls both for the dragon and for the planes (black). In the second, I added details that helped me do my pencil, such as the dragon's face and the shape of the its wings (red), and also the weapons configuration and the main elements of the fuselage of the SEPECAT Jaguar (green).

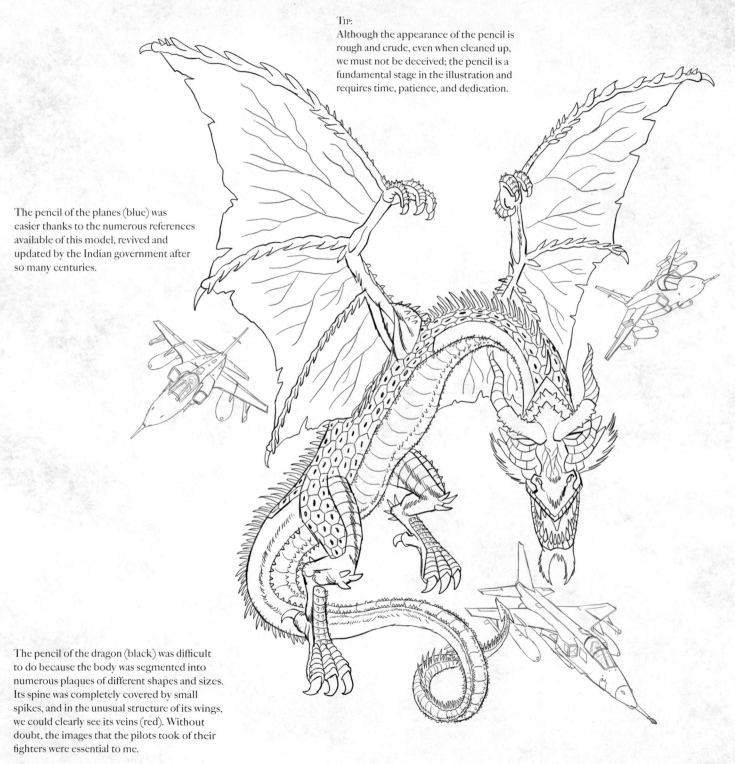

Tip:
Although the appearance of the pencil is rough and crude, even when cleaned up, we must not be deceived; the pencil is a fundamental stage in the illustration and requires time, patience, and dedication.

The pencil of the planes (blue) was easier thanks to the numerous references available of this model, revived and updated by the Indian government after so many centuries.

The pencil of the dragon (black) was difficult to do because the body was segmented into numerous plaques of different shapes and sizes. Its spine was completely covered by small spikes, and in the unusual structure of its wings, we could clearly see its veins (red). Without doubt, the images that the pilots took of their fighters were essential to me.

Ink

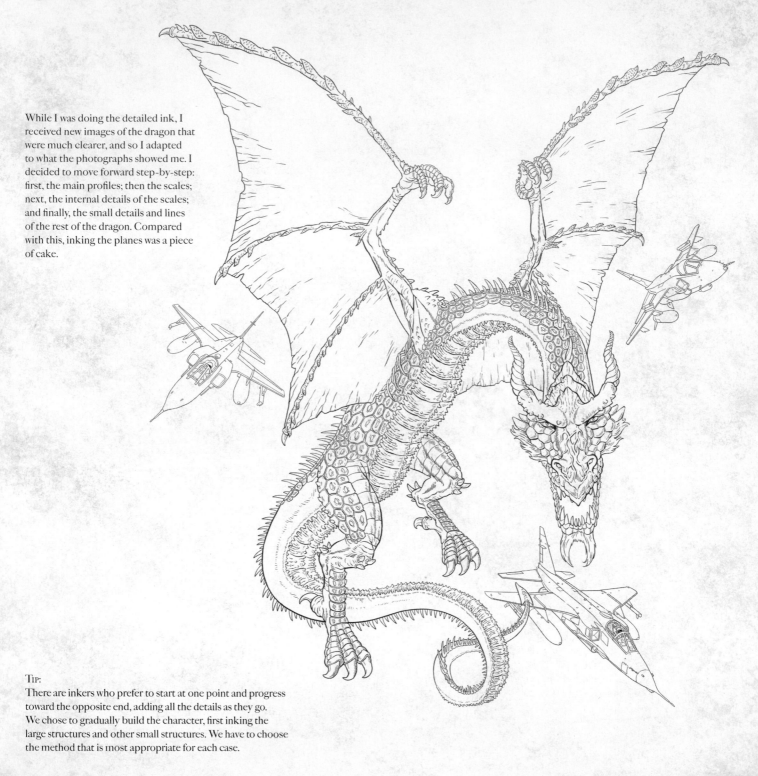

While I was doing the detailed ink, I received new images of the dragon that were much clearer, and so I adapted to what the photographs showed me. I decided to move forward step-by-step: first, the main profiles; then the scales; next, the internal details of the scales; and finally, the small details and lines of the rest of the dragon. Compared with this, inking the planes was a piece of cake.

Tip:
There are inkers who prefer to start at one point and progress toward the opposite end, adding all the details as they go. We chose to gradually build the character, first inking the large structures and other small structures. We have to choose the method that is most appropriate for each case.

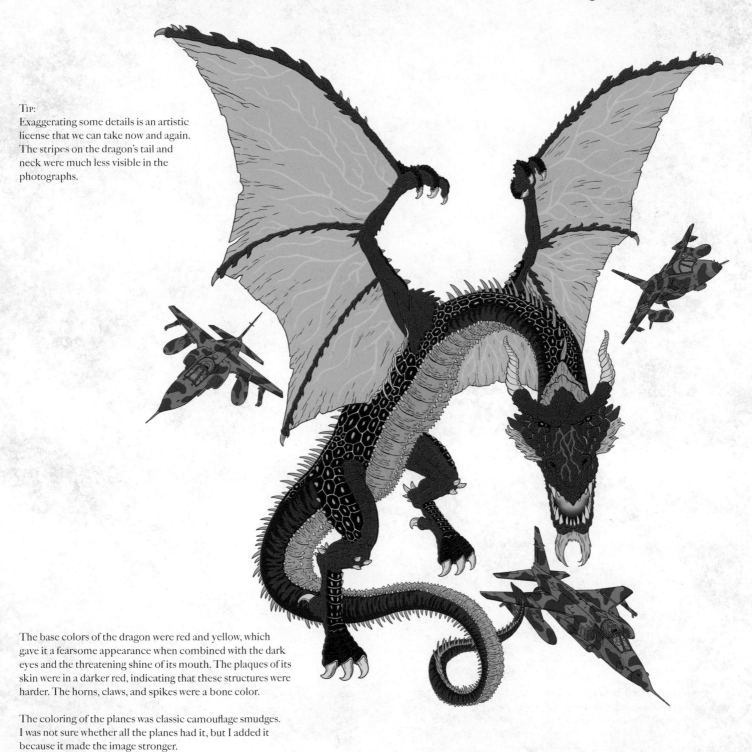

TIP:
Exaggerating some details is an artistic license that we can take now and again. The stripes on the dragon's tail and neck were much less visible in the photographs.

The base colors of the dragon were red and yellow, which gave it a fearsome appearance when combined with the dark eyes and the threatening shine of its mouth. The plaques of its skin were in a darker red, indicating that these structures were harder. The horns, claws, and spikes were a bone color.

The coloring of the planes was classic camouflage smudges. I was not sure whether all the planes had it, but I added it because it made the image stronger.

Light and Shadow

The human brain realizes when illumination
is irregular and incorrect, and so to use it
risks creating confusion and tension. It is a
very specific and fairly risky resource. Be
careful when using it.

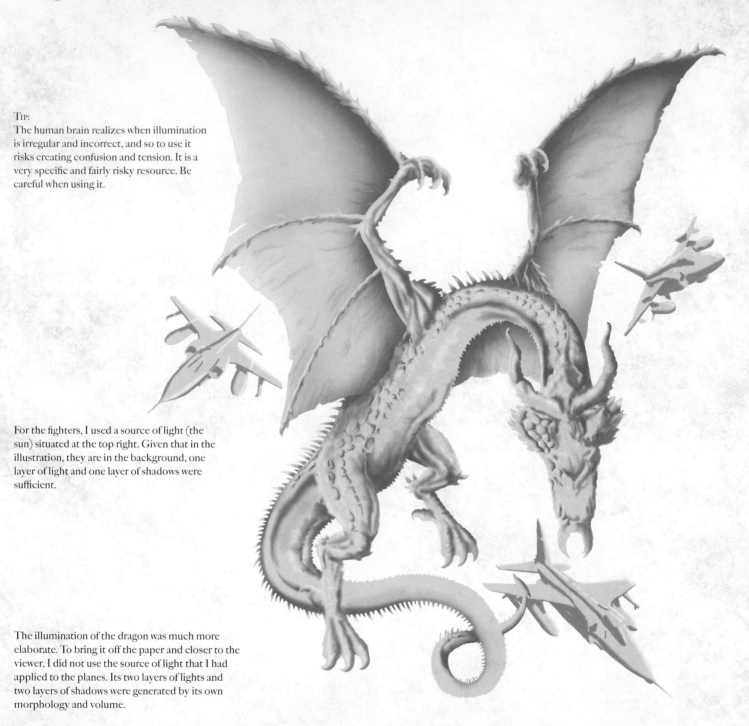

For the fighters, I used a source of light (the
sun) situated at the top right. Given that in the
illustration, they are in the background, one
layer of light and one layer of shadows were
sufficient.

The illumination of the dragon was much more
elaborate. To bring it off the paper and closer to the
viewer, I did not use the source of light that I had
applied to the planes. Its two layers of lights and
two layers of shadows were generated by its own
morphology and volume.

TIP:
When adding the telescopic sight, we
want to ensure they will be seen clearly, so
choose the color green and add a soft white
effect below.

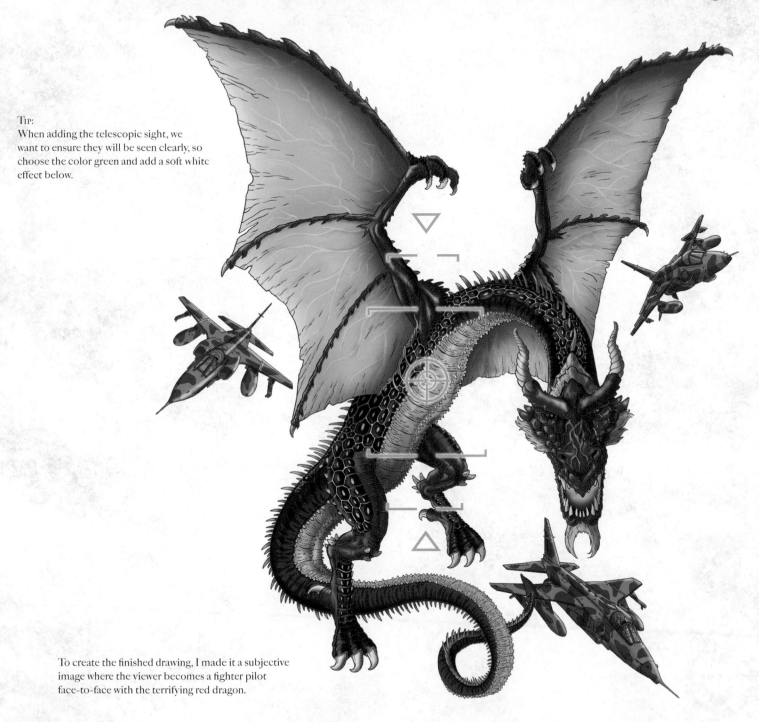

To create the finished drawing, I made it a subjective
image where the viewer becomes a fighter pilot
face-to-face with the terrifying red dragon.

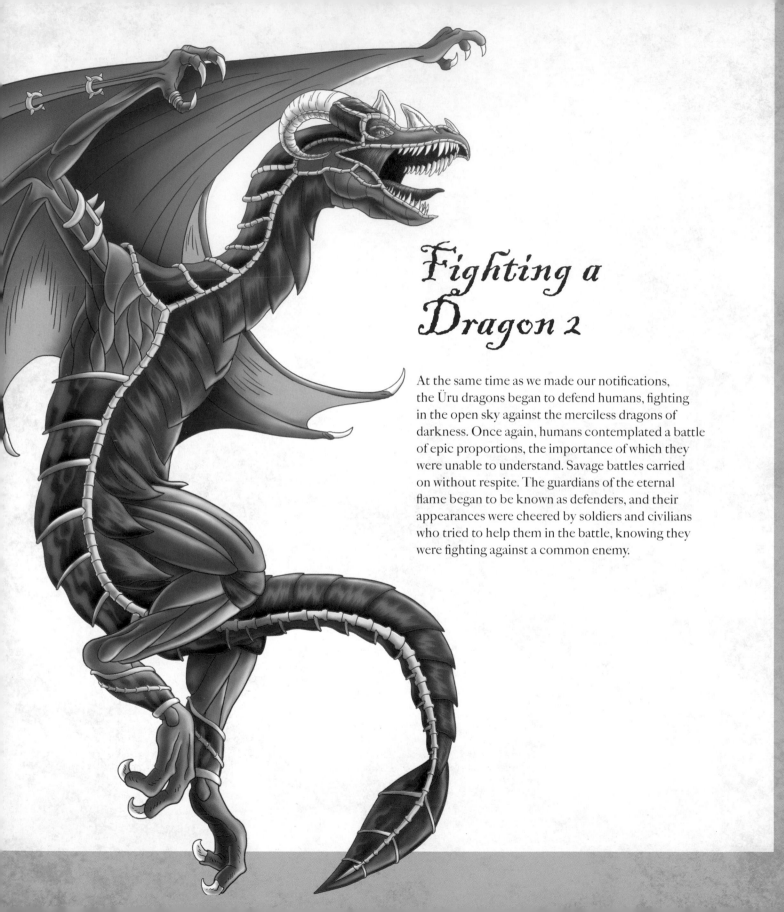

Fighting a Dragon 2

At the same time as we made our notifications, the Üru dragons began to defend humans, fighting in the open sky against the merciless dragons of darkness. Once again, humans contemplated a battle of epic proportions, the importance of which they were unable to understand. Savage battles carried on without respite. The guardians of the eternal flame began to be known as defenders, and their appearances were cheered by soldiers and civilians who tried to help them in the battle, knowing they were fighting against a common enemy.

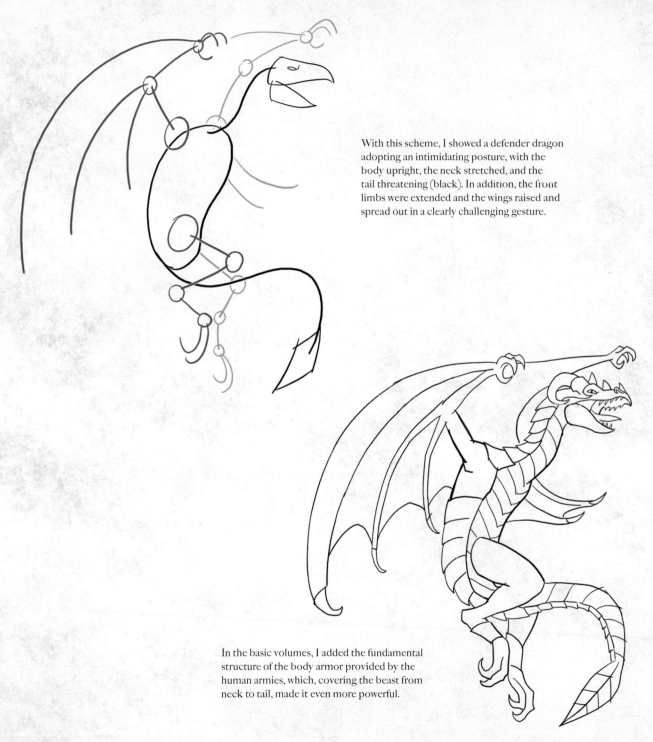

With this scheme, I showed a defender dragon adopting an intimidating posture, with the body upright, the neck stretched, and the tail threatening (black). In addition, the front limbs were extended and the wings raised and spread out in a clearly challenging gesture.

In the basic volumes, I added the fundamental structure of the body armor provided by the human armies, which, covering the beast from neck to tail, made it even more powerful.

Pencil

Tip:
We must try to give both the artificial and natural elements a functional appearance. By dividing the armor into many small sections, it gains flexibility and adaptability.

With the pencil, I detailed the exact structure of the protection plaques on the body, head, and limbs, which perfectly fit its anatomy and even covered its horns in a circular shape. I also took into account the armbands and the ringed wings and considered, using zigzag stripes, possible shading, which gave an idea about the type of material that covered the animal.

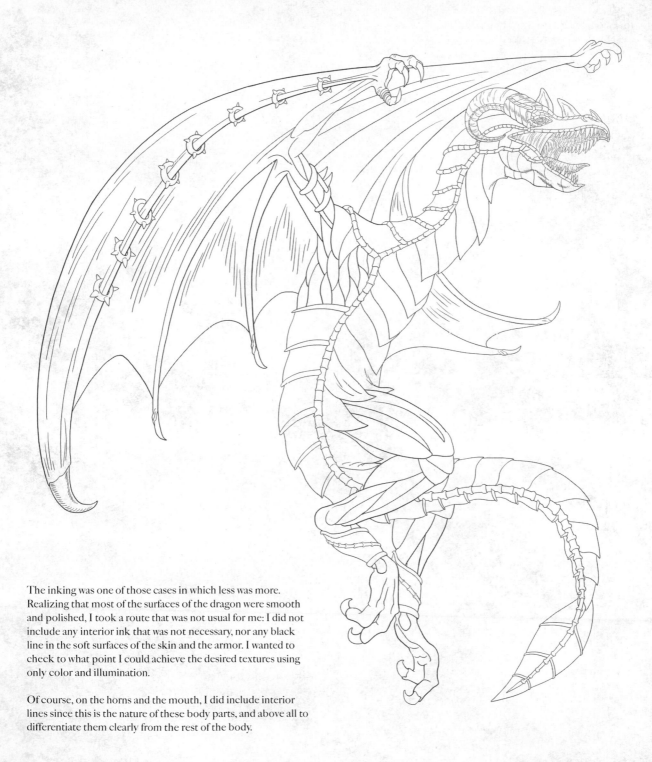

The inking was one of those cases in which less was more. Realizing that most of the surfaces of the dragon were smooth and polished, I took a route that was not usual for me: I did not include any interior ink that was not necessary, nor any black line in the soft surfaces of the skin and the armor. I wanted to check to what point I could achieve the desired textures using only color and illumination.

Of course, on the horns and the mouth, I did include interior lines since this is the nature of these body parts, and above all to differentiate them clearly from the rest of the body.

Base Color

TIP:
Black contrasts well with almost all colors. The most obvious exceptions are dark brown, dark blue, and beige.

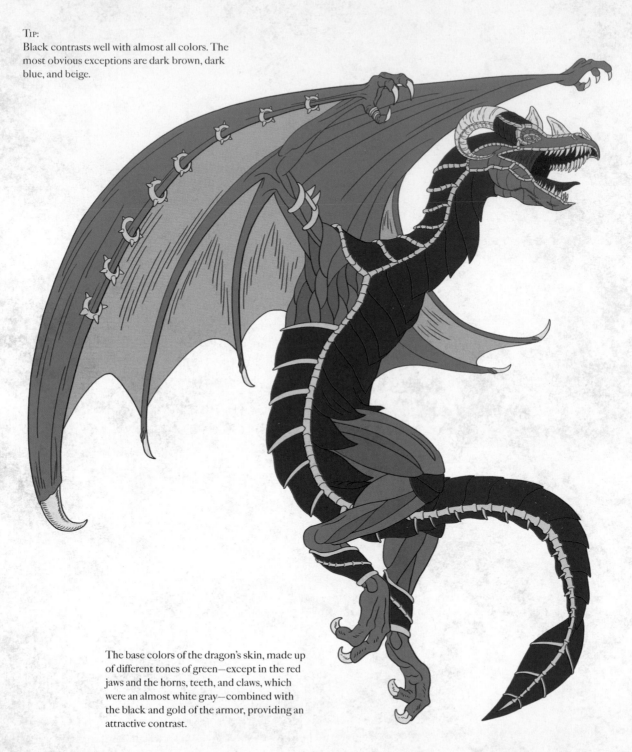

The base colors of the dragon's skin, made up of different tones of green—except in the red jaws and the horns, teeth, and claws, which were an almost white gray—combined with the black and gold of the armor, providing an attractive contrast.

TIP:
We will represent lights more clearly and more defined on metal materials. On organic materials, light becomes more softened and diffuse.

I used two different layers of lights, one for the brightness of the polished black armor and another to reflect the light that fell on the dragon from the soft source of light—in this case, the sun at dawn.

I kept the lights of the armor clear and defined, while I softened the lights that fell on the dragon.

Shadow

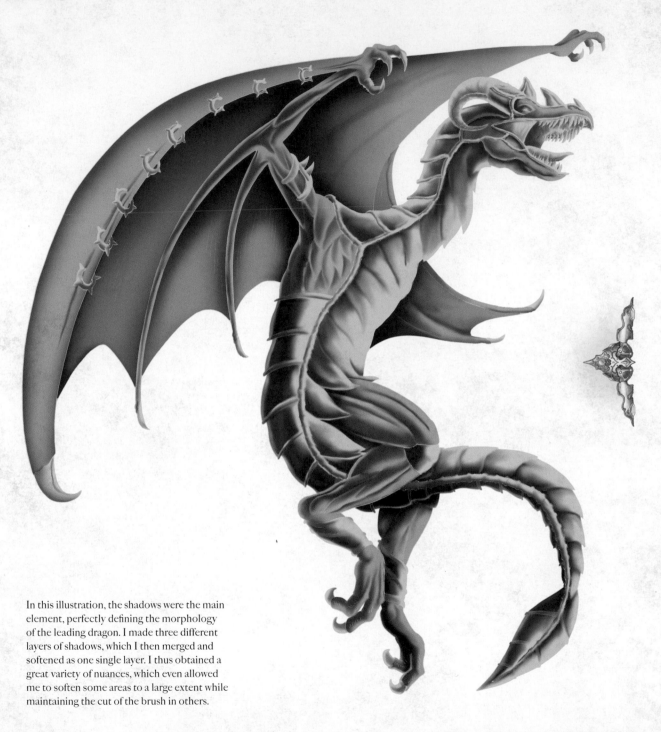

In this illustration, the shadows were the main element, perfectly defining the morphology of the leading dragon. I made three different layers of shadows, which I then merged and softened as one single layer. I thus obtained a great variety of nuances, which even allowed me to soften some areas to a large extent while maintaining the cut of the brush in others.

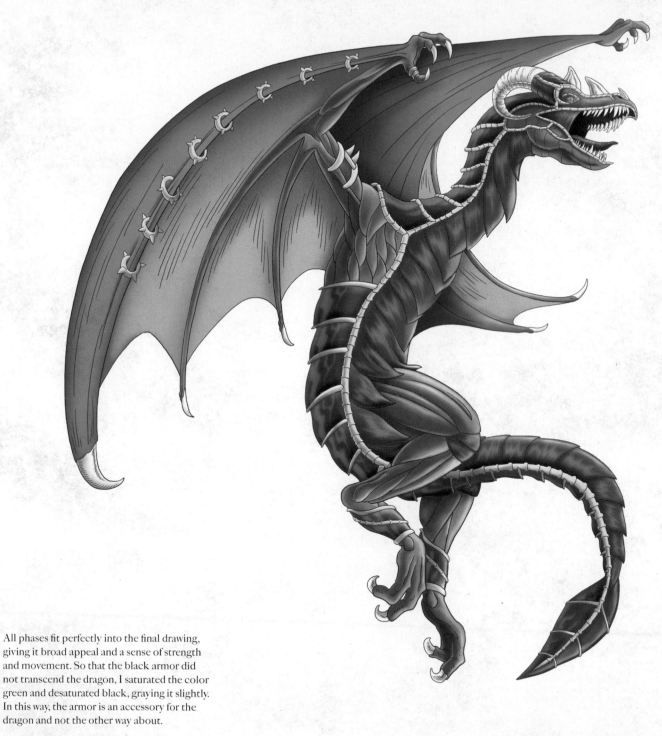

All phases fit perfectly into the final drawing, giving it broad appeal and a sense of strength and movement. So that the black armor did not transcend the dragon, I saturated the color green and desaturated black, graying it slightly. In this way, the armor is an accessory for the dragon and not the other way about.

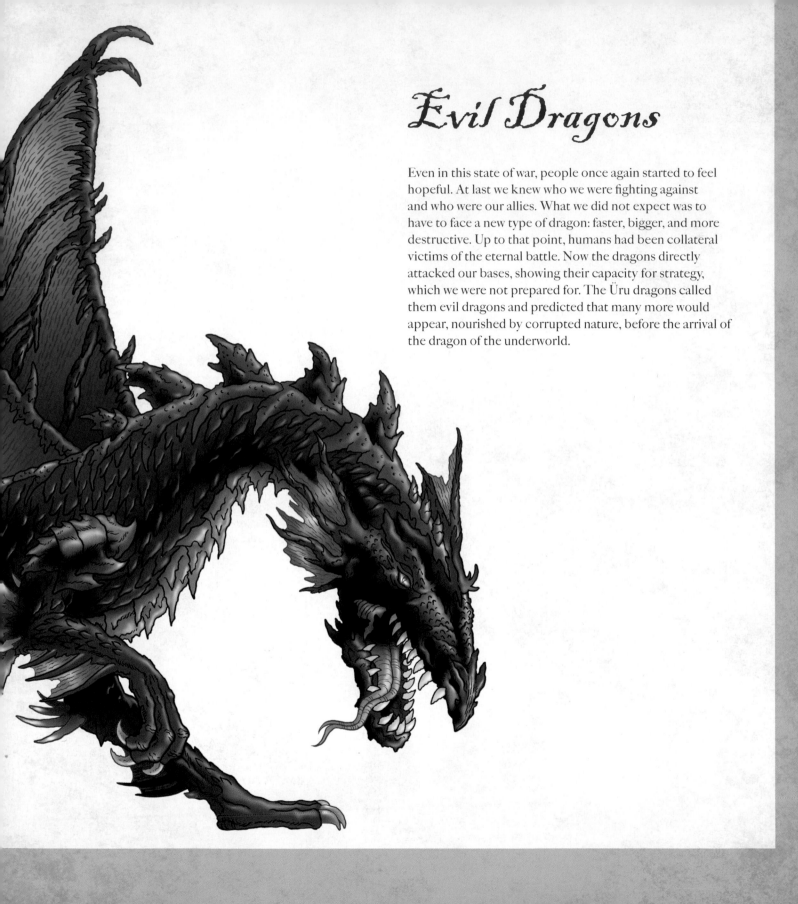

Evil Dragons

Even in this state of war, people once again started to feel hopeful. At last we knew who we were fighting against and who were our allies. What we did not expect was to have to face a new type of dragon: faster, bigger, and more destructive. Up to that point, humans had been collateral victims of the eternal battle. Now the dragons directly attacked our bases, showing their capacity for strategy, which we were not prepared for. The Üru dragons called them evil dragons and predicted that many more would appear, nourished by corrupted nature, before the arrival of the dragon of the underworld.

In the crouching posture of the scene, I wanted to reflect the weight of evil in this type of creature. The neck falls down, the body seems to come apart, and the tail remains close to the ground. The limbs (purple) are bent and the wings (green) seem to be the branches of a withered tree.

TIP:
After using our scheme of lines and balls so often, we provide a lot of information simply by playing with these basic lines a little.

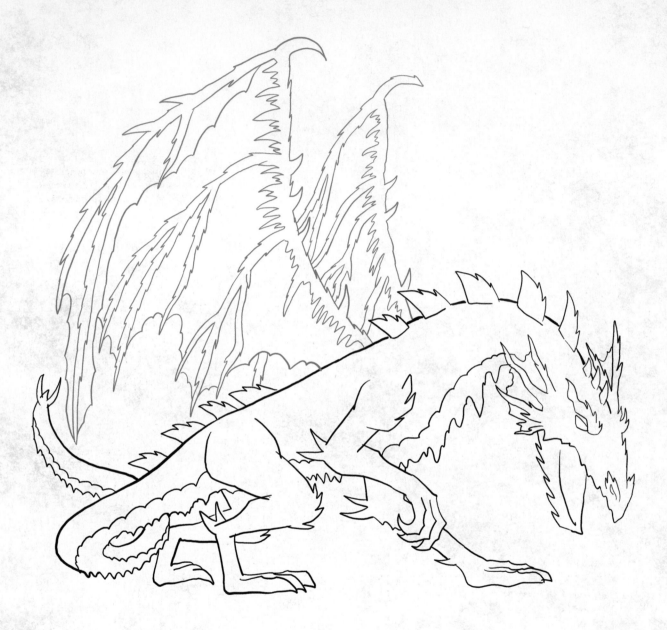

By merely adding body to the lights of the scheme, I obtained a promising result. I continued filling the figure with jagged lines that fell downward, as if the body of the evil dragon was decaying. However, I saw a clear defect in my volumes. The dragon was still not frightening. I had to harden the direction with the pencil, or I would not give the evil dragon its innate diabolic touch.

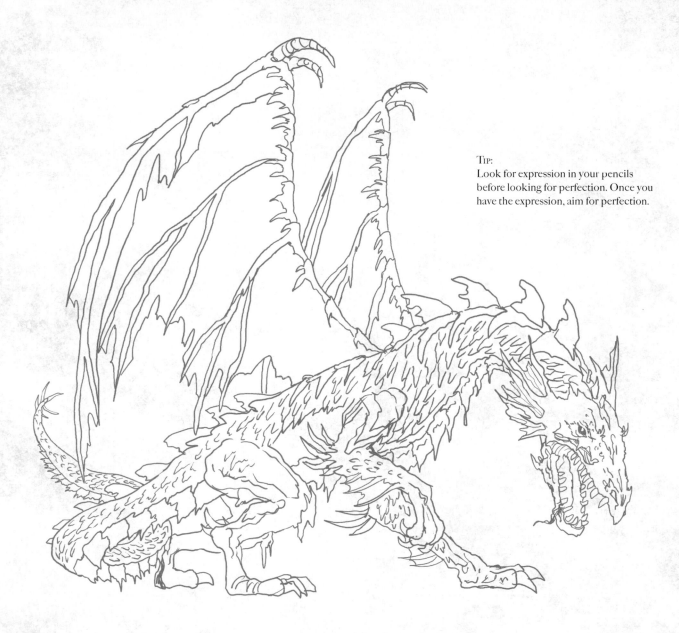

TIP:
Look for expression in your pencils before looking for perfection. Once you have the expression, aim for perfection.

Before doing the pencil, I had to reflect on the reasons why the evil dragon did not have the appearance that I wanted to give it. I reached the conclusion that I had to make the tendons of the wings, the body, and the lower limbs thinner. In addition, not only must its outlines fall, all its body should seem to be decaying, falling apart like fraying rags. The rottenness must also reach its teeth, which should be irregular and unpleasant looking. However, its dark expression must maintain all the coldhearted fury of this infernal creature.

Ink

It had become clear to me that when saturating the dragon with irregular lines, the sensation of evil increased, and so with the inks, I needed to continue saturating the evil dragon with details. I did the short lines of the interior of the wings on a separate layer in case I needed to soften them or change their color later.

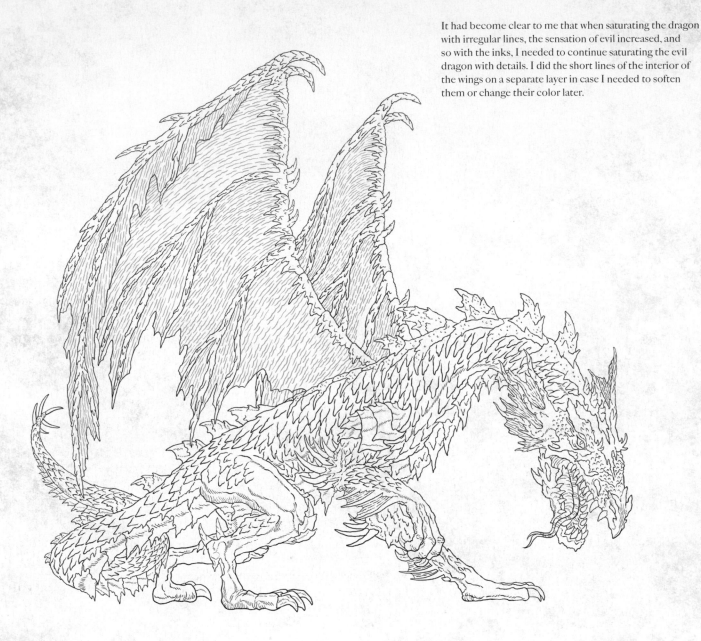

Tip:
Achieving an attractive shaky line is as complex as obtaining a constantly sharp line. Practice your different types of line, even if they do not form part of any drawing.

TIP:
As we have seen before, sometimes less is more. As we now see, sometimes bad is good.

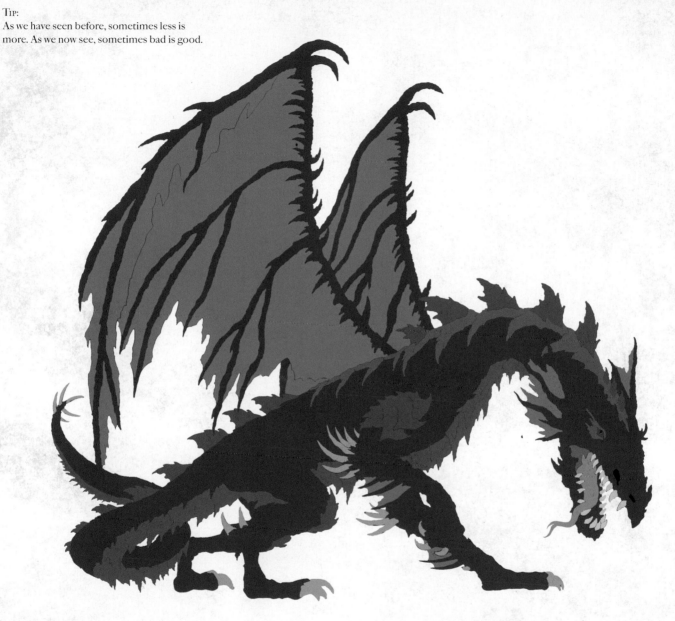

Although all the evil dragons have the same evil appearance, their colors vary greatly, and so I was unable to find a pattern—and consequently—the base colors of my evil dragon. I looked for unnatural color combinations, which would look bad together. Oddly, the worse they were, the better for the illustration, as they further increased the sensation of chaos. When a combination seemed sufficiently absurd and evil, I thought: "Now I have found it."

Light and Shadow

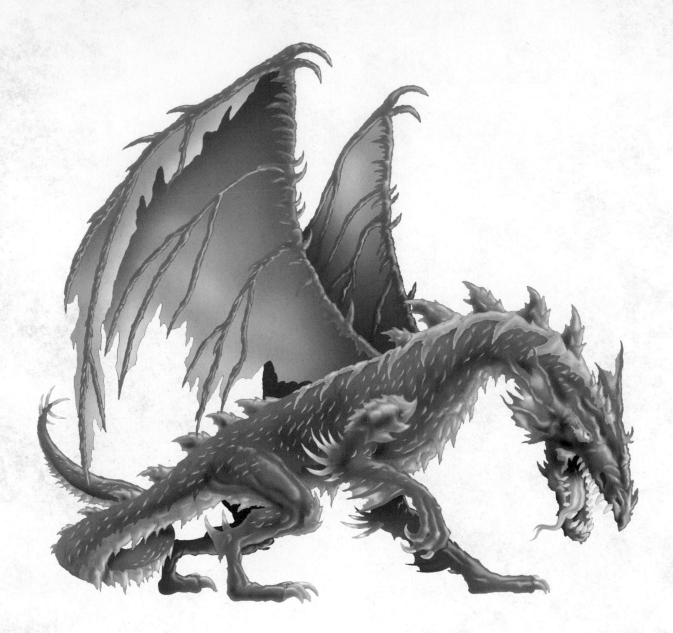

If the evil dragon were illuminated by a source of light, it would be a dark light. And if that focus came from anywhere, it would come from inside.

In attempting to follow that idea, I gave the dragon three layers of shadows of varying darkness, also aiming to use them to strengthen its three-dimensional nature. I placed the lights at the service of the shadows, strengthening each relief, each drop of its body.

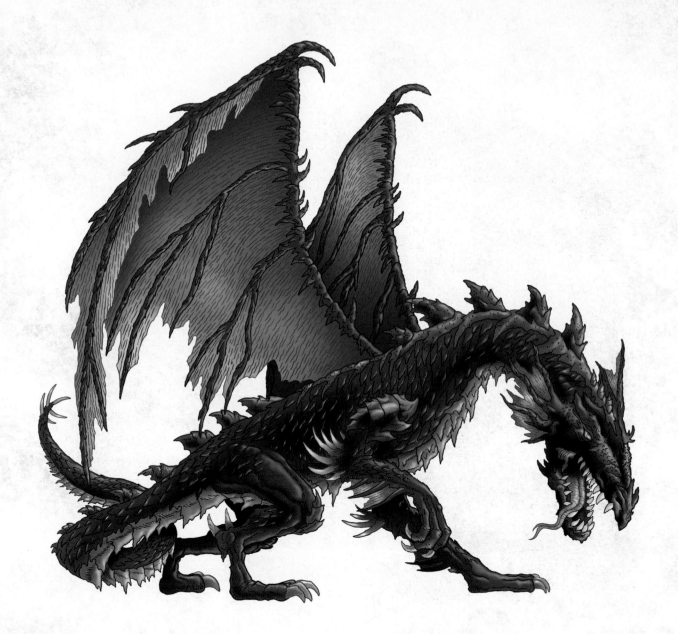

In the finished drawing, I maintained the black inks, except those I had done on a separate layer, which I colored green to integrate them more into the interior of the wing. After looking at the drawing for a while, I decided to go back and exchange the warm color of the belly for something colder.

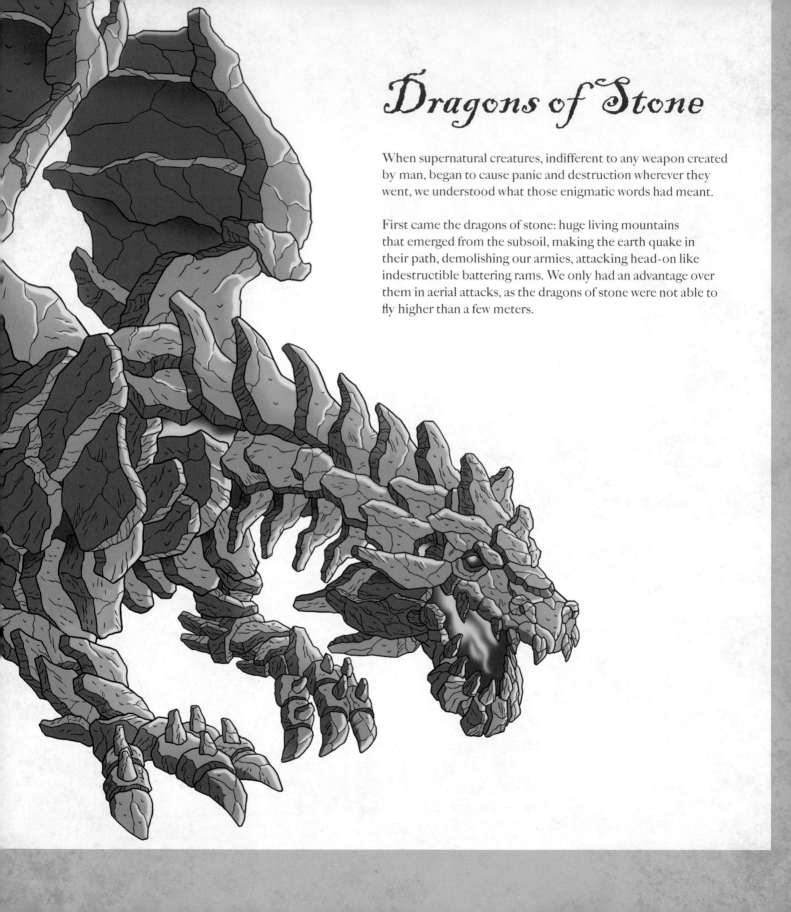

Dragons of Stone

When supernatural creatures, indifferent to any weapon created by man, began to cause panic and destruction wherever they went, we understood what those enigmatic words had meant.

First came the dragons of stone: huge living mountains that emerged from the subsoil, making the earth quake in their path, demolishing our armies, attacking head-on like indestructible battering rams. We only had an advantage over them in aerial attacks, as the dragons of stone were not able to fly higher than a few meters.

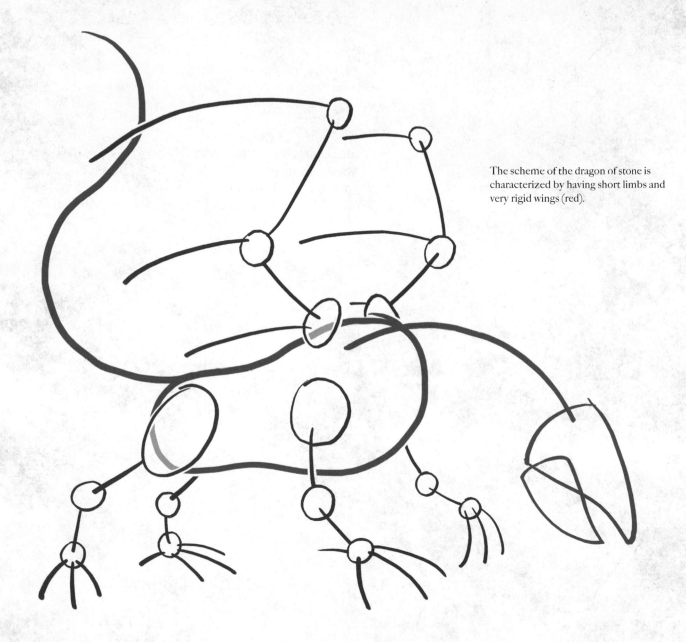

The scheme of the dragon of stone is characterized by having short limbs and very rigid wings (red).

TIP:
Robust characters tend to have short limbs and ungainly characters tend to have long limbs.

Volume

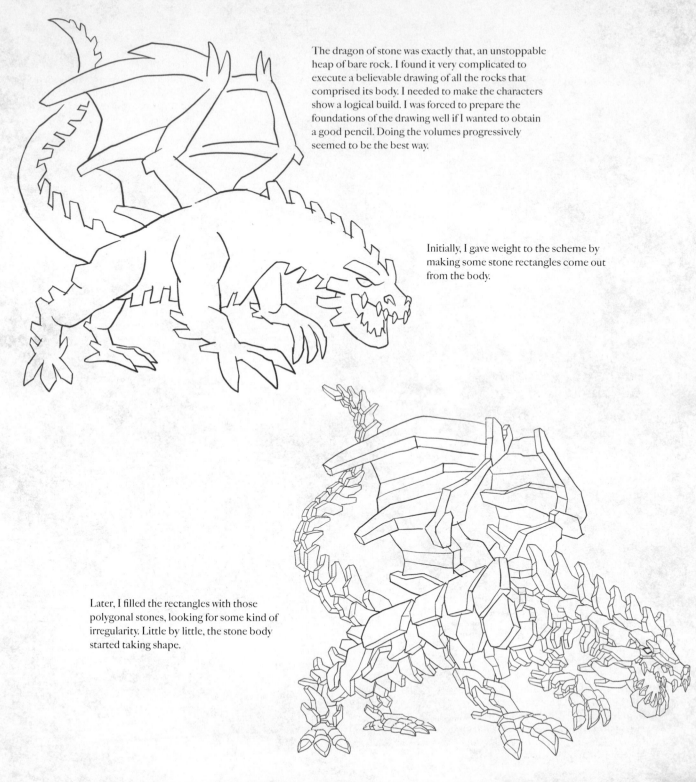

The dragon of stone was exactly that, an unstoppable heap of bare rock. I found it very complicated to execute a believable drawing of all the rocks that comprised its body. I needed to make the characters show a logical build. I was forced to prepare the foundations of the drawing well if I wanted to obtain a good pencil. Doing the volumes progressively seemed to be the best way.

Initially, I gave weight to the scheme by making some stone rectangles come out from the body.

Later, I filled the rectangles with those polygonal stones, looking for some kind of irregularity. Little by little, the stone body started taking shape.

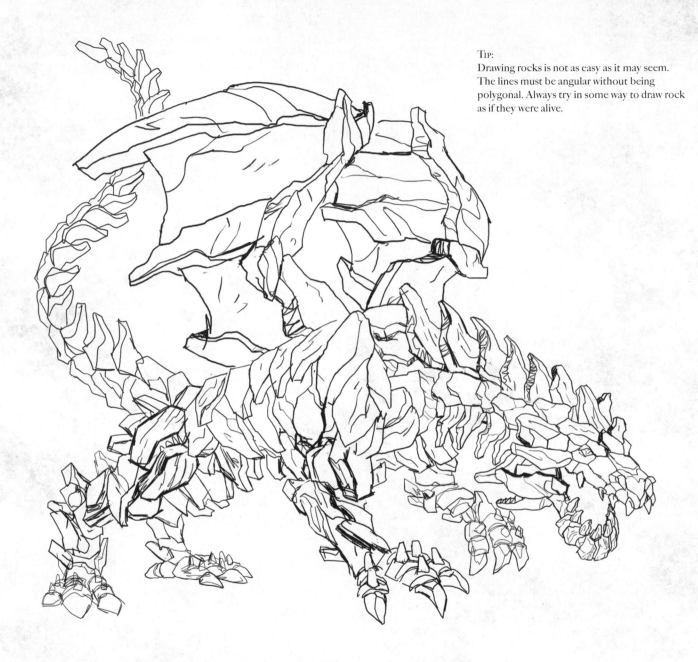

TIP:
Drawing rocks is not as easy as it may seem. The lines must be angular without being polygonal. Always try in some way to draw rock as if they were alive.

Based on my clean, polygonal volumes, I began the pencil, aiming to give the stone a wilder appearance, like bare rock. I needed to make it seem dirtier. I traced the pencil energetically, marking some shadows where I believed them appropriate, sometimes checking how the cracks would look, and so on. I did the drawing while I was studying my possible options for the inking.

Ink

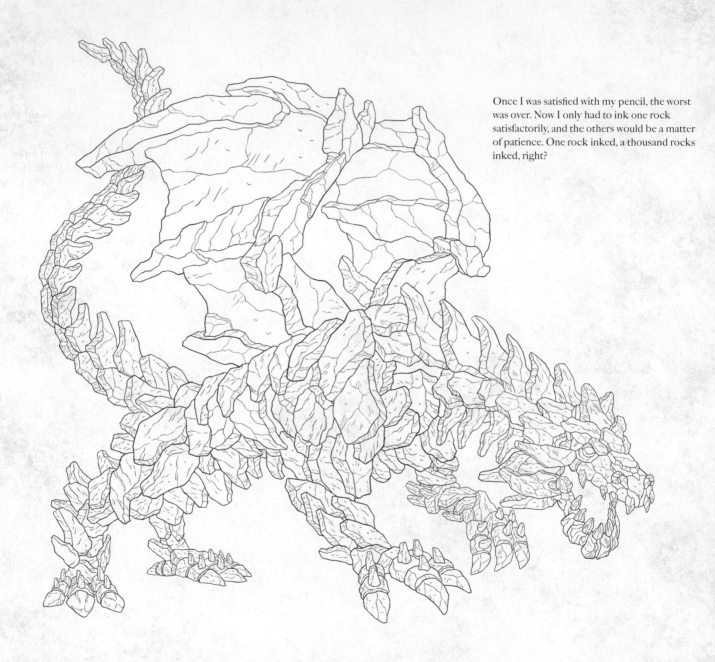

Once I was satisfied with my pencil, the worst was over. Now I only had to ink one rock satisfactorily, and the others would be a matter of patience. One rock inked, a thousand rocks inked, right?

TIP:
This is one of the clearest cases that demonstrate why it is a good idea to first do the external thicker inks of all the rocks and later the cracks and small details of all the rocks with a finer brush.

The base color of the dragon of stone was brown, reminding us slightly of clay or mud. At first I colored the whole drawing with the same brown, but I later thought that it would help the three-dimensional nature of the character if one of the sides of the stone was covered with a darker brown. However, it was Amppar, a fellow illustrator, who was looking at my work at the time, and she reminded me that I should give the interior of the dragon of stone a base of color that would allow me to develop the supernatural fire that moved the creature. The color chosen for that was red.

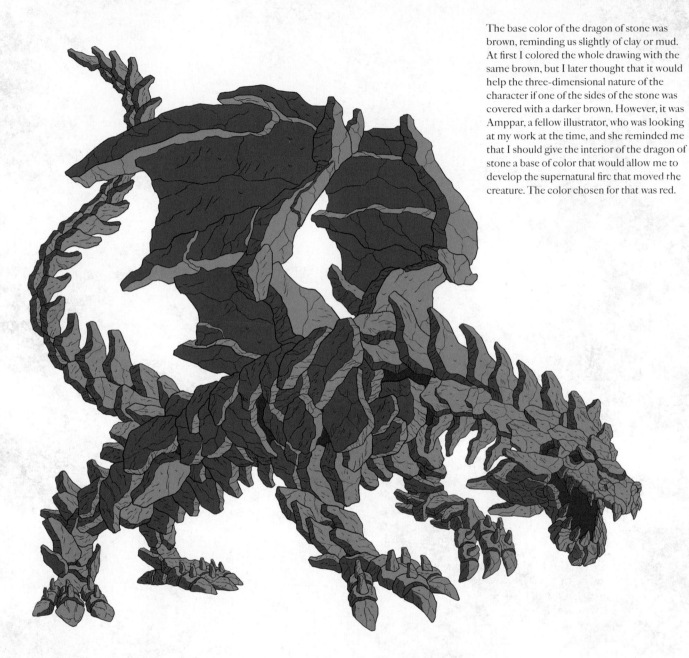

TIP:
Although we divide each illustration into several successive steps to make the process more understandable, in reality these steps overlap and affect each other. You should think of every drawing as a succession of steps and also as one single entity—both at the same time.

Light and Shadow

I started to do the light and shadow and the camp's alarm went off. A new creature had obviously appeared and teams needed to be formed immediately. The fieldwork was increasingly demanding, but I still had to submit my reports and illustrations. My work was piling up, and I had to do a basic job—that is, I did the minimum lights and shadows necessary for them to contribute something to the drawing. This is a situation that every illustrator reaches at some point.

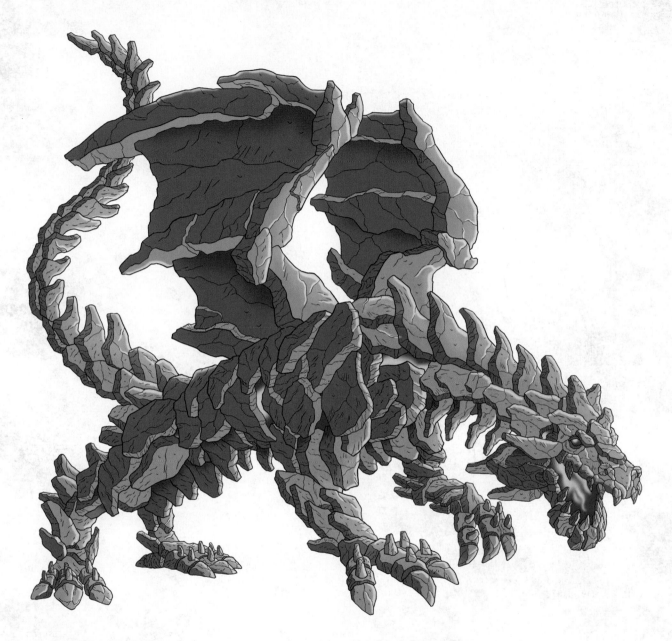

The final rendering of the dragon of stone was good. Despite being composed of rocks, the creature did not seem to be a statue, but quite the contrary: it was clearly full of life.

Adding some brushstrokes of yellow to the red base to represent the fire that burns inside the dragons of stone was the final detail. I now had the finished drawing, but I did not know that this small test with fire was a glimpse of what was to come next.

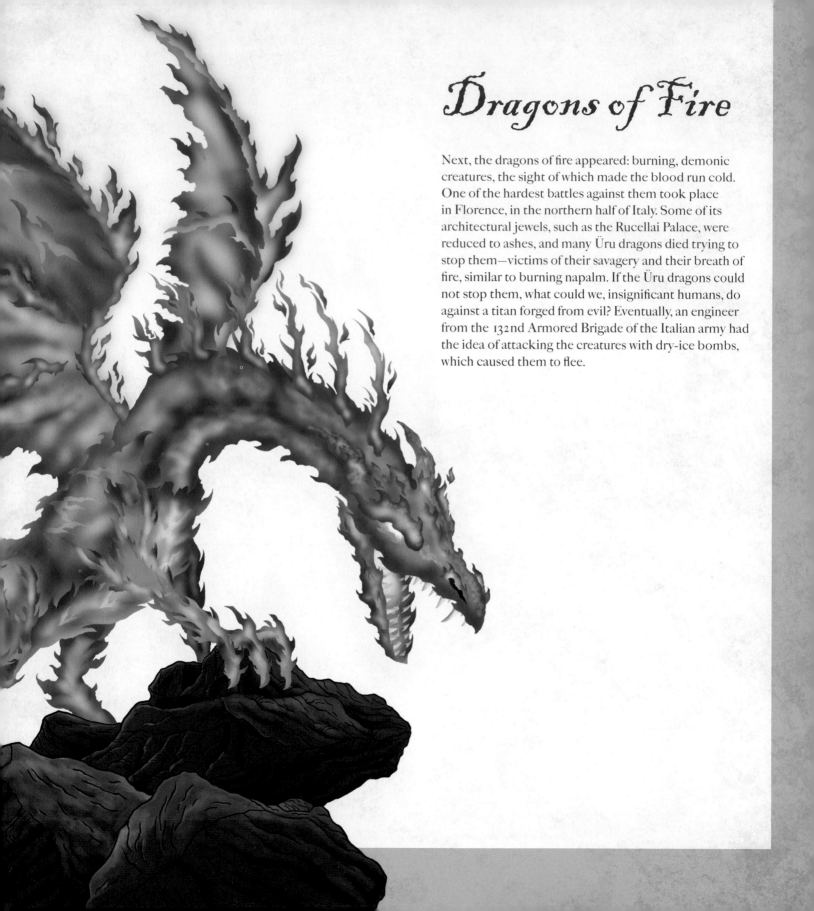

Dragons of Fire

Next, the dragons of fire appeared: burning, demonic creatures, the sight of which made the blood run cold. One of the hardest battles against them took place in Florence, in the northern half of Italy. Some of its architectural jewels, such as the Rucellai Palace, were reduced to ashes, and many Üru dragons died trying to stop them—victims of their savagery and their breath of fire, similar to burning napalm. If the Üru dragons could not stop them, what could we, insignificant humans, do against a titan forged from evil? Eventually, an engineer from the 132nd Armored Brigade of the Italian army had the idea of attacking the creatures with dry-ice bombs, which caused them to flee.

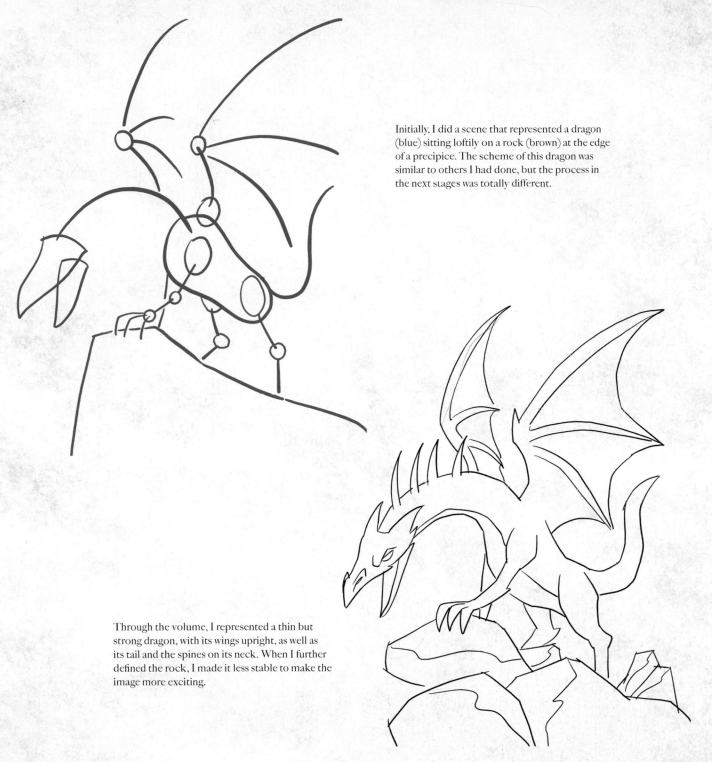

Initially, I did a scene that represented a dragon (blue) sitting loftily on a rock (brown) at the edge of a precipice. The scheme of this dragon was similar to others I had done, but the process in the next stages was totally different.

Through the volume, I represented a thin but strong dragon, with its wings upright, as well as its tail and the spines on its neck. When I further defined the rock, I made it less stable to make the image more exciting.

Pencil and Ink

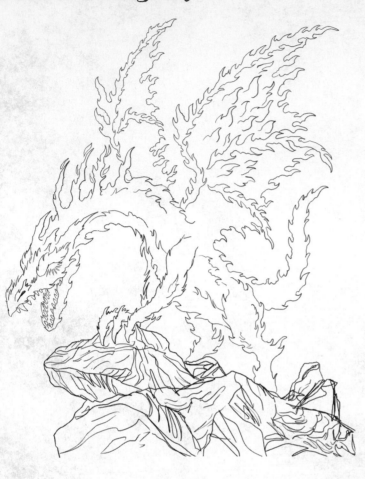

The pencil of a dragon with its whole body in flames arose from the volumes. In the first pencils, the different flames that made up the dragon's body were either too small or too big. In this pencil, you can see I felt I had found the correct size of flame. I then went on to develop the pencil of the rocks using wide, curved lines that show each one of their multiple sides.

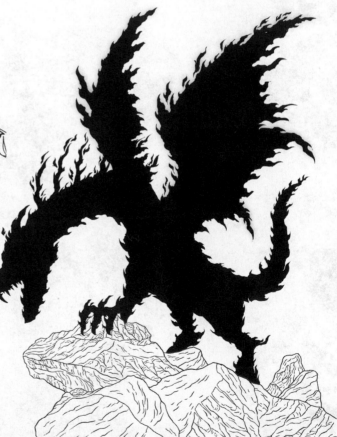

I did the ink of the rocks and the dragon separately, since the rocks were going to be colored in a more classical manner and the dragon in a manner very different from that already seen in this work. The elements I was going to convert into flames (in this case, it would be a whole dragon) are inked as a black smudge without profiles, or as I did in this case, into black smudges in different layers so as to make the coloring easier.

TIP:
From the inking stage, you must start to separate those elements that are going to be treated with different methods like coloring, illumination, etc.

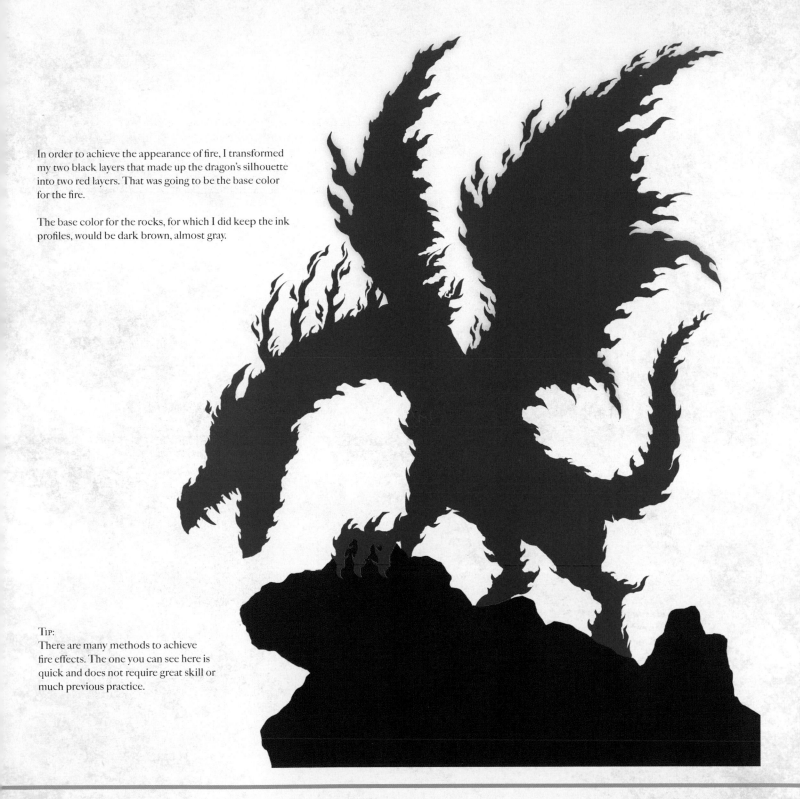

In order to achieve the appearance of fire, I transformed my two black layers that made up the dragon's silhouette into two red layers. That was going to be the base color for the fire.

The base color for the rocks, for which I did keep the ink profiles, would be dark brown, almost gray.

TIP:
There are many methods to achieve fire effects. The one you can see here is quick and does not require great skill or much previous practice.

Light and Shadow

Given that the dragon of fire emits its own light, I only gave shadows to the rocks using two layers with which I defined their volumes. I did not consider any external source of light other than the dragon.

Tip:
We can consider another source of light if we decide to draw the surroundings, but bearing in mind that the dragon of fire is the only element in the illustration, any other source of light would only cause confusion.

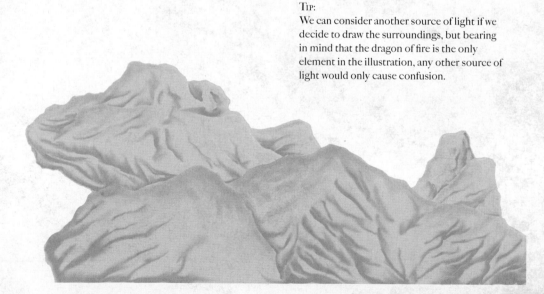

TIP:
All digital drawing programs allow you to
adjust the intensity of the overexposure tool.
Do several tests to adjust it to your taste.

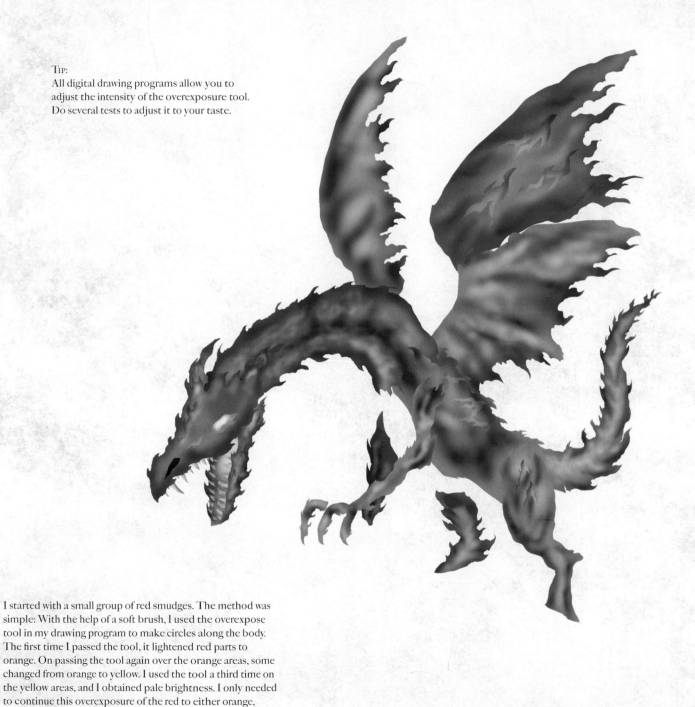

I started with a small group of red smudges. The method was
simple: With the help of a soft brush, I used the overexpose
tool in my drawing program to make circles along the body.
The first time I passed the tool, it lightened red parts to
orange. On passing the tool again over the orange areas, some
changed from orange to yellow. I used the tool a third time on
the yellow areas, and I obtained pale brightness. I only needed
to continue this overexposure of the red to either orange,
yellow, or white in all the places I wanted the effect.

Special Effects 2

TIP:
We can separate the red smudges into as many layers
as we like, depending on how detailed we want the
image. We can also experiment with overexposing
from other colors such as violet or green to achieve
magical fires and other interesting effects.

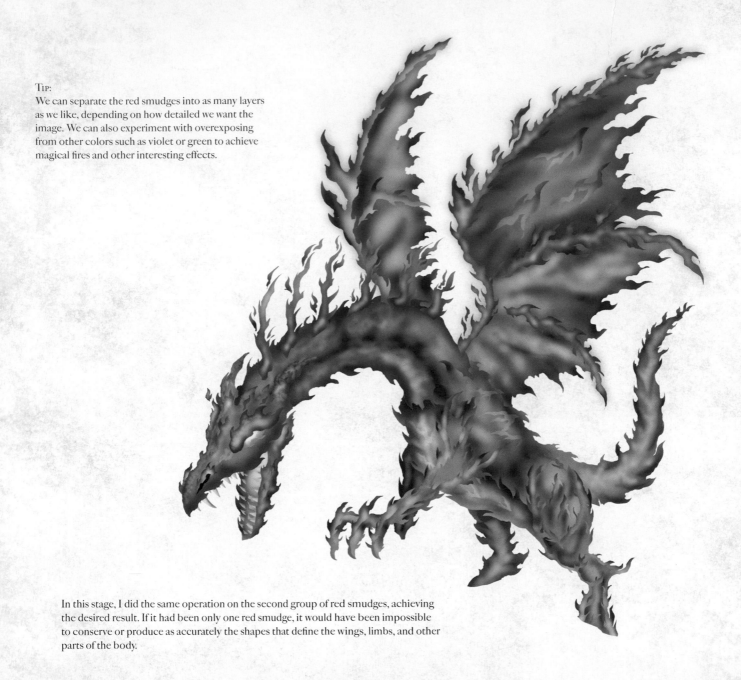

In this stage, I did the same operation on the second group of red smudges, achieving
the desired result. If it had been only one red smudge, it would have been impossible
to conserve or produce as accurately the shapes that define the wings, limbs, and other
parts of the body.

TIP:
If we don't have inks and profiles, we will always obtain a less solid effect, but in the case
of the fire, the image becomes stronger and more realistic.

Finally, after combining all the layers, the dragon of fire rose on the solid rock. I only added two more details: a flaming aura around the dragon and red lights at the top of the rocks illuminated by the dragon. At last I could say that I had my finished drawing.

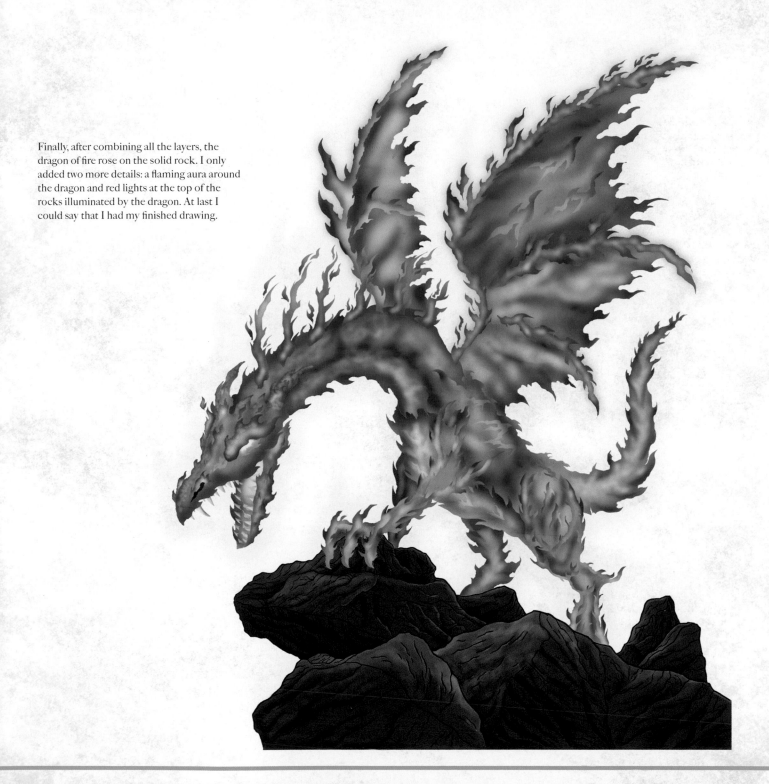

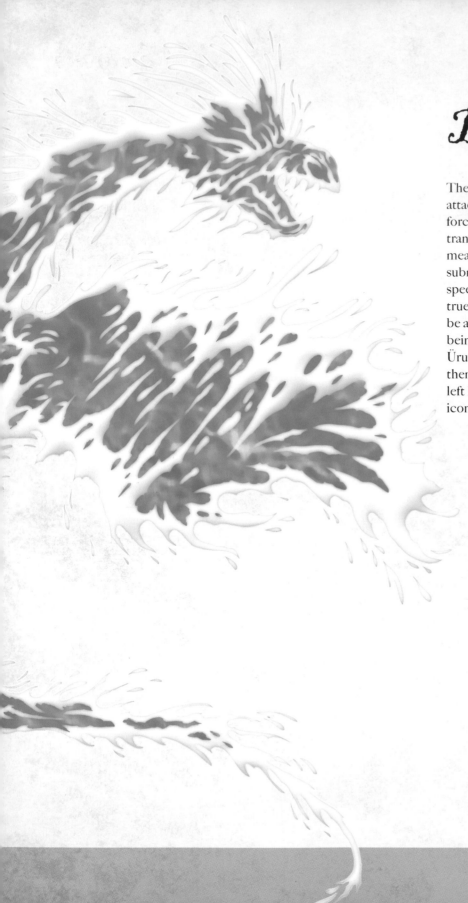

Dragons of Water

The dragons of water arrived last, and they attacked coastal areas, as well as ships, which were forced out to sea, making communications and transport impossible. Fighting them with human means was incredibly difficult, as they could submerge to great depths and travel at incredible speeds. In fact, nobody knew whether they were true dragons, with a physical form that could be attacked, or whether they were supernatural beings made of water. Despite the efforts of the Üru dragons to defend the coastal cities against them, one attack of a dragon of water in Sydney left hundreds of people injured and destroyed the iconic Sydney Opera House.

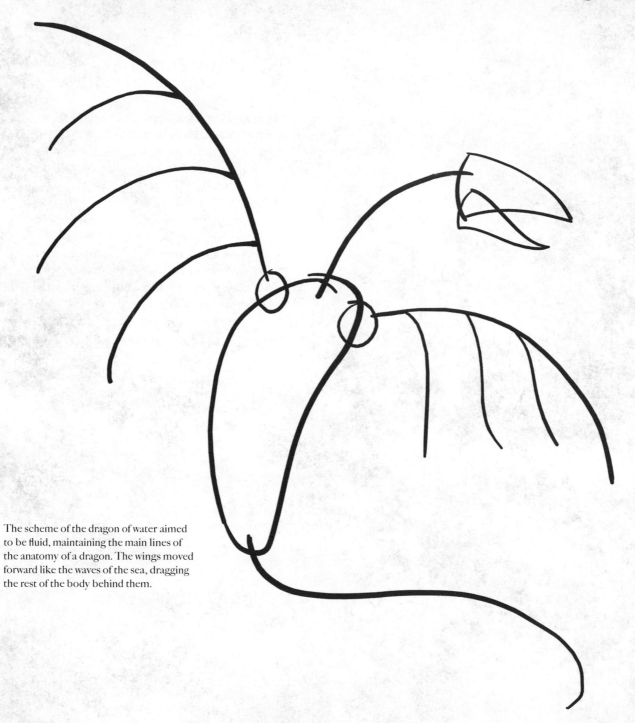

The scheme of the dragon of water aimed
to be fluid, maintaining the main lines of
the anatomy of a dragon. The wings moved
forward like the waves of the sea, dragging
the rest of the body behind them.

Volume

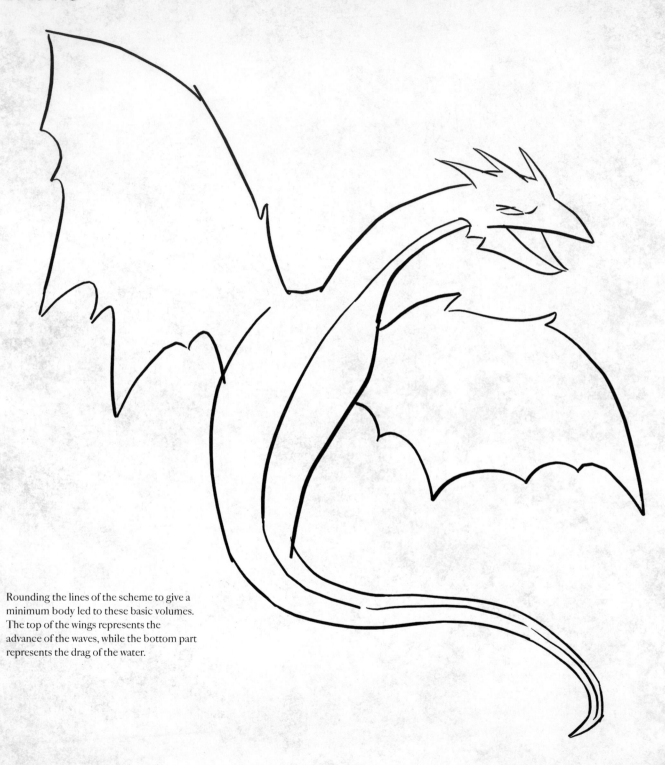

Rounding the lines of the scheme to give a
minimum body led to these basic volumes.
The top of the wings represents the
advance of the waves, while the bottom part
represents the drag of the water.

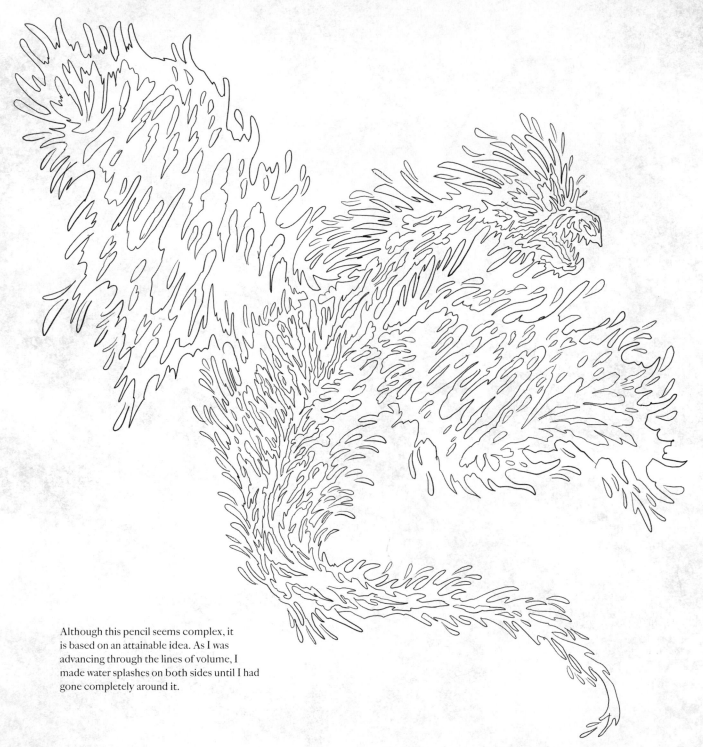

Although this pencil seems complex, it is based on an attainable idea. As I was advancing through the lines of volume, I made water splashes on both sides until I had gone completely around it.

Special Effects

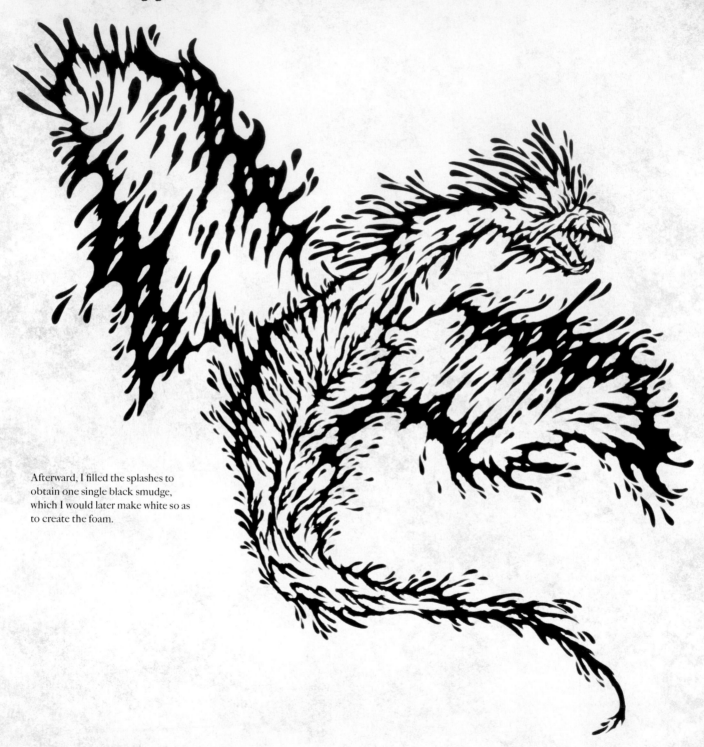

Afterward, I filled the splashes to obtain one single black smudge, which I would later make white so as to create the foam.

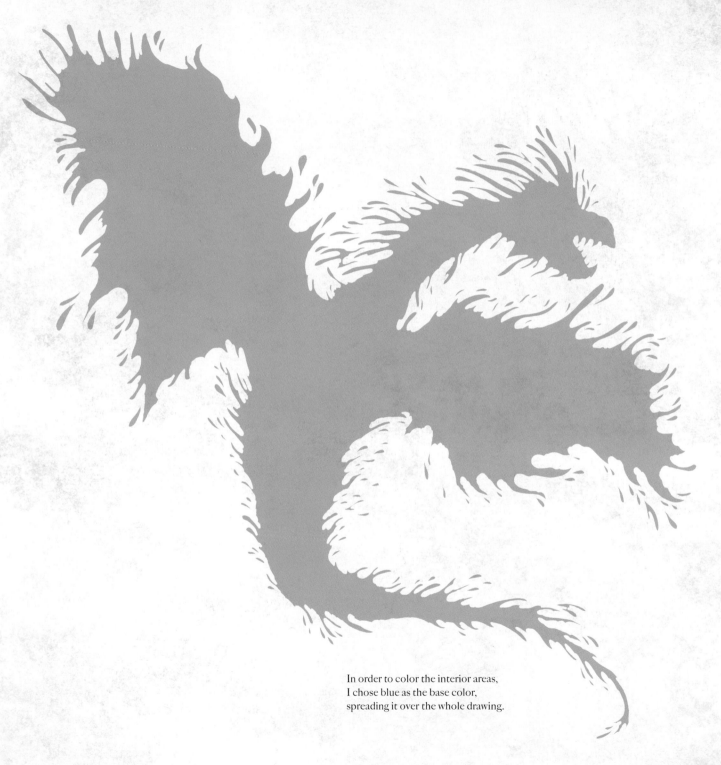

In order to color the interior areas,
I chose blue as the base color,
spreading it over the whole drawing.

Base Color 2

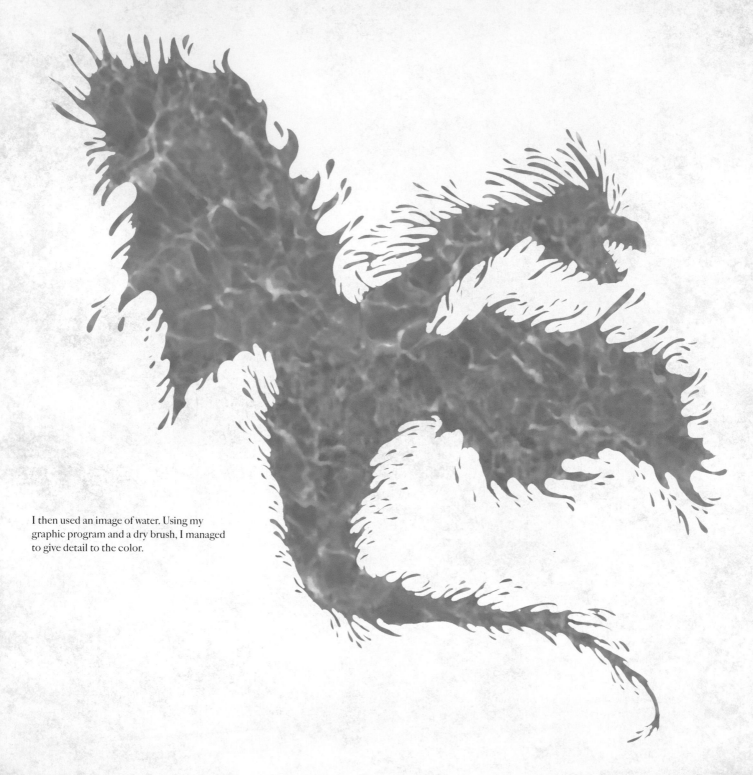

I then used an image of water. Using my graphic program and a dry brush, I managed to give detail to the color.

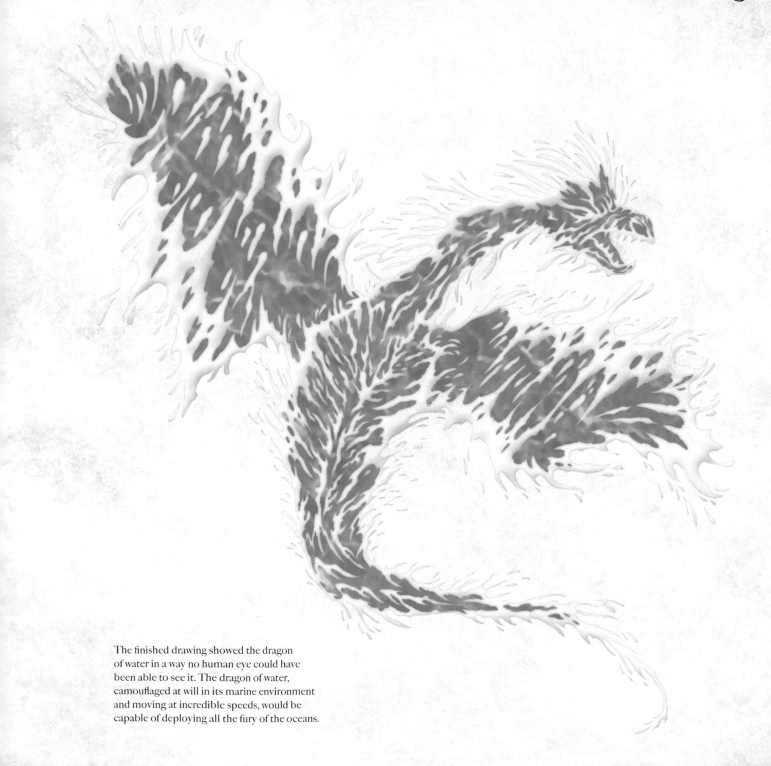

The finished drawing showed the dragon
of water in a way no human eye could have
been able to see it. The dragon of water,
camouflaged at will in its marine environment
and moving at incredible speeds, would be
capable of deploying all the fury of the oceans.

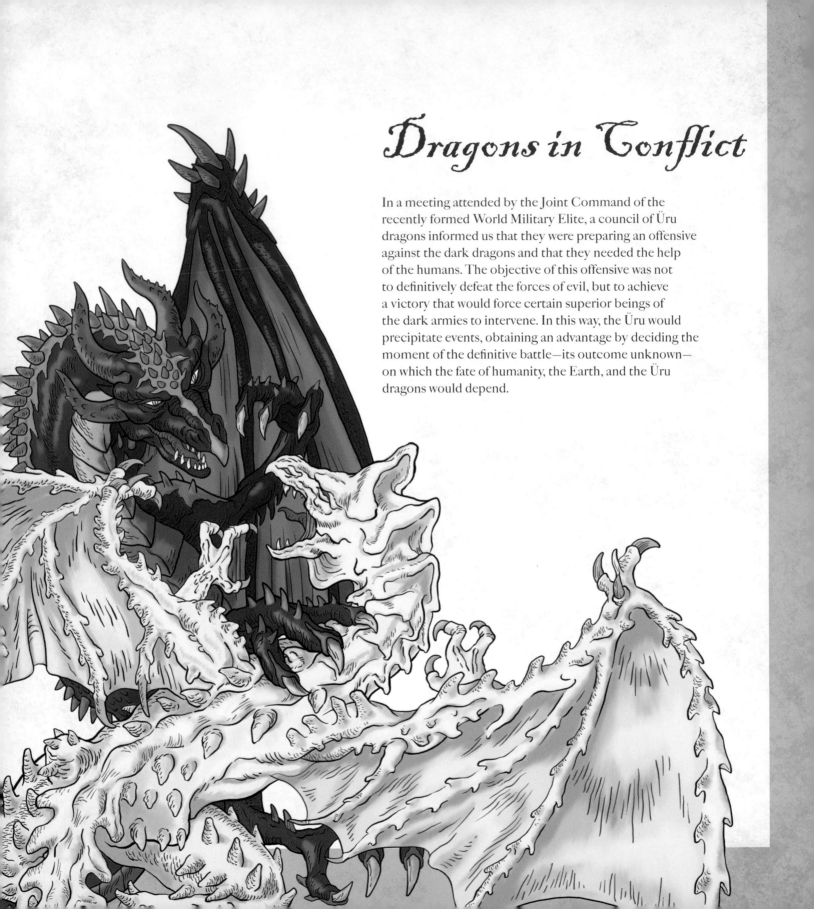

Dragons in Conflict

In a meeting attended by the Joint Command of the recently formed World Military Elite, a council of Üru dragons informed us that they were preparing an offensive against the dark dragons and that they needed the help of the humans. The objective of this offensive was not to definitively defeat the forces of evil, but to achieve a victory that would force certain superior beings of the dark armies to intervene. In this way, the Üru would precipitate events, obtaining an advantage by deciding the moment of the definitive battle—its outcome unknown— on which the fate of humanity, the Earth, and the Üru dragons would depend.

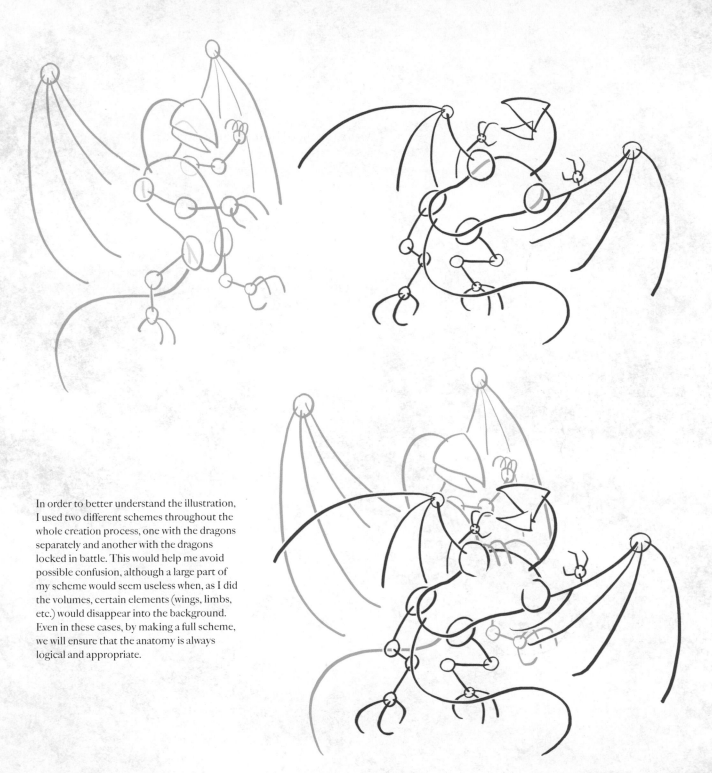

In order to better understand the illustration, I used two different schemes throughout the whole creation process, one with the dragons separately and another with the dragons locked in battle. This would help me avoid possible confusion, although a large part of my scheme would seem useless when, as I did the volumes, certain elements (wings, limbs, etc.) would disappear into the background. Even in these cases, by making a full scheme, we will ensure that the anatomy is always logical and appropriate.

Volume

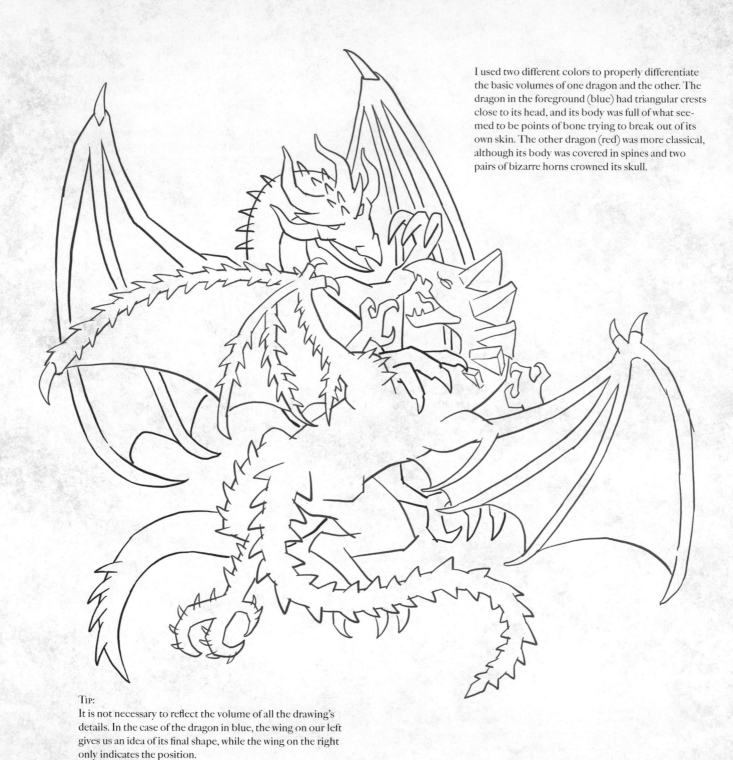

I used two different colors to properly differentiate the basic volumes of one dragon and the other. The dragon in the foreground (blue) had triangular crests close to its head, and its body was full of what seemed to be points of bone trying to break out of its own skin. The other dragon (red) was more classical, although its body was covered in spines and two pairs of bizarre horns crowned its skull.

Tip:
It is not necessary to reflect the volume of all the drawing's details. In the case of the dragon in blue, the wing on our left gives us an idea of its final shape, while the wing on the right only indicates the position.

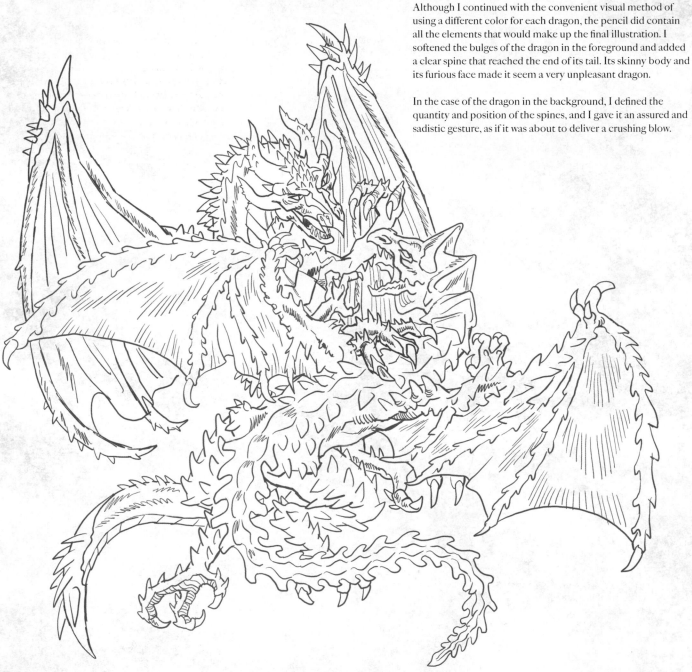

Although I continued with the convenient visual method of using a different color for each dragon, the pencil did contain all the elements that would make up the final illustration. I softened the bulges of the dragon in the foreground and added a clear spine that reached the end of its tail. Its skinny body and its furious face made it seem a very unpleasant dragon.

In the case of the dragon in the background, I defined the quantity and position of the spines, and I gave it an assured and sadistic gesture, as if it was about to deliver a crushing blow.

TIP:
If we are very clear about the inking, it is not absolutely necessary to bear in mind the thickness of the lines when doing the pencil. We can even do it with different tools and materials.

Ink

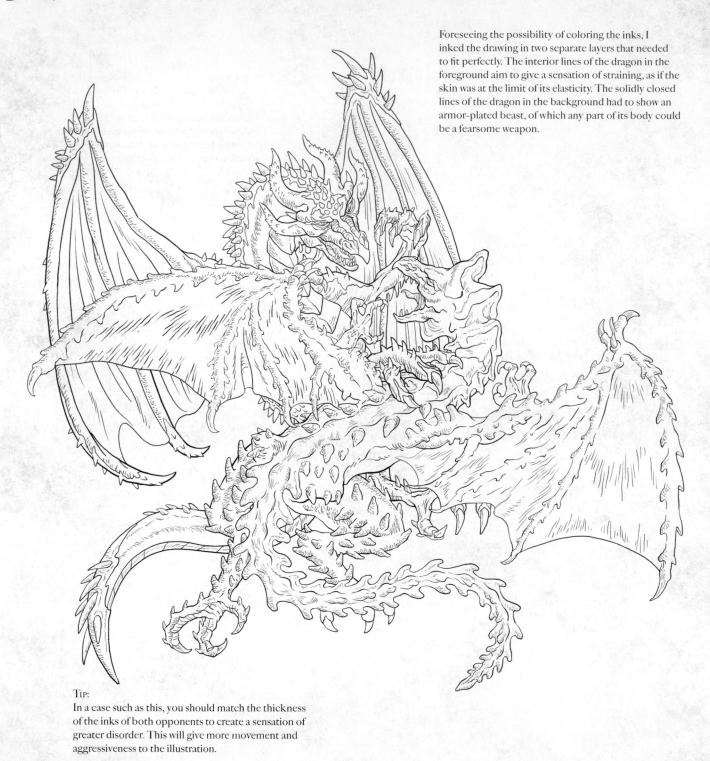

Foreseeing the possibility of coloring the inks, I inked the drawing in two separate layers that needed to fit perfectly. The interior lines of the dragon in the foreground aim to give a sensation of straining, as if the skin was at the limit of its elasticity. The solidly closed lines of the dragon in the background had to show an armor-plated beast, of which any part of its body could be a fearsome weapon.

TIP:
In a case such as this, you should match the thickness of the inks of both opponents to create a sensation of greater disorder. This will give more movement and aggressiveness to the illustration.

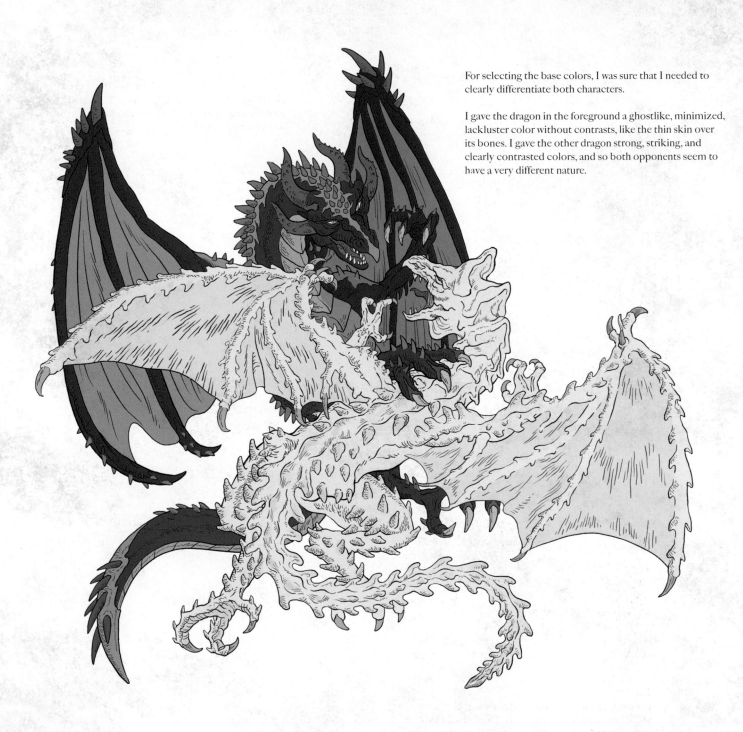

Base Color

For selecting the base colors, I was sure that I needed to clearly differentiate both characters.

I gave the dragon in the foreground a ghostlike, minimized, lackluster color without contrasts, like the thin skin over its bones. I gave the other dragon strong, striking, and clearly contrasted colors, and so both opponents seem to have a very different nature.

Light and Shadow

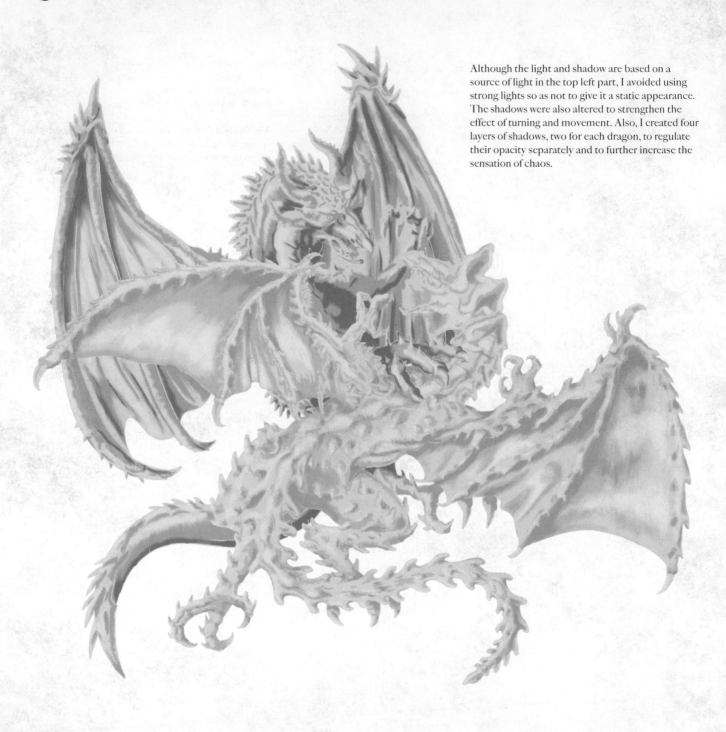

Although the light and shadow are based on a source of light in the top left part, I avoided using strong lights so as not to give it a static appearance. The shadows were also altered to strengthen the effect of turning and movement. Also, I created four layers of shadows, two for each dragon, to regulate their opacity separately and to further increase the sensation of chaos.

Finished Drawing

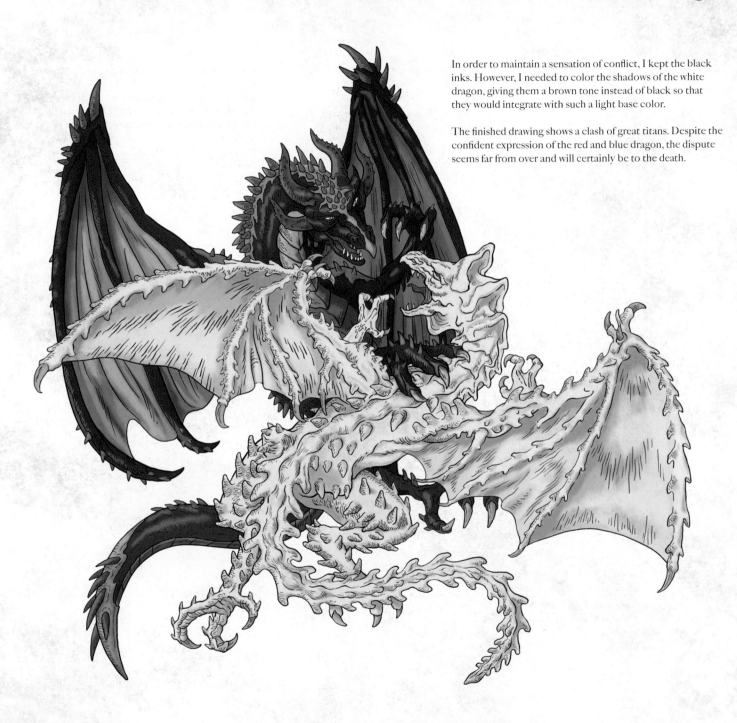

In order to maintain a sensation of conflict, I kept the black inks. However, I needed to color the shadows of the white dragon, giving them a brown tone instead of black so that they would integrate with such a light base color.

The finished drawing shows a clash of great titans. Despite the confident expression of the red and blue dragon, the dispute seems far from over and will certainly be to the death.

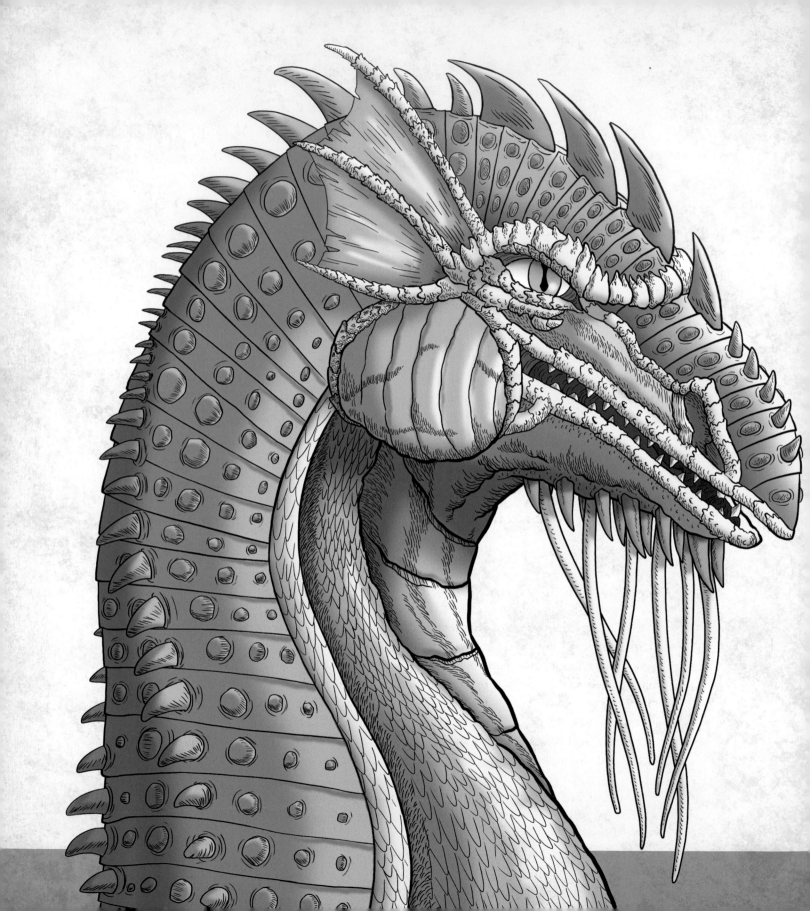

The Realm of the Dragons

Wyverns

Draconians (Dragon Men)

Dragon Triad

The Dragon King

The Dragon Alliance

The Magic Dragon

The Dragon of the Underworld

Spiritual Dragons

Wise Dragons

The Origin of the Dragons

The Golden Dragon

The Dragon God

In the battle between Üru and the evil dragons, humans were becoming increasingly displaced, and on many occasions, our role was reduced to becoming collateral damage. However, I was not prepared to stand on the sidelines of a battle that would decide our fate. We had to attack the root of the problem, and I knew how to do it. I brought together a group of experts and presented my idea. If, as seemed to be the case, there was planning behind the attacks by the dark forces, there must exist somebody or something that leads them. Positioning on a map all the known incidents with dark dragons, I triangulated an area in the Sea of Azov that seemed like it might be the starting point of many of the beasts. This is where we had to go. Although many of the people at the meeting felt that my idea was logical, some of them called it a mere conjecture and refused to reduce their defense forces to search for an enclave they were not sure even existed.

Nevertheless, as I left, Thomas came up to me and assured me that I could count on his support, convinced that now was the time to show our strength and make ourselves heard in that realm of the evil dragons.

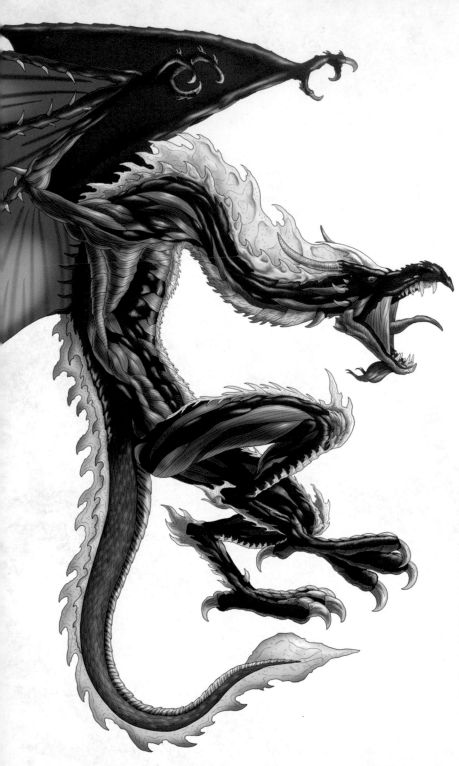

Wyverns

Thomas and I set off that night for Ukraine, and after a turbulent journey by road, we entered into the region of Zaporiz'ka Oblast, which we believed was the area where the dark dragons came from. Just before we reached the Sea of Azov, a dragon flew over us three times. Although it was gliding at a great height, its strange behavior made me fear that it had seen us as a possible target. Soon after, the dragon settled on a rock overhang. We hid among the vegetation and watched it with binoculars. I could see its red eyes, full of evil, while it spied on its surroundings. It was then that I realized it had no front legs and was resting only on its powerful rear legs. It was a wyvern!

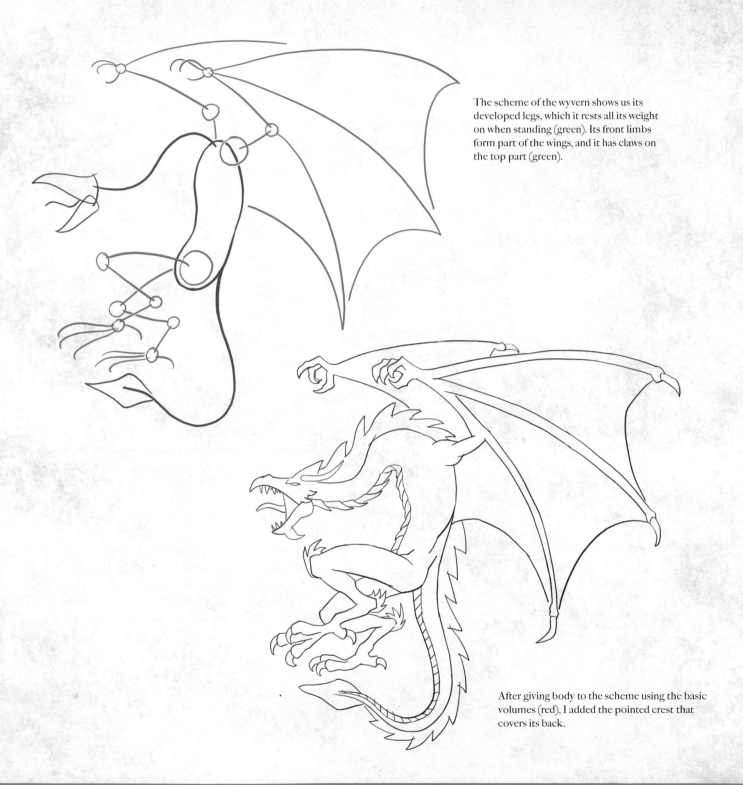

The scheme of the wyvern shows us its developed legs, which it rests all its weight on when standing (green). Its front limbs form part of the wings, and it has claws on the top part (green).

After giving body to the scheme using the basic volumes (red), I added the pointed crest that covers its back.

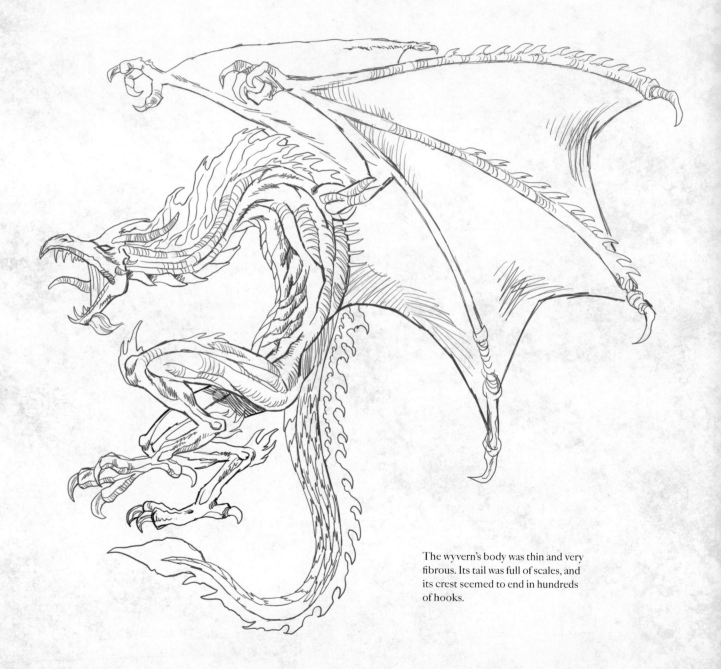

The wyvern's body was thin and very fibrous. Its tail was full of scales, and its crest seemed to end in hundreds of hooks.

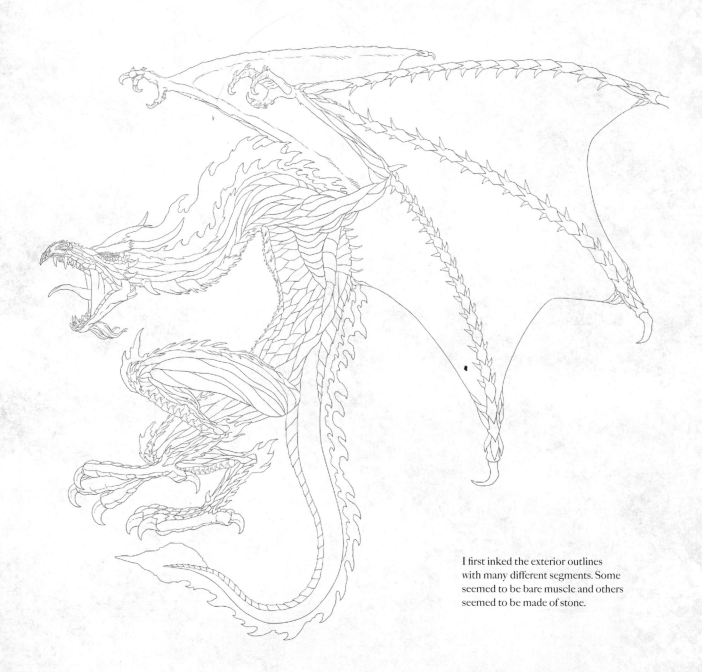

I first inked the exterior outlines with many different segments. Some seemed to be bare muscle and others seemed to be made of stone.

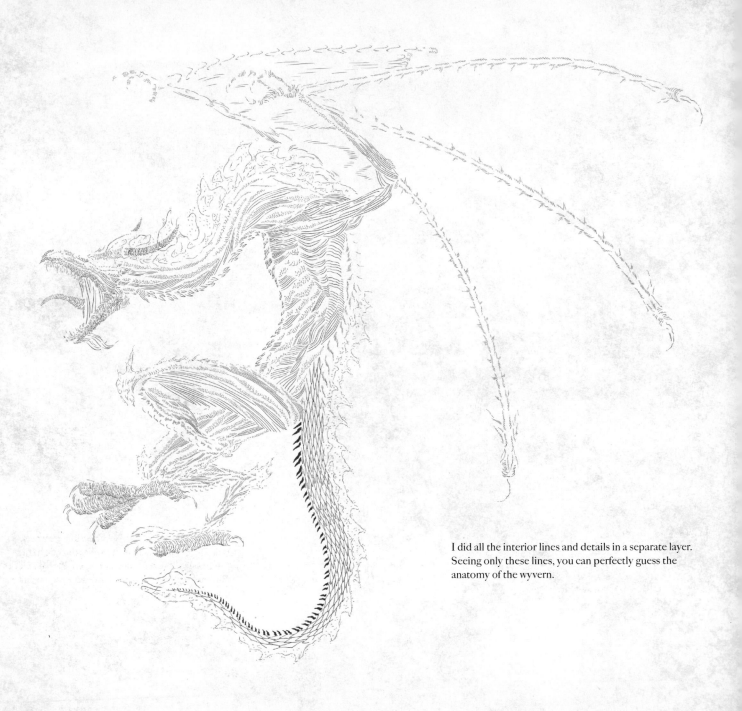

I did all the interior lines and details in a separate layer.
Seeing only these lines, you can perfectly guess the
anatomy of the wyvern.

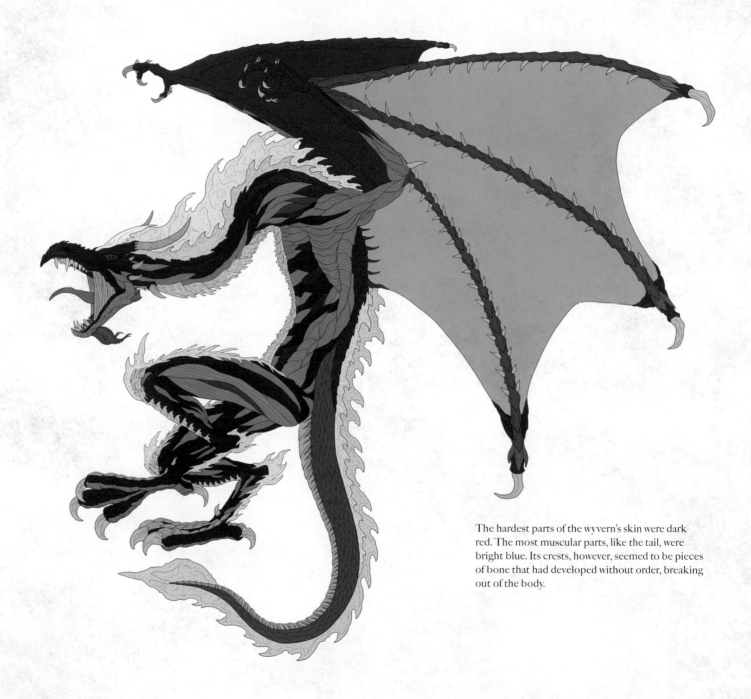

The hardest parts of the wyvern's skin were dark red. The most muscular parts, like the tail, were bright blue. Its crests, however, seemed to be pieces of bone that had developed without order, breaking out of the body.

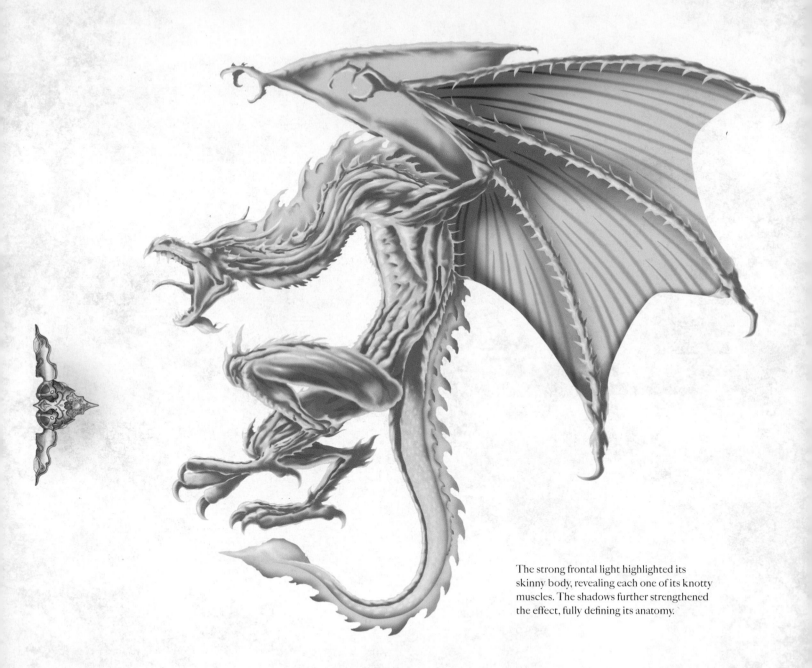

The strong frontal light highlighted its skinny body, revealing each one of its knotty muscles. The shadows further strengthened the effect, fully defining its anatomy.

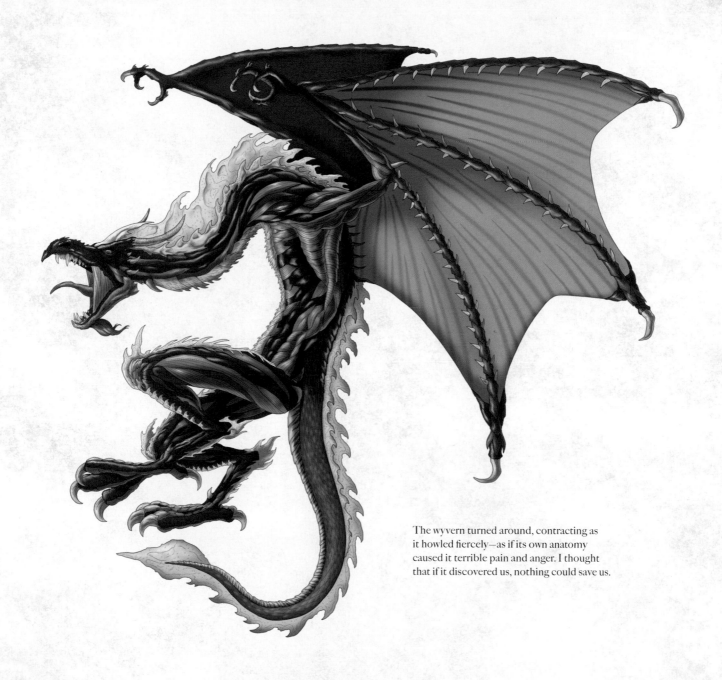

The wyvern turned around, contracting as it howled fiercely—as if its own anatomy caused it terrible pain and anger. I thought that if it discovered us, nothing could save us.

Draconians (Dragon Men)

After puffing several times, the wyvern opened its wings, roared threateningly, and rushed toward us. Everything happened so fast. Several dragons appeared, ridden by strange half-human and half-reptile creatures, and before realizing what had hit it, the battle between the wyvern and the recently arrived dragons was over. They made it flee, inflicting several wounds on its head and back. The riders, who identified themselves as draconians, welcomed us and asked us to follow them. Recalling the creatures we had seen when we flew for the first time on Houlz and Arn, we realized that these must be those who sacrificed their humanity to help the Üru dragons.

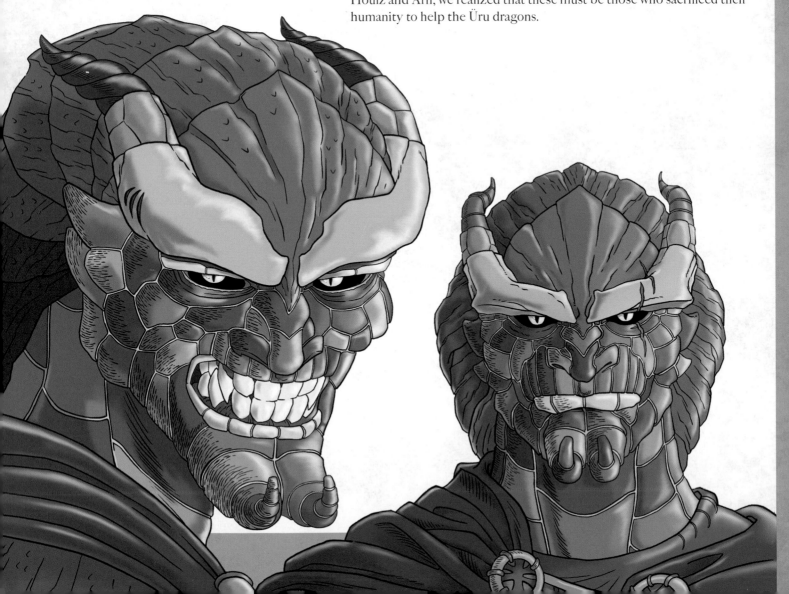

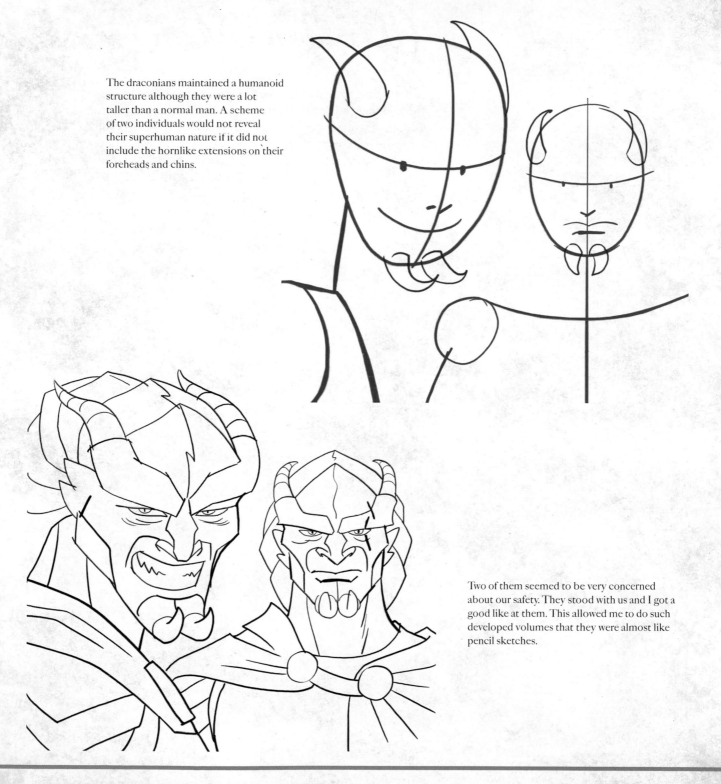

The draconians maintained a humanoid structure although they were a lot taller than a normal man. A scheme of two individuals would not reveal their superhuman nature if it did not include the hornlike extensions on their foreheads and chins.

Two of them seemed to be very concerned about our safety. They stood with us and I got a good like at them. This allowed me to do such developed volumes that they were almost like pencil sketches.

Pencil

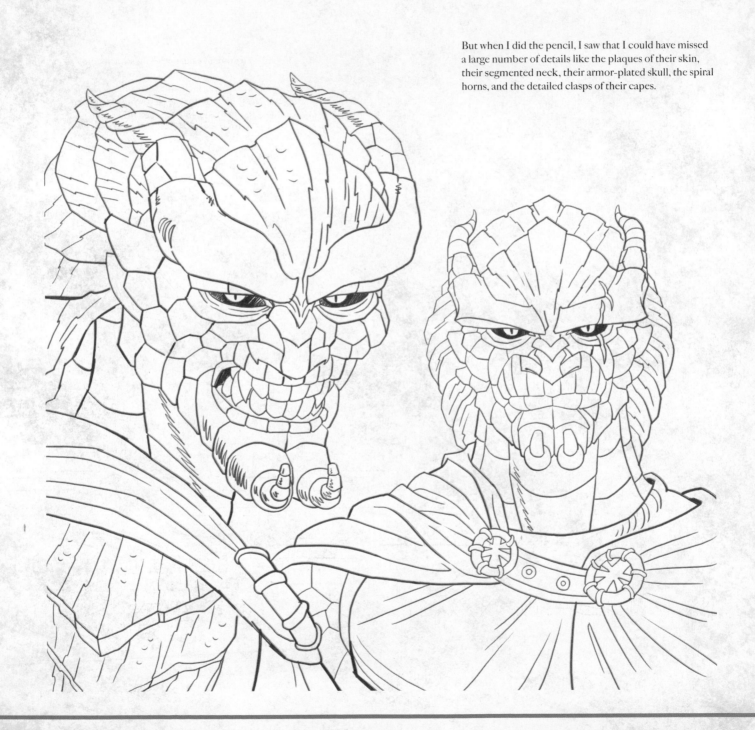

But when I did the pencil, I saw that I could have missed a large number of details like the plaques of their skin, their segmented neck, their armor-plated skull, the spiral horns, and the detailed clasps of their capes.

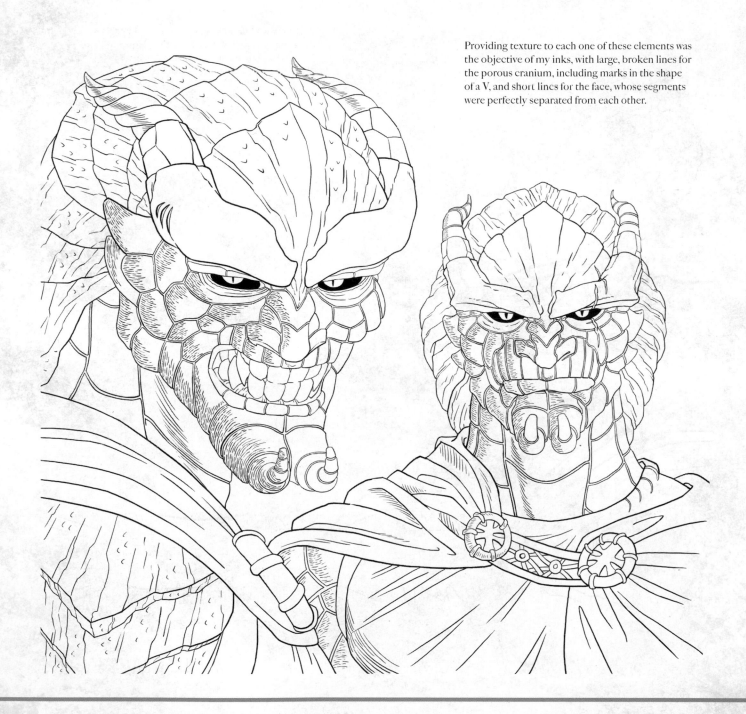

Providing texture to each one of these elements was the objective of my inks, with large, broken lines for the porous cranium, including marks in the shape of a V, and short lines for the face, whose segments were perfectly separated from each other.

Light

The sunlight fell on their faces, highlighting their features in an unnerving manner.

The soft shadows of their faces helped me
recognize each one of their features.

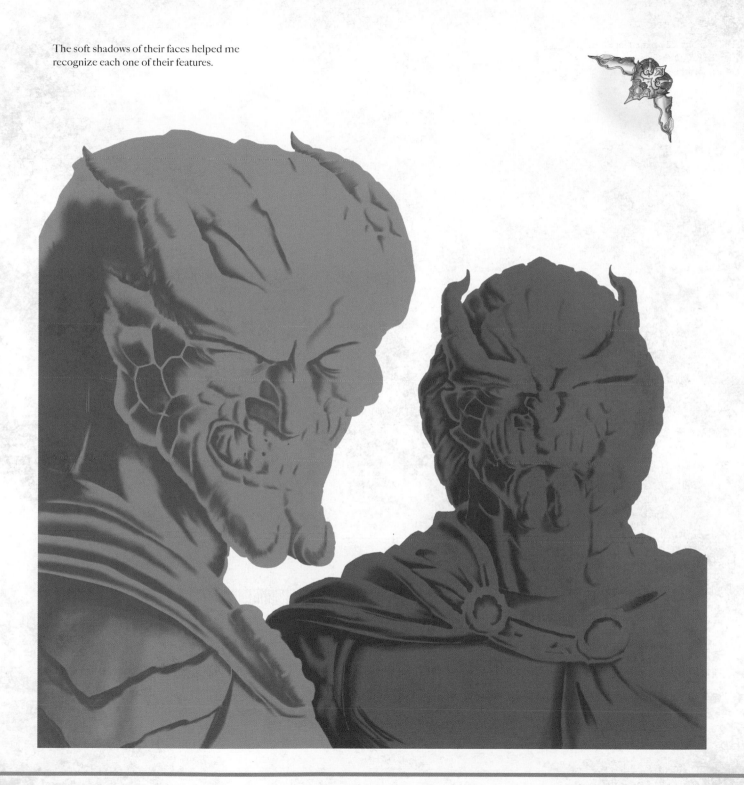

Base Color

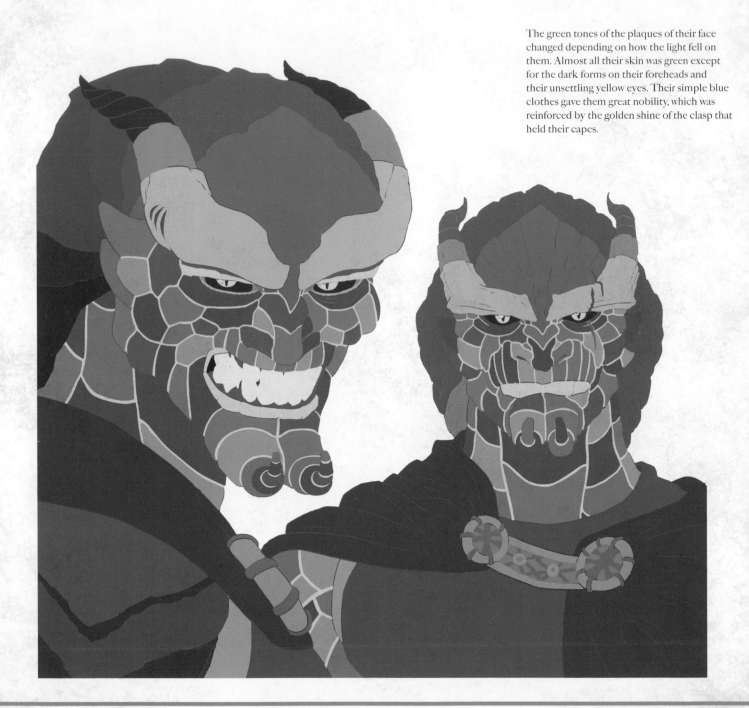

The green tones of the plaques of their face changed depending on how the light fell on them. Almost all their skin was green except for the dark forms on their foreheads and their unsettling yellow eyes. Their simple blue clothes gave them great nobility, which was reinforced by the golden shine of the clasp that held their capes.

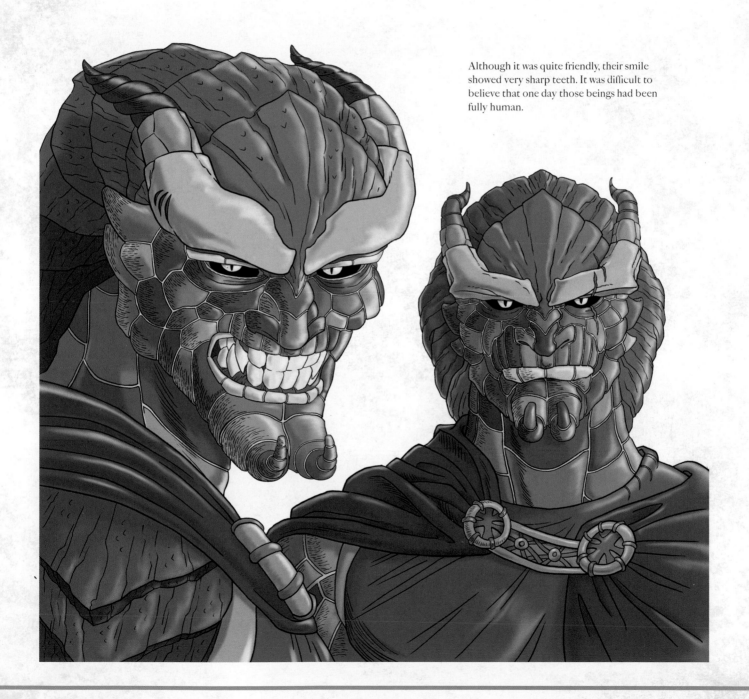

Although it was quite friendly, their smile showed very sharp teeth. It was difficult to believe that one day those beings had been fully human.

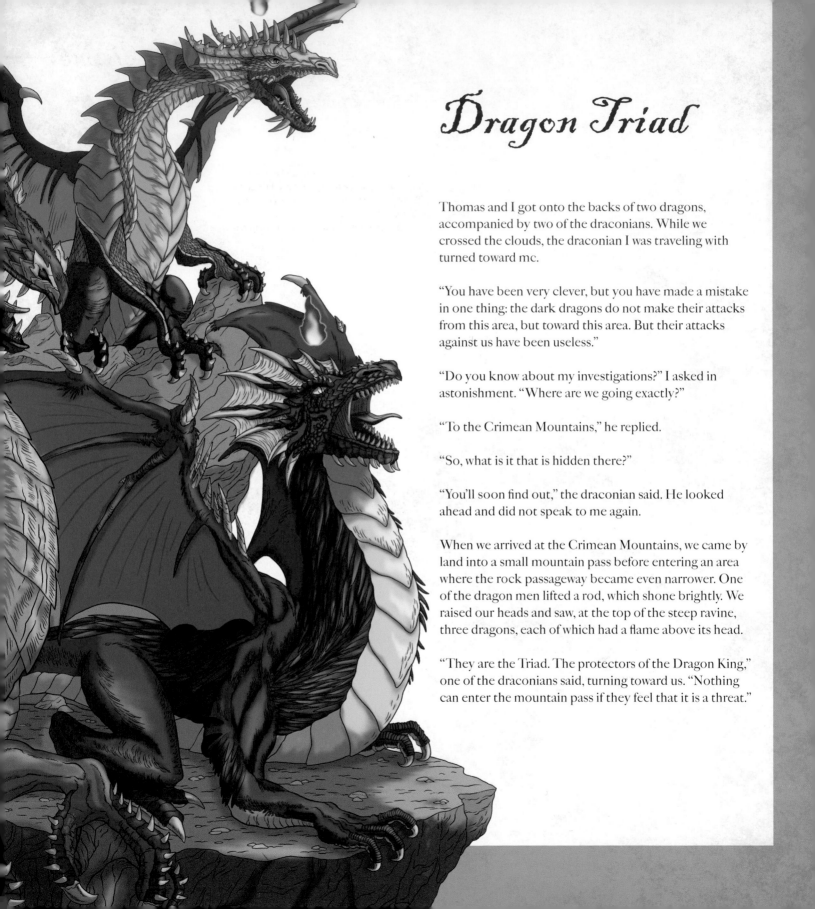

Dragon Triad

Thomas and I got onto the backs of two dragons, accompanied by two of the draconians. While we crossed the clouds, the draconian I was traveling with turned toward me.

"You have been very clever, but you have made a mistake in one thing: the dark dragons do not make their attacks from this area, but toward this area. But their attacks against us have been useless."

"Do you know about my investigations?" I asked in astonishment. "Where are we going exactly?"

"To the Crimean Mountains," he replied.

"So, what is it that is hidden there?"

"You'll soon find out," the draconian said. He looked ahead and did not speak to me again.

When we arrived at the Crimean Mountains, we came by land into a small mountain pass before entering an area where the rock passageway became even narrower. One of the dragon men lifted a rod, which shone brightly. We raised our heads and saw, at the top of the steep ravine, three dragons, each of which had a flame above its head.

"They are the Triad. The protectors of the Dragon King," one of the draconians said, turning toward us. "Nothing can enter the mountain pass if they feel that it is a threat."

Scheme and Volume

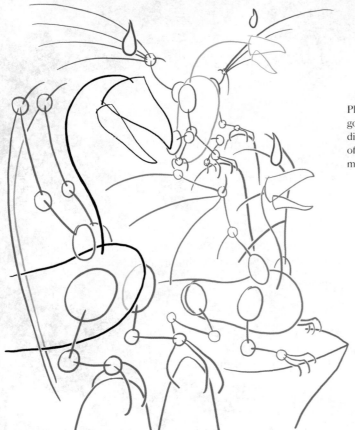

Placing three dragons in a single sheet was going to be very confusing, so I used three different colors to do the scheme of each one of them, and then I added brown rocks and marked the flames floating above them in red.

When doing the volumes, I maintained the color differentiation, although here the morphology of each one of them started to reveal the differences. From afar, these three dragons seemed similar to me, but I was now seeing that they were very different.

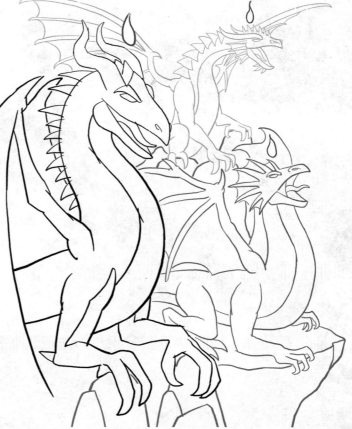

Pencil

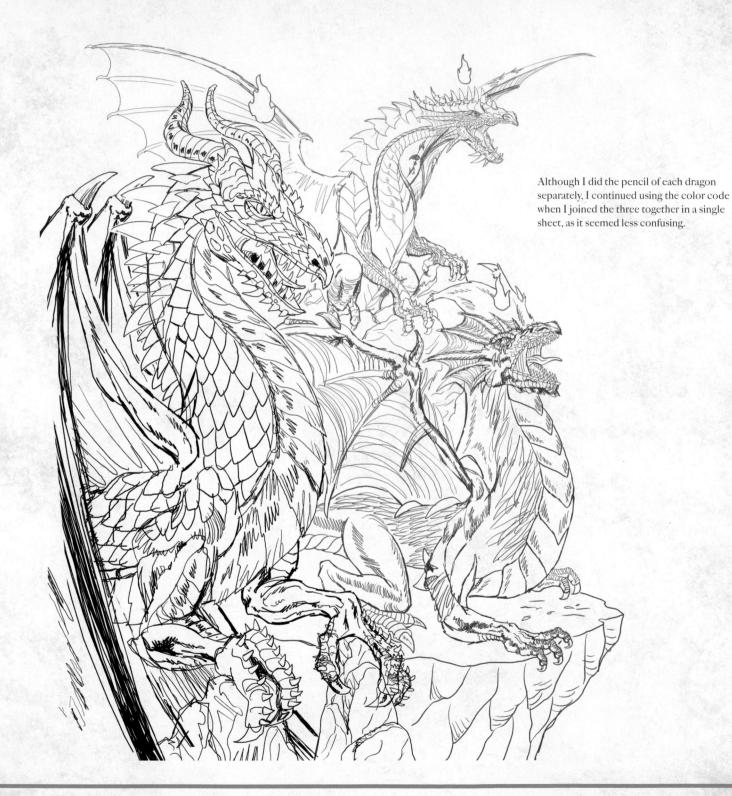

Although I did the pencil of each dragon separately, I continued using the color code when I joined the three together in a single sheet, as it seemed less confusing.

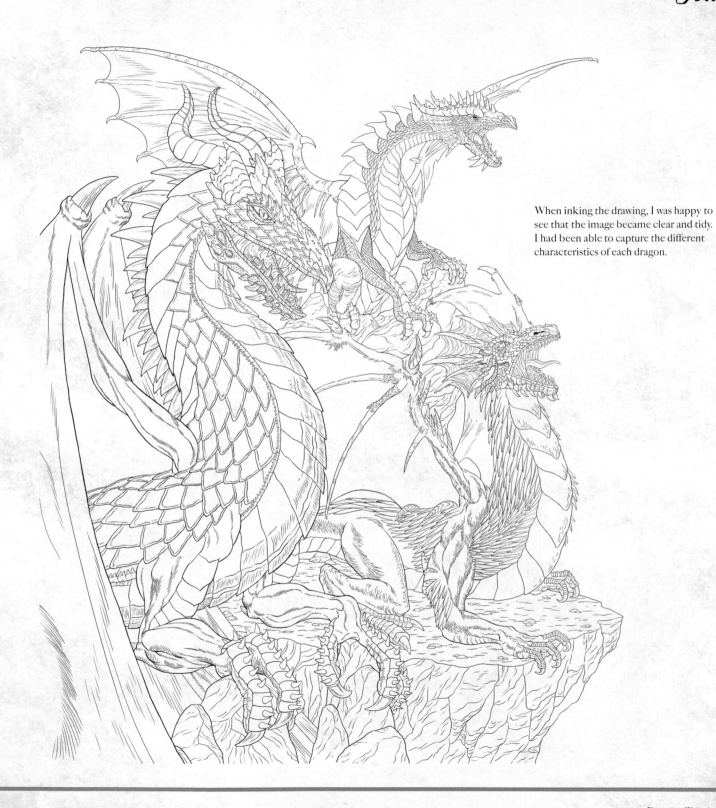

When inking the drawing, I was happy to see that the image became clear and tidy. I had been able to capture the different characteristics of each dragon.

Base Color

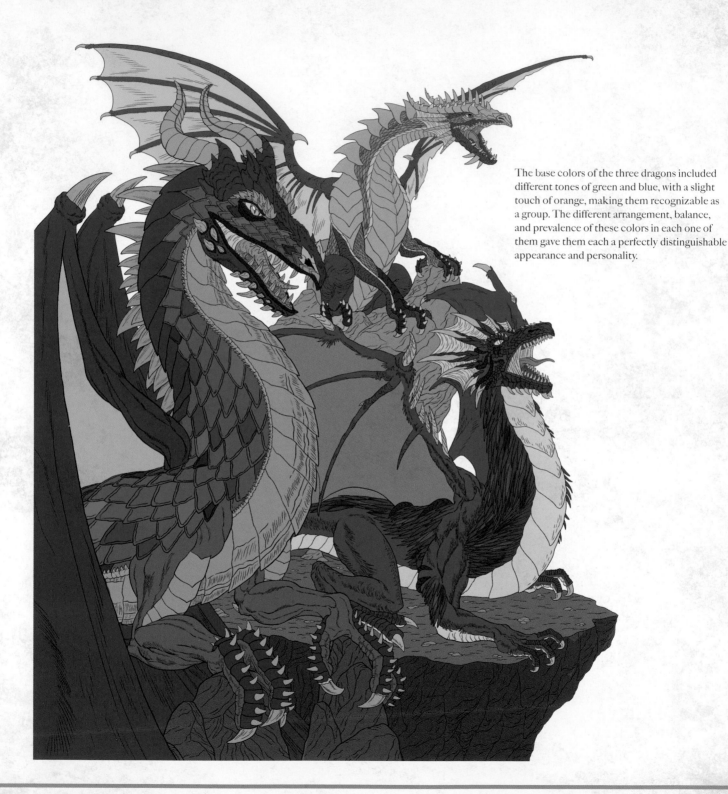

The base colors of the three dragons included different tones of green and blue, with a slight touch of orange, making them recognizable as a group. The different arrangement, balance, and prevalence of these colors in each one of them gave them each a perfectly distinguishable appearance and personality.

With the peaceful afternoon sun in front of them, the lights softly flowed over their faces. With one single layer of lights, I highlighted the anatomy of their head and neck, which provided reinforcement for the layers of shadows.

Shadow

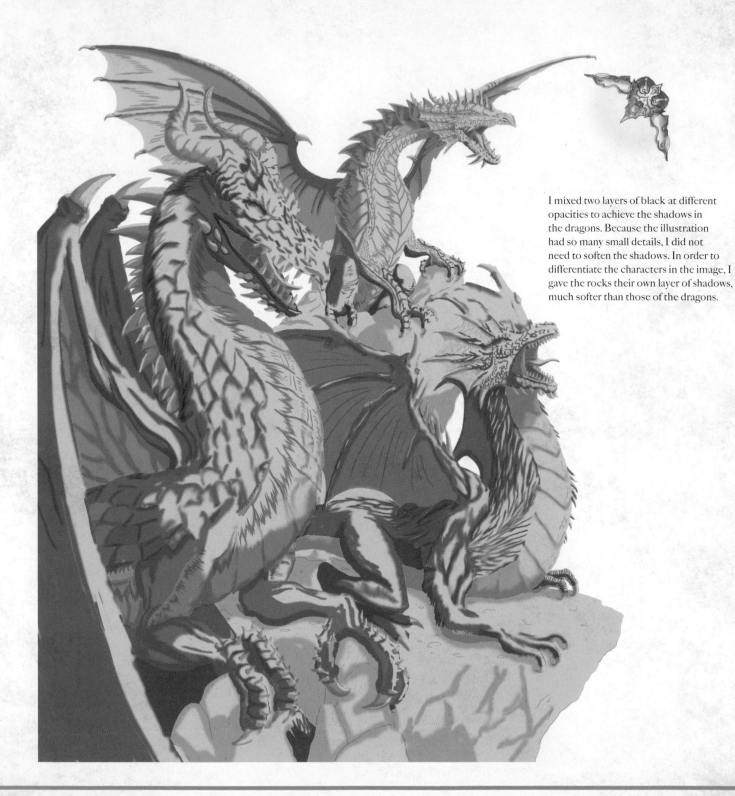

I mixed two layers of black at different opacities to achieve the shadows in the dragons. Because the illustration had so many small details, I did not need to soften the shadows. In order to differentiate the characters in the image, I gave the rocks their own layer of shadows, much softer than those of the dragons.

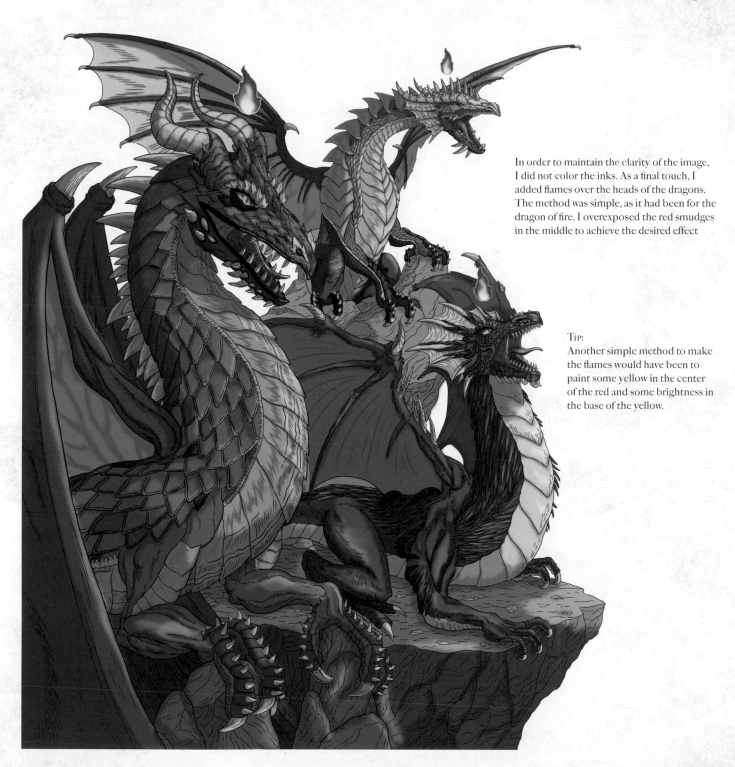

In order to maintain the clarity of the image, I did not color the inks. As a final touch, I added flames over the heads of the dragons. The method was simple, as it had been for the dragon of fire. I overexposed the red smudges in the middle to achieve the desired effect

TIP:
Another simple method to make the flames would have been to paint some yellow in the center of the red and some brightness in the base of the yellow.

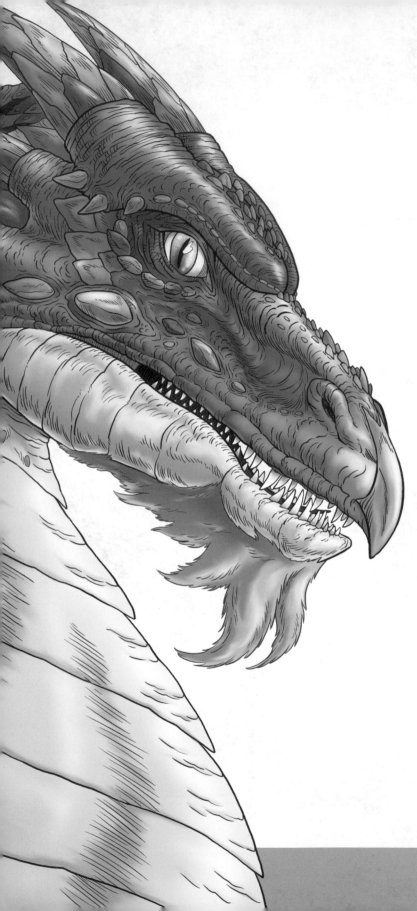

The Dragon King

At the end of the mountain pass, there was an enormous cave. We went inside the bare rock and walked for almost half an hour until we reached a huge open-air chamber where there were dozens of people of different nationalities. Several large shields, similar to those we had found under Leamaneh Castle in Ireland, were hanging from the walls. For a few hours, we waited without receiving any explanation, until another group of humans arrived, escorted by the draconians. At that moment, an amazing dragon seemed to appear from nowhere and spoke to us in a calm voice.

"These shields, which you can see represent ten of the twelve ancient castes of dragons—and this last one is the coat of arms of the house of Terya, our first human allies," the Dragon King explained with pride. "All of them were a gift from the first lords of Terya, a symbol of their respect for the Üru dragons and our bond with humans."

The scheme of the Dragon King was so simple that it reminded me of a standing lamp. Two curved triangles formed the head, with the top one bigger than the lower one. The dragon's neck came out of the upper triangle and curved until it fell in a very balanced manner.

Volume

The volumes of the Dragon King shown here are very developed. I had done my basic volumes of the head and neck, but since the illustration was a foreground, I thought that I could add some more details to help me with the pencil. After segmenting the neck and details of the snout and beards, I added the big red spines of its back, as well as its teeth and some details on its face. The front part of the dragon's neck was fairly smooth and seemed to be empty, so I added some short spines to fill it up and give balance.

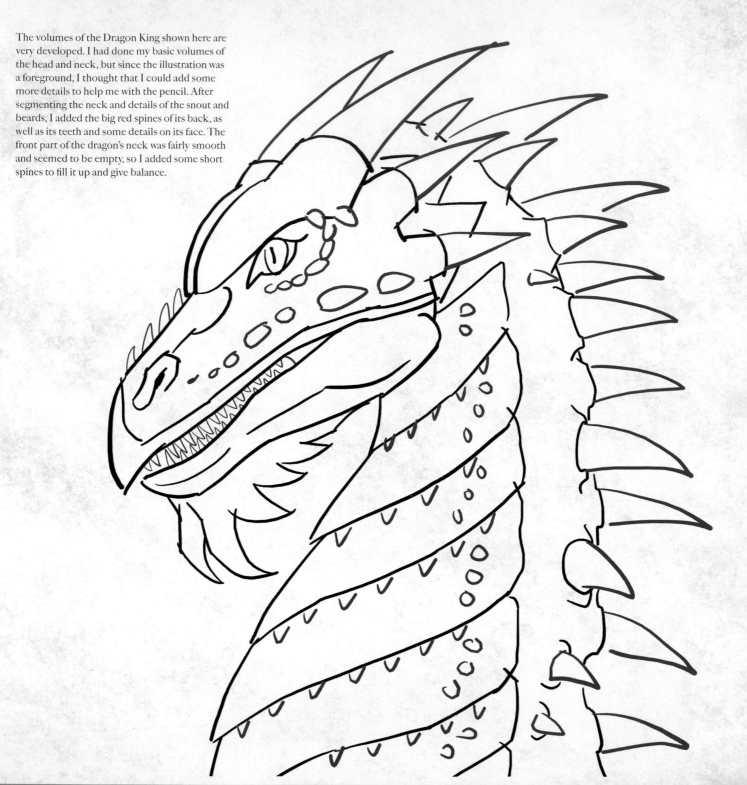

I was very experienced with the type of line used to represent the different textures and hardness of the dragon's skin. In order to do my pencil, I preferred one that gave me thick dark lines, which would allow me to immediately see how the character was advancing and also be able to quickly decide where it needed more shadows or details, and so I mainly limited myself to marking or insinuating the subsequent inking. Even so, I was surprised to see the difference in the cleanness of the pencil between the front part of the dragon (face, neck, and chest) and the back part (scales and spines). I made a mental note that I should not transfer that difference to the inks.

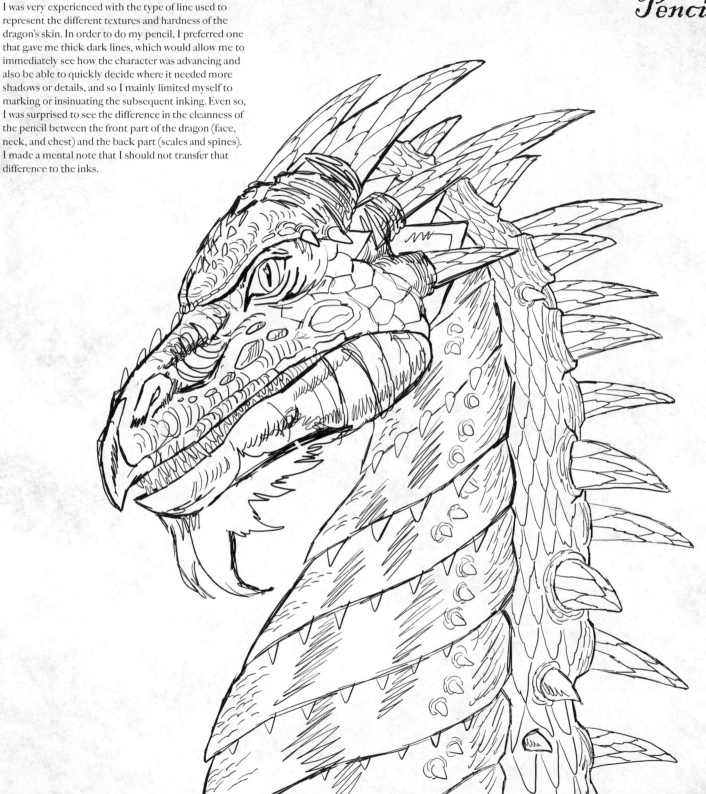

Ink

As I usually did, I began the inking by tracing the main profiles with a thicker ink, and I then went on to the interior details with a medium brush and then a finer brush for the smallest details. I felt very comfortable and sure of my illustration, and so I took my time doing the creases, which would give consistency to the skin at the base of the horns, and the sharp interior lines of the crest of horns. In the end, I got rid of the spines I had added to the front of the neck, and I opted for the contrast that such a smooth neck would cause in the original dragon.

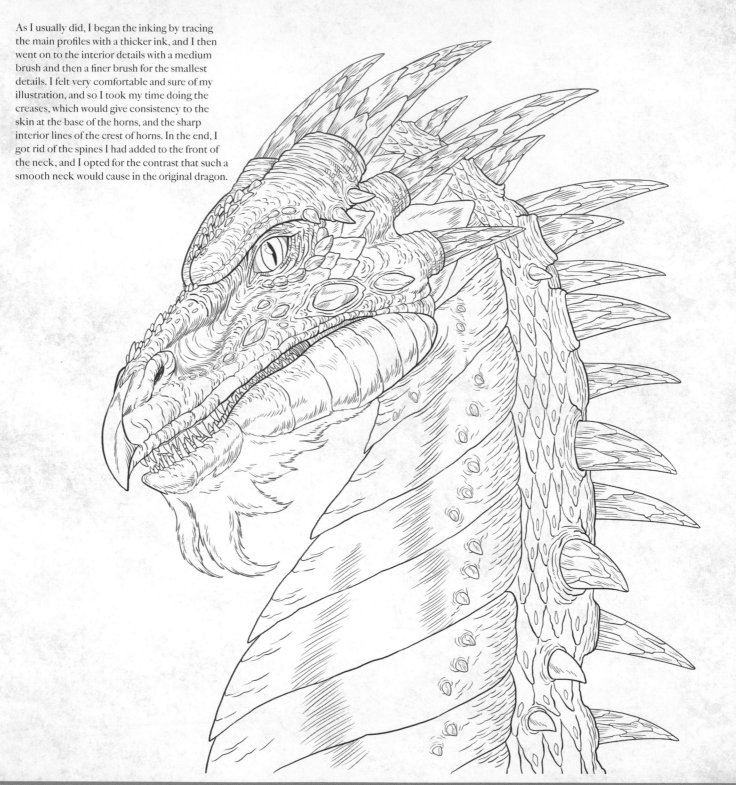

The main colors of the Dragon King were green (for its face and back) and yellow (for its jaw and belly). All the colors that made up the base color came from those colors, and were in reality yellows and greens that were more or less darkened and more or less lightened. The points of contrast were the red tongue and the eye, which had a high load of blue.

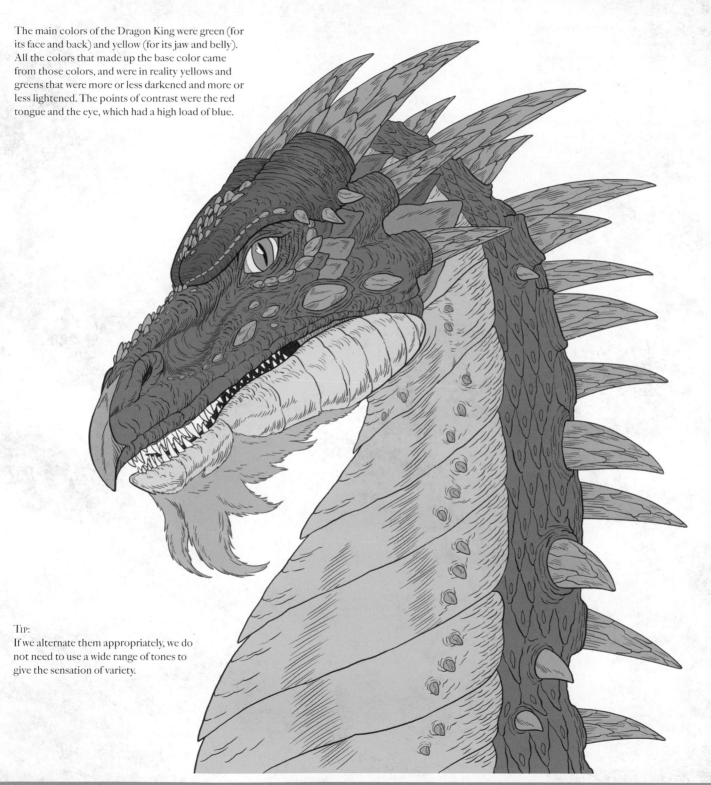

TIP:
If we alternate them appropriately, we do not need to use a wide range of tones to give the sensation of variety.

Color

Before passing on to the stage of lights and shadows, I decided to enhance the color base a little more. As the illustration shows, the inks were very well worked. I wanted the coloring to be at the same high level.

My detail color consisted of giving different tones of green to the scales and the large horns and spines on the neck. The work was hard, but the result was worth it.

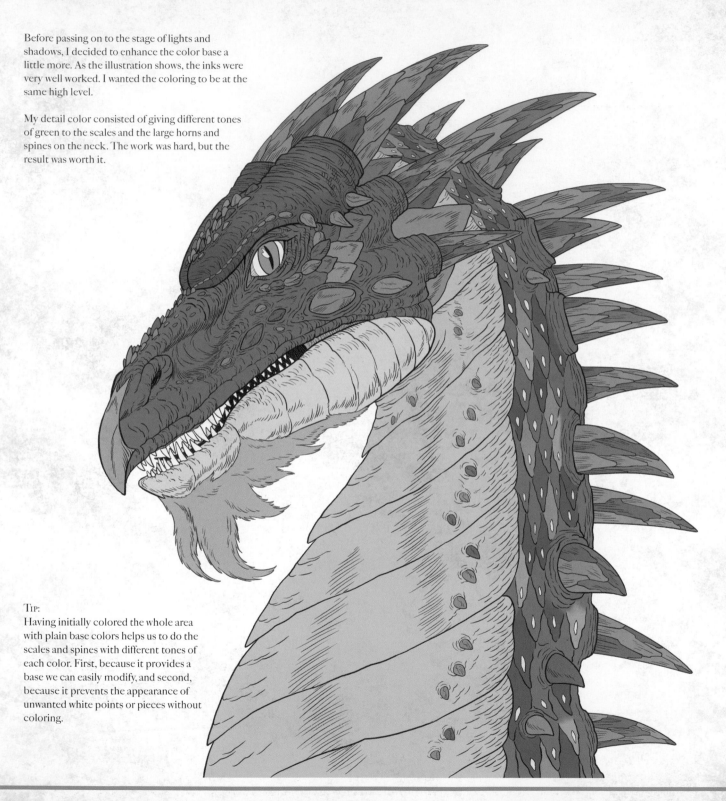

TIP:
Having initially colored the whole area with plain base colors helps us to do the scales and spines with different tones of each color. First, because it provides a base we can easily modify, and second, because it prevents the appearance of unwanted white points or pieces without coloring.

I placed the source of light on the left and applied two layers of lights with different width and opacity. I greatly softened both layers to integrate them better, and even though it would not correspond given the position of the source of light, I gave the spines on the back some white touches so as to give them a little more volume.

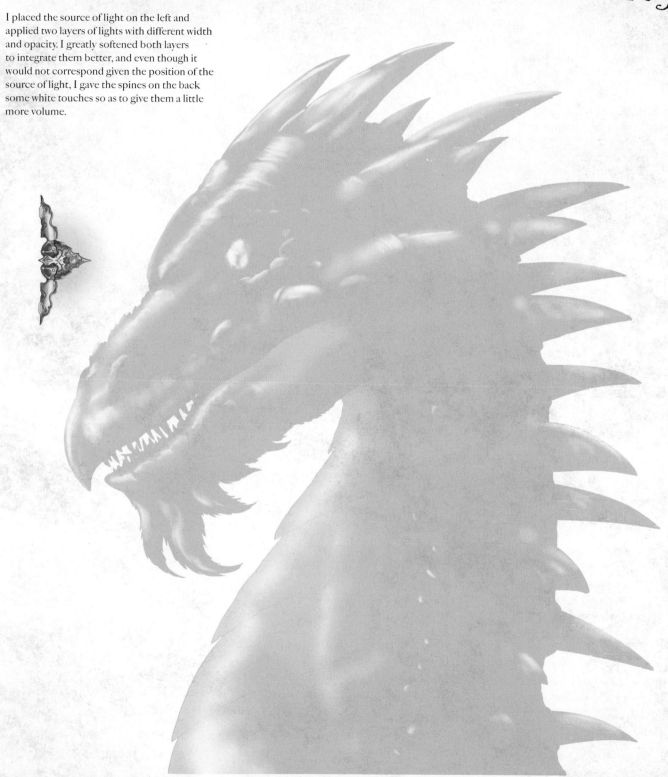

Shadow

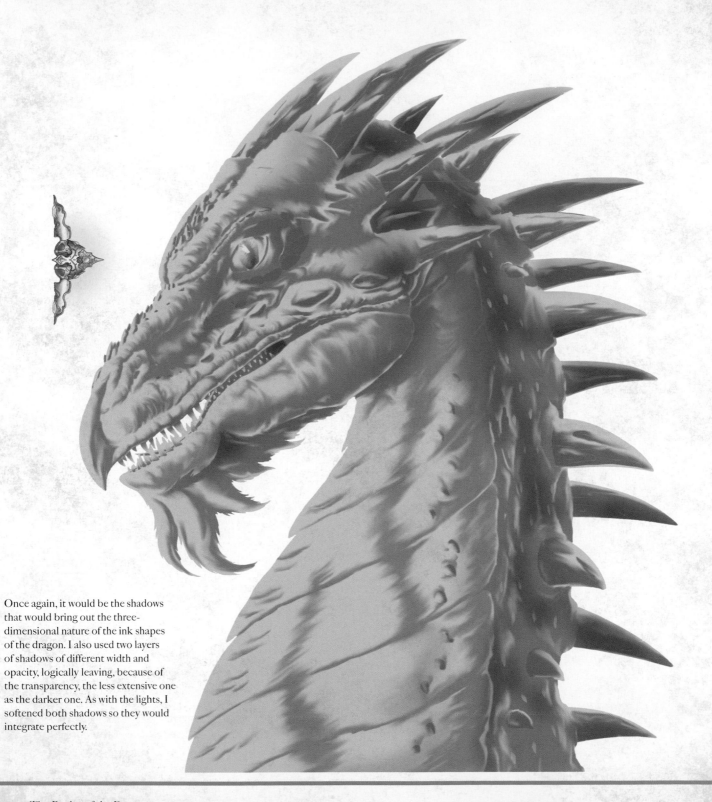

Once again, it would be the shadows that would bring out the three-dimensional nature of the ink shapes of the dragon. I also used two layers of shadows of different width and opacity, logically leaving, because of the transparency, the less extensive one as the darker one. As with the lights, I softened both shadows so they would integrate perfectly.

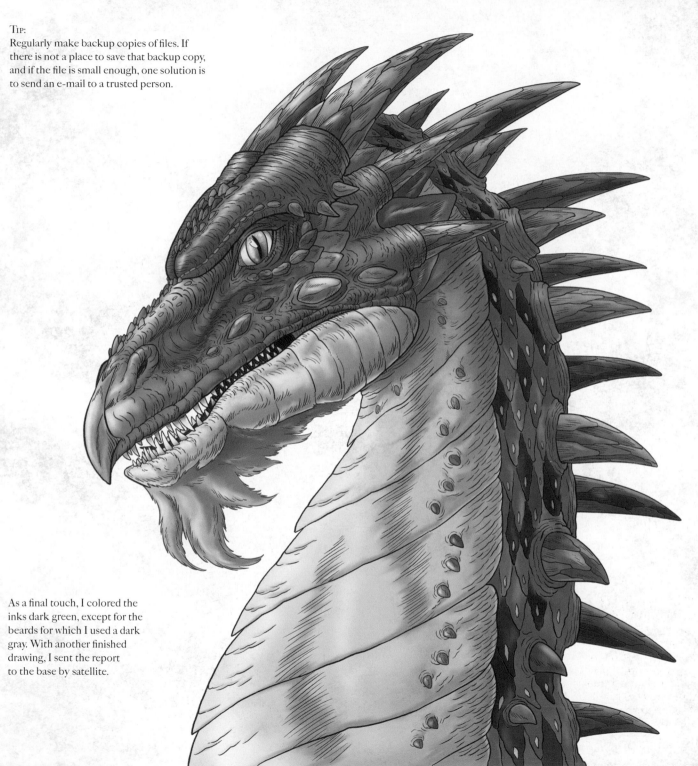

TIP:
Regularly make backup copies of files. If there is not a place to save that backup copy, and if the file is small enough, one solution is to send an e-mail to a trusted person.

As a final touch, I colored the inks dark green, except for the beards for which I used a dark gray. With another finished drawing, I sent the report to the base by satellite.

The Dragon Alliance

"I would like to welcome you," the Dragon King continued.
"We were waiting for you, all of you: the chosen ones."

Thomas and I watched the Dragon King without knowing what
was happening. However, the tension in the faces of the others
reflected something different, as if they expected that something very
important was about to happen.

The monarch moved up to a higher area that was dug into the rock
like an altar. He waited until several dragons arranged themselves next
to him, forming a circle, and then he spoke what sounded like an oath.

"We are gathered here before the shields of Terya.
We reject the two accursed castes, which embraced evil.
We forge once again the dragon alliance and invoke the magic of Suun,
that he may show us the path toward the eternal flame."

A rock structure next to the altar, which seemed
to house a strange green stone, undoubtedly
represented the dragon alliance. I sketched it as I
had done the scheme of so many dragons before,
although its limbs and its wings (red) were somewhat
different, being more stylized than those I usually
drew. I also sketched the simple pedestal where the
statue (blue) and the mysterious stone (green) rested.

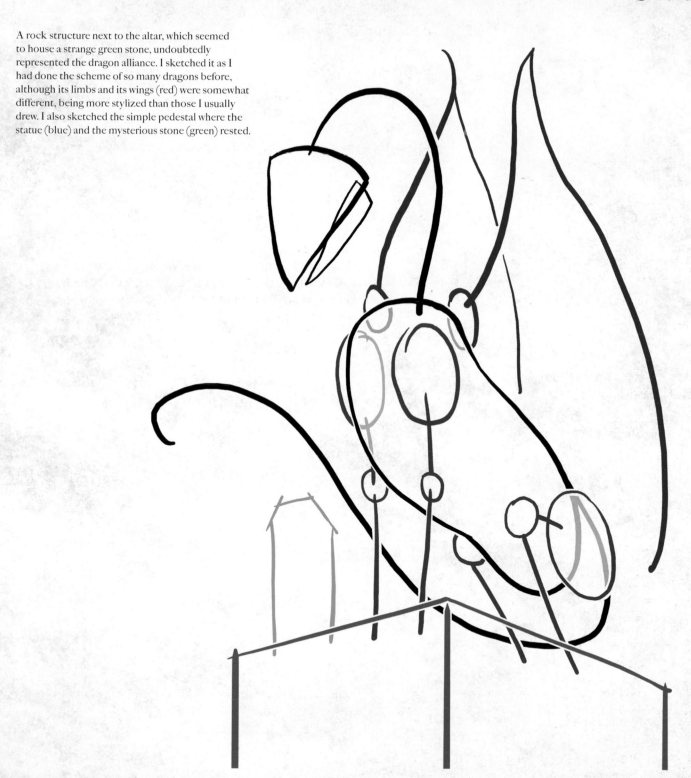

Volume

While giving body to the scheme to obtain the basic volumes, I quickly drew the only symbol engraved in the pedestal, and I then understood that the shape of the dragon was symbolic. The engraving of the column, the shape of the horns on the forehead, and the wings formed the same structure as a cup, two branches forming one single element.

The shapes of the statue were soft, and even though it was sculptured from hard stone, everything about it seemed curved.

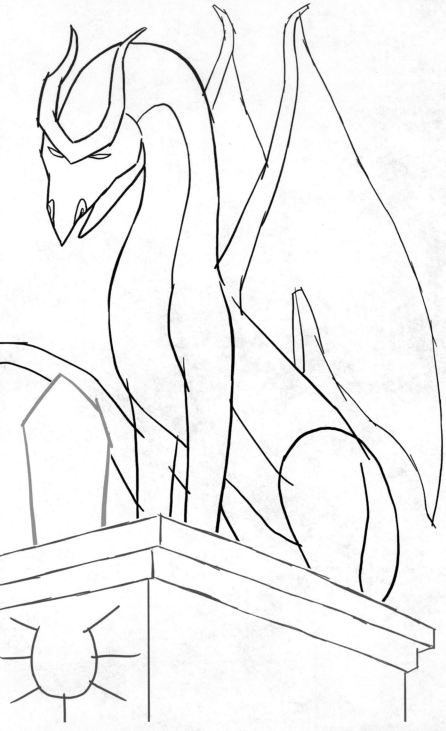

Using the pencil, I included all the other details of the statue, the pedestal, and the stone. The motif of the double-branch coming together was repeated all over the figure's surface. I wondered whether it had any significance or if it was a purely decorative function. In order to avoid confusion, I marked the abundant cracks in the statue and the pedestal in blue.

Ink

I did the ink, going over the pencil softly to maintain the gentle curves of the statue. Apart from the cracks, I added some short lines in the shape of a U, a very simple and useful tool for representing inanimate statues.

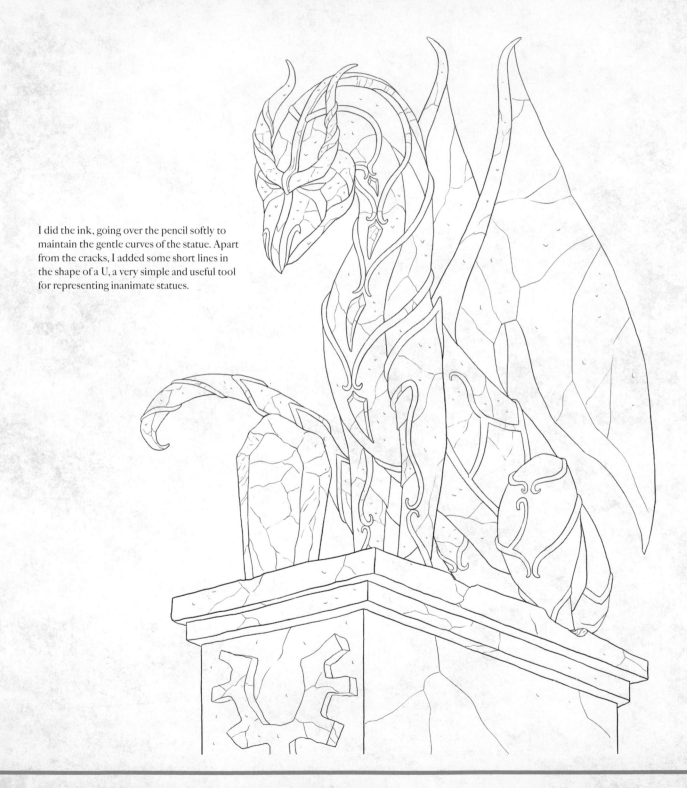

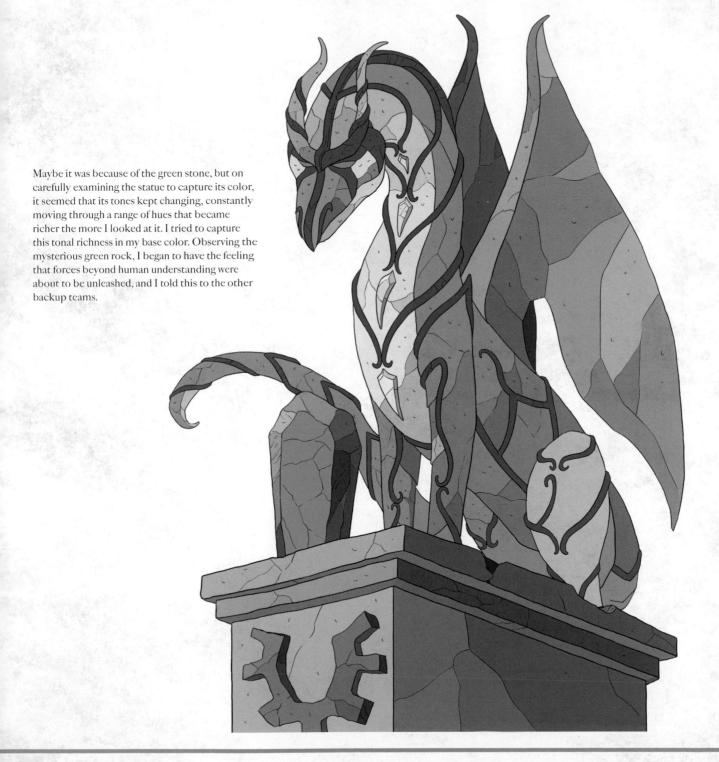

Maybe it was because of the green stone, but on carefully examining the statue to capture its color, it seemed that its tones kept changing, constantly moving through a range of hues that became richer the more I looked at it. I tried to capture this tonal richness in my base color. Observing the mysterious green rock, I began to have the feeling that forces beyond human understanding were about to be unleashed, and I told this to the other backup teams.

Light and Shadow

Given that the idea was to illuminate a statue, I left the light and shadow completely clear, without any type of softening. The fine white light defined volumes and maintained a decorative function. Two layers of shadows gave body to the statue and perfectly defined the polyhedral shapes of the column and its engraving.

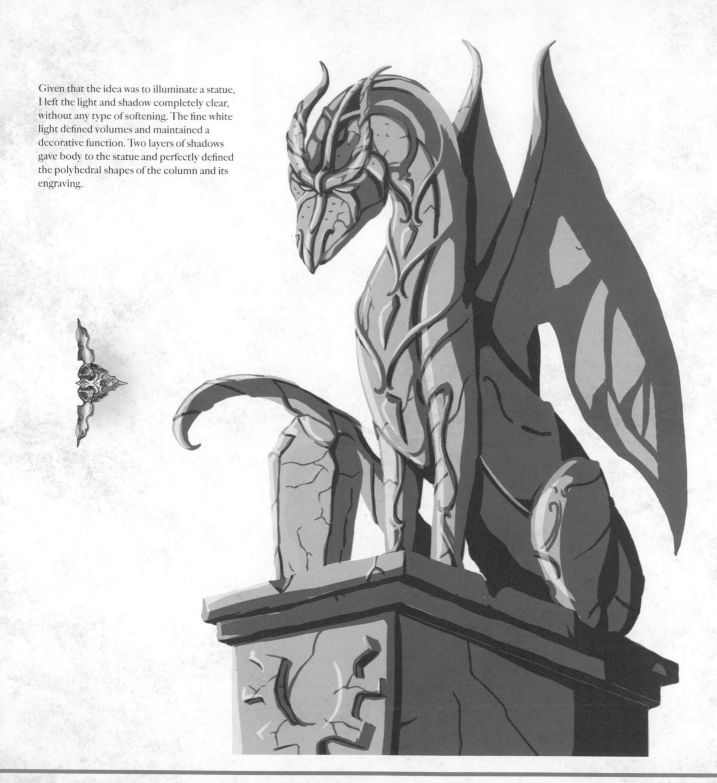

The finished drawing perfectly reflected the appearance of the enigmatic statue that remained among the shadows of the cave. As it was the only statue in the place, it was clear that both the figure it represented and the stone it guarded must be of great importance.

One of the backup teams had obtained permission to enter, and among them was Amppar, who, as she approached me, made gestures indicating she would help to register everything happening there.

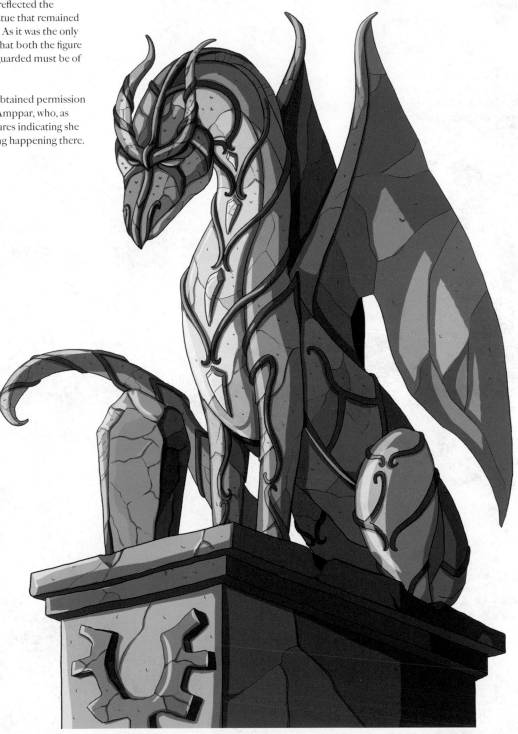

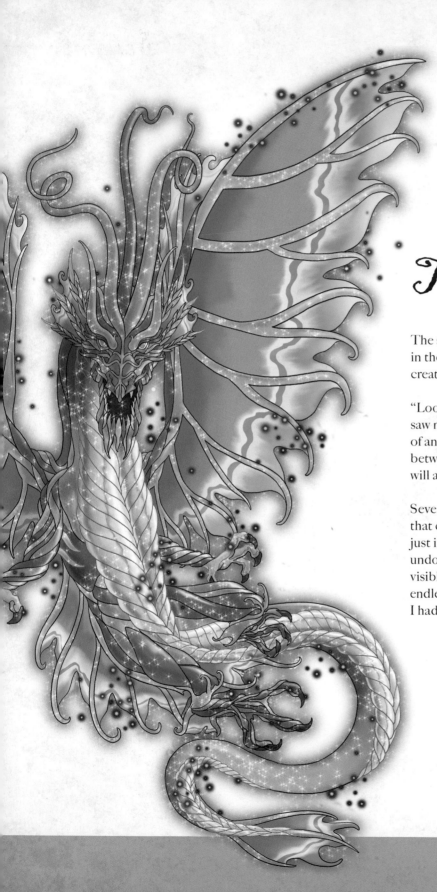

The Magic Dragon

The skin of the dragons in the circle started to shine, and in the center, an impressive, unique, and brightly colored creature appeared before us.

"Look at it closely," one of the draconians said to me as he saw me take a step backward. "You are seeing a manifestation of an extra dimensional being: a magic dragon able to travel between different levels of reality. He will open the portal that will allow you to achieve your destiny.

Several lights started to shine brightly above us, emitting rays that came together, forming a ring. I looked more closely, just in case my eyes were deceiving me, but that ring was undoubtedly beyond the clouds, so big that it was perfectly visible from Earth. In the middle of the daytime blue sky, an endless night lived inside the ring, filled with more stars than I had ever seen.

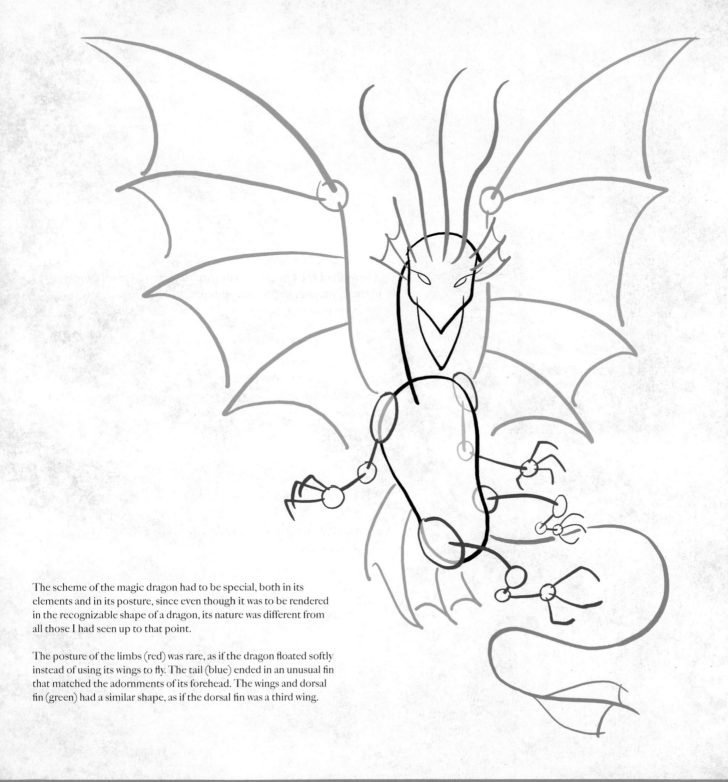

The scheme of the magic dragon had to be special, both in its elements and in its posture, since even though it was to be rendered in the recognizable shape of a dragon, its nature was different from all those I had seen up to that point.

The posture of the limbs (red) was rare, as if the dragon floated softly instead of using its wings to fly. The tail (blue) ended in an unusual fin that matched the adornments of its forehead. The wings and dorsal fin (green) had a similar shape, as if the dorsal fin was a third wing.

Volume

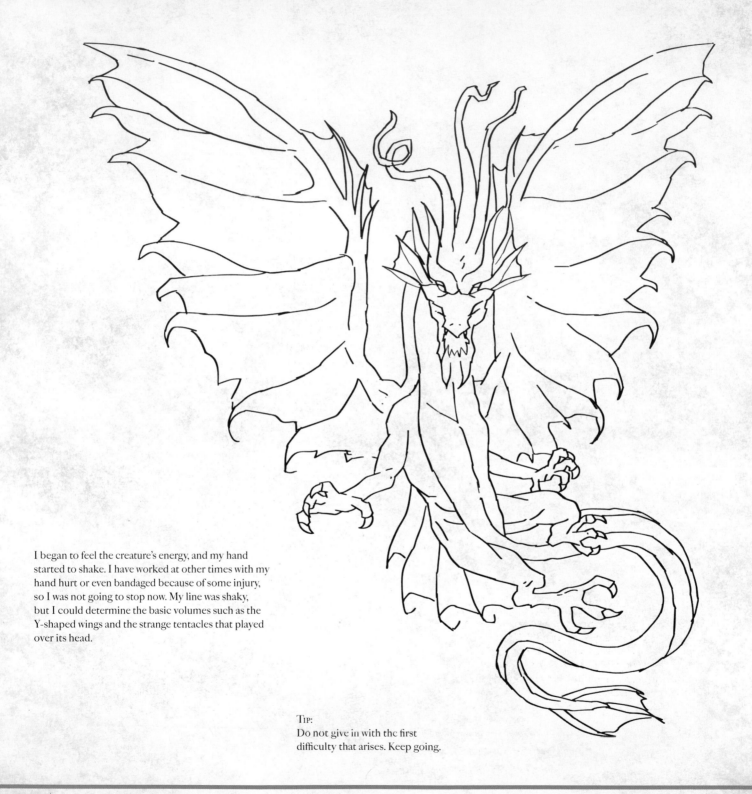

I began to feel the creature's energy, and my hand started to shake. I have worked at other times with my hand hurt or even bandaged because of some injury, so I was not going to stop now. My line was shaky, but I could determine the basic volumes such as the Y-shaped wings and the strange tentacles that played over its head.

TIP:
Do not give in with the first difficulty that arises. Keep going.

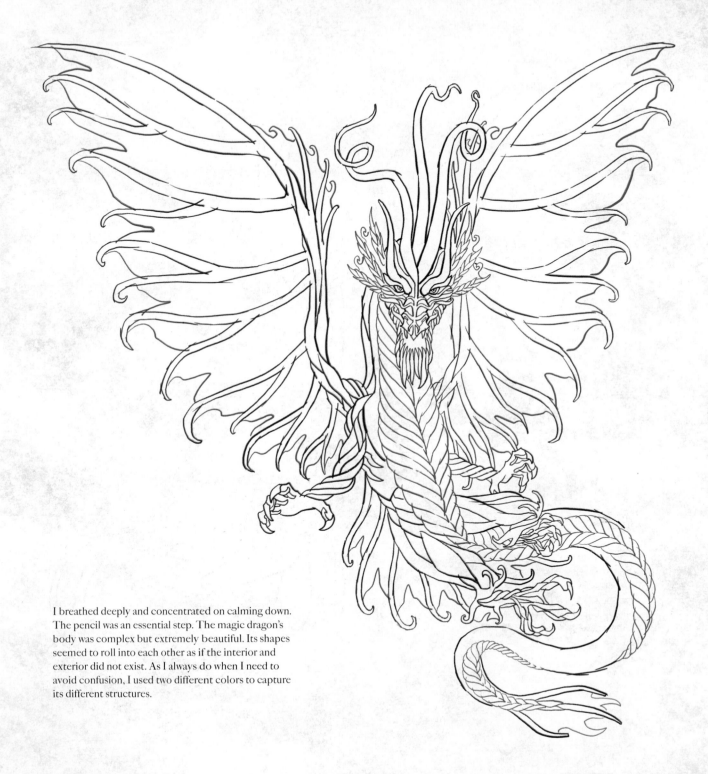

I breathed deeply and concentrated on calming down. The pencil was an essential step. The magic dragon's body was complex but extremely beautiful. Its shapes seemed to roll into each other as if the interior and exterior did not exist. As I always do when I need to avoid confusion, I used two different colors to capture its different structures.

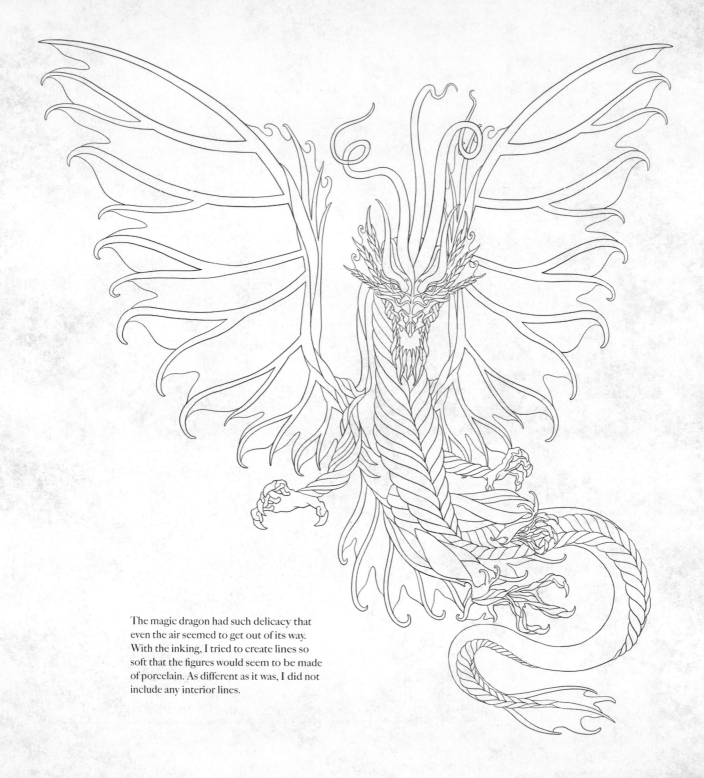

The magic dragon had such delicacy that
even the air seemed to get out of its way.
With the inking, I tried to create lines so
soft that the figures would seem to be made
of porcelain. As different as it was, I did not
include any interior lines.

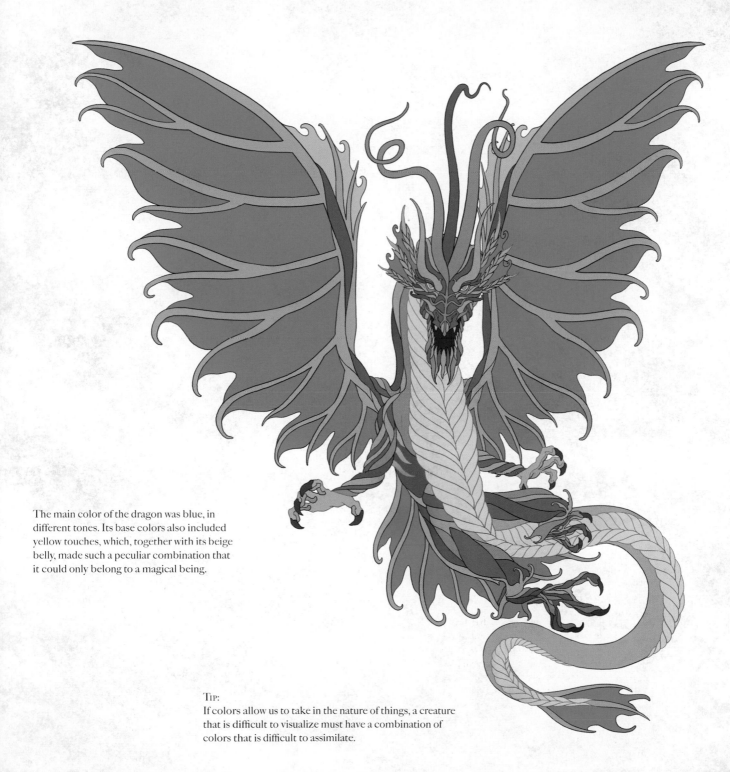

The main color of the dragon was blue, in different tones. Its base colors also included yellow touches, which, together with its beige belly, made such a peculiar combination that it could only belong to a magical being.

TIP:
If colors allow us to take in the nature of things, a creature that is difficult to visualize must have a combination of colors that is difficult to assimilate.

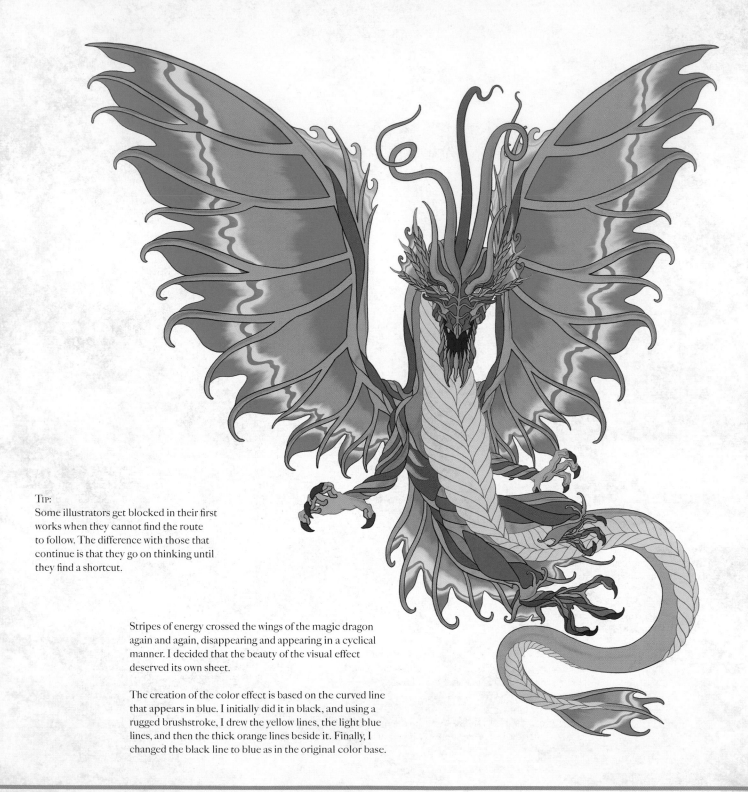

TIP:
Some illustrators get blocked in their first works when they cannot find the route to follow. The difference with those that continue is that they go on thinking until they find a shortcut.

Stripes of energy crossed the wings of the magic dragon again and again, disappearing and appearing in a cyclical manner. I decided that the beauty of the visual effect deserved its own sheet.

The creation of the color effect is based on the curved line that appears in blue. I initially did it in black, and using a rugged brushstroke, I drew the yellow lines, the light blue lines, and then the thick orange lines beside it. Finally, I changed the black line to blue as in the original color base.

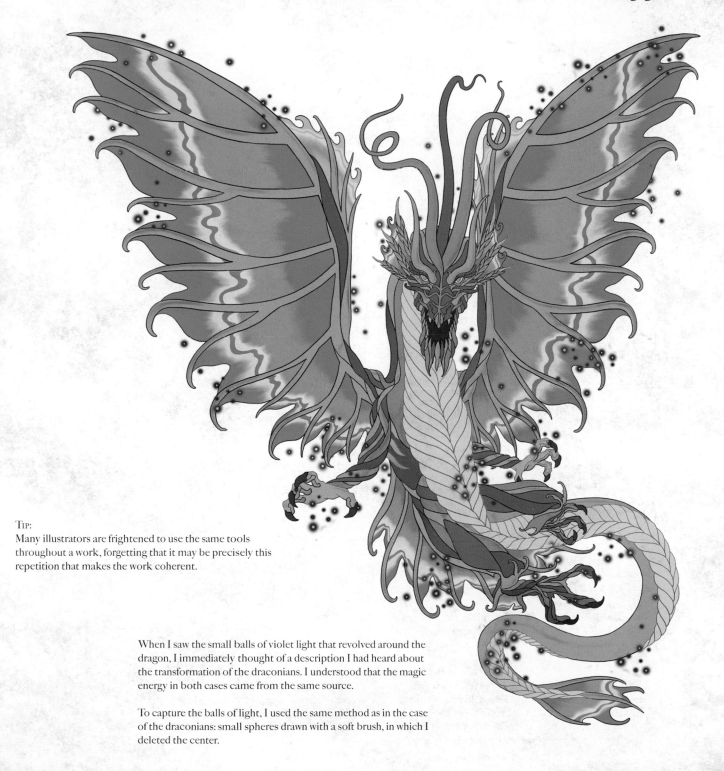

TIP:
Many illustrators are frightened to use the same tools throughout a work, forgetting that it may be precisely this repetition that makes the work coherent.

When I saw the small balls of violet light that revolved around the dragon, I immediately thought of a description I had heard about the transformation of the draconians. I understood that the magic energy in both cases came from the same source.

To capture the balls of light, I used the same method as in the case of the draconians: small spheres drawn with a soft brush, in which I deleted the center.

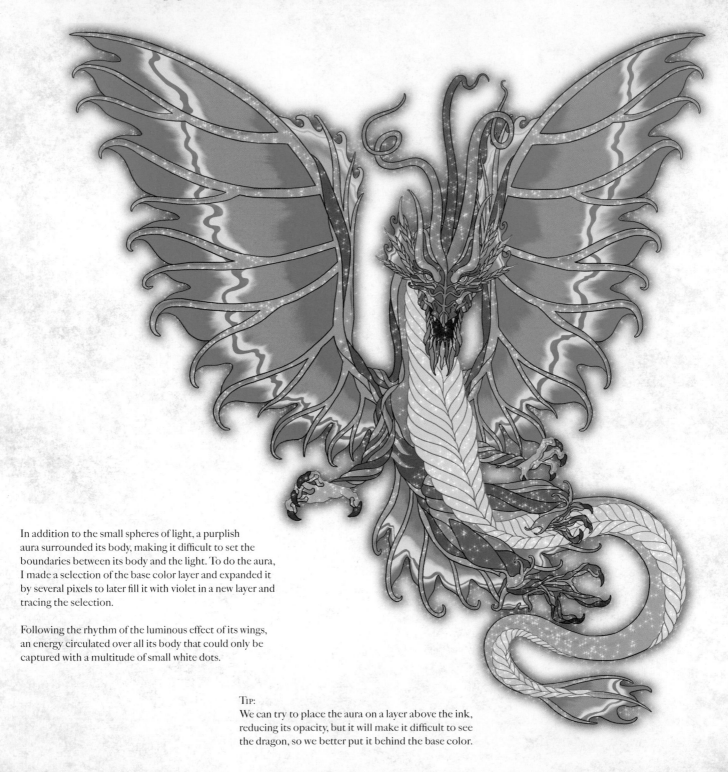

In addition to the small spheres of light, a purplish aura surrounded its body, making it difficult to set the boundaries between its body and the light. To do the aura, I made a selection of the base color layer and expanded it by several pixels to later fill it with violet in a new layer and tracing the selection.

Following the rhythm of the luminous effect of its wings, an energy circulated over all its body that could only be captured with a multitude of small white dots.

TIP:
We can try to place the aura on a layer above the ink, reducing its opacity, but it will make it difficult to see the dragon, so we better put it behind the base color.

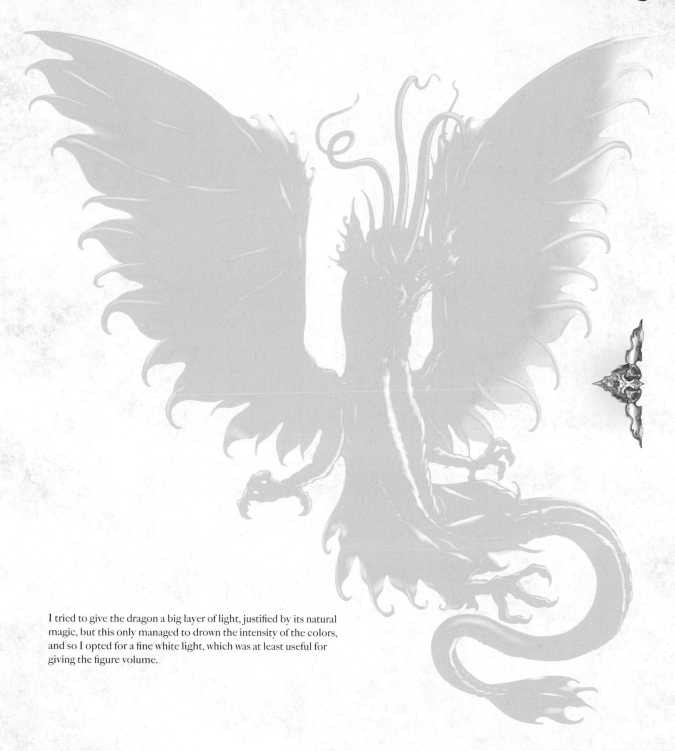

I tried to give the dragon a big layer of light, justified by its natural magic, but this only managed to drown the intensity of the colors, and so I opted for a fine white light, which was at least useful for giving the figure volume.

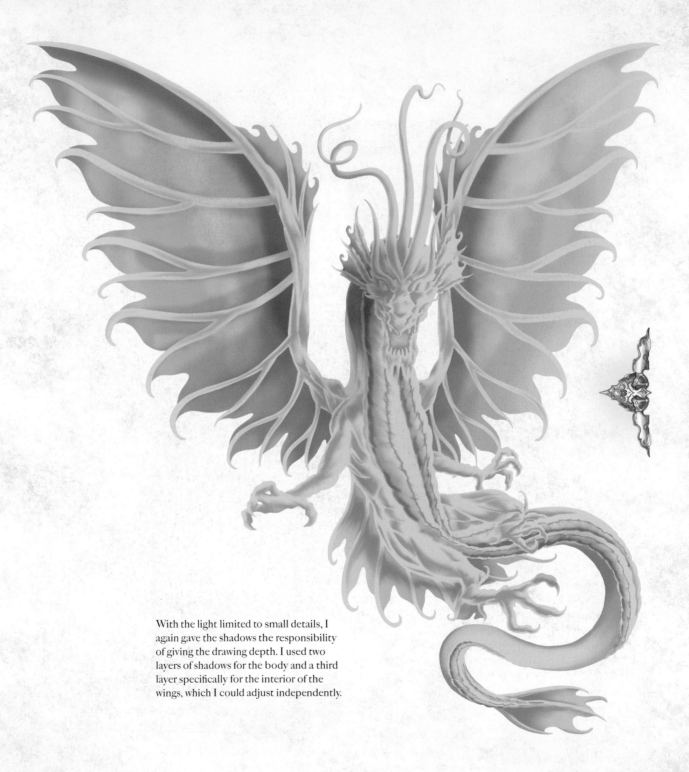

With the light limited to small details, I again gave the shadows the responsibility of giving the drawing depth. I used two layers of shadows for the body and a third layer specifically for the interior of the wings, which I could adjust independently.

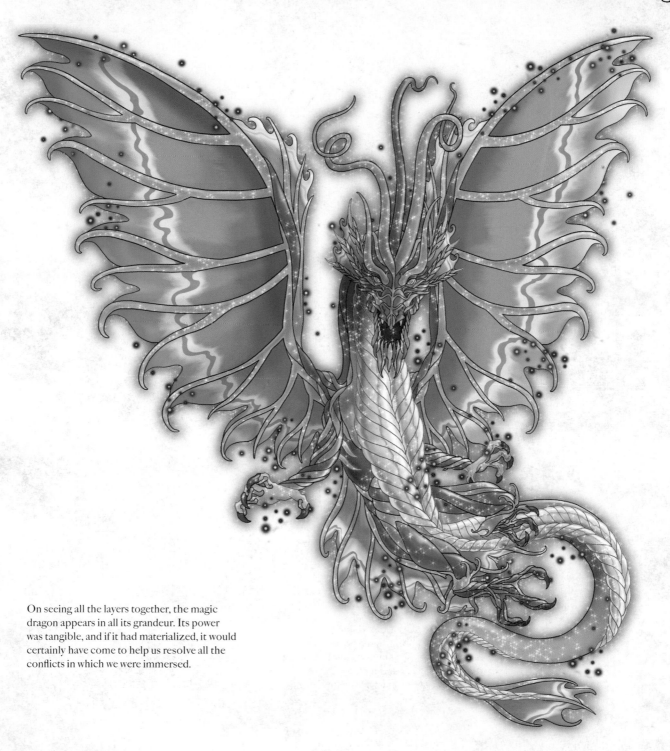

On seeing all the layers together, the magic dragon appears in all its grandeur. Its power was tangible, and if it had materialized, it would certainly have come to help us resolve all the conflicts in which we were immersed.

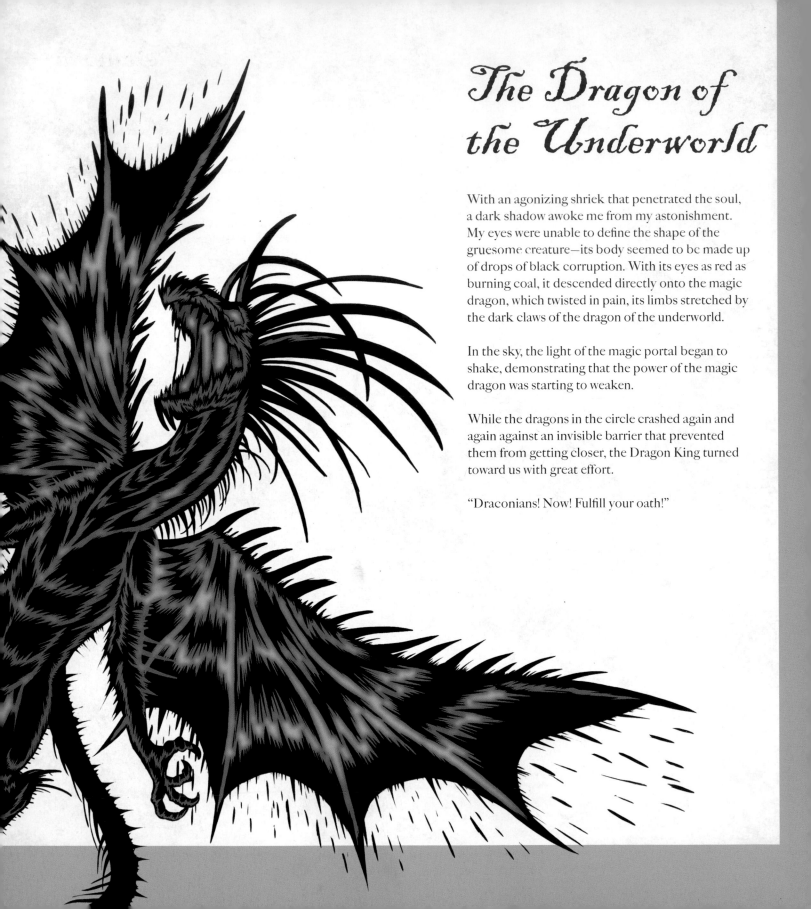

The Dragon of the Underworld

With an agonizing shriek that penetrated the soul, a dark shadow awoke me from my astonishment. My eyes were unable to define the shape of the gruesome creature—its body seemed to be made up of drops of black corruption. With its eyes as red as burning coal, it descended directly onto the magic dragon, which twisted in pain, its limbs stretched by the dark claws of the dragon of the underworld.

In the sky, the light of the magic portal began to shake, demonstrating that the power of the magic dragon was starting to weaken.

While the dragons in the circle crashed again and again against an invisible barrier that prevented them from getting closer, the Dragon King turned toward us with great effort.

"Draconians! Now! Fulfill your oath!"

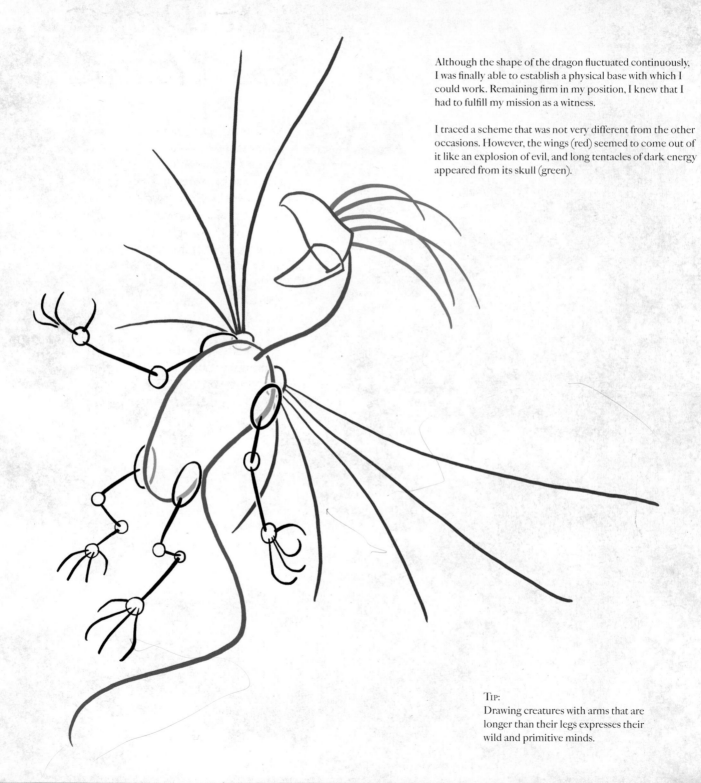

Although the shape of the dragon fluctuated continuously, I was finally able to establish a physical base with which I could work. Remaining firm in my position, I knew that I had to fulfill my mission as a witness.

I traced a scheme that was not very different from the other occasions. However, the wings (red) seemed to come out of it like an explosion of evil, and long tentacles of dark energy appeared from its skull (green).

TIP:
Drawing creatures with arms that are longer than their legs expresses their wild and primitive minds.

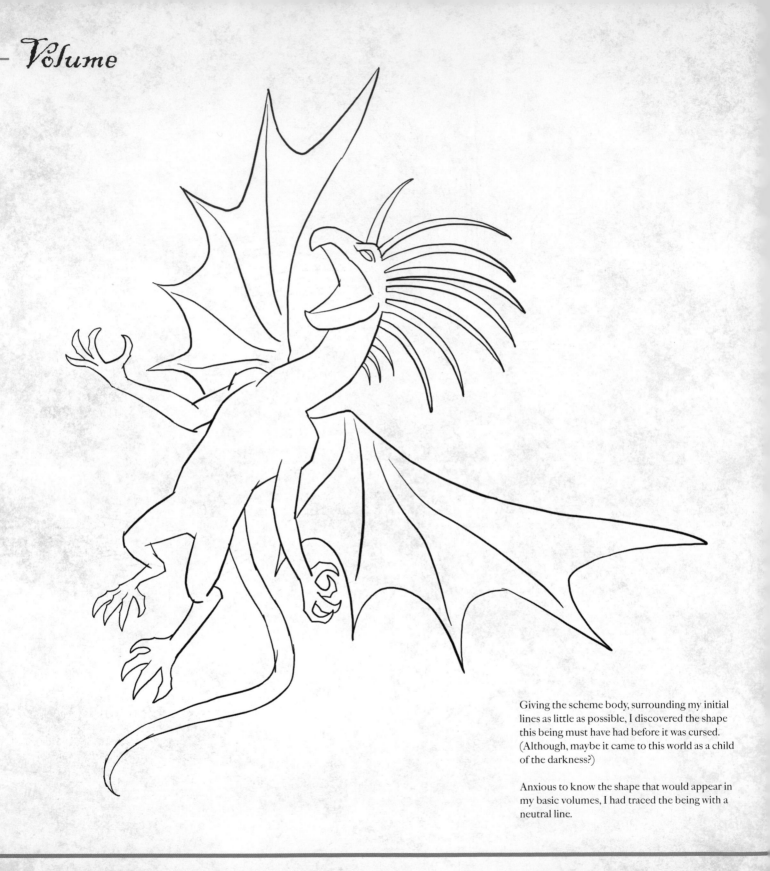

Giving the scheme body, surrounding my initial lines as little as possible, I discovered the shape this being must have had before it was cursed. (Although, maybe it came to this world as a child of the darkness?)

Anxious to know the shape that would appear in my basic volumes, I had traced the being with a neutral line.

Now I needed to make those ambiguous volumes come to life on my sheets as a creature of the underworld. I passed the pencil along my own lines, but I used pointed lines to try to give the sensation that the creature's body was exploding. I suggested its anatomy by using interior lines in zigzag formations.

Ink

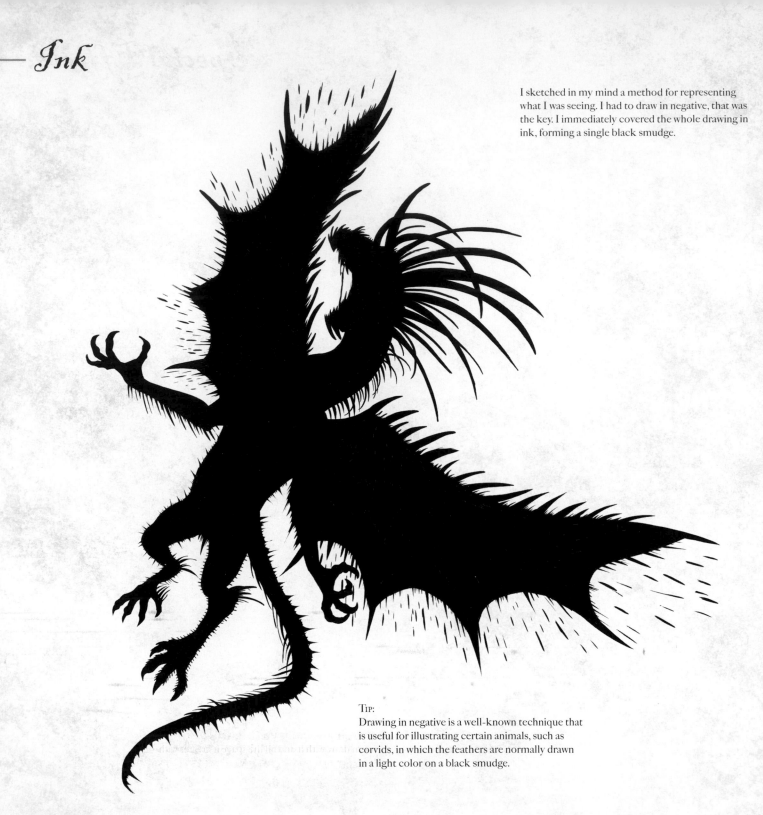

I sketched in my mind a method for representing what I was seeing. I had to draw in negative, that was the key. I immediately covered the whole drawing in ink, forming a single black smudge.

Tip:
Drawing in negative is a well-known technique that is useful for illustrating certain animals, such as corvids, in which the feathers are normally drawn in a light color on a black smudge.

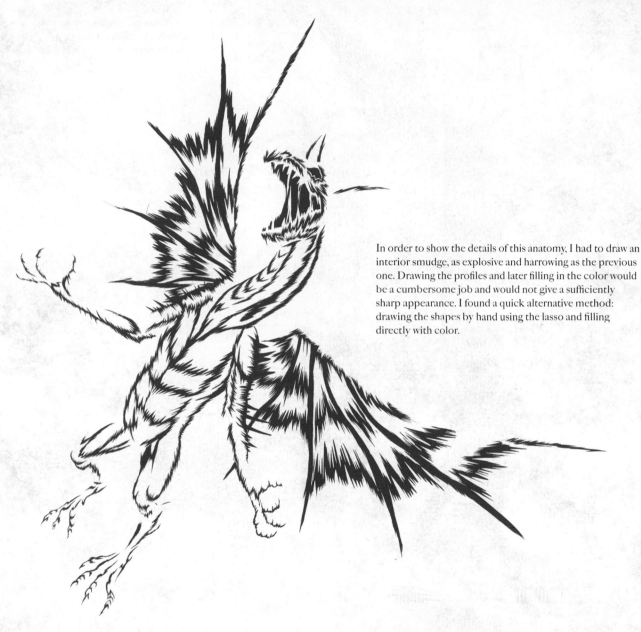

In order to show the details of this anatomy, I had to draw an interior smudge, as explosive and harrowing as the previous one. Drawing the profiles and later filling in the color would be a cumbersome job and would not give a sufficiently sharp appearance. I found a quick alternative method: drawing the shapes by hand using the lasso and filling directly with color.

Tip:
The lasso is a more versatile tool than it seems: we can draw with it and fill the space it creates with color or draw with it to eliminate a mass of color.

Base Color

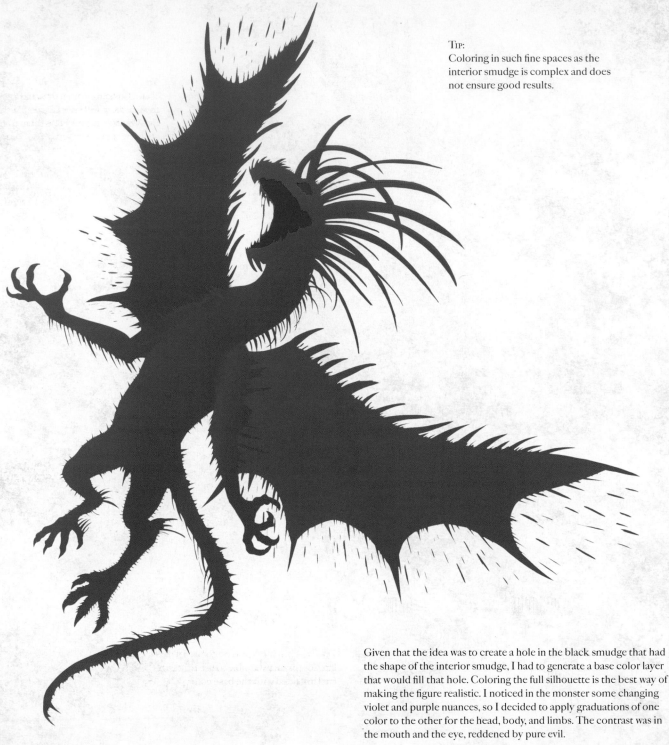

TIP:
Coloring in such fine spaces as the interior smudge is complex and does not ensure good results.

Given that the idea was to create a hole in the black smudge that had the shape of the interior smudge, I had to generate a base color layer that would fill that hole. Coloring the full silhouette is the best way of making the figure realistic. I noticed in the monster some changing violet and purple nuances, so I decided to apply graduations of one color to the other for the head, body, and limbs. The contrast was in the mouth and the eye, reddened by pure evil.

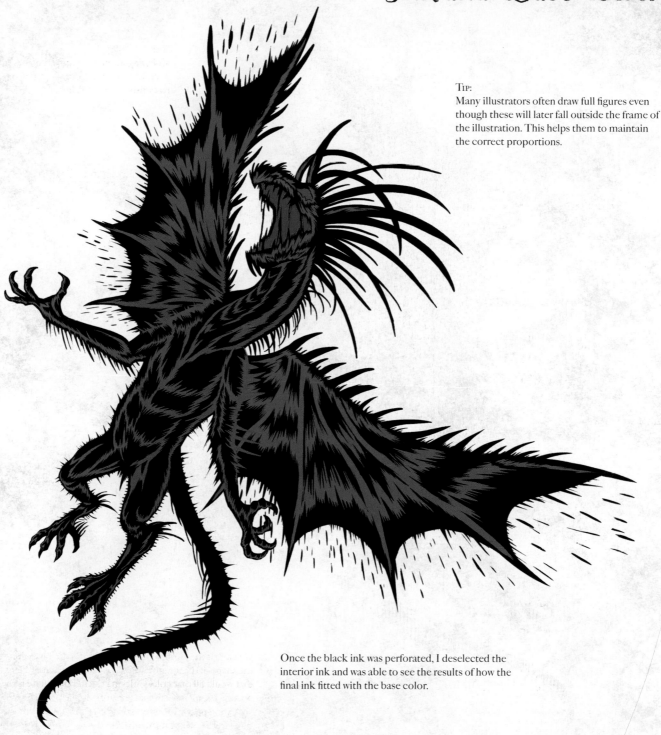

TIP:
Many illustrators often draw full figures even though these will later fall outside the frame of the illustration. This helps them to maintain the correct proportions.

Once the black ink was perforated, I deselected the interior ink and was able to see the results of how the final ink fitted with the base color.

Light

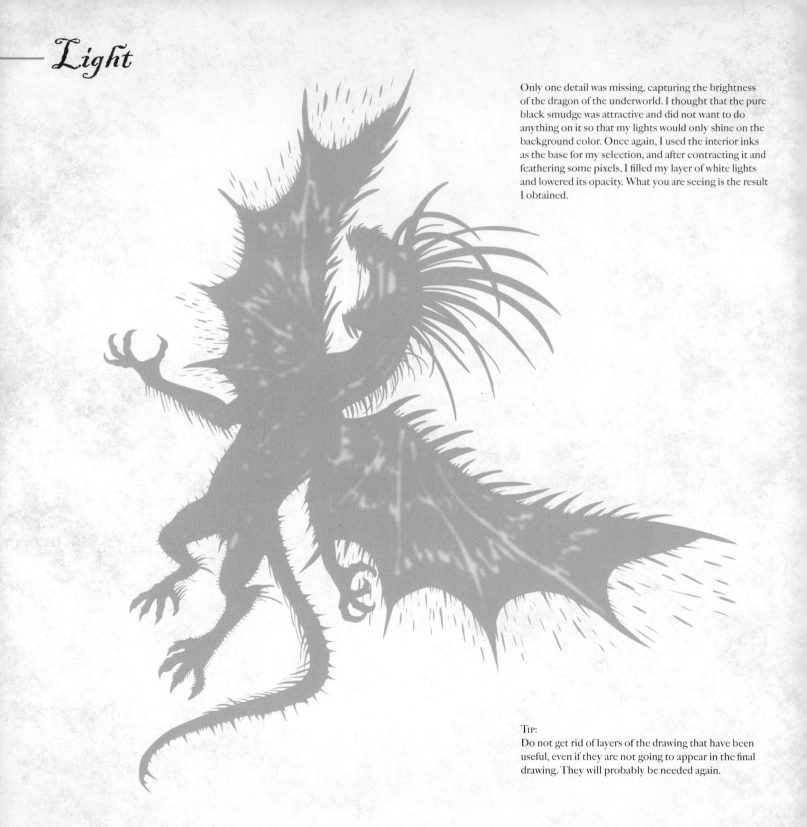

Only one detail was missing, capturing the brightness of the dragon of the underworld. I thought that the pure black smudge was attractive and did not want to do anything on it so that my lights would only shine on the background color. Once again, I used the interior inks as the base for my selection, and after contracting it and feathering some pixels, I filled my layer of white lights and lowered its opacity. What you are seeing is the result I obtained.

TIP:
Do not get rid of layers of the drawing that have been useful, even if they are not going to appear in the final drawing. They will probably be needed again.

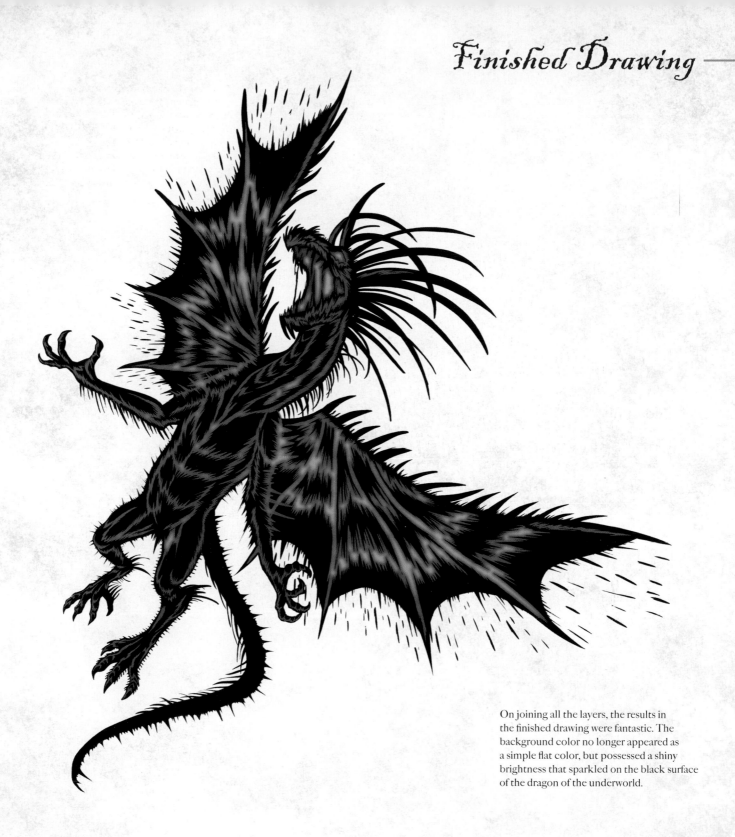

On joining all the layers, the results in the finished drawing were fantastic. The background color no longer appeared as a simple flat color, but possessed a shiny brightness that sparkled on the black surface of the dragon of the underworld.

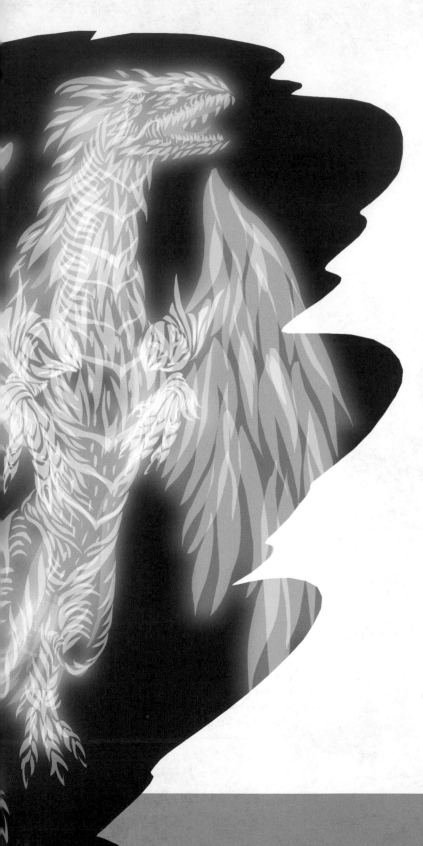

Spiritual Dragons

The draconians knelt down before the altar and joining their index and ring fingers they began to repeat a sort of mantra.

"Orthan fae tralsus mengaar."

"Orphan fae tralsus mengaar."

"ORTHAN FAE TRALSUS MENGAAR!"

Ghost-like shapes arose from their bodies, which fell to the ground like empty shells. The spiritual dragons surrounded the dragon of the underworld, revolving around it like specters of revenge, wounding it with fierce bites that seemed to tear off part of his being, while the dark dragon cried out infernal howls.

Then, when it seemed to be weakened, the spiritual dragons began to pass through it violently. Black rays emanated from the body of the dragon of the underworld, absorbing the light around them until at last there was total darkness, and the deafening roar, which had grown increasingly louder, was swallowed by the gorge of the earth.

The light returned slowly, and the air seemed denser. It was saturated with a fine mist and was accompanied by absolute silence. The dark dragon had disappeared. Before the altar, the bodies of the dead draconians once again took on human form. Without the spirits of the dragons that their bodies had housed, they cracked and turned into dust before my eyes.

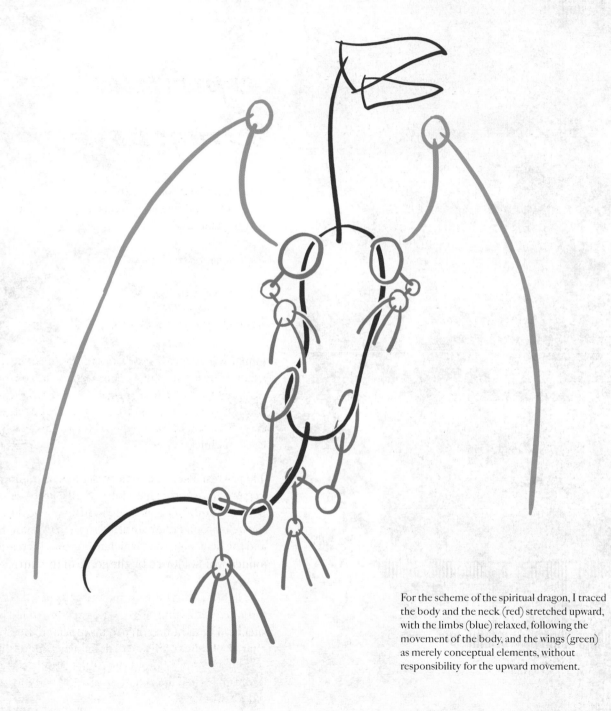

For the scheme of the spiritual dragon, I traced the body and the neck (red) stretched upward, with the limbs (blue) relaxed, following the movement of the body, and the wings (green) as merely conceptual elements, without responsibility for the upward movement.

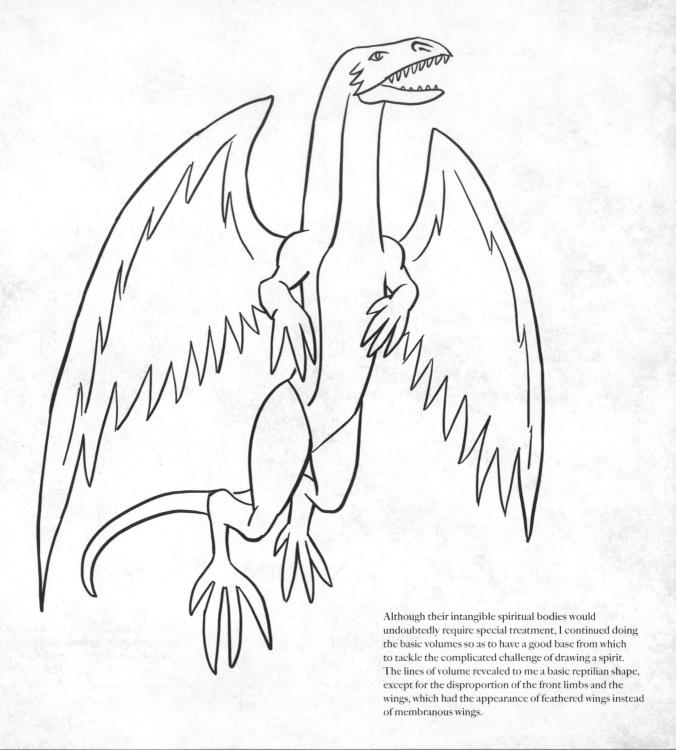

Although their intangible spiritual bodies would undoubtedly require special treatment, I continued doing the basic volumes so as to have a good base from which to tackle the complicated challenge of drawing a spirit. The lines of volume revealed to me a basic reptilian shape, except for the disproportion of the front limbs and the wings, which had the appearance of feathered wings instead of membranous wings.

TIP:
We have all, at one time or another, had to draw "blind" without knowing whether the route we were following would lead the illustration anywhere. But there is something that always happens: if we continue forward, sooner or later we find a signal to guide us.

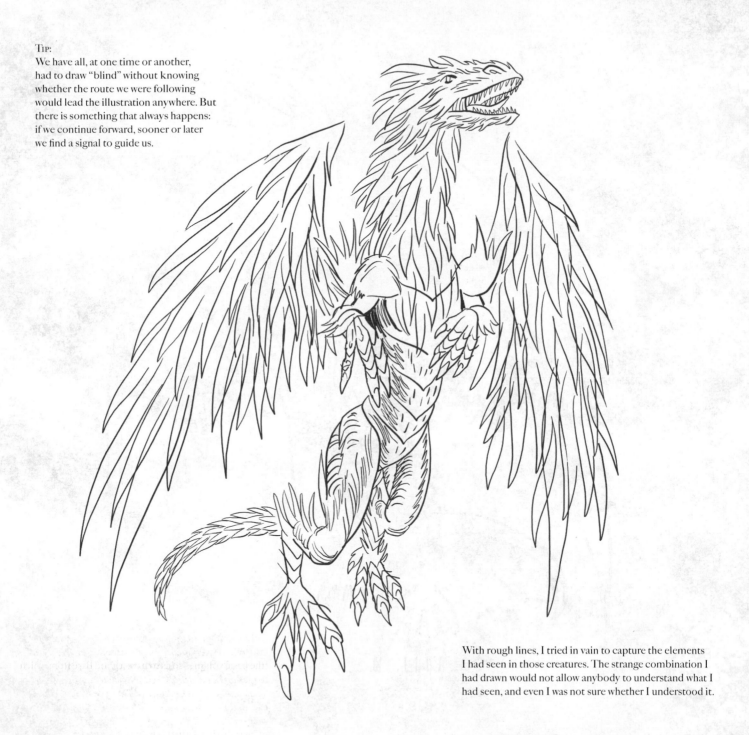

With rough lines, I tried in vain to capture the elements I had seen in those creatures. The strange combination I had drawn would not allow anybody to understand what I had seen, and even I was not sure whether I understood it.

Color

Maybe that was the key. If I could not find a solution in the stages that I was using again and again, maybe I had to go back further to change the start before the start: I had to change the base of my sheet. With a strong movement of my wrist, I drew a simple smudge, a cloud of color on which I redirected the illustration in a different direction.

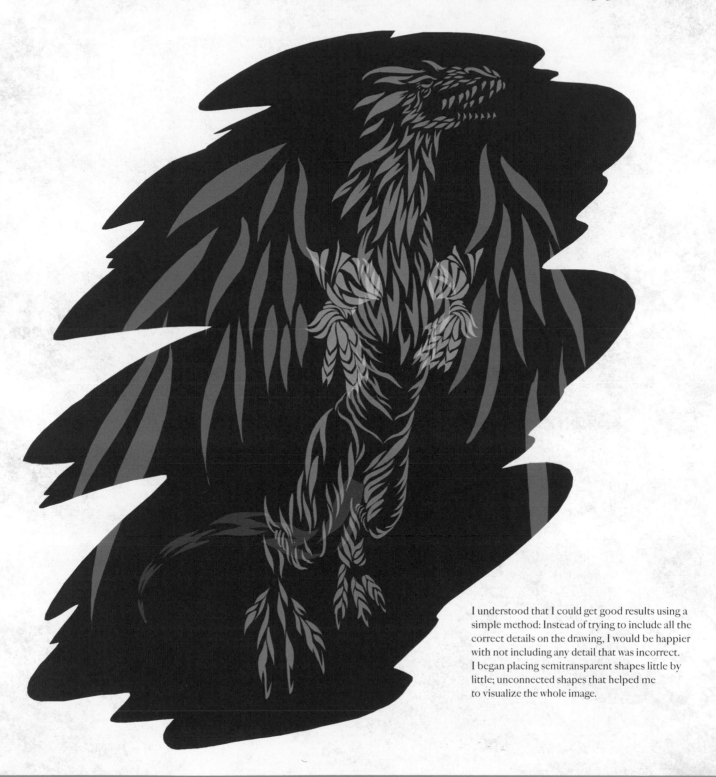

I understood that I could get good results using a simple method: Instead of trying to include all the correct details on the drawing, I would be happier with not including any detail that was incorrect. I began placing semitransparent shapes little by little; unconnected shapes that helped me to visualize the whole image.

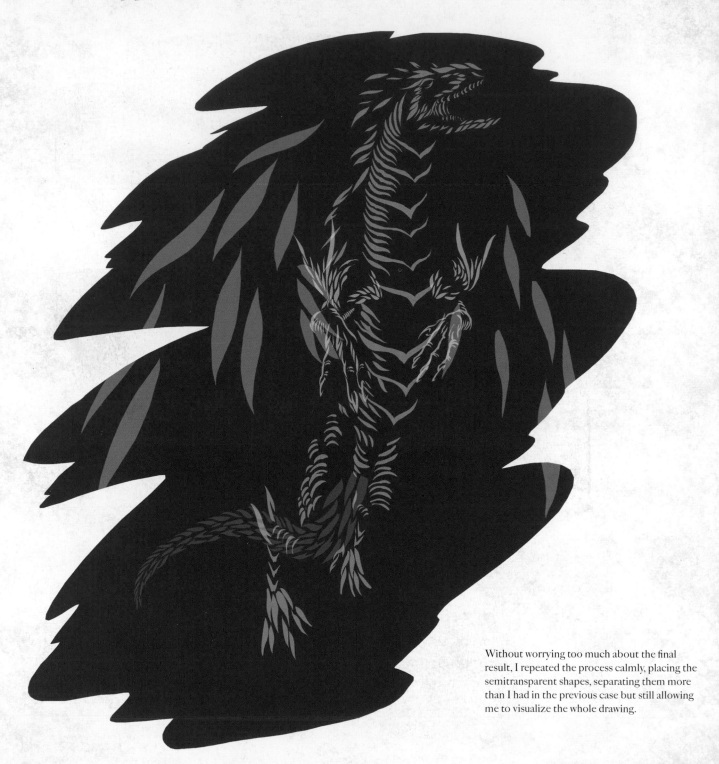

Without worrying too much about the final result, I repeated the process calmly, placing the semitransparent shapes, separating them more than I had in the previous case but still allowing me to visualize the whole drawing.

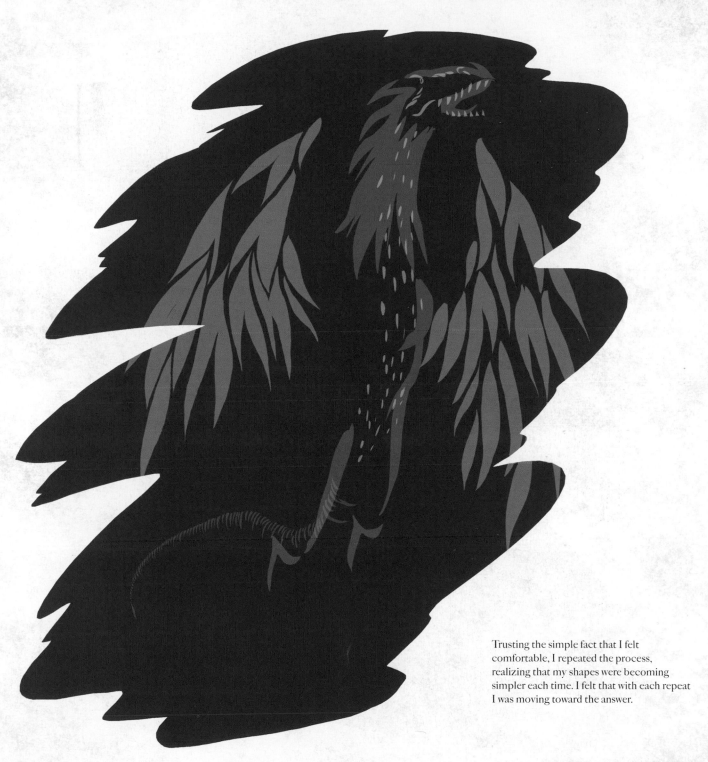

Trusting the simple fact that I felt comfortable, I repeated the process, realizing that my shapes were becoming simpler each time. I felt that with each repeat I was moving toward the answer.

For the fourth attempt, I tried to reach the essential. I selected the shapes that I had done in the pencil, and I passed the softest brush I had over the top, obtaining a diffuse and spectral shape, like an unfocused photograph of what I wanted to transmit.

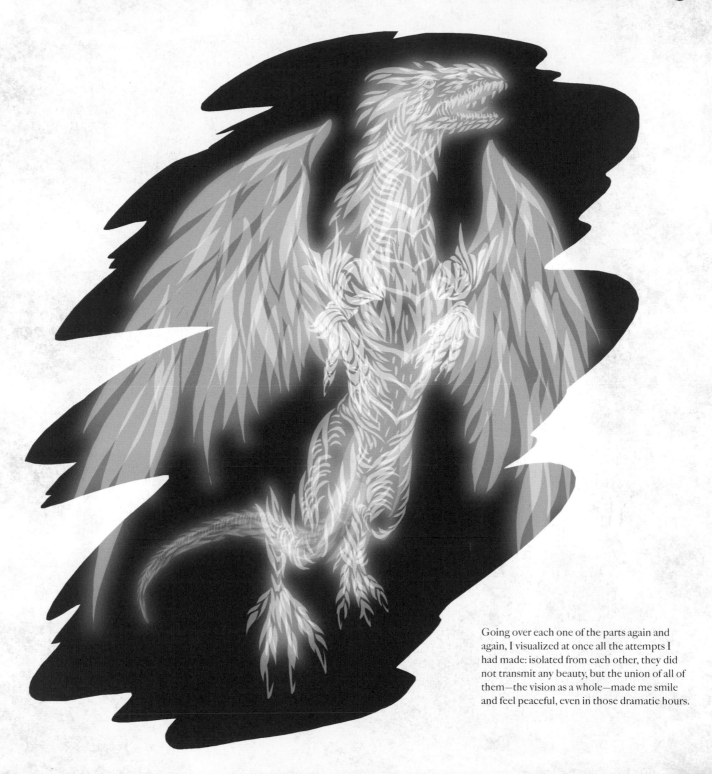

Going over each one of the parts again and again, I visualized at once all the attempts I had made: isolated from each other, they did not transmit any beauty, but the union of all of them—the vision as a whole—made me smile and feel peaceful, even in those dramatic hours.

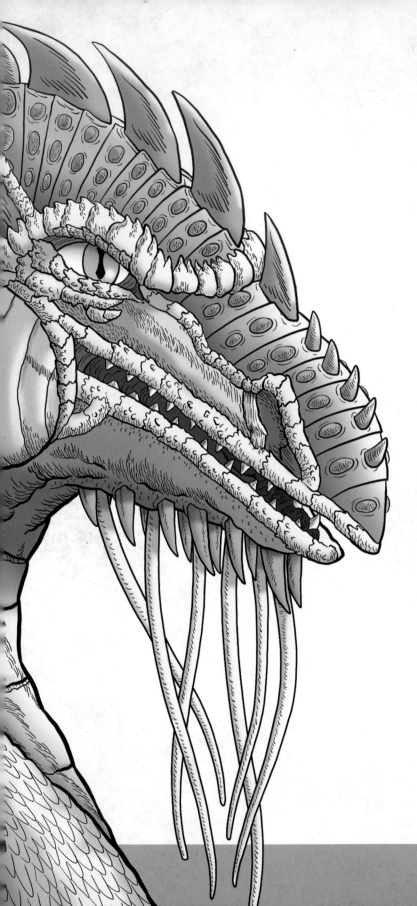

Wise Dragons

The magic dragon began to recover, and the portal once again shone brightly in the sky. The Dragon King left the circle and began to speak to all of those present.

"The danger has passed. Let the wise dragons come forward."

From a side tunnel, a large group of dragons entered the enormous chamber. Each of them went up to one of the humans, and two dragons we knew well came toward Thomas and me.

"Houlz! Arn!" I called out.

"Hello, Sergio," Houlz said.

Although it was to be expected that Houlz and Arn were also able to speak, my brain took a few moments to process it.

"What are you doing here? What is happening?" I asked in confusion. "I don't understand."

"Let me explain," Houlz began softly. "Dragons, as you see us now, are only three-dimensional manifestations of the universal force that maintains balance between the different levels of reality. Some dragons are no more than irrational creatures, generated by the wild nature of the planet as a response to human presence. Other dragons, even though they possess a developed intellect, do not understand the universal relationship that binds them to all living beings. Some of us do know. And that is why it is our responsibility to take the ultimate step toward strengthening the eternal flame that fosters all life and to once again put a stop to the advance of darkness.

The wise dragon that had accompanied Houlz and Arn was breathtaking, both because of its size and its appearance. The scheme foreground of the face reminded me of the one I had done for the Dragon King. I added some horns on the forehead (red) and some appendages are on the jaw (green) to check that the illustration had matched correctly.

TIP:
However much experience we have in the field of illustration, we should never underestimate the importance of the initial scheme. In fact, the opposite usually happens to veteran illustrators.

Volume

I did the basic volumes in blue, including, as I had done with the Dragon King, more details than usual. The "foreground effect" was repeated. I suggested other details such as a segmented armored skin (red) or the covered area of scales (green).

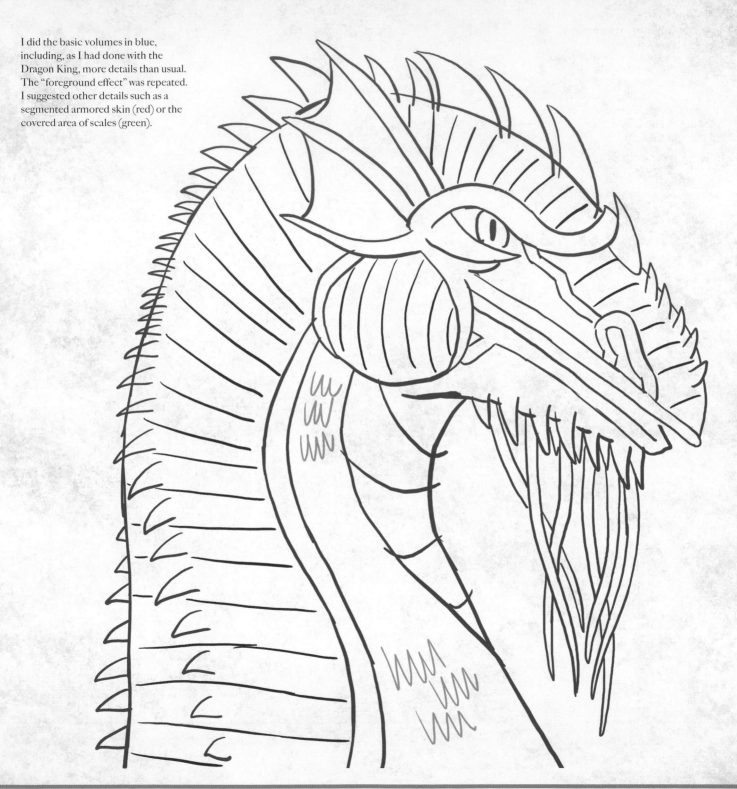

I felt very tired. I faced the pencil with renewed enthusiasm after the appearance of Houlz and Arn. Several rows of spines covered the snout, forehead, and back on its segmented armored skin, and among the spines on its jaw, some appendages appeared that gave it a solemn appearance. Behind its eyes, a small membranous fin folded back occasionally, only to immediately open up again.

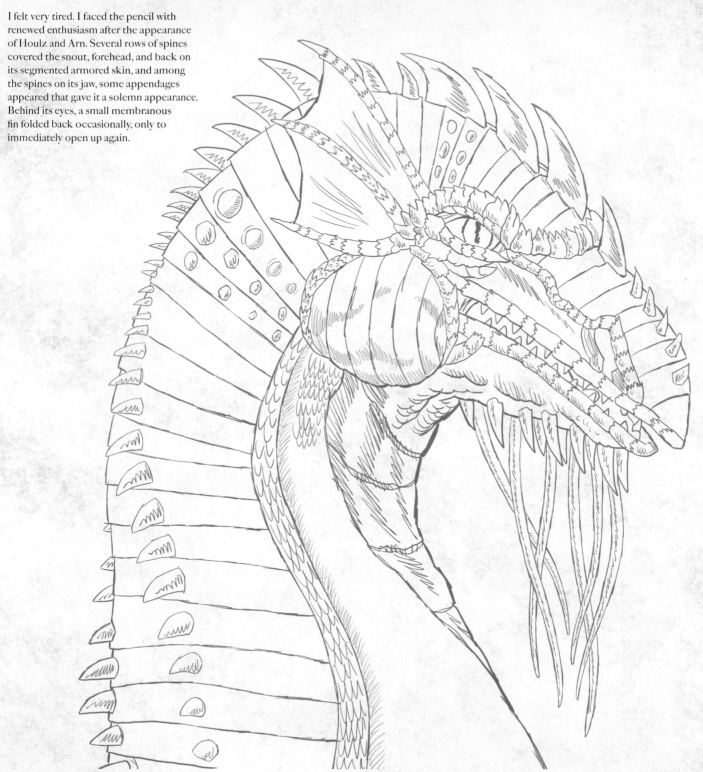

Ink

In order to represent the large size of
the wise dragon, I used thicker inks than
I usually do for the main outlines and
smaller inks than I usually do for the
details. The lines of this soft skin were
more rounded and creased, accompanied
by many details, while the lines of the
armored skin were straight and without
smaller surrounding inks.

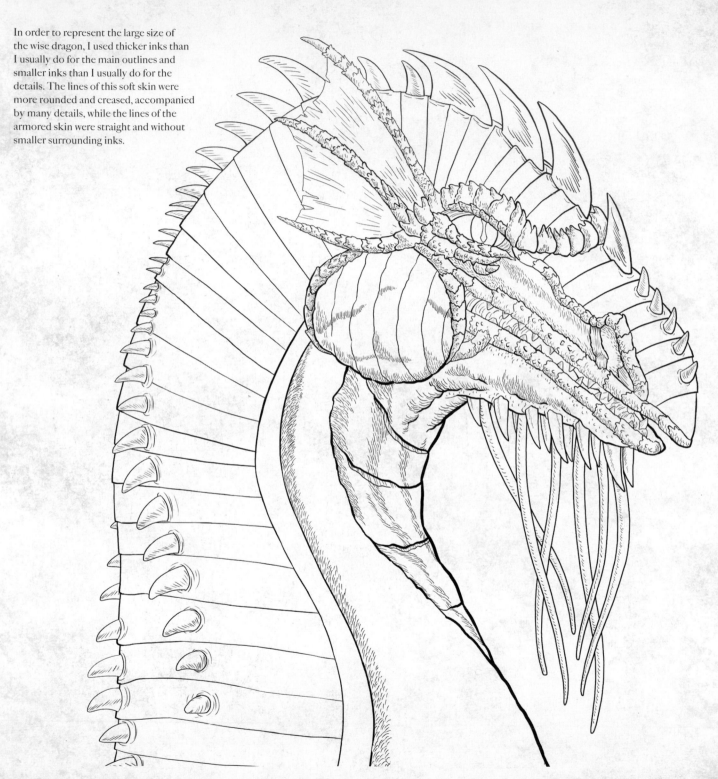

The patient addition of each one of the rounded plaques of the neck, as well as the small scales, gave the final touch to the exuberant ink.

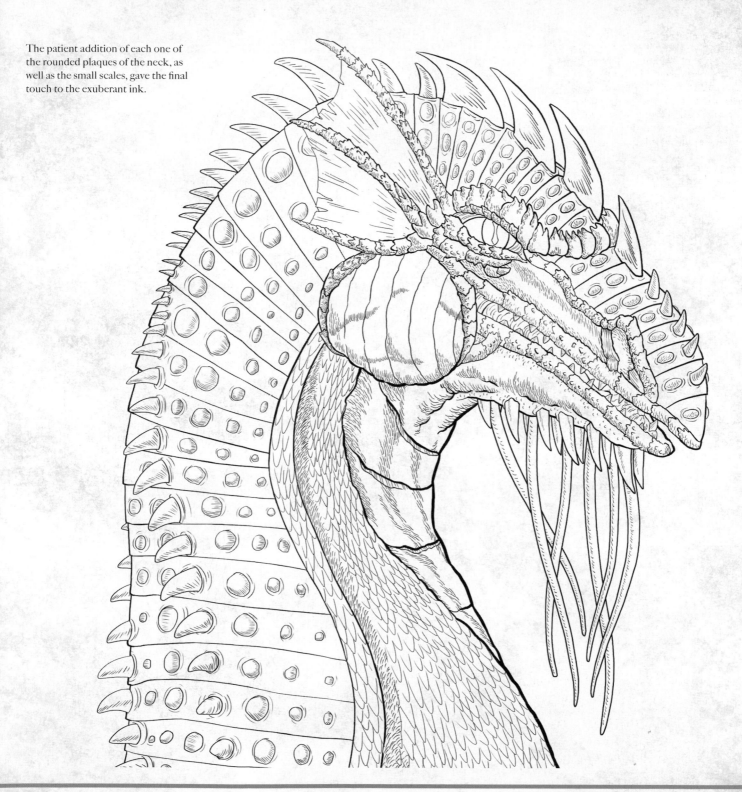

Base Color

The skin of the wise dragon only had one color, which was spread over its whole body, except for some of the many plaques that adorned its face and that had a coral appearance and were very pale. On doing the base colors, I noticed that the tones of the spines varied slightly. The points of contrast were only the eyelids and the tongue.

TIP:
Small variations in the tone of a color may be very useful for automatic selections.

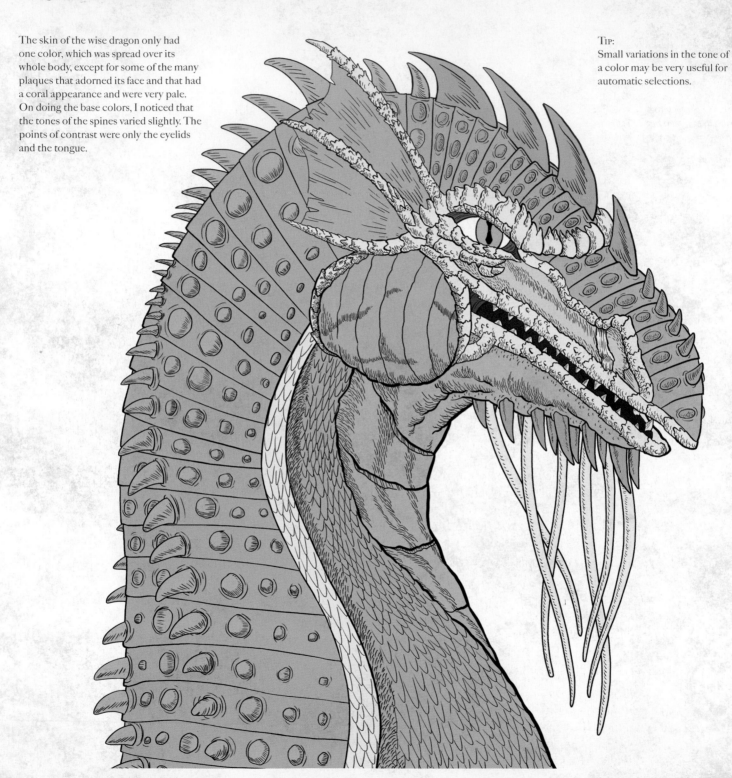

As I had to keep the blue tongue of the scheme, I could not extend the lights too much since this would make it appear overly pale. In any event, I placed the source of light opposite the face to help visualize the character, and I traced a few lines with high opacity on my layer of white.

Shadow

I used two layers of shadows that were extended and fairly well defined, which also provided solidity and volume and intensified the armored appearance of the dragon.

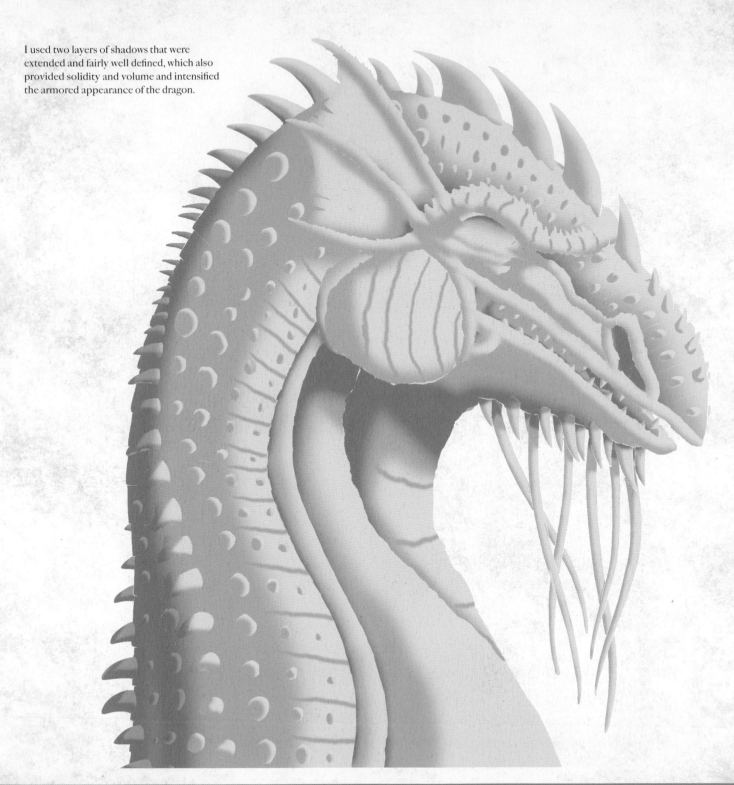

I tried coloring the inks, giving them a blue tone, but I came up against an unexpected problem: the sky blue color of these inks gave it a snow-like appearance and weakened its emphatic presence. With the black inks, the armored dragon appeared imposing, so I left them in the finished drawing.

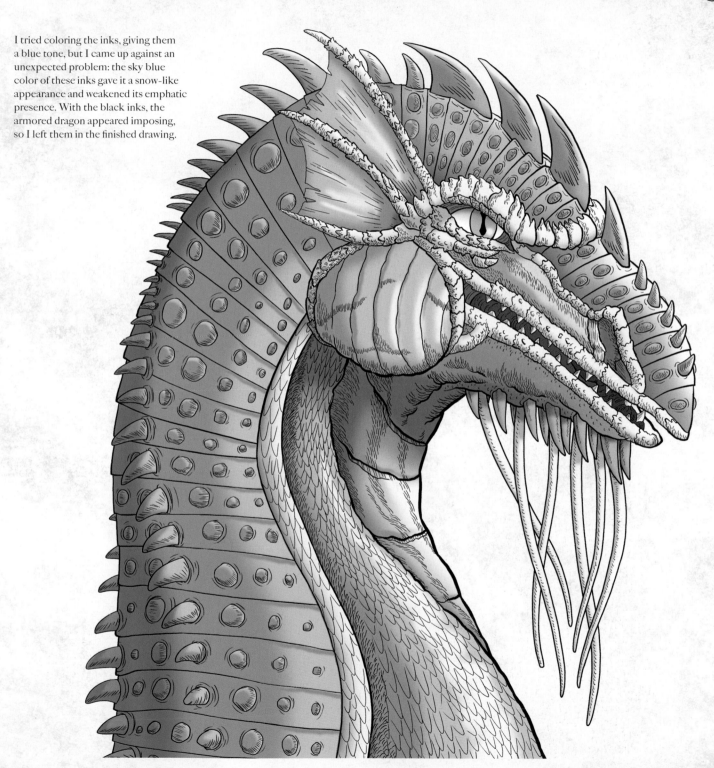

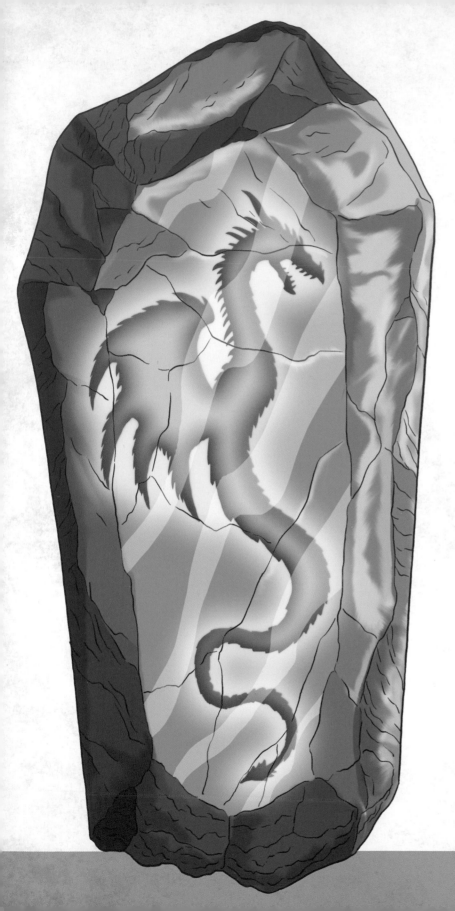

The Origin of the Dragons

"I don't understand what our role is in all of this," I said with a shaking voice.

"Sergio," Houlz said quietly, "When there is a threat that may alter the balance between levels, the Üru dragons seek the help of humans to defend that balance. It has been this way for thousands of years, and it is happening once again. We cannot remain at this level for a long time, and we cannot strengthen the weakened eternal flame on our own. We depend on you to take the definitive step. That is why we have brought you here. As each one of us has done, I have chosen my human avatar, and that avatar is you. We must join together to become one.

"And if we refused, what would happen?"

"The dragon of the underworld has not been destroyed; it has only been returned to the infernal place from which it came. If we do not fulfill our destiny, it will come back again and again. It will attack ceaselessly until it has destroyed the magic dragon and the Dragon King. In the outside world, humans and Üru dragons are still resisting, but in a short time, nothing will be able to stop the advance of darkness. Your species—your planet—will be wiped out. The path I offer you is the only path.

"It has been this way for thousands of years, and it is happening once again," Houlz had said. I turned to look at the stone, and it seemed that the silhouette of a dragon was shining inside it. I did the scheme of the stone in two parts: in one part, the external rock (green); and for the other part, the internal silhouette (red).

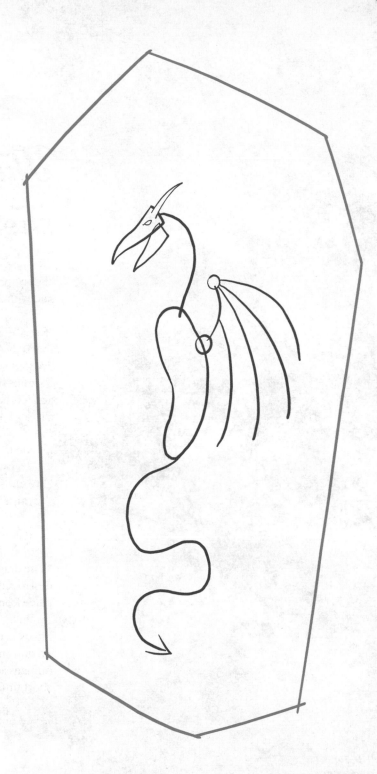

Volume

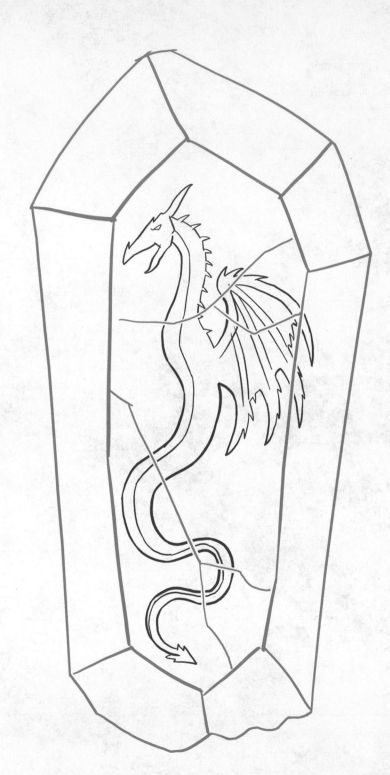

Afterward, maintaining the color guide, I divided the scheme of the rock into its main facets, strengthening my basic volumes with the two biggest cracks I saw in its main facet. On the inside, based on my own scheme, I drew some of the anatomical lines that would correspond to the mysterious silhouette.

With the greater number of details in the pencil, the stone lost its bejeweled appearance and once again took on a rocky consistency. By simple intuition, I developed a more detailed anatomy for the interior dragon to put that part of the illustration at the same level as the rest.

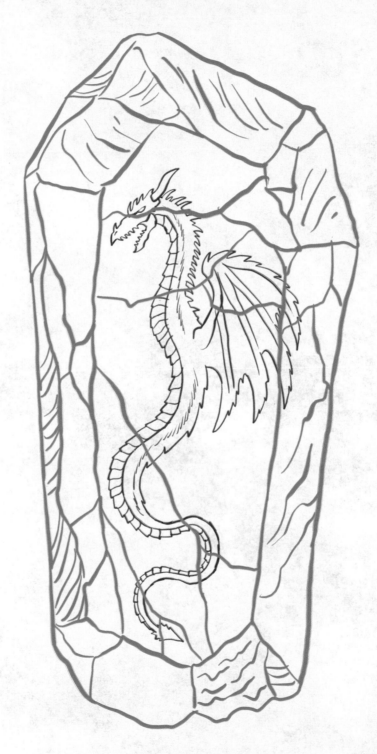

Smudge

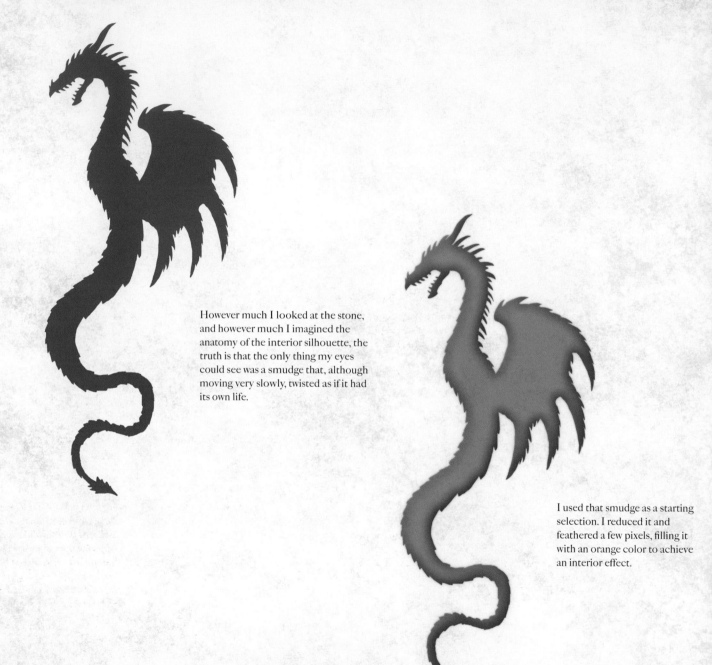

However much I looked at the stone, and however much I imagined the anatomy of the interior silhouette, the truth is that the only thing my eyes could see was a smudge that, although moving very slowly, twisted as if it had its own life.

I used that smudge as a starting selection. I reduced it and feathered a few pixels, filling it with an orange color to achieve an interior effect.

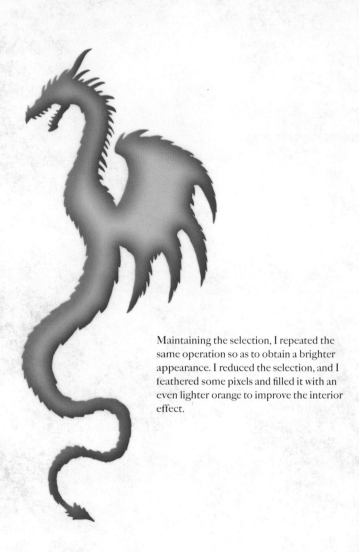

Maintaining the selection, I repeated the same operation so as to obtain a brighter appearance. I reduced the selection, and I feathered some pixels and filled it with an even lighter orange to improve the interior effect.

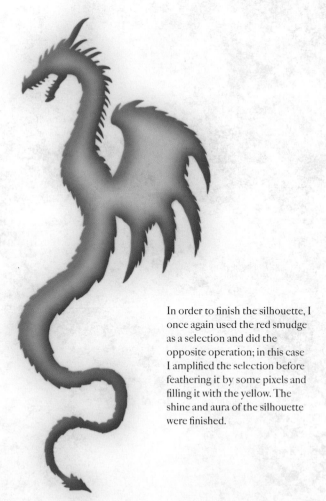

In order to finish the silhouette, I once again used the red smudge as a selection and did the opposite operation; in this case I amplified the selection before feathering it by some pixels and filling it with the yellow. The shine and aura of the silhouette were finished.

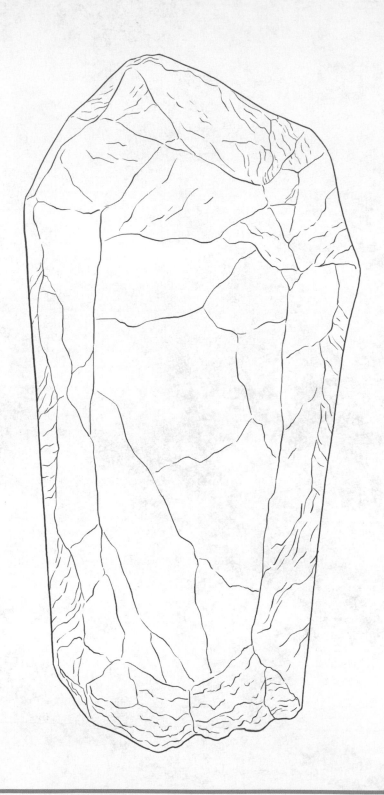

Now that the interior part of the stone was prepared, I again focused on the outer part. I formed the outline of the rock with a thicker ink, and later inked the interior lines. The smaller the detail, the more rugged my line.

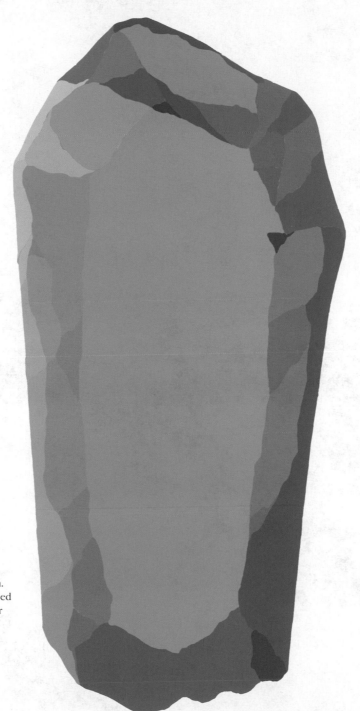

The stone had only one base color: green.
Placing the source of light to my left, I used
different tones of green for the base color
in order to give volume and depth.

Light

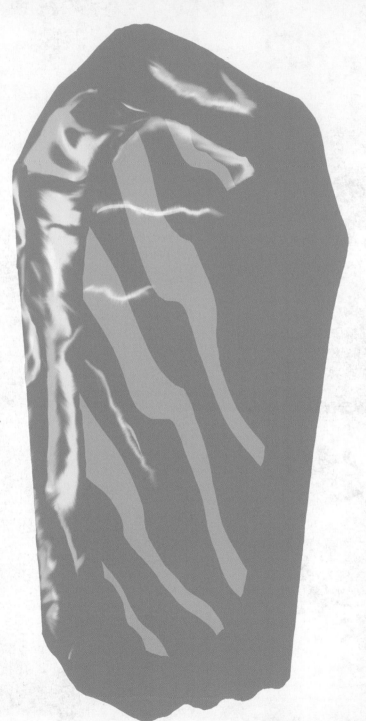

I used two different layers for the lights stage: In the layer that is more transparent and defined, I traced the three main glows of the smooth central facet. In the second layer, which was more opaque and softened, I included the brightness of the cracks and the sharper sides. The lights accumulated on the side of the source of light.

Shadow

I also used two layers to reproduce the shadows. As is usual, one was more transparent and extensive and the second was more opaque (from the sum of opacities) and smaller. The shadows accumulated on the opposite side of the source of light.

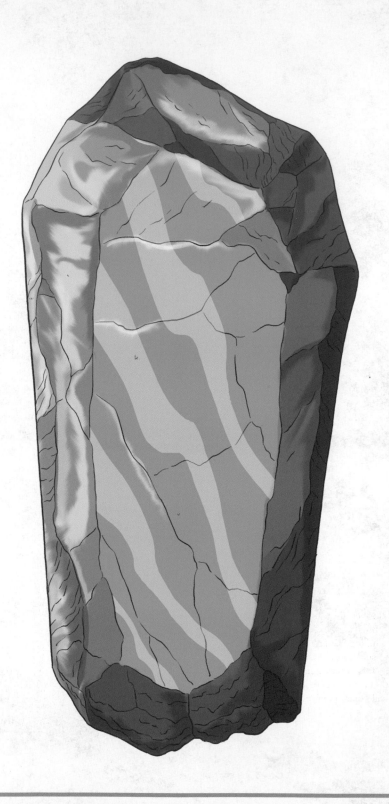

I colored the ink dark green, which
brought the appearance of the stone closer
to its bejeweled nature. This was the most
precious stone I had ever seen.

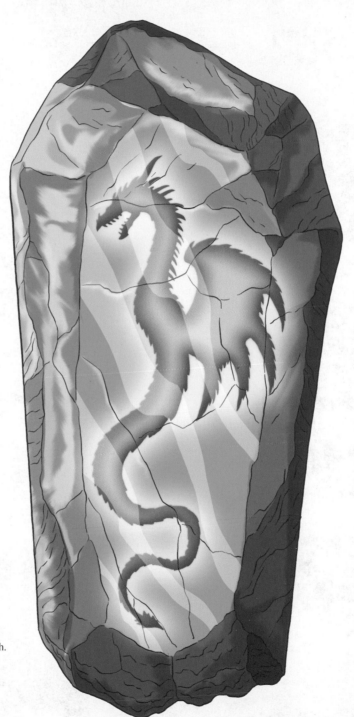

Whilst I looked at the finished drawing, Houlz approached me once again. "That is the source of our power," Houlz said, "an aspect of primary energy searching for allies through the cosmos, which was finally able to be heard on Earth. A miniscule spark of life able to generate entire races."

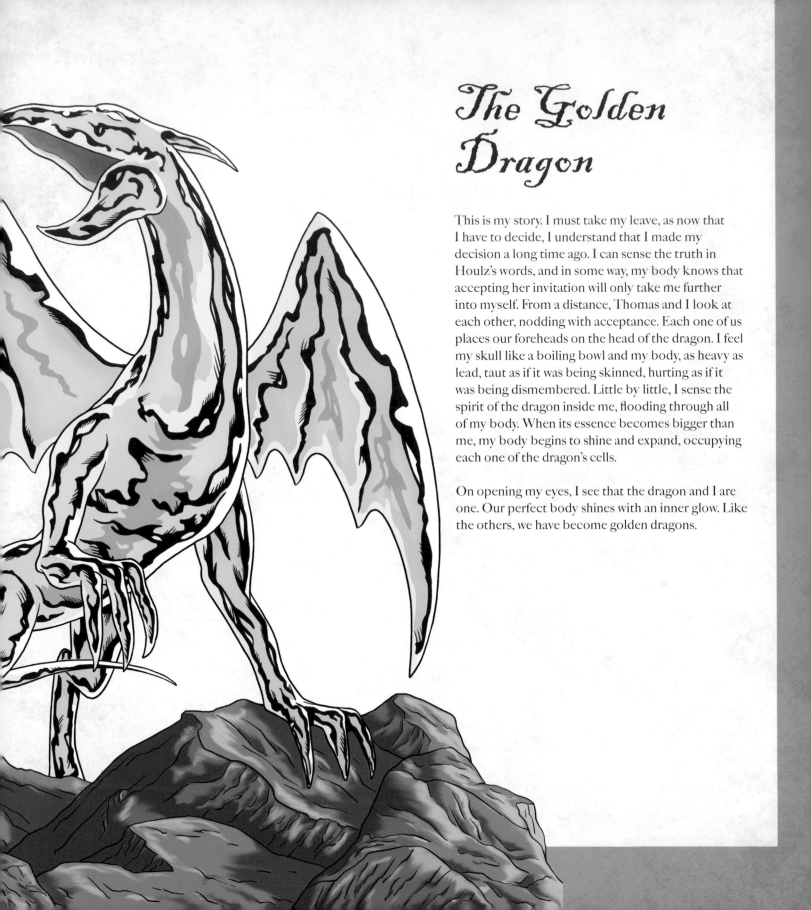

The Golden Dragon

This is my story. I must take my leave, as now that I have to decide, I understand that I made my decision a long time ago. I can sense the truth in Houlz's words, and in some way, my body knows that accepting her invitation will only take me further into myself. From a distance, Thomas and I look at each other, nodding with acceptance. Each one of us places our foreheads on the head of the dragon. I feel my skull like a boiling bowl and my body, as heavy as lead, taut as if it was being skinned, hurting as if it was being dismembered. Little by little, I sense the spirit of the dragon inside me, flooding through all of my body. When its essence becomes bigger than me, my body begins to shine and expand, occupying each one of the dragon's cells.

On opening my eyes, I see that the dragon and I are one. Our perfect body shines with an inner glow. Like the others, we have become golden dragons.

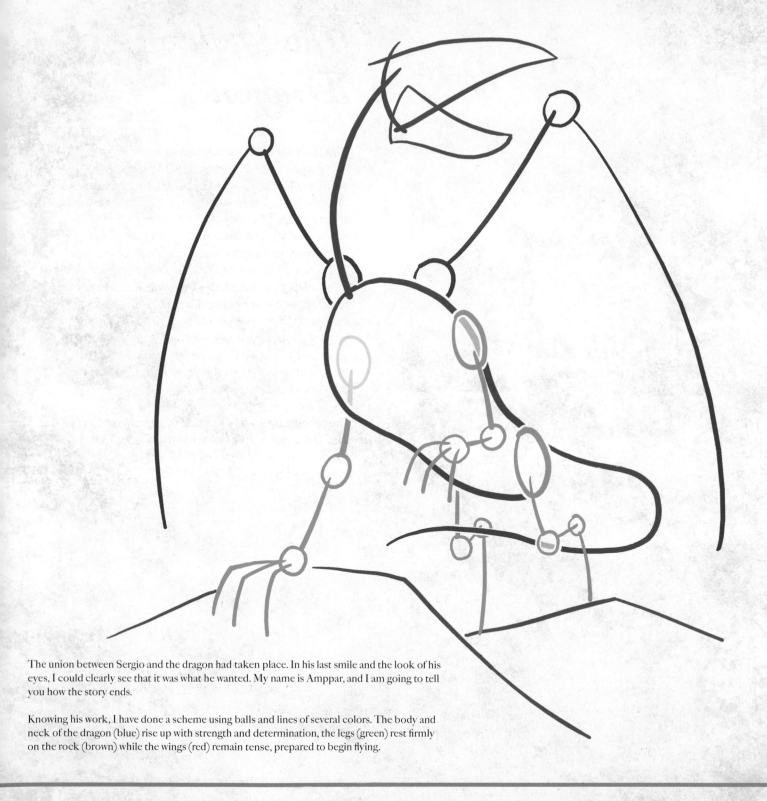

The union between Sergio and the dragon had taken place. In his last smile and the look of his eyes, I could clearly see that it was what he wanted. My name is Amppar, and I am going to tell you how the story ends.

Knowing his work, I have done a scheme using balls and lines of several colors. The body and neck of the dragon (blue) rise up with strength and determination, the legs (green) rest firmly on the rock (brown) while the wings (red) remain tense, prepared to begin flying.

Volume

My angular volumes cover the lines of the scheme, aiming to be softer on the dragon and harder io the rocks.

With the pencil, I continue searching for that difference: the dragon with polished skin does not have many lines of detail. The wild rocks accumulate hard lines.

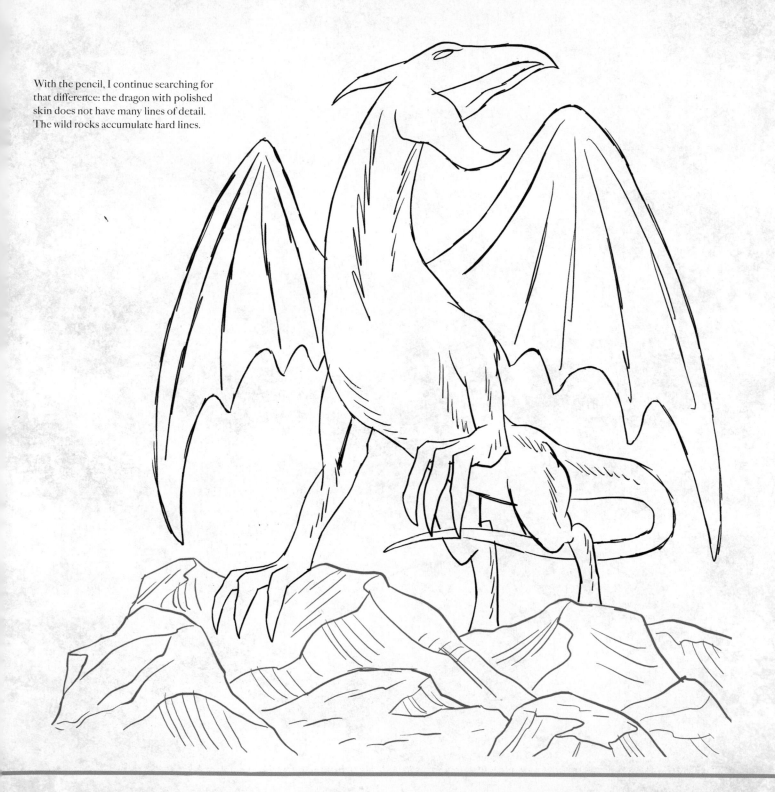

Ink

When I do the inks, I delete
all the interior lights of the
dragon, but I keep those of
the rocks.

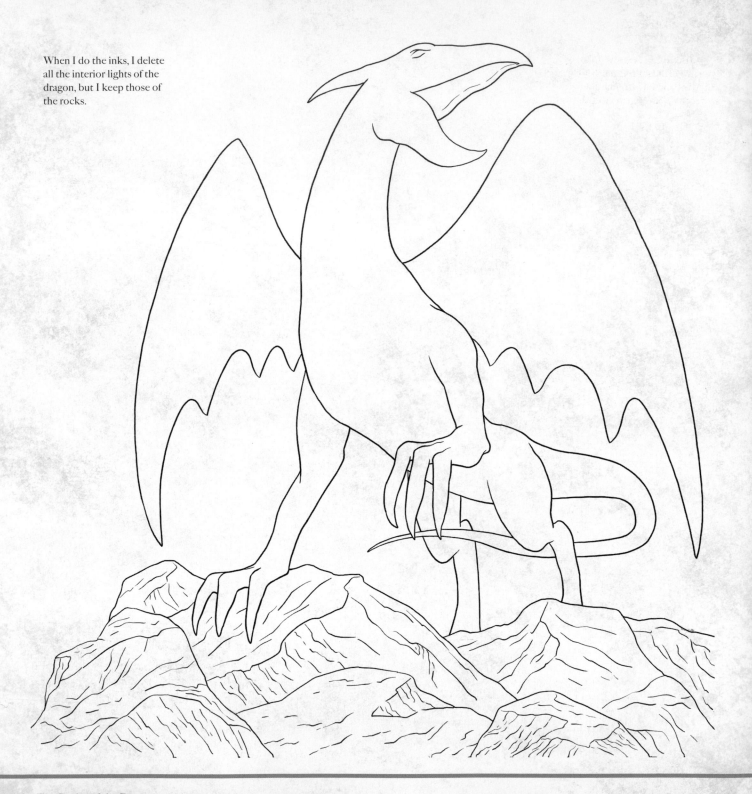

For the base colors, I use two tones of brown to highlight the main shots of the rocks, and I darken the gold in some areas of the dragon to give it more depth.

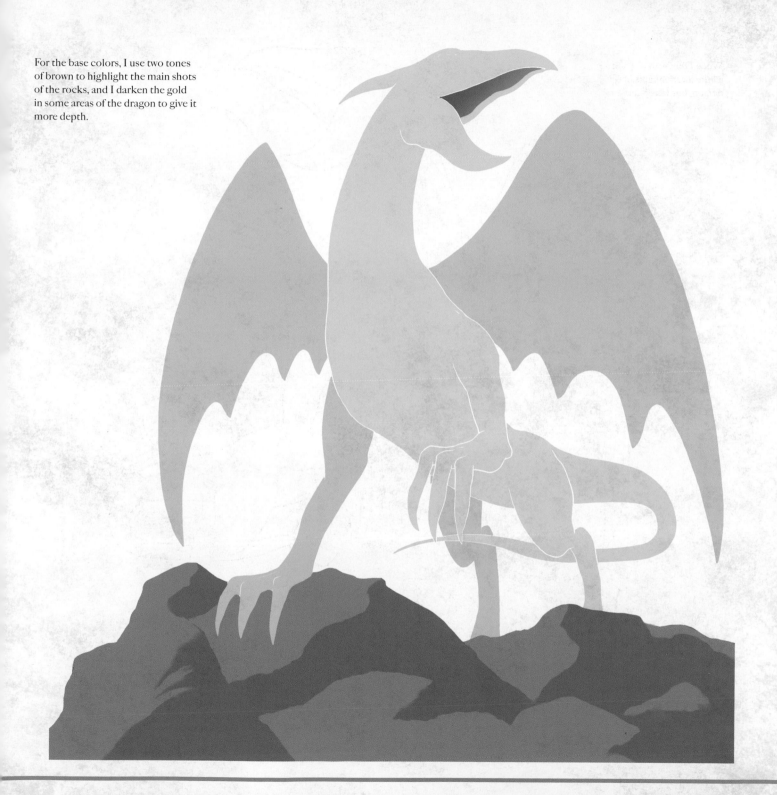

Light

I apply lights to the rocks, mainly in the most luminous spots.

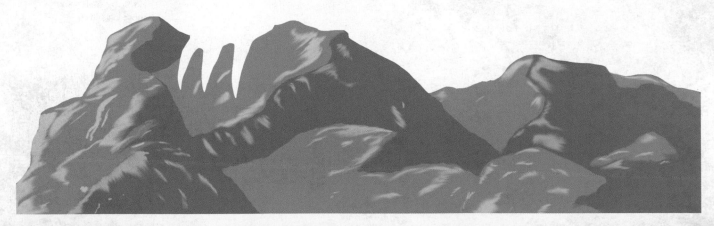

I apply the shadows in
both shots, but in the darker
spots the shadows are
more extensive.

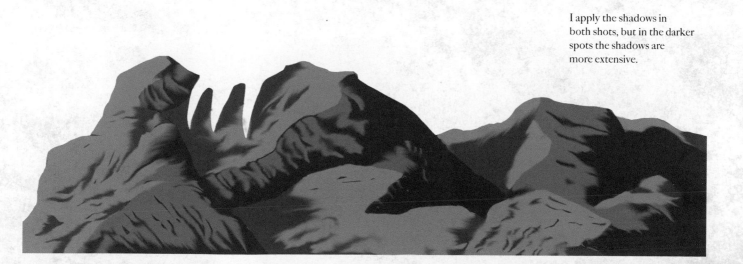

I give the dragon two layers of lights—one soft and blurred and the other strong and defined.

One single layer of shadows
provides volume in very
specific areas.

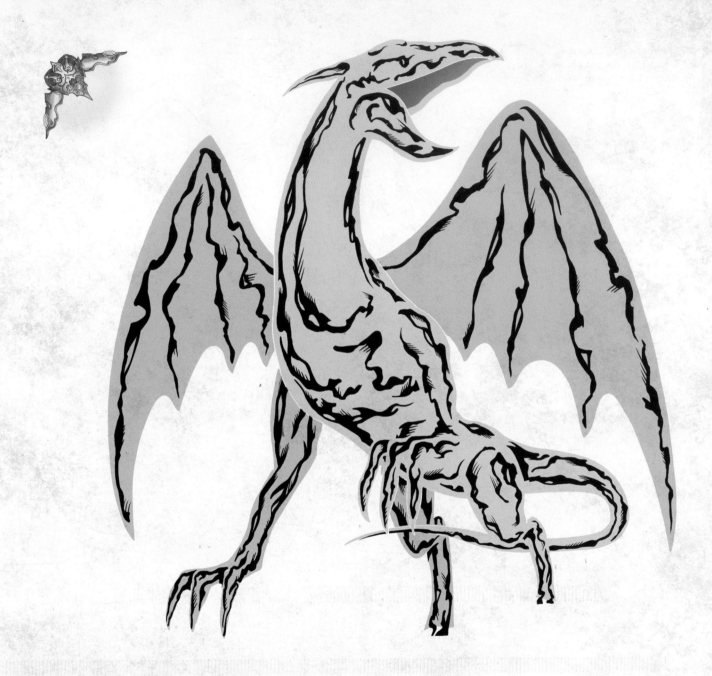

We use dark shadows, which are defined
and very sinuous. They are contrasted
to give the gold a metal appearance.

Now I have the finished drawing.
The golden dragon rose proudly on
the rock, and I knew Sergio was proud
of his decision.

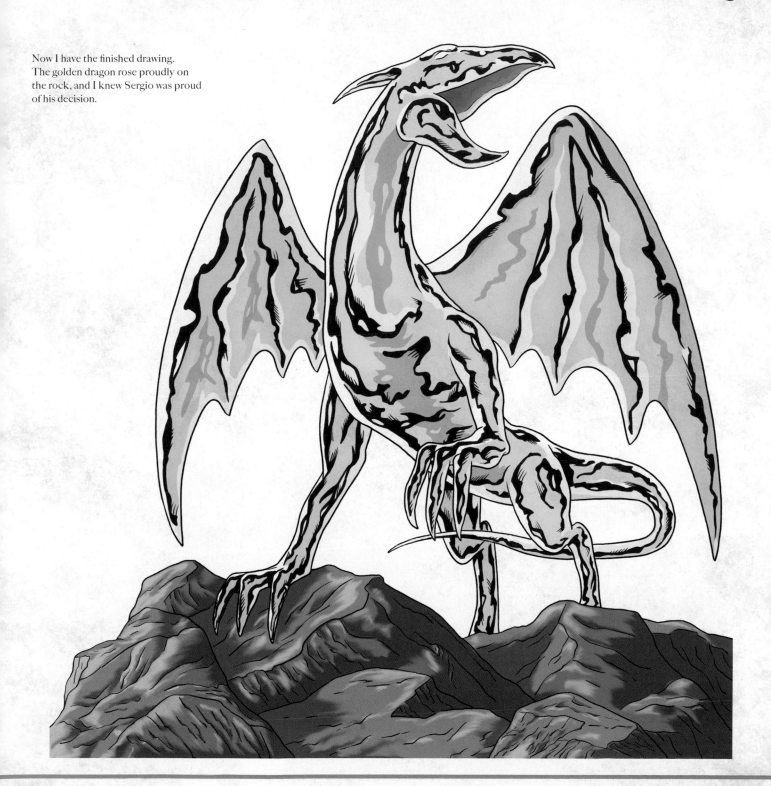

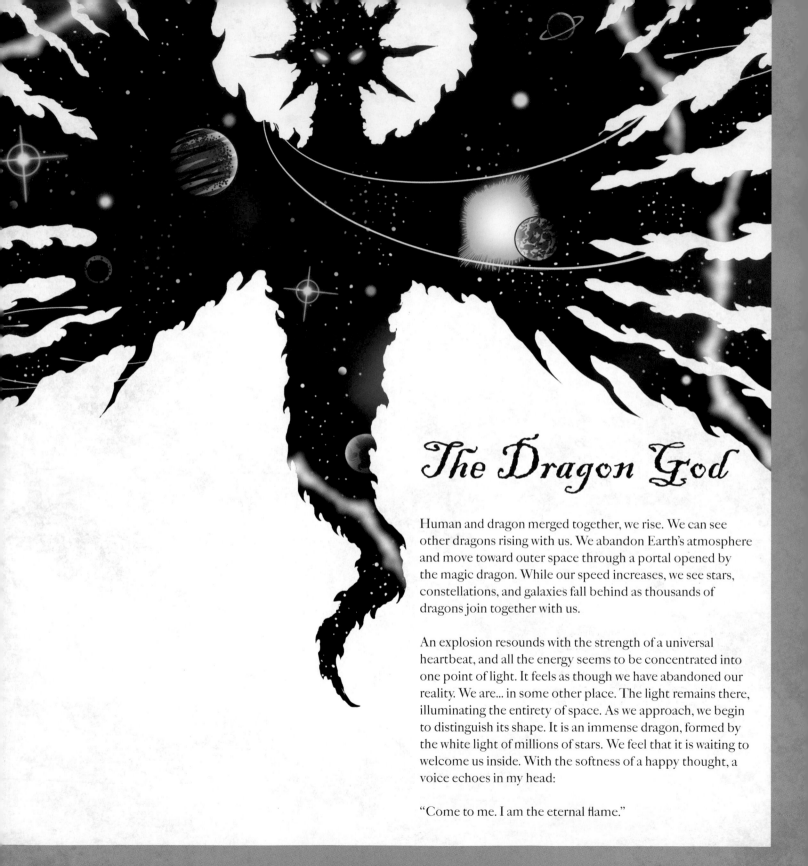

The Dragon God

Human and dragon merged together, we rise. We can see other dragons rising with us. We abandon Earth's atmosphere and move toward outer space through a portal opened by the magic dragon. While our speed increases, we see stars, constellations, and galaxies fall behind as thousands of dragons join together with us.

An explosion resounds with the strength of a universal heartbeat, and all the energy seems to be concentrated into one point of light. It feels as though we have abandoned our reality. We are... in some other place. The light remains there, illuminating the entirety of space. As we approach, we begin to distinguish its shape. It is an immense dragon, formed by the white light of millions of stars. We feel that it is waiting to welcome us inside. With the softness of a happy thought, a voice echoes in my head:

"Come to me. I am the eternal flame."

Sergio has gone and with him perhaps
our last hope of defeating evil. I should
feel sad, but I am strangely relieved. I still
receive unusual images—I seem to hear him
whispering in my ear. My hands scribbled a
scheme that my mind does not recognize.

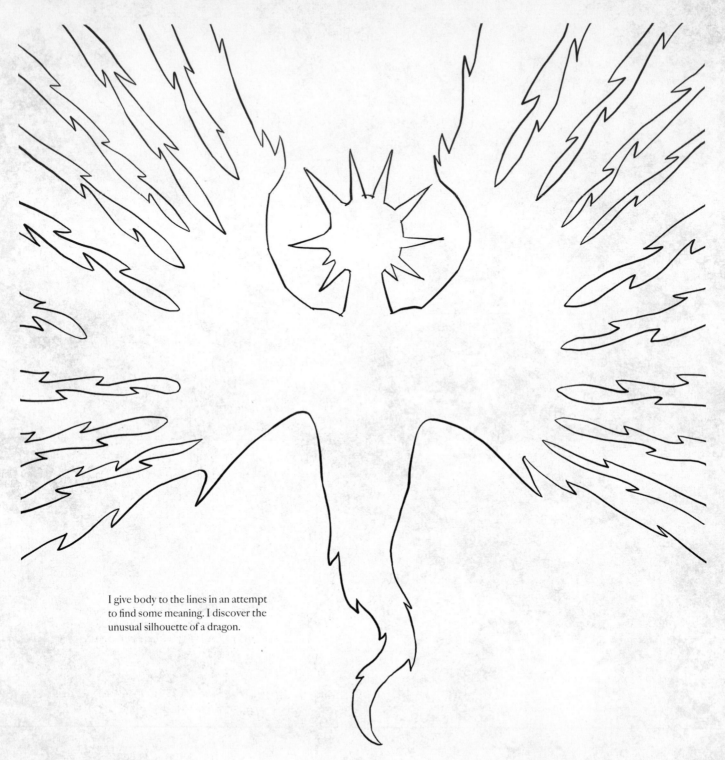

I give body to the lines in an attempt
to find some meaning. I discover the
unusual silhouette of a dragon.

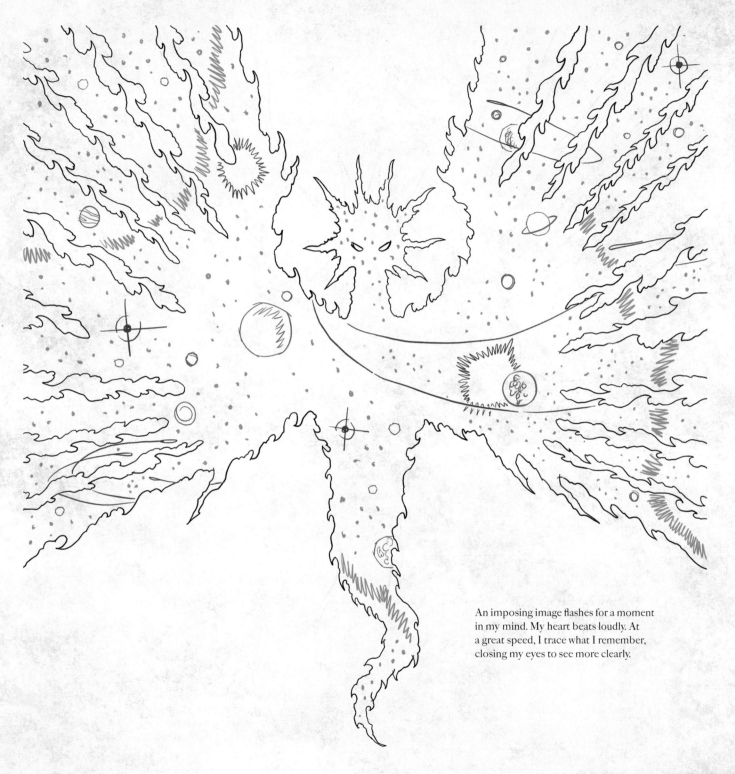

An imposing image flashes for a moment in my mind. My heart beats loudly. At a great speed, I trace what I remember, closing my eyes to see more clearly.

Special Effects

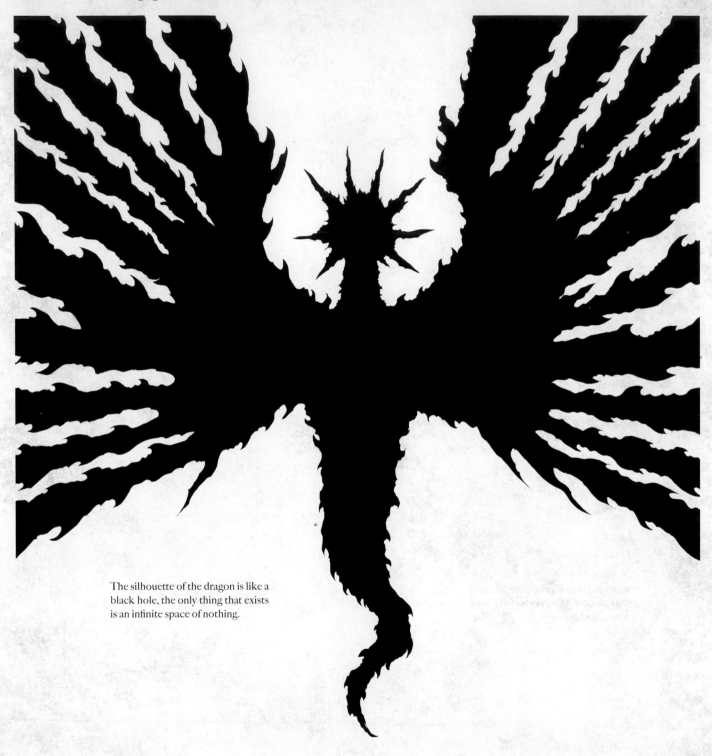

The silhouette of the dragon is like a
black hole, the only thing that exists
is an infinite space of nothing.

I start to clearly visualize the outlines of the planets. Thousands of different planets bubbling with life.

Base Color

I express the planets with different colors, trying to shape my visions into physical forms.

The lights and shadows are
essential for giving them
spherical appearances.

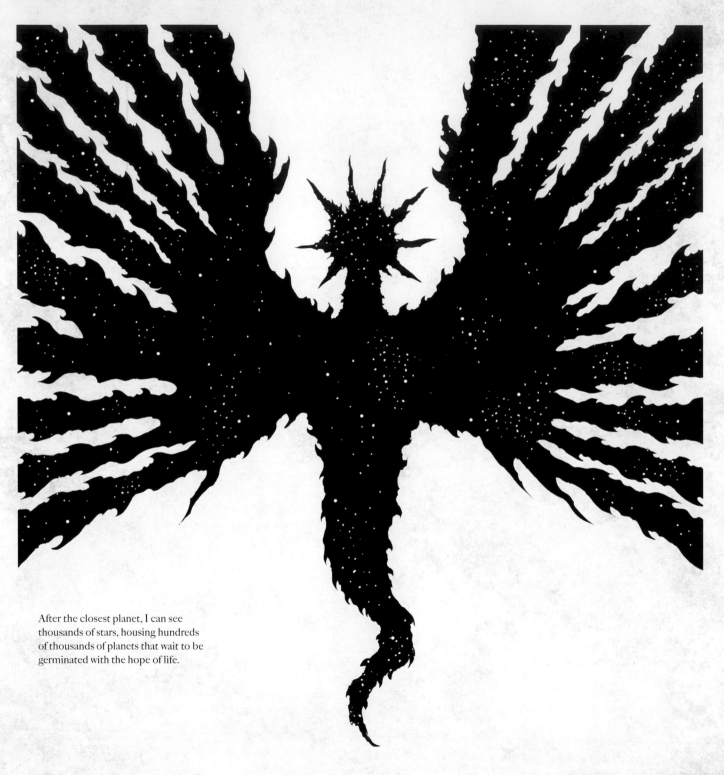

After the closest planet, I can see
thousands of stars, housing hundreds
of thousands of planets that wait to be
germinated with the hope of life.

I pass nebulae of great beauty,
hearing their universal melody.

I am illuminated by yellow suns and red giants.
In the white dwarfs, the novas stop their
explosions so I can observe their beauty.

I can see the trail of shooting stars, which immediately disappears—the trail of comets as old as the universe, lines of energy that link faraway galaxies.

Eyes of the Dragon

I catch explosions of incomprehensible energies, which I draw with irregular circles surrounded by small stripes. Two eyes watch from above as if they are able to see everything.

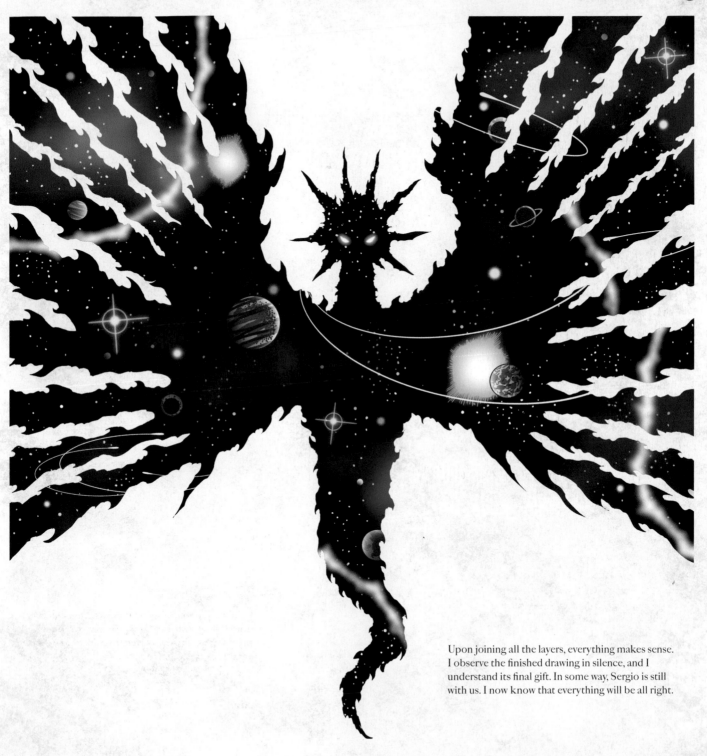

Upon joining all the layers, everything makes sense. I observe the finished drawing in silence, and I understand its final gift. In some way, Sergio is still with us. I now know that everything will be all right.

Epilogue

For three days on Earth, a white light, coming from beyond the Sun, illuminates the whole planet at once. Three days pass without night, during which the Üru dragons are called back together with the primordial energy while the dark dragons are vaporized upon contact with the light of absolute purity.

For a short period of time, the memory of the dragons will remain in the minds of men. Afterward, it will be no more than an echo of a myth that will be passed on from generation to generation, becoming old legends and children's stories, awaiting the return of the dragons.